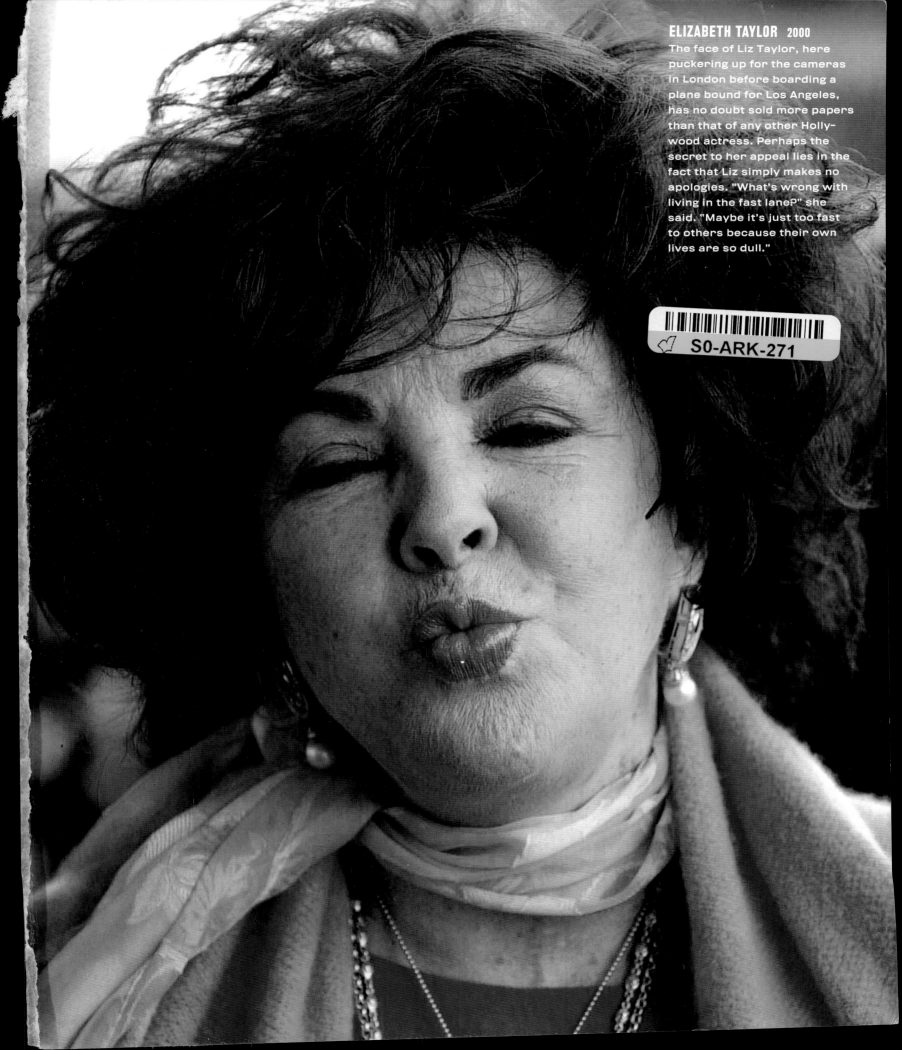

ELIZABETH TAYLOR 2000
The face of Liz Taylor, here puckering up for the cameras in London before boarding a plane bound for Los Angeles, has no doubt sold more papers than that of any other Hollywood actress. Perhaps the secret to her appeal lies in the fact that Liz simply makes no apologies. "What's wrong with living in the fast lane?" she said. "Maybe it's just too fast to others because their own lives are so dull."

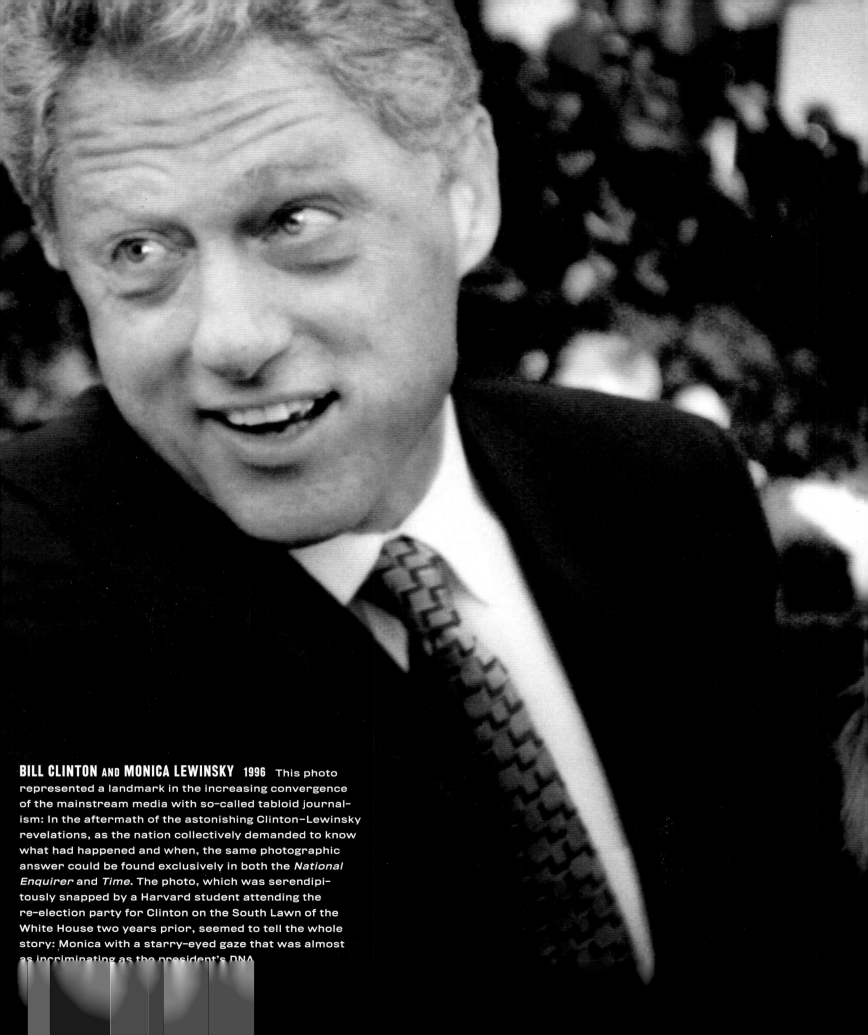

BILL CLINTON AND **MONICA LEWINSKY** 1996 This photo represented a landmark in the increasing convergence of the mainstream media with so-called tabloid journalism: In the aftermath of the astonishing Clinton–Lewinsky revelations, as the nation collectively demanded to know what had happened and when, the same photographic answer could be found exclusively in both the *National Enquirer* and *Time*. The photo, which was serendipitously snapped by a Harvard student attending the re-election party for Clinton on the South Lawn of the White House two years prior, seemed to tell the whole story: Monica with a starry-eyed gaze that was almost as incriminating as the president's DNA.

THE NATIONAL
ENQU

THIRTY YEARS OF UNFORGETTABLE IMAGES

Photography edited by Charles Melcher and Valerie Virga

Introduction by Steve Coz

Text by David Keeps

Afterword by Jonathan Mahler

PRODUCED BY MELCHER MEDIA, INC.

talk miramax books

HYPERION

NEW YORK

This book was produced by Melcher Media, Inc.,
55 Vandam Street, New York, NY 10013, under the
editorial direction of Charles Melcher.

Project Editor: Lia Ronnen

Senior Editor: Duncan Bock

Text Editor: Tim Moss

Production Director: Andrea Hirsh

Editorial Assistants: Andrew Ackermann and Megan Worman

Additional captions by Michael Hainey

Melcher Media would like to thank Farley Chase, Kristin
Powers, and everyone else at Talk Miramax Books, Jonathan
Craven, Tommy Dunne, Carole Goodman, Ruby Huang, Lance
Loud, Janie Matthews, Claire McConaughy, Chris Parry,
Stephen V. Saban, and Gillian Sowell. Special thanks to David
Pecker and John Hughes.

The *National Enquirer* would like to thank all of the photogra-
phers, editors, and reporters who have contributed their time
and energy to the paper throughout the last thirty years.
Special thanks to Sally Boyd. Additional thanks to Anita Eby,
Vincent Eckersley, Ray Fairall, Bill Graham, Jim Johnston,
Stephanie Keiper, Theresa Nettles, Kim Riendeau, Edith
Schorah, Ed Sigall, Chris Visoke, and Mike Vohmann.

ISBN 0-7868-6848-1

Library of Congress Cataloging-in-Publication Data is available
upon request.

Printed in China

First Edition

10 9 8 7 6 5 4 3 2 1

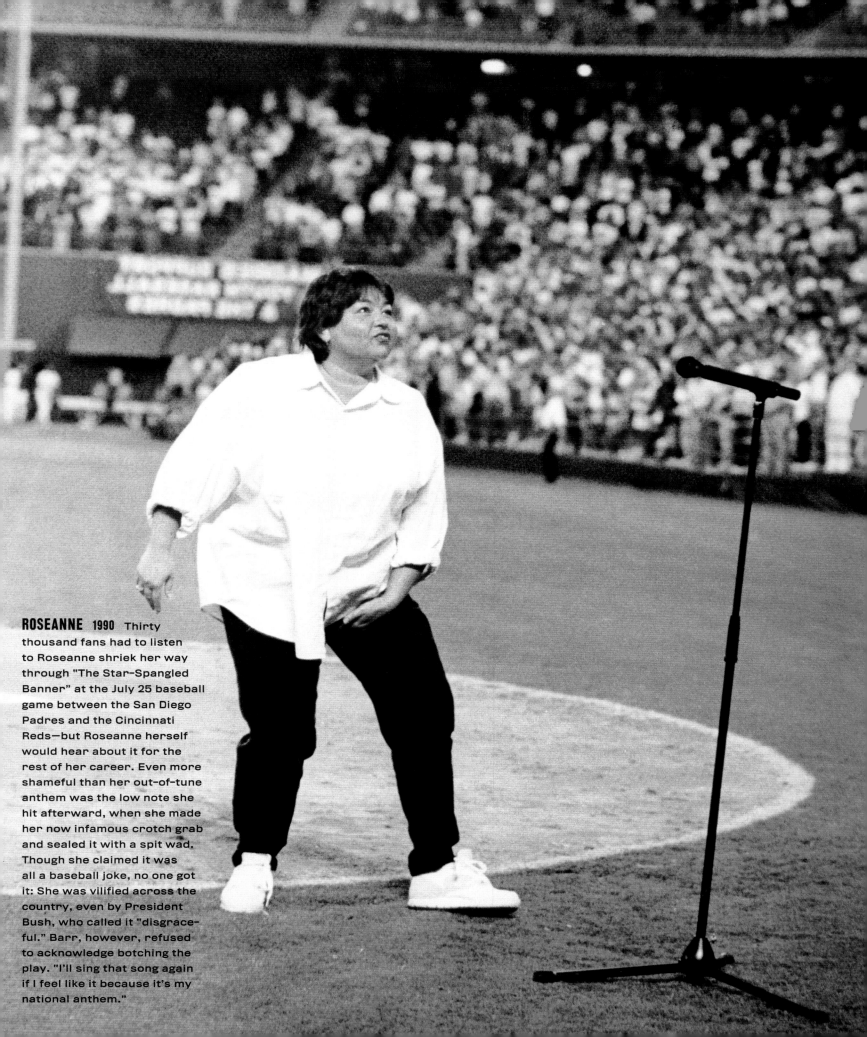

ROSEANNE 1990 Thirty thousand fans had to listen to Roseanne shriek her way through "The Star-Spangled Banner" at the July 25 baseball game between the San Diego Padres and the Cincinnati Reds—but Roseanne herself would hear about it for the rest of her career. Even more shameful than her out-of-tune anthem was the low note she hit afterward, when she made her now infamous crotch grab and sealed it with a spit wad. Though she claimed it was all a baseball joke, no one got it: She was vilified across the country, even by President Bush, who called it "disgraceful." Barr, however, refused to acknowledge botching the play. "I'll sing that song again if I feel like it because it's my national anthem."

INTRODUCTION

I DID A BAD, BAD THING.

Two years out of Harvard, I stood on a cold street corner in Gary, Indiana, on a wacked-out assignment with $2,000 stuffed in my pockets and a stack of legal contracts in one numb hand. I was desperately trying to convince total strangers to sell their souls to the devil for twenty dollars. So far I had netted five different deals, signatures and all, and handed over five crisp twenty-dollar bills.

What *was* I doing?

Four years of schooling at a Benedictine monastery (complete with swinging incense and mute monks), a cum laude diploma in classics and literature from Harvard, even summers in Nantucket, and now here I was, a *National Enquirer* reporter looking for a story in depressed Gary, wondering how long it would take somebody to figure out that I was a dumb white guy overburdened with cash.

Then one man walked up and not only sold his soul for the twenty bucks, but he sold his brother's, his grandma's, his dad's, his mom's—and his last name was Goodson. Oh, Baby! Welcome to the world of the *National Enquirer*.

* * *

The first day I arrived at the *Enquirer*'s Florida headquarters in 1981, I walked across a scruffy ball field into a low-slung, seemingly quiet building. But once inside the doors, I could feel a strange, sometimes awful, energy pressing against my skin. Stressed-out, hardened celebrity journalists, many with British accents, scurried across the thin carpet of the newsroom. Photographs were piled high on metal desks. Old black rotary phones rang incessantly. Stale cigarette smoke filled the air. The whole building was maniacally possessed by one thought: Get the story, get the photo—or get fired.

Generoso Pope, the founder of the *National Enquirer*, was the single-minded and tyrannical force behind the *Enquirer*'s focus. To many people in the outside world, and certainly to the Hollywood community that he ordered his reporters to cover relentlessly, he was a feared and evil genius. But he was also an eccentric man with bushy eyebrows, shuffling around a near-empty office building on a Saturday morning in his trademark slippers and graying pajama shorts.

GP, as he was called by the staff, had brought the *Enquirer* remarkable success since he purchased it in 1952. His premise was simple: What image—even if they don't want to admit it—does the American public most want to see? What secret does Martha in Kansas City really want to know?

And here in a sleepy little coastal town in South Florida, like the giant Dr. T. J. Eckleburg billboard from *The Great Gatsby*, sat the *National Enquirer*, slavishly devoted to answering those questions.

And answer them it did. The *Enquirer* pioneered a brand of celebrity journalism that had driven circulation from 17,000 to an unheard-of six and a half million copies by the late '70s—capped by the publication of the infamous page-one photograph of dead Elvis in his coffin. It unabashedly splashed emotions across its pages like an eager child with an over-filled bucket of bright paint.

Along the way, the *Enquirer*'s focus on celebrity news had spawned a whole industry. By the '80s several other tabloids had sprung up to copy its success. Time, Inc., held a closed-door meeting in the early '70s and, with the *Enquirer* as their model, launched *People* magazine. A rash of TV tabloid shows started filling the airways. But through it all, and to this day, there was, and is, only one *National Enquirer*.

Over the last thirty years, the *National Enquirer* has reflected the American public's changing, sometimes confused, relationship with celebrity like no other publication. The most vital element of that relationship is the photographs. There are literally millions of them in the archives. And the most dramatic, enduring, and definitive images, some of them never before published, are captured here. Each picture speaks to us in a different way—some are glamorous, others damning, some funny, some tragic—but each one is irrepressibly alive. Viewed together, these photographs take the reader on a journey through a kaleidoscope of human emotions and reveal interesting, sometimes uncomfortable, truths about a culture wrapped up in a love/hate relationship with celebrity and the media that covers it.

What is it about the *National Enquirer* that makes it so unique and so powerful? What is it that makes people and the press react so viscerally to it?

The *Enquirer* fills the needy psyche of an American society caught in a tortured love affair with celebrity. We love to feel part of this lifestyle—the privilege, the money, the mansions—but at the same time we want to know that there is a price, that after the glory comes the fall, the drugs, the scandal, the divorce, the murder. We feel guilty for wanting to see the famous fail, and when they do, we most often want to see them rise back up to new heights of glamour and fame.

Among the images in this book, there is a photo of a shining Liza Minnelli stepping out of a limousine onto the red carpet at a glamorous Hollywood reception. There's also a photograph of Liza bloated, wheelchair bound, sad—and alone. These are the two sides of the coin of celebrity: the success and the tragedy. And the public wants it all.

When the *Enquirer* is on a story, it is relentless. And sometimes, like a giant boulder gathering speed as it rolls down a hill, it doesn't realize how damaging it can be. But when this force is focused on a major news story, the results can be astonishing.

A perfect example is the O.J. Simpson trial. We had done a hell of a job covering the murder case. In fact, we had astounded the "mainstream" press. Reporters from around the world came to our headquarters to do elaborate pieces on our news gathering and our seemingly endless supply of stunning photographs. A Japanese crew filmed us over two days, ever so politely asking us to please wear the same clothes on the second day so their viewers would not be confused. (The Japanese crew showed up in their same rumpled clothes the next day, too—and bearing gifts.) The *Enquirer* had been praised by the *New York Times* and had been on every major network. Our reporters were continual guests on TV news shows. We were no longer the whipping boys for the rest of the media. When I went to the O.J. courtroom, strangers asked for my autograph. We were tied to the O.J. murder case like no other publication in the world.

And when the criminal verdict came down "not guilty," the entire newsroom was silent. Hard-bitten journalists had tears in their eyes. All that work, it seemed, for nothing.

Weeks later, I was sitting in my office while a violent thunderstorm brewed outside. The newsroom hadn't been the same since the end of the O.J. case—our spirits had completely sunk. Suddenly, a strange ball of blue and white lightning came through the window behind me. It traveled slowly down the right-hand wall, slapped and whipped at my computer, then my phone, and continued on until it reached a potted fig tree in the corner, where it disappeared.

My phone and computer were fried. My right hand was tingling, my teeth and knees ached. The newsroom and my fellow editors who witnessed it, a group of people with a healthy respect for the bizarre, were wide-eyed. We knew there must be a scientific explanation for this, but we didn't care. We took it as a sign; we needed to.

Three weeks later, we uncovered the damning photo we had been searching for since the beginning of the trial: O.J. wearing the Bruno Magli murder shoes. O.J. had repeatedly and publicly denied ever owning a pair of these shoes. These very shoes had left bloody footprints all around his wife Nicole's nearly decapitated body.

We published the picture, and it resulted in a $33 million judgment against O.J. for wrongful death in the civil court case.

When chasing a news event that is truly larger than life, the *Enquirer* is at its best. There is a cleanness to the *Enquirer* then. It can uncover magical photos that are enduring and telling, such as those in the JonBenet murder case, the Jesse Jackson love-child story, the Clinton and Monica scandal—or the famous image of Donna Rice sitting on presidential contender Gary Hart's lap.

The paper is happiest then. And the public, the celebrities, and the media are happiest with us. There is no queasy questioning of our role in the media, and there is no questionable intrusion into private moments.

The *Enquirer* is no longer in the low-slung building. GP has been dead for more than a decade. I work in front of a turbo-powered computer, in a sparkling new office building that houses ten different magazines. We have our own TV production studio and a booming Internet site. British accents are hard to find. There is no smell of stale cigarettes. The carpet is color coordinated to match the furniture. The walls are adorned with awards and photos.

Twenty years ago, when I started at the *Enquirer*, I had a severe handicap. To me, the difference between Liz and Liza was the letter "a." I didn't know who they were, I didn't care who they were, and I couldn't understand how people could care who they were. But through the *Enquirer* and its photographs, I now understand. There is a real-life movie taking place in Hollywood, across America, and sometimes beyond—complete with the heroic, the triumphant, the tragic, the unthinkable, and the absurd. It is a movie that never ends.

And the pictures capture that movie, frame after frame.

—STEVE COZ

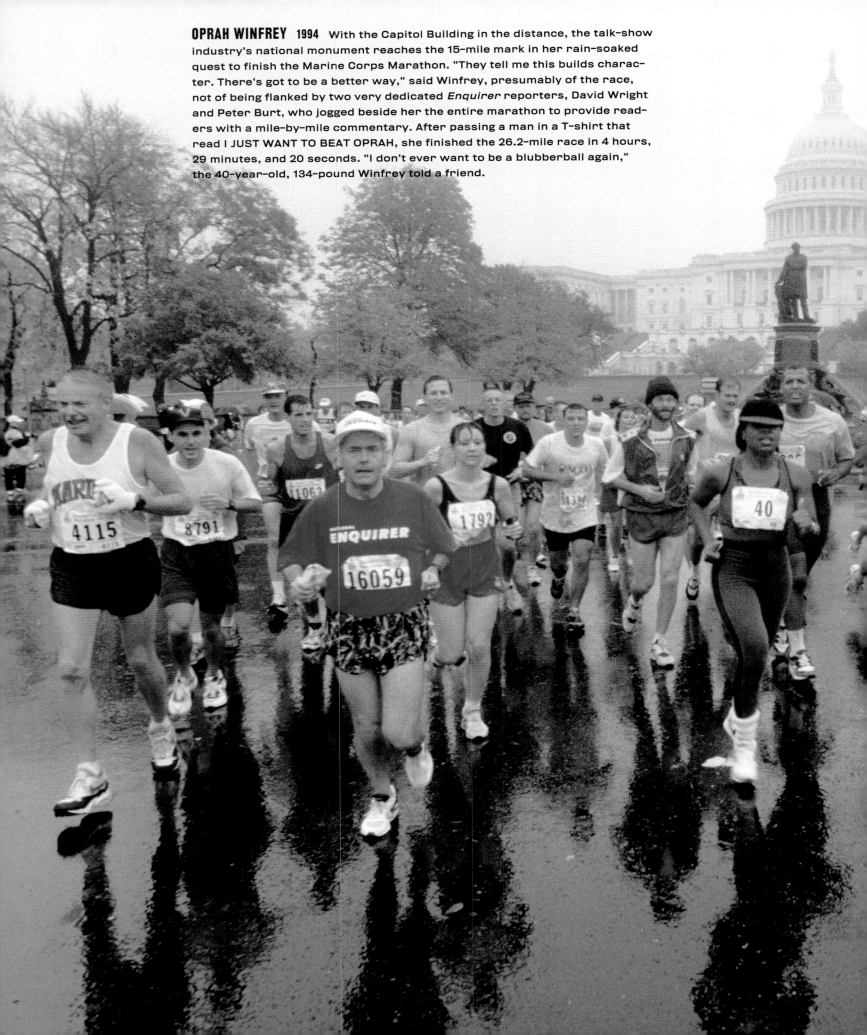

OPRAH WINFREY **1994** With the Capitol Building in the distance, the talk-show industry's national monument reaches the 15-mile mark in her rain-soaked quest to finish the Marine Corps Marathon. "They tell me this builds character. There's got to be a better way," said Winfrey, presumably of the race, not of being flanked by two very dedicated *Enquirer* reporters, David Wright and Peter Burt, who jogged beside her the entire marathon to provide readers with a mile-by-mile commentary. After passing a man in a T-shirt that read I JUST WANT TO BEAT OPRAH, she finished the 26.2-mile race in 4 hours, 29 minutes, and 20 seconds. "I don't ever want to be a blubberball again," the 40-year-old, 134-pound Winfrey told a friend.

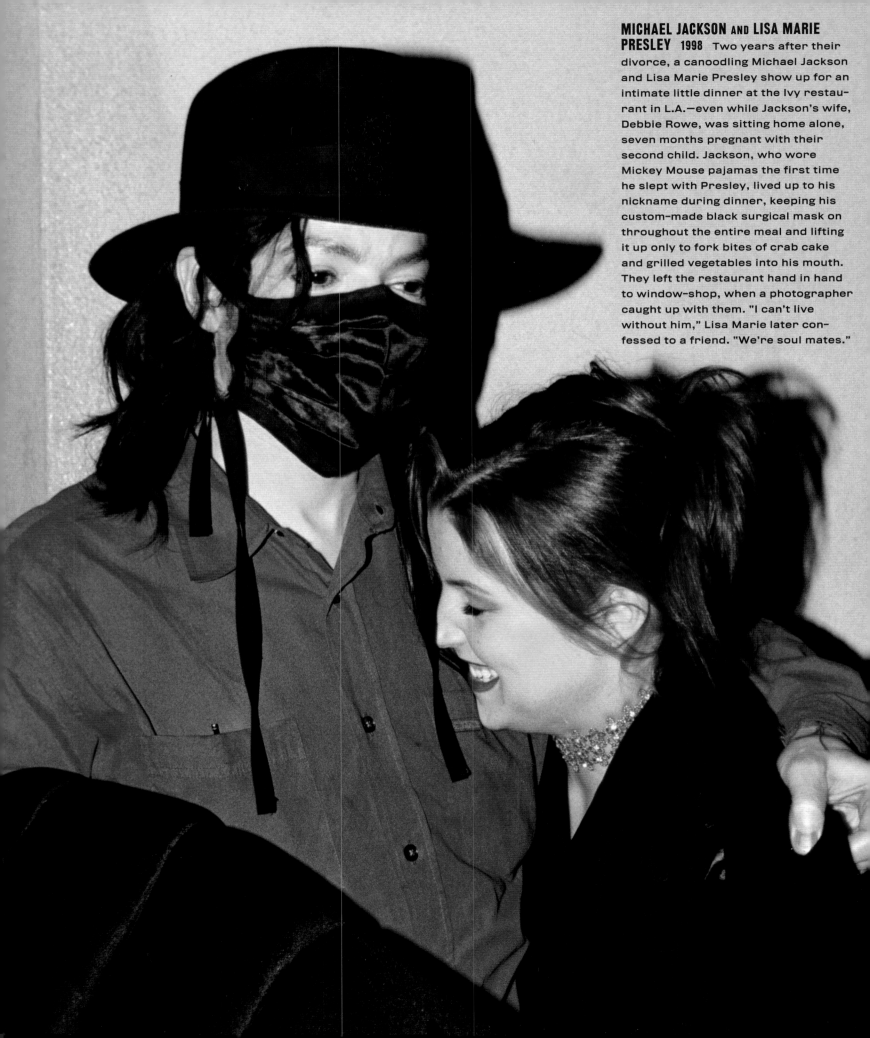

MICHAEL JACKSON AND LISA MARIE PRESLEY 1998 Two years after their divorce, a canoodling Michael Jackson and Lisa Marie Presley show up for an intimate little dinner at the Ivy restaurant in L.A.—even while Jackson's wife, Debbie Rowe, was sitting home alone, seven months pregnant with their second child. Jackson, who wore Mickey Mouse pajamas the first time he slept with Presley, lived up to his nickname during dinner, keeping his custom-made black surgical mask on throughout the entire meal and lifting it up only to fork bites of crab cake and grilled vegetables into his mouth. They left the restaurant hand in hand to window-shop, when a photographer caught up with them. "I can't live without him," Lisa Marie later confessed to a friend. "We're soul mates."

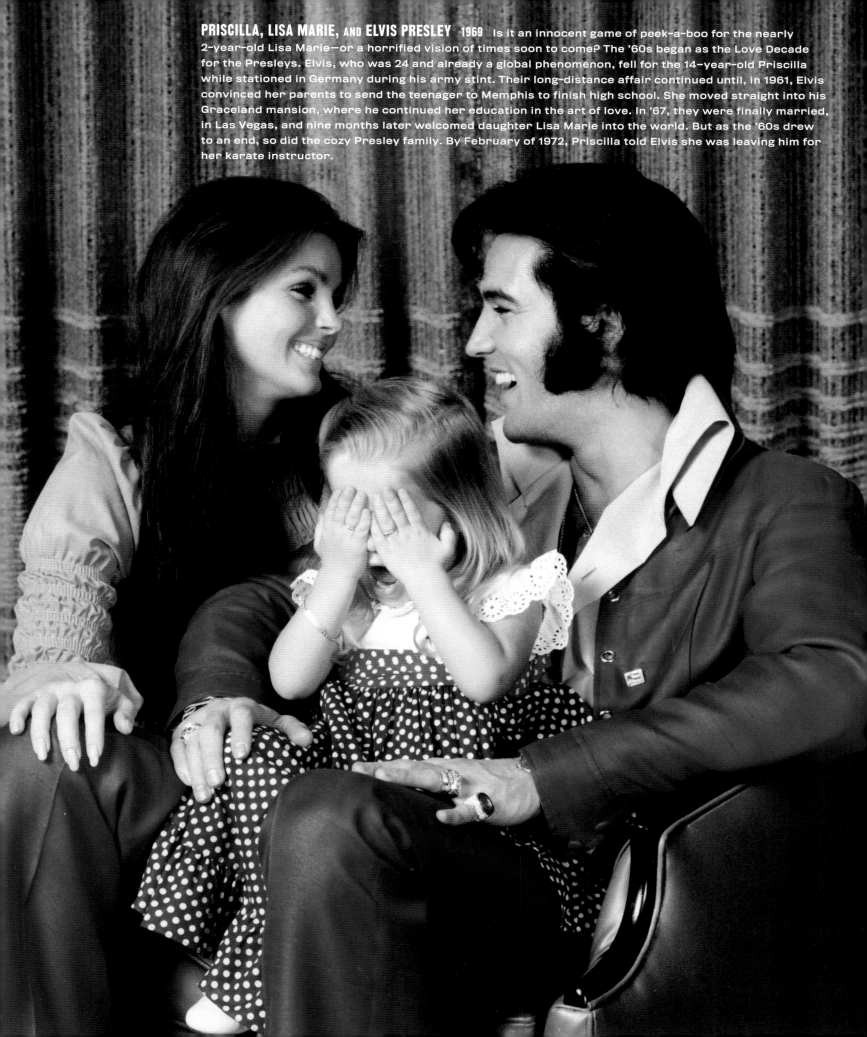

PRISCILLA, LISA MARIE, AND ELVIS PRESLEY 1969 Is it an innocent game of peek-a-boo for the nearly 2-year-old Lisa Marie—or a horrified vision of times soon to come? The '60s began as the Love Decade for the Presleys. Elvis, who was 24 and already a global phenomenon, fell for the 14-year-old Priscilla while stationed in Germany during his army stint. Their long-distance affair continued until, in 1961, Elvis convinced her parents to send the teenager to Memphis to finish high school. She moved straight into his Graceland mansion, where he continued her education in the art of love. In '67, they were finally married, in Las Vegas, and nine months later welcomed daughter Lisa Marie into the world. But as the '60s drew to an end, so did the cozy Presley family. By February of 1972, Priscilla told Elvis she was leaving him for her karate instructor.

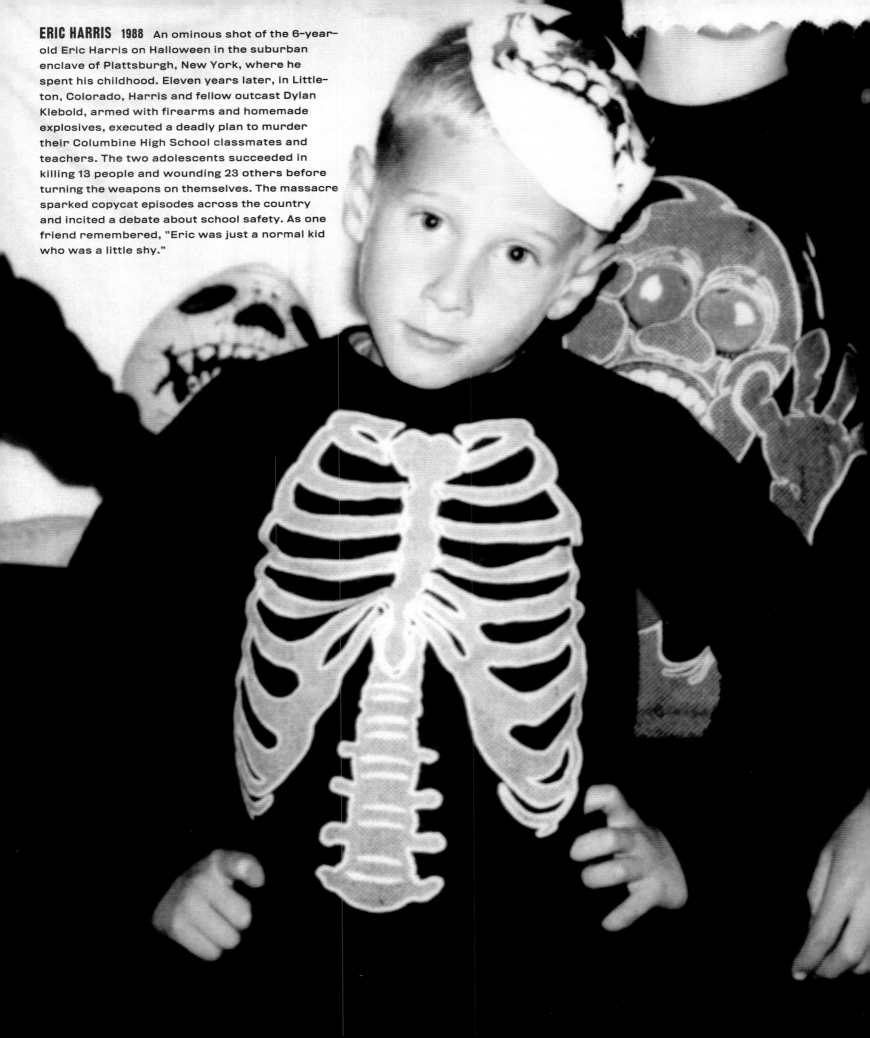

ERIC HARRIS 1988 An ominous shot of the 6-year-old Eric Harris on Halloween in the suburban enclave of Plattsburgh, New York, where he spent his childhood. Eleven years later, in Little-ton, Colorado, Harris and fellow outcast Dylan Klebold, armed with firearms and homemade explosives, executed a deadly plan to murder their Columbine High School classmates and teachers. The two adolescents succeeded in killing 13 people and wounding 23 others before turning the weapons on themselves. The massacre sparked copycat episodes across the country and incited a debate about school safety. As one friend remembered, "Eric was just a normal kid who was a little shy."

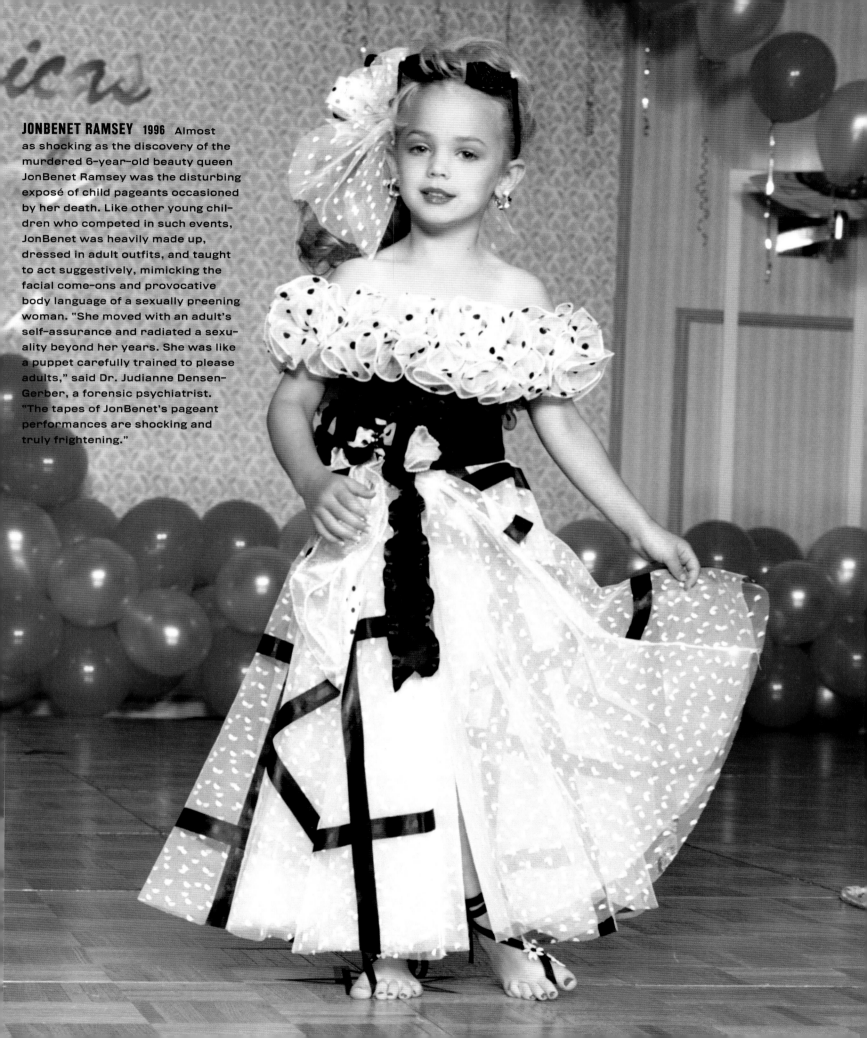

JONBENET RAMSEY 1996 Almost
as shocking as the discovery of the
murdered 6-year-old beauty queen
JonBenet Ramsey was the disturbing
exposé of child pageants occasioned
by her death. Like other young chil-
dren who competed in such events,
JonBenet was heavily made up,
dressed in adult outfits, and taught
to act suggestively, mimicking the
facial come-ons and provocative
body language of a sexually preening
woman. "She moved with an adult's
self-assurance and radiated a sexu-
ality beyond her years. She was like
a puppet carefully trained to please
adults," said Dr. Judianne Densen-
Gerber, a forensic psychiatrist.
"The tapes of JonBenet's pageant
performances are shocking and
truly frightening."

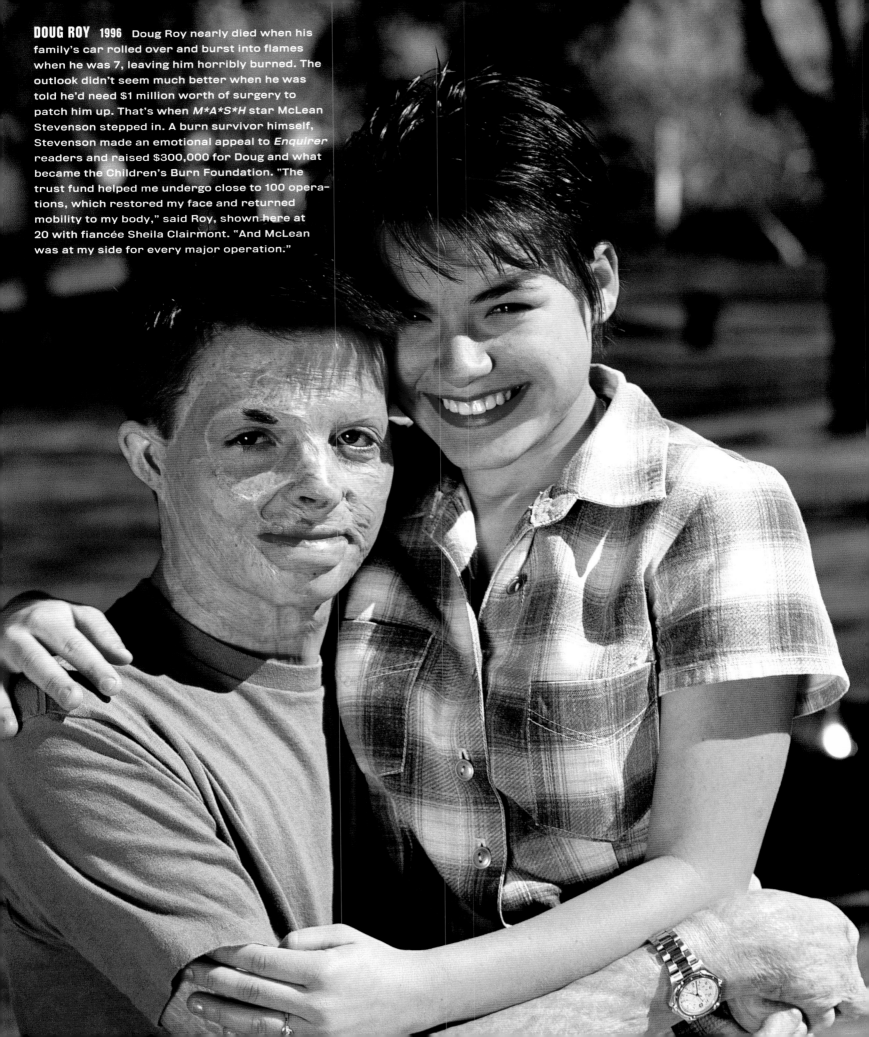

DOUG ROY 1996 Doug Roy nearly died when his family's car rolled over and burst into flames when he was 7, leaving him horribly burned. The outlook didn't seem much better when he was told he'd need $1 million worth of surgery to patch him up. That's when *M*A*S*H* star McLean Stevenson stepped in. A burn survivor himself, Stevenson made an emotional appeal to *Enquirer* readers and raised $300,000 for Doug and what became the Children's Burn Foundation. "The trust fund helped me undergo close to 100 operations, which restored my face and returned mobility to my body," said Roy, shown here at 20 with fiancée Sheila Clairmont. "And McLean was at my side for every major operation."

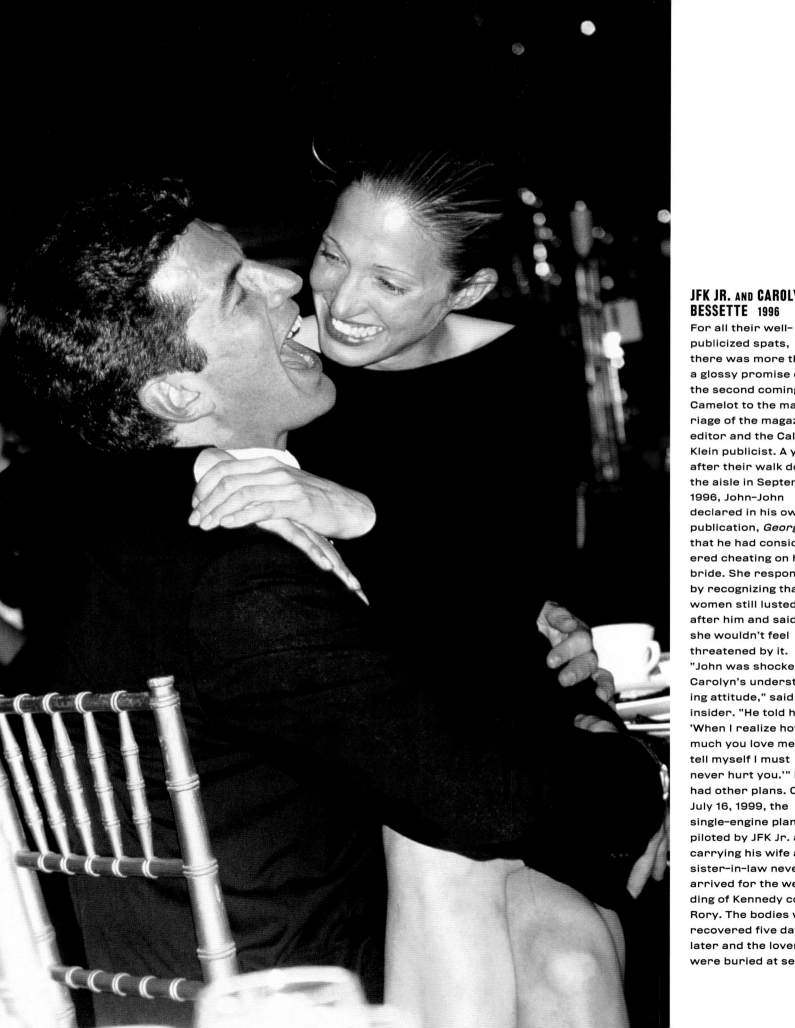

JFK JR. AND CAROLYN BESSETTE 1996

For all their well-publicized spats, there was more than a glossy promise of the second coming of Camelot to the marriage of the magazine editor and the Calvin Klein publicist. A year after their walk down the aisle in September 1996, John-John declared in his own publication, *George,* that he had considered cheating on his bride. She responded by recognizing that women still lusted after him and said she wouldn't feel threatened by it. "John was shocked at Carolyn's understanding attitude," said an insider. "He told her, 'When I realize how much you love me, I tell myself I must never hurt you.'" Fate had other plans. On July 16, 1999, the single-engine plane piloted by JFK Jr. and carrying his wife and sister-in-law never arrived for the wedding of Kennedy cousin Rory. The bodies were recovered five days later and the lovers were buried at sea.

19

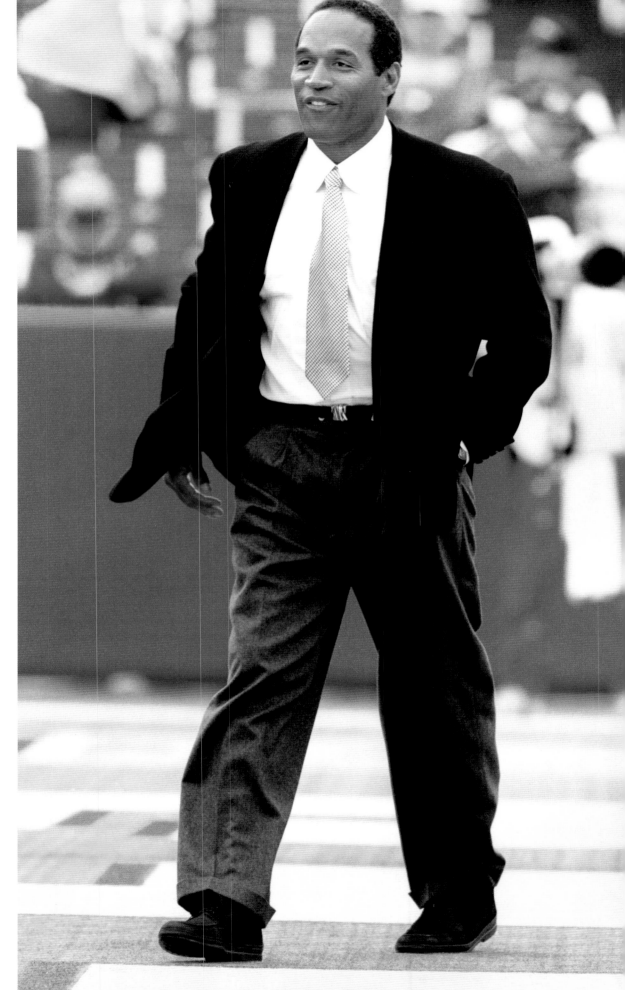

O.J. SIMPSON 1996 The FBI said the murderer of Nicole Brown Simpson and Ron Goldman wore a rare pair of size-12 Bruno Magli shoes, fewer than 300 of which were sold in the United States. Although O.J. Simpson denied ever owning "those ugly-ass shoes," his feet seem to have picked up a pair somewhere, as this 1996 photo taken at a Buffalo Bills football game proved. Although the picture was discovered too late to be used in O.J.'s criminal trial, it was put to good use in the Brown and Goldman families' victorious wrongful-death suits against him, during which his lawyers claimed it was a fake.

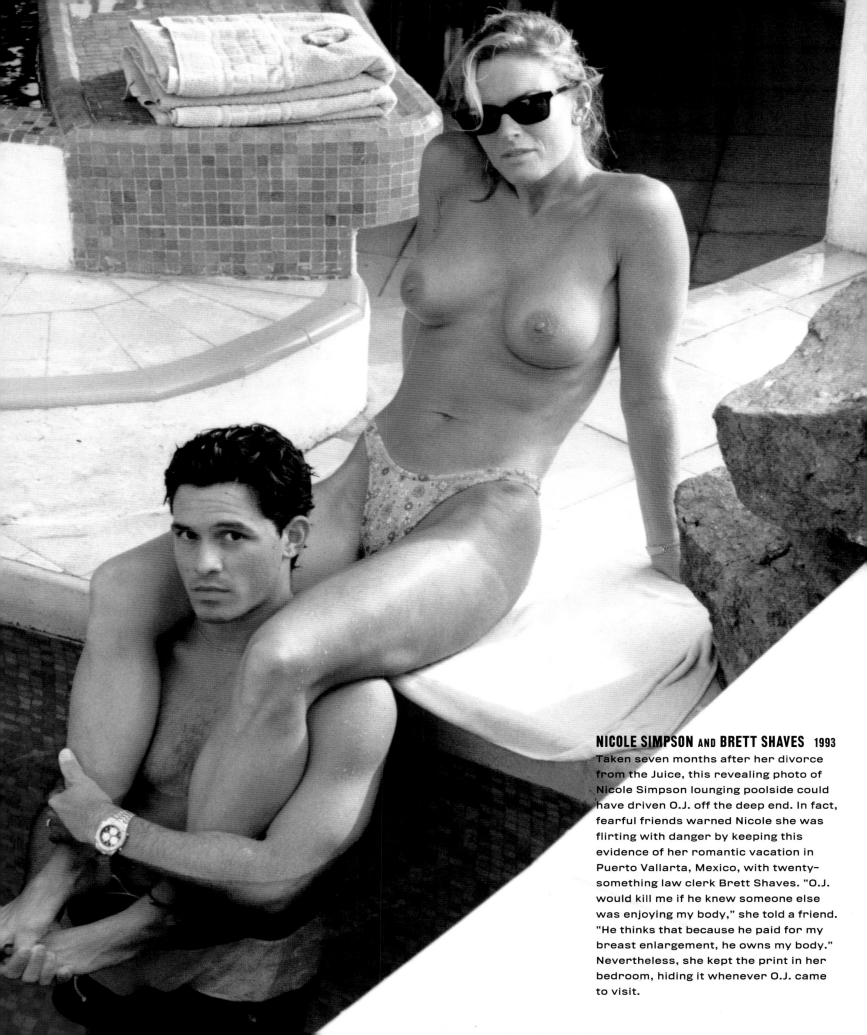

NICOLE SIMPSON AND BRETT SHAVES 1993
Taken seven months after her divorce from the Juice, this revealing photo of Nicole Simpson lounging poolside could have driven O.J. off the deep end. In fact, fearful friends warned Nicole she was flirting with danger by keeping this evidence of her romantic vacation in Puerto Vallarta, Mexico, with twenty-something law clerk Brett Shaves. "O.J. would kill me if he knew someone else was enjoying my body," she told a friend. "He thinks that because he paid for my breast enlargement, he owns my body." Nevertheless, she kept the print in her bedroom, hiding it whenever O.J. came to visit.

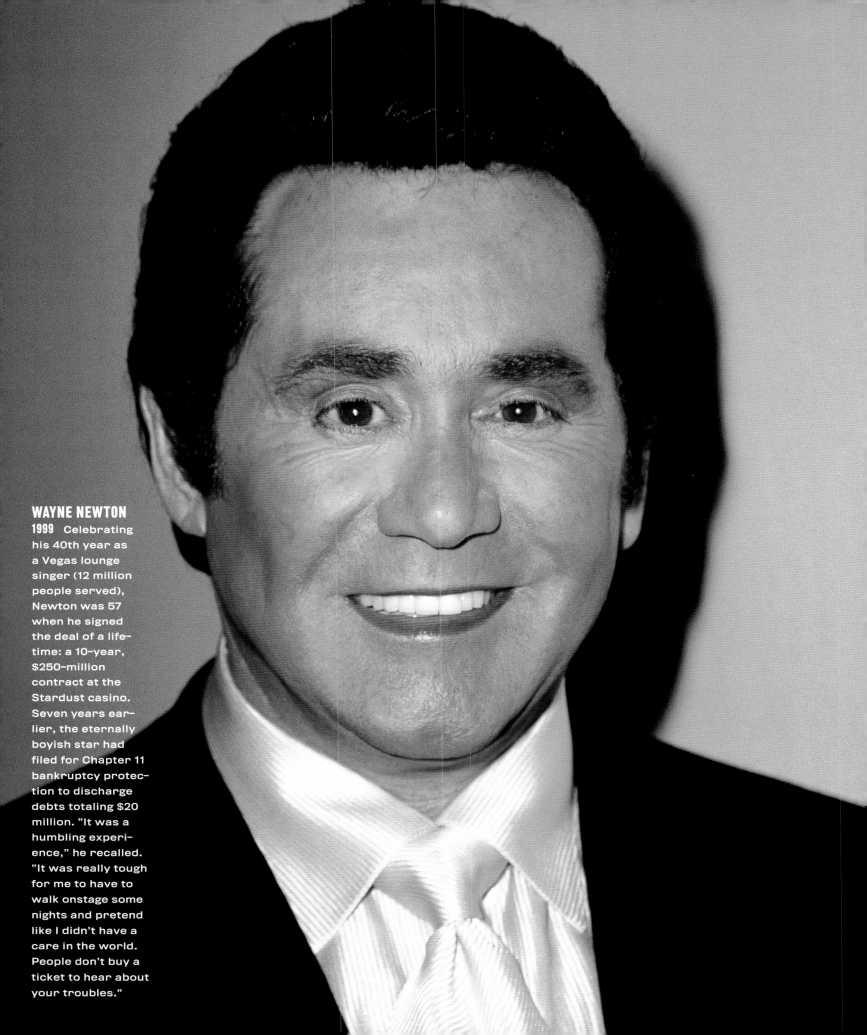

WAYNE NEWTON
1999 Celebrating his 40th year as a Vegas lounge singer (12 million people served), Newton was 57 when he signed the deal of a lifetime: a 10-year, $250-million contract at the Stardust casino. Seven years earlier, the eternally boyish star had filed for Chapter 11 bankruptcy protection to discharge debts totaling $20 million. "It was a humbling experience," he recalled. "It was really tough for me to have to walk onstage some nights and pretend like I didn't have a care in the world. People don't buy a ticket to hear about your troubles."

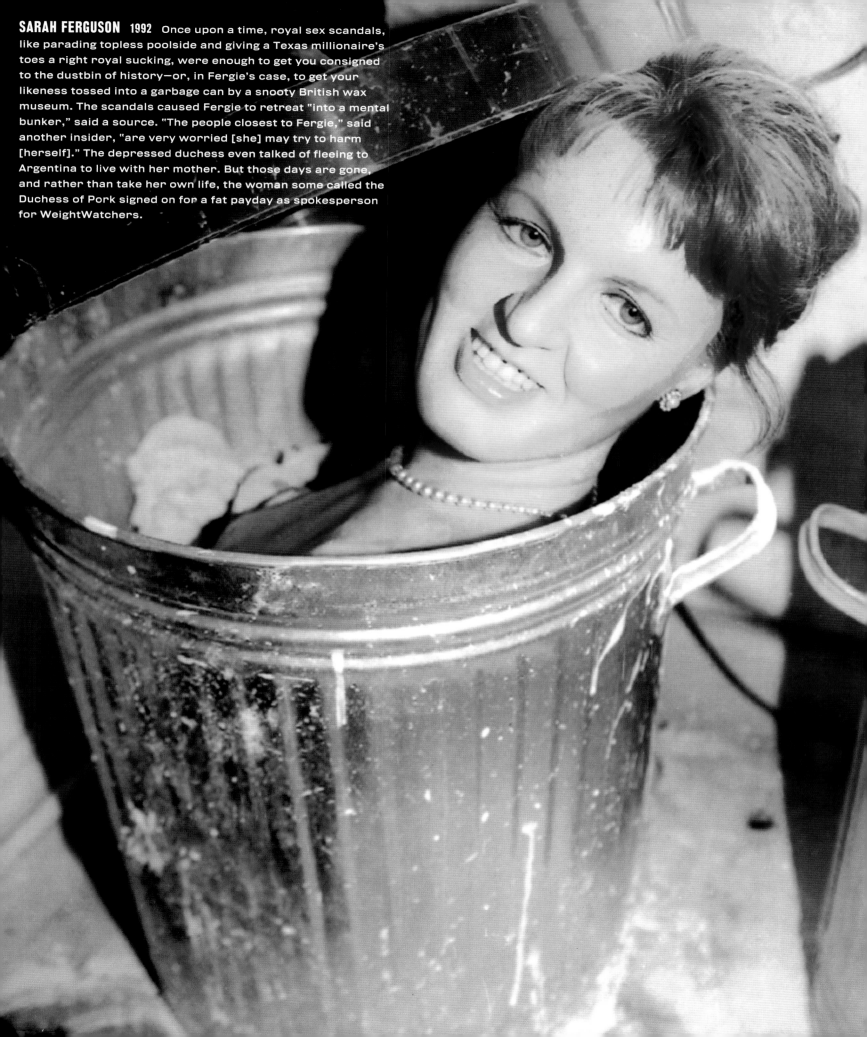

SARAH FERGUSON 1992 Once upon a time, royal sex scandals, like parading topless poolside and giving a Texas millionaire's toes a right royal sucking, were enough to get you consigned to the dustbin of history—or, in Fergie's case, to get your likeness tossed into a garbage can by a snooty British wax museum. The scandals caused Fergie to retreat "into a mental bunker," said a source. "The people closest to Fergie," said another insider, "are very worried [she] may try to harm [herself]." The depressed duchess even talked of fleeing to Argentina to live with her mother. But those days are gone, and rather than take her own life, the woman some called the Duchess of Pork signed on for a fat payday as spokesperson for WeightWatchers.

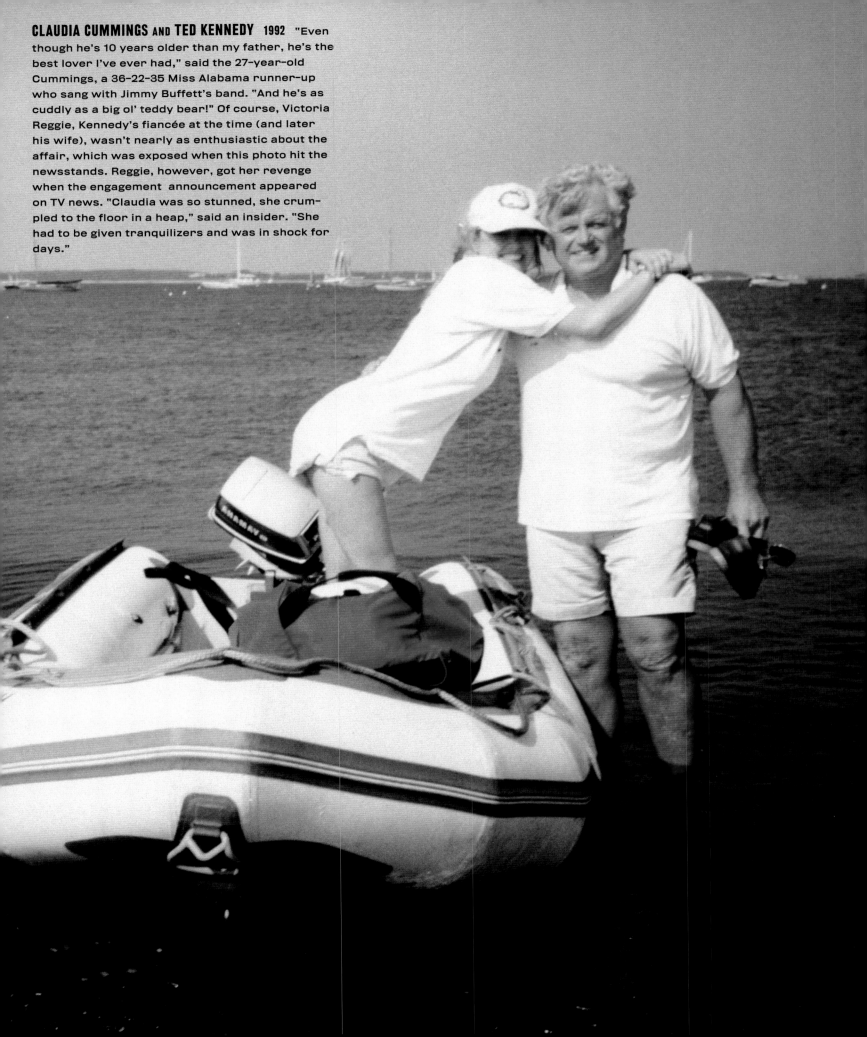

CLAUDIA CUMMINGS AND TED KENNEDY 1992 "Even though he's 10 years older than my father, he's the best lover I've ever had," said the 27-year-old Cummings, a 36-22-35 Miss Alabama runner-up who sang with Jimmy Buffett's band. "And he's as cuddly as a big ol' teddy bear!" Of course, Victoria Reggie, Kennedy's fiancée at the time (and later his wife), wasn't nearly as enthusiastic about the affair, which was exposed when this photo hit the newsstands. Reggie, however, got her revenge when the engagement announcement appeared on TV news. "Claudia was so stunned, she crumpled to the floor in a heap," said an insider. "She had to be given tranquilizers and was in shock for days."

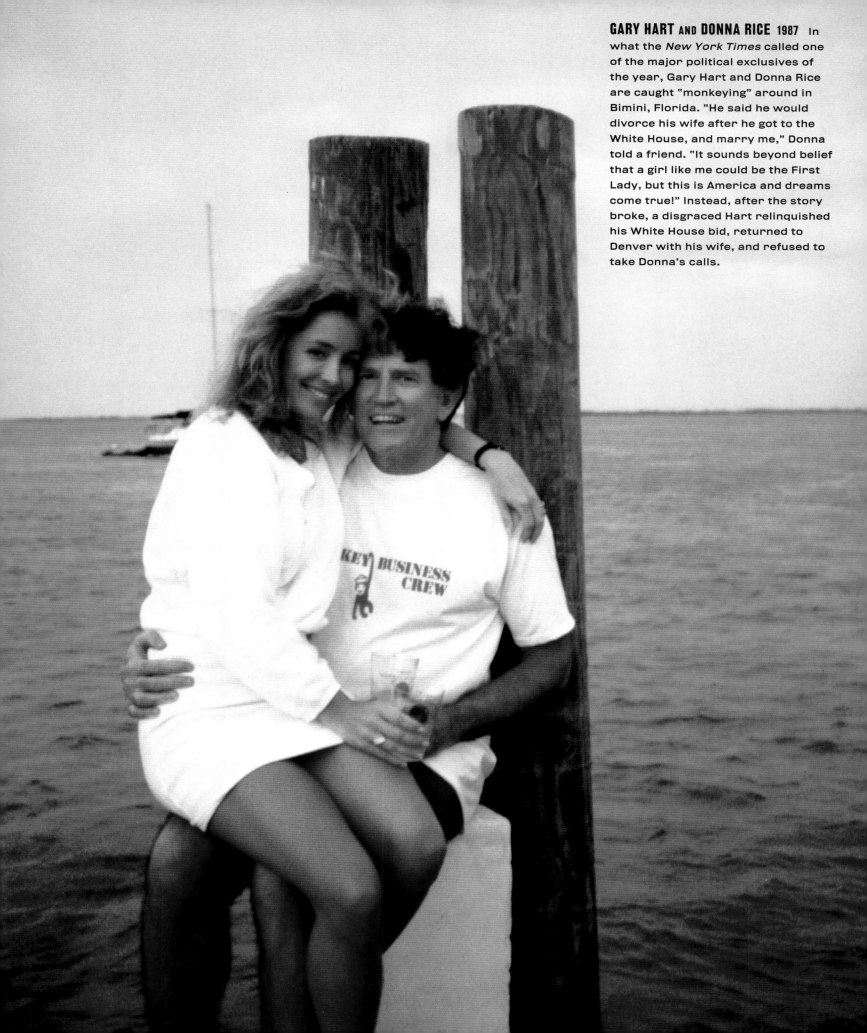

GARY HART AND DONNA RICE 1987 In what the *New York Times* called one of the major political exclusives of the year, Gary Hart and Donna Rice are caught "monkeying" around in Bimini, Florida. "He said he would divorce his wife after he got to the White House, and marry me," Donna told a friend. "It sounds beyond belief that a girl like me could be the First Lady, but this is America and dreams come true!" Instead, after the story broke, a disgraced Hart relinquished his White House bid, returned to Denver with his wife, and refused to take Donna's calls.

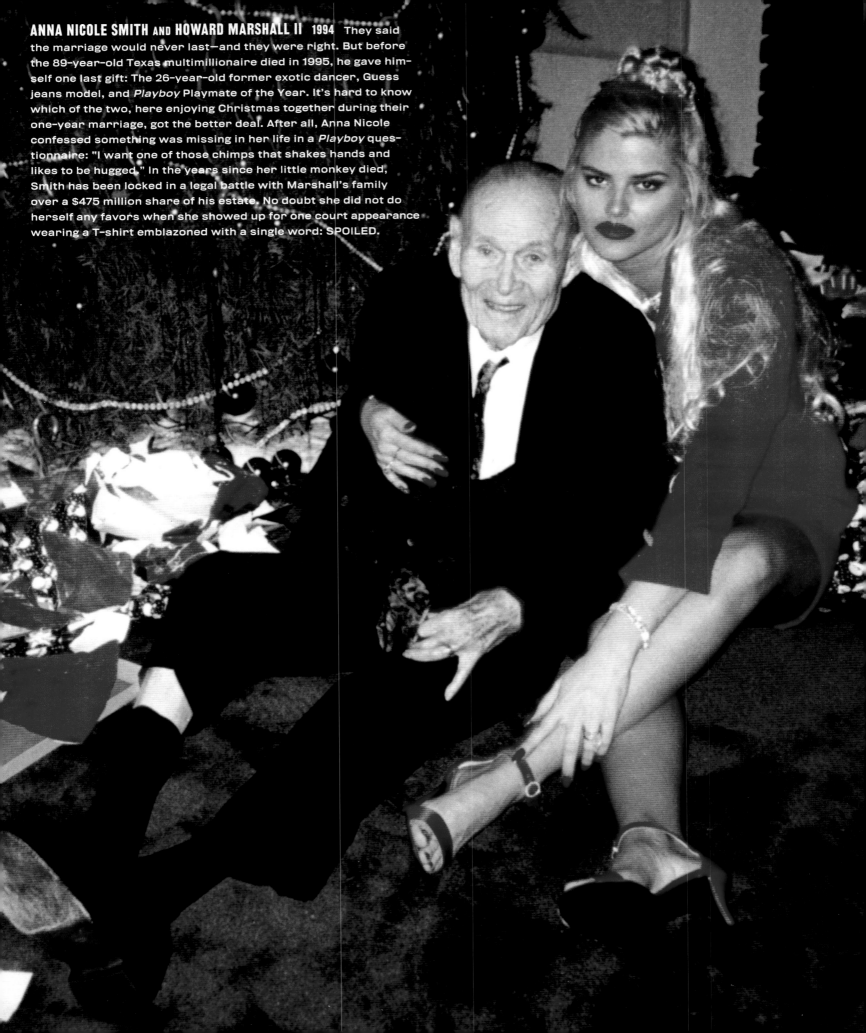

ANNA NICOLE SMITH AND **HOWARD MARSHALL II** 1994 They said the marriage would never last—and they were right. But before the 89-year-old Texas multimillionaire died in 1995, he gave himself one last gift: The 26-year-old former exotic dancer, Guess jeans model, and *Playboy* Playmate of the Year. It's hard to know which of the two, here enjoying Christmas together during their one-year marriage, got the better deal. After all, Anna Nicole confessed something was missing in her life in a *Playboy* questionnaire: "I want one of those chimps that shakes hands and likes to be hugged." In the years since her little monkey died, Smith has been locked in a legal battle with Marshall's family over a $475 million share of his estate. No doubt she did not do herself any favors when she showed up for one court appearance wearing a T-shirt emblazoned with a single word: SPOILED.

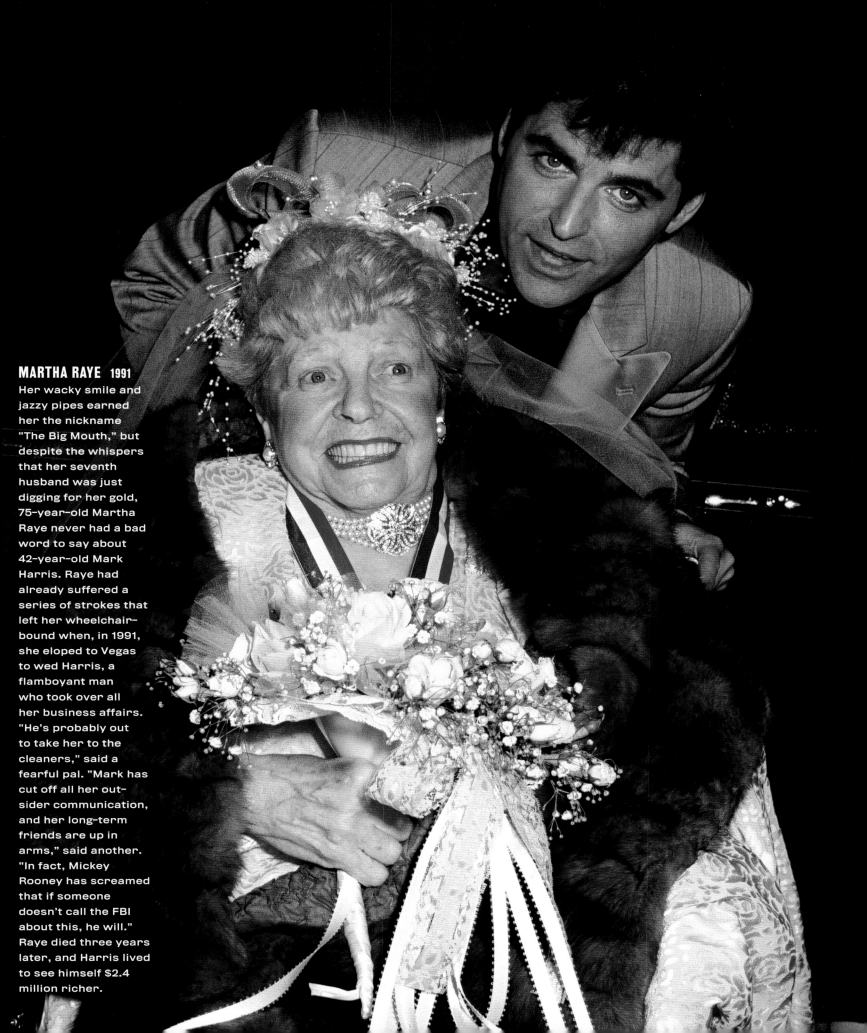

MARTHA RAYE 1991
Her wacky smile and jazzy pipes earned her the nickname "The Big Mouth," but despite the whispers that her seventh husband was just digging for her gold, 75-year-old Martha Raye never had a bad word to say about 42-year-old Mark Harris. Raye had already suffered a series of strokes that left her wheelchair-bound when, in 1991, she eloped to Vegas to wed Harris, a flamboyant man who took over all her business affairs. "He's probably out to take her to the cleaners," said a fearful pal. "Mark has cut off all her outsider communication, and her long-term friends are up in arms," said another. "In fact, Mickey Rooney has screamed that if someone doesn't call the FBI about this, he will." Raye died three years later, and Harris lived to see himself $2.4 million richer.

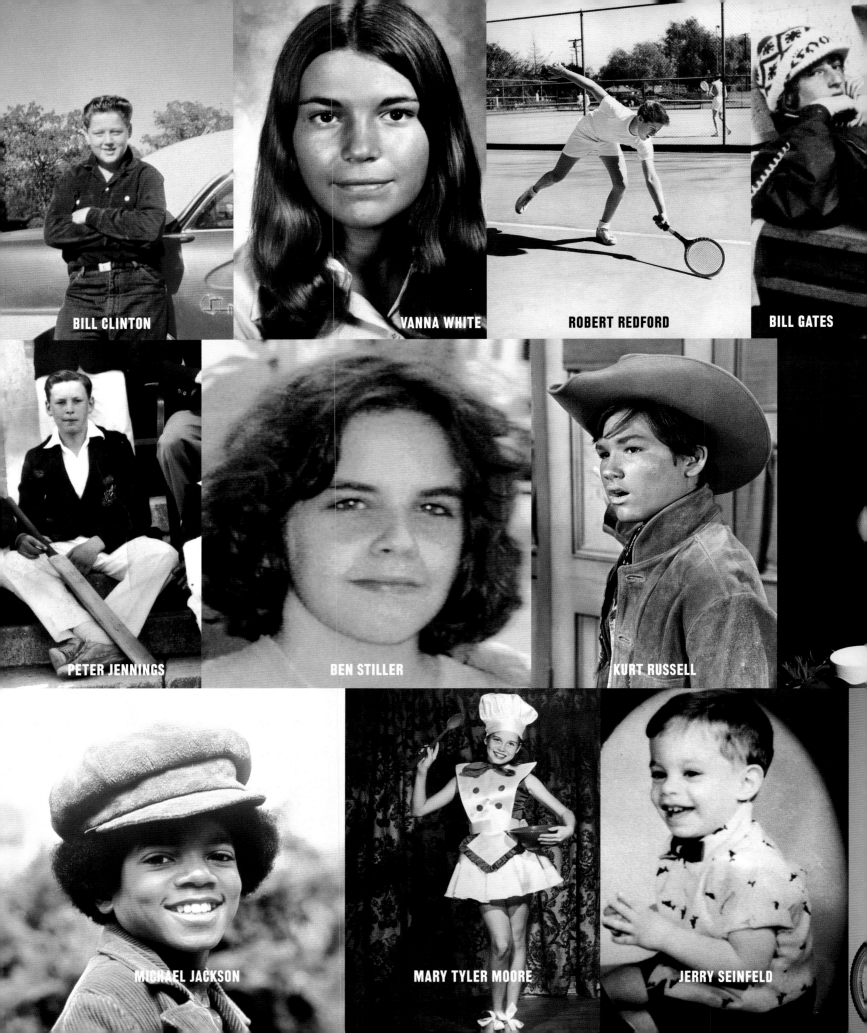

BILL CLINTON

VANNA WHITE

ROBERT REDFORD

BILL GATES

PETER JENNINGS

BEN STILLER

KURT RUSSELL

MICHAEL JACKSON

MARY TYLER MOORE

JERRY SEINFELD

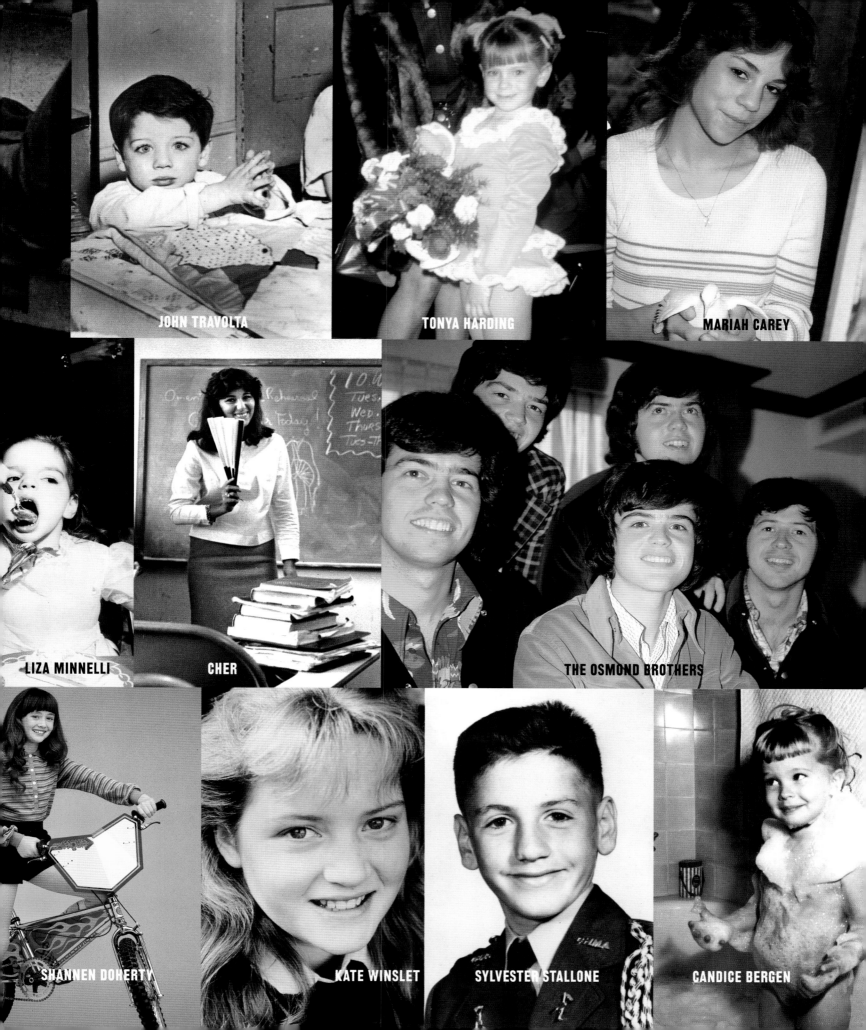

JOHN TRAVOLTA

TONYA HARDING

MARIAH CAREY

LIZA MINNELLI

CHER

THE OSMOND BROTHERS

SHANNEN DOHERTY

KATE WINSLET

SYLVESTER STALLONE

CANDICE BERGEN

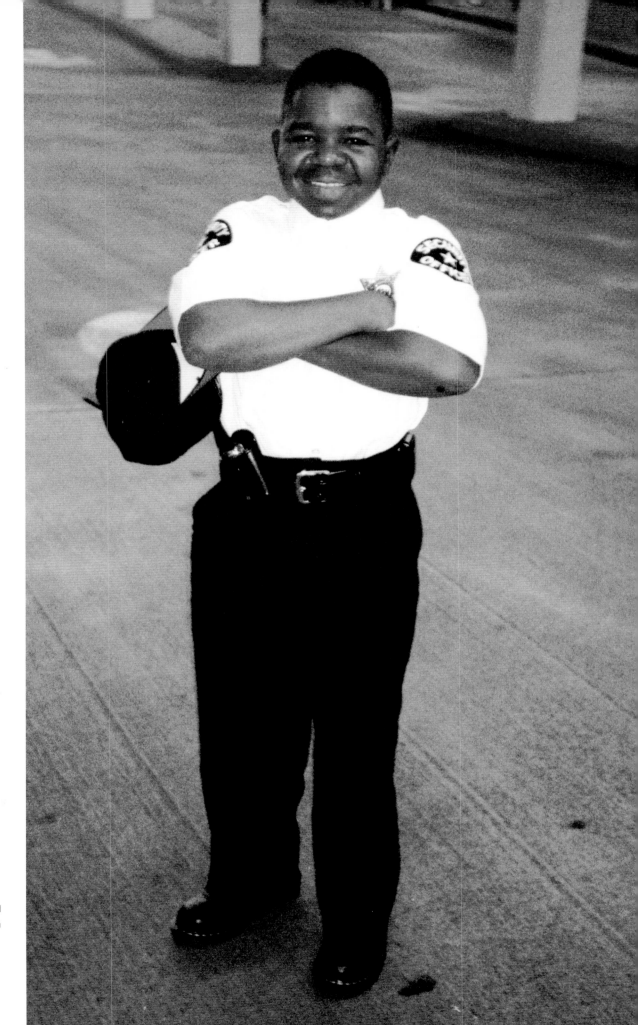

GARY COLEMAN 1998 Twelve years after starring on *Diff'rent Strokes,* the still tiny 30-year-old was discovered (despite the nametag that read WAYNE) working on the set of the film *The Other Sister* as a lowly security guard. "When I first saw Gary come on the set dressed in a security uniform, I thought he had to be appearing in the movie," reported a witness. Though Coleman, once the highest-paid child actor on TV, was reduced to a puny $7- to $8-per-hour gig, he wasn't embarrassed. "I've done this before," he said. "At least it pays the bills." The humiliation would come later: While shopping for a bulletproof vest, the 95-pound Coleman allegedly punched a 170-pound female bus driver. Coleman told his arresting officer the woman had complained about the autograph he'd given her and accused him of being a failed actor.

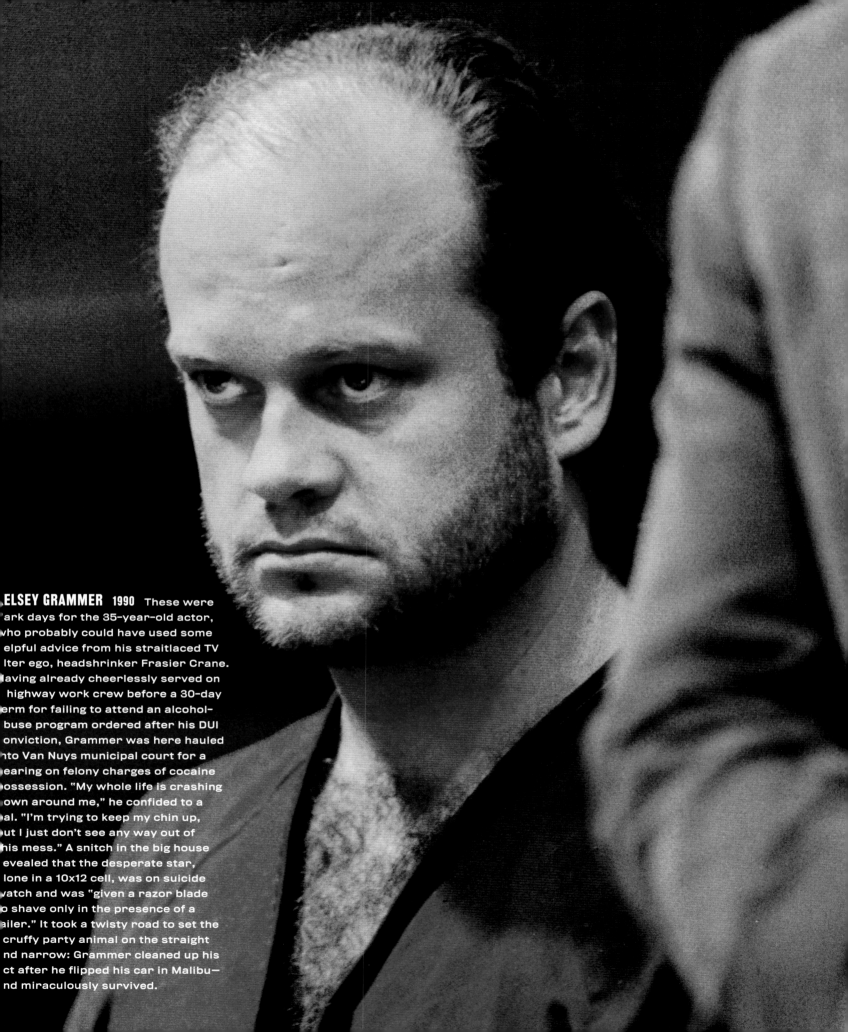

KELSEY GRAMMER 1990 These were dark days for the 35-year-old actor, who probably could have used some helpful advice from his straitlaced TV alter ego, headshrinker Frasier Crane. Having already cheerlessly served on a highway work crew before a 30-day term for failing to attend an alcohol-abuse program ordered after his DUI conviction, Grammer was here hauled into Van Nuys municipal court for a hearing on felony charges of cocaine possession. "My whole life is crashing down around me," he confided to a pal. "I'm trying to keep my chin up, but I just don't see any way out of this mess." A snitch in the big house revealed that the desperate star, alone in a 10x12 cell, was on suicide watch and was "given a razor blade to shave only in the presence of a jailer." It took a twisty road to set the scruffy party animal on the straight and narrow: Grammer cleaned up his act after he flipped his car in Malibu—and miraculously survived.

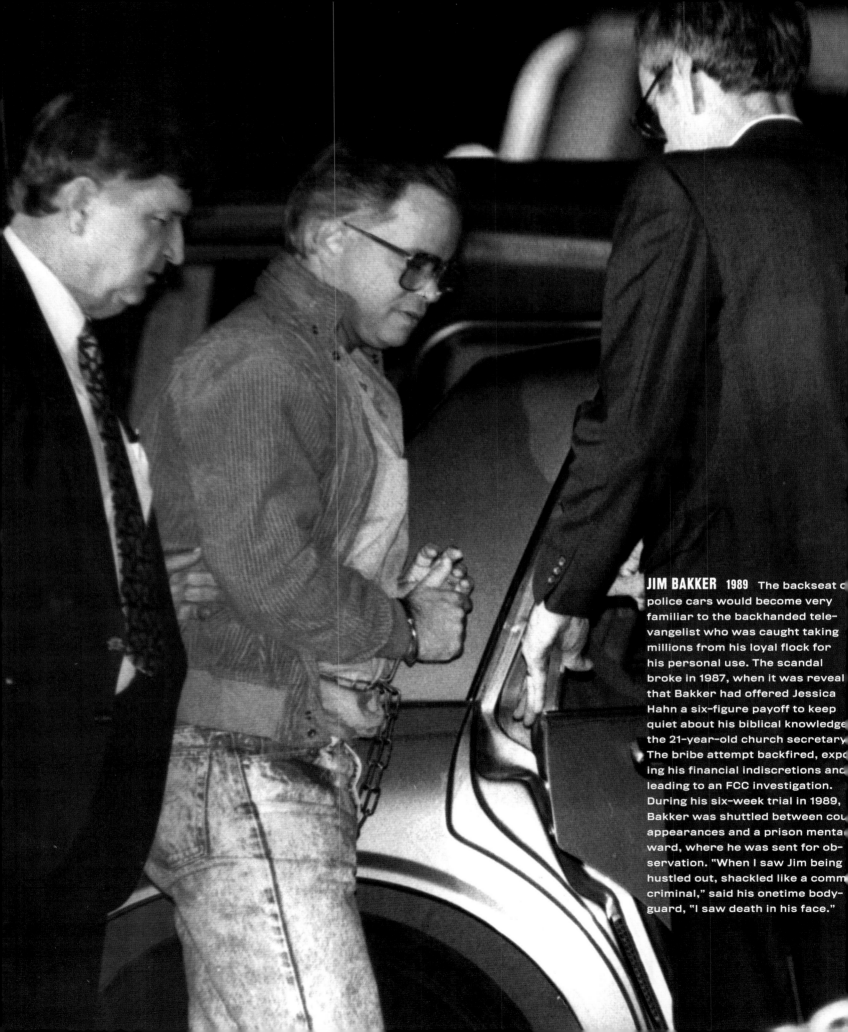

JIM BAKKER 1989 The backseat of police cars would become very familiar to the backhanded tele- vangelist who was caught taking millions from his loyal flock for his personal use. The scandal broke in 1987, when it was reveal that Bakker had offered Jessica Hahn a six-figure payoff to keep quiet about his biblical knowledge the 21-year-old church secretary The bribe attempt backfired, expoing his financial indiscretions and leading to an FCC investigation. During his six-week trial in 1989, Bakker was shuttled between cou appearances and a prison menta ward, where he was sent for ob- servation. "When I saw Jim being hustled out, shackled like a comm criminal," said his onetime body- guard, "I saw death in his face."

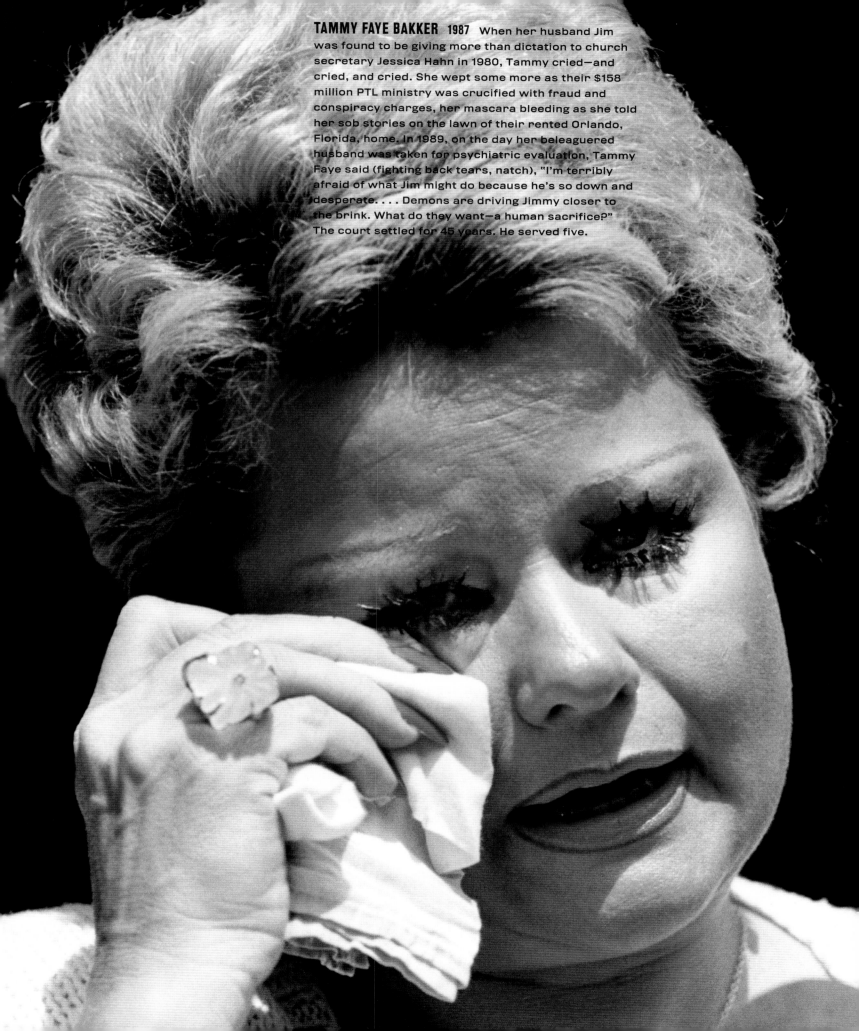

TAMMY FAYE BAKKER 1987 When her husband Jim was found to be giving more than dictation to church secretary Jessica Hahn in 1980, Tammy cried—and cried, and cried. She wept some more as their $158 million PTL ministry was crucified with fraud and conspiracy charges, her mascara bleeding as she told her sob stories on the lawn of their rented Orlando, Florida, home. In 1989, on the day her beleaguered husband was taken for psychiatric evaluation, Tammy Faye said (fighting back tears, natch), "I'm terribly afraid of what Jim might do because he's so down and desperate. . . . Demons are driving Jimmy closer to the brink. What do they want—a human sacrifice?" The court settled for 45 years. He served five.

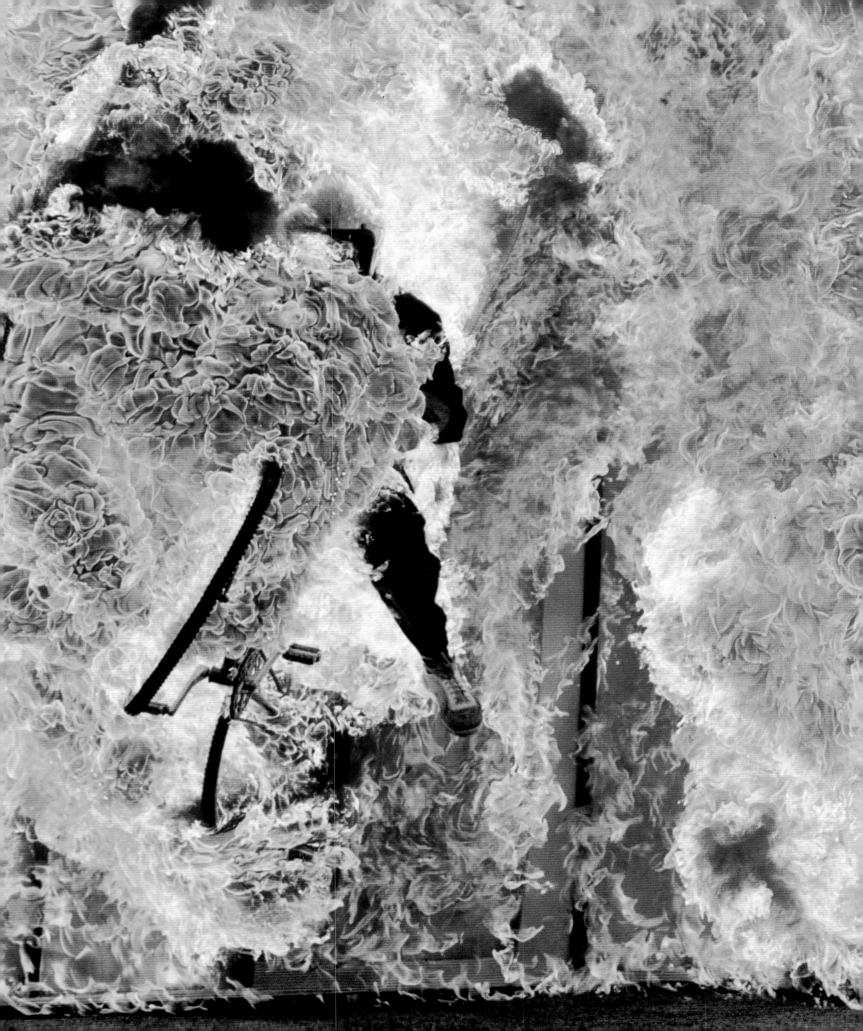

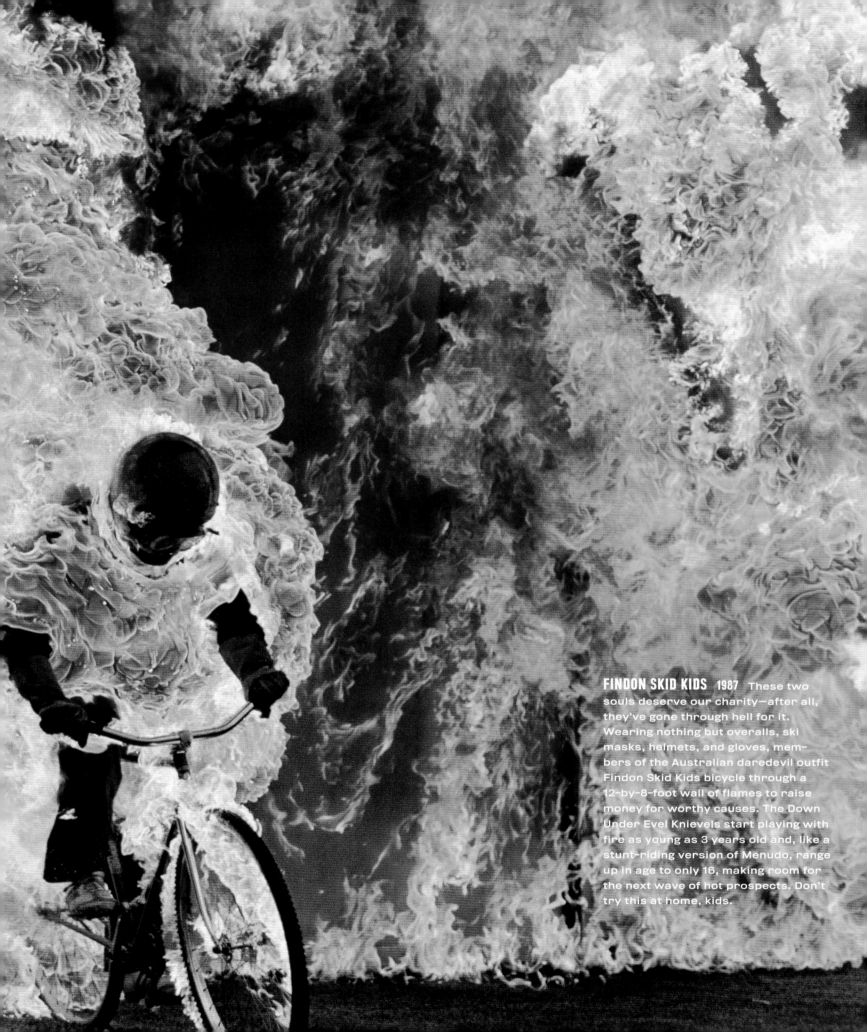

FINDON SKID KIDS 1987 These two souls deserve our charity—after all, they've gone through hell for it. Wearing nothing but overalls, ski masks, helmets, and gloves, members of the Australian daredevil outfit Findon Skid Kids bicycle through a 12-by-8-foot wall of flames to raise money for worthy causes. The Down Under Evel Knievels start playing with fire as young as 3 years old and, like a stunt-riding version of Menudo, range up in age to only 16, making room for the next wave of hot prospects. Don't try this at home, kids.

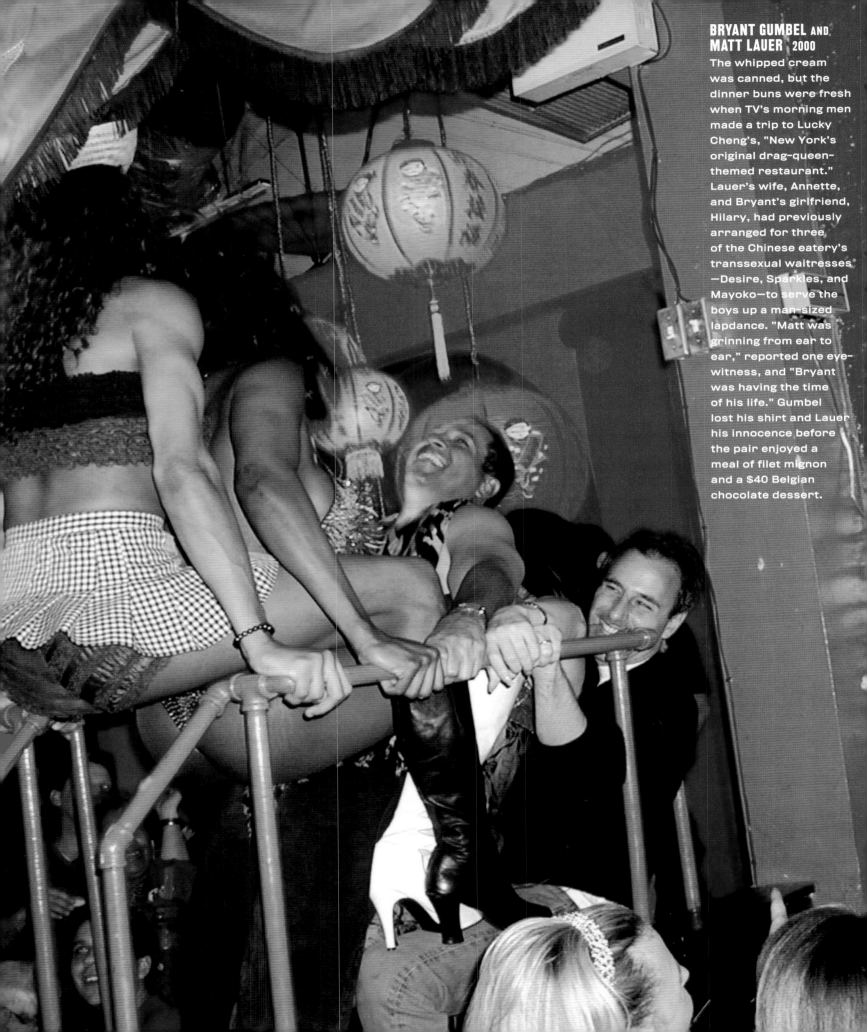

BRYANT GUMBEL AND **MATT LAUER** 2000

The whipped cream was canned, but the dinner buns were fresh when TV's morning men made a trip to Lucky Cheng's, "New York's original drag-queen-themed restaurant." Lauer's wife, Annette, and Bryant's girlfriend, Hilary, had previously arranged for three of the Chinese eatery's transsexual waitresses —Desire, Sparkles, and Mayoko—to serve the boys up a man-sized lapdance. "Matt was grinning from ear to ear," reported one eye-witness, and "Bryant was having the time of his life." Gumbel lost his shirt and Lauer his innocence before the pair enjoyed a meal of filet mignon and a $40 Belgian chocolate dessert.

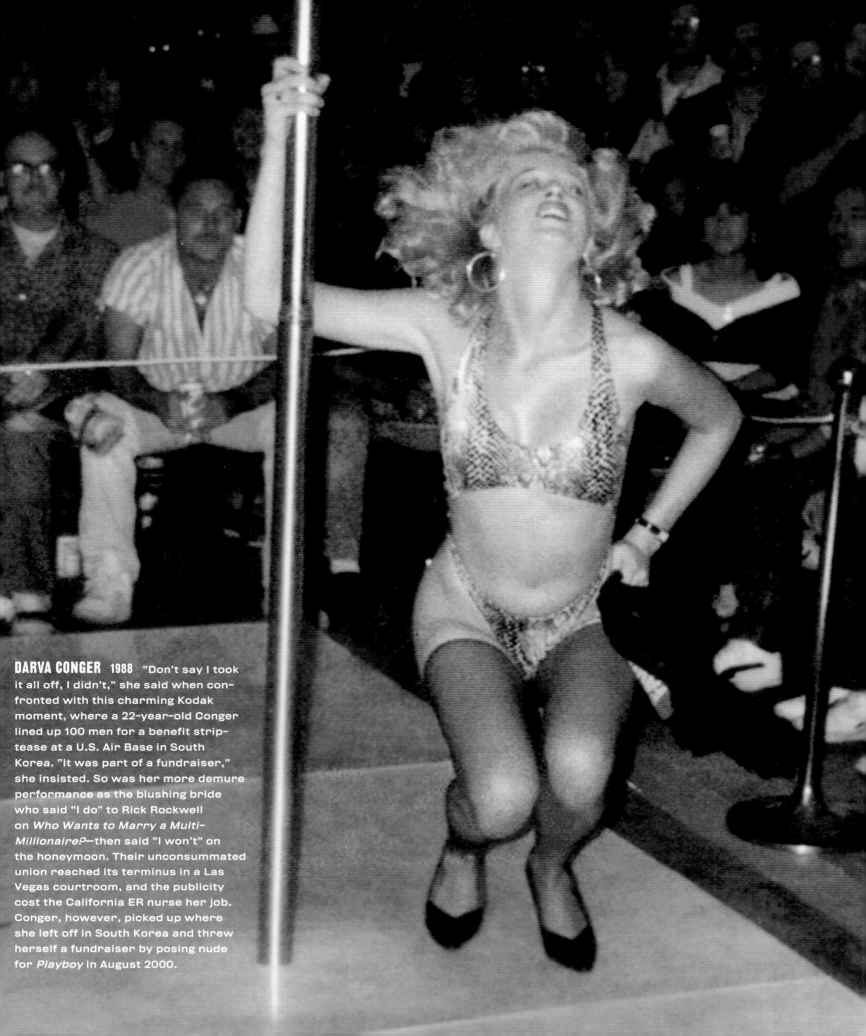

DARVA CONGER 1988 "Don't say I took it all off, I didn't," she said when confronted with this charming Kodak moment, where a 22-year-old Conger lined up 100 men for a benefit strip-tease at a U.S. Air Base in South Korea. "It was part of a fundraiser," she insisted. So was her more demure performance as the blushing bride who said "I do" to Rick Rockwell on *Who Wants to Marry a Multi-Millionaire?*—then said "I won't" on the honeymoon. Their unconsummated union reached its terminus in a Las Vegas courtroom, and the publicity cost the California ER nurse her job. Conger, however, picked up where she left off in South Korea and threw herself a fundraiser by posing nude for *Playboy* in August 2000.

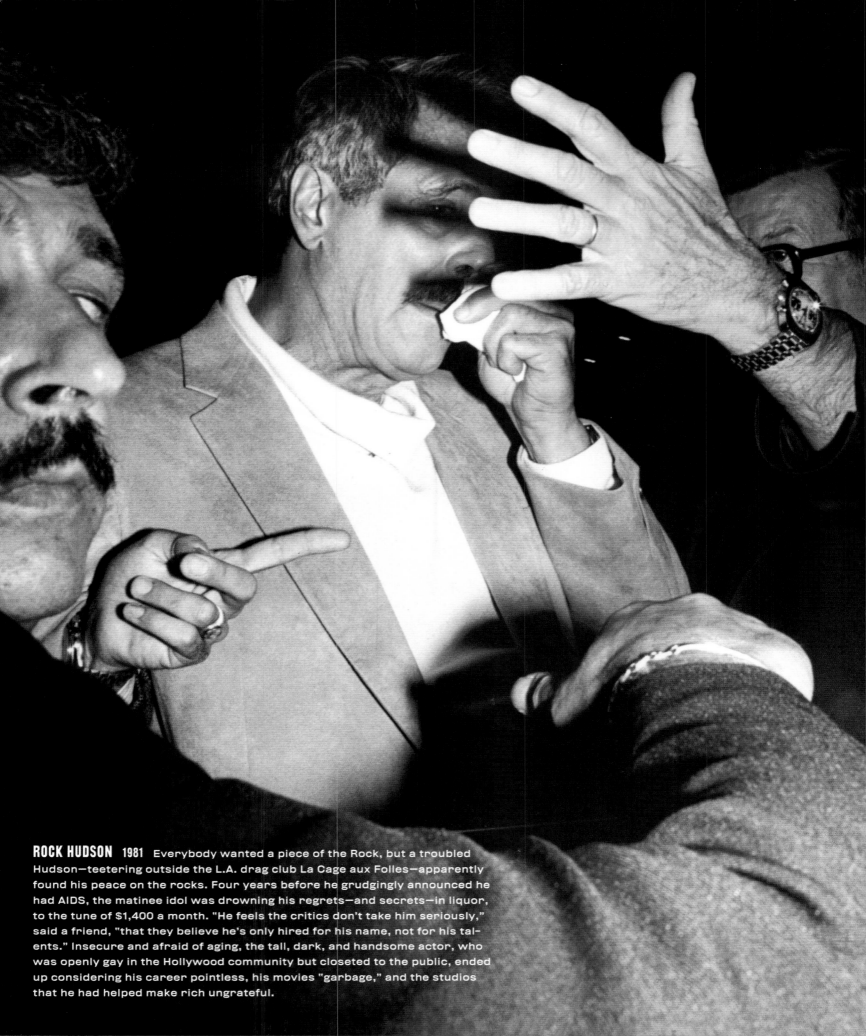

ROCK HUDSON 1981 Everybody wanted a piece of the Rock, but a troubled Hudson—teetering outside the L.A. drag club La Cage aux Folles—apparently found his peace on the rocks. Four years before he grudgingly announced he had AIDS, the matinee idol was drowning his regrets—and secrets—in liquor, to the tune of $1,400 a month. "He feels the critics don't take him seriously," said a friend, "that they believe he's only hired for his name, not for his talents." Insecure and afraid of aging, the tall, dark, and handsome actor, who was openly gay in the Hollywood community but closeted to the public, ended up considering his career pointless, his movies "garbage," and the studios that he had helped make rich ungrateful.

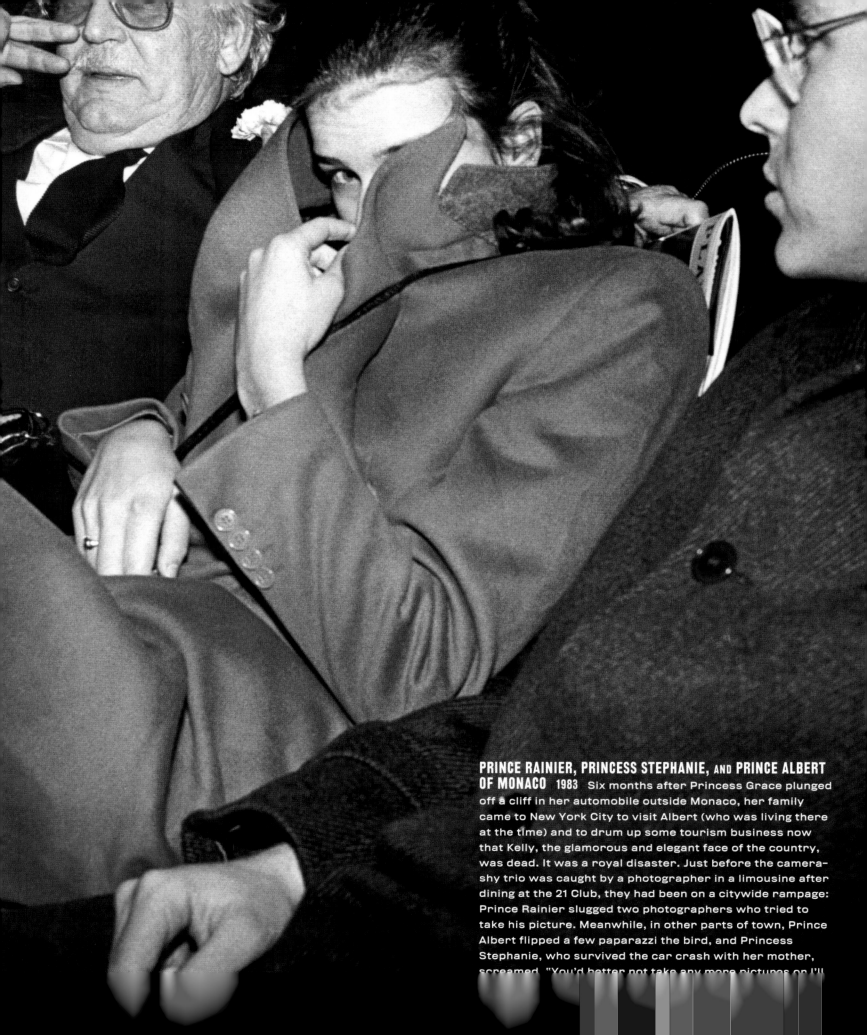

PRINCE RAINIER, PRINCESS STEPHANIE, AND PRINCE ALBERT OF MONACO 1983 Six months after Princess Grace plunged off a cliff in her automobile outside Monaco, her family came to New York City to visit Albert (who was living there at the time) and to drum up some tourism business now that Kelly, the glamorous and elegant face of the country, was dead. It was a royal disaster. Just before the camera-shy trio was caught by a photographer in a limousine after dining at the 21 Club, they had been on a citywide rampage: Prince Rainier slugged two photographers who tried to take his picture. Meanwhile, in other parts of town, Prince Albert flipped a few paparazzi the bird, and Princess Stephanie, who survived the car crash with her mother, screamed, "You'd better not take any more pictures or I'll

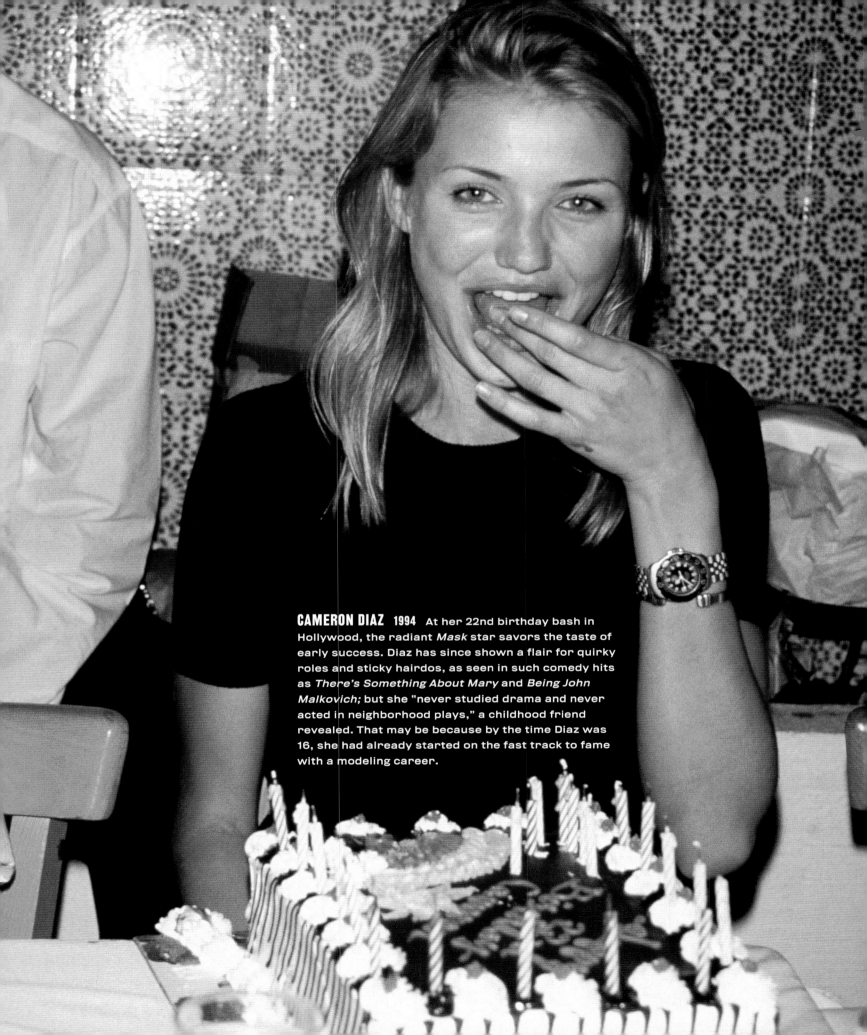

CAMERON DIAZ 1994 At her 22nd birthday bash in Hollywood, the radiant *Mask* star savors the taste of early success. Diaz has since shown a flair for quirky roles and sticky hairdos, as seen in such comedy hits as *There's Something About Mary* and *Being John Malkovich;* but she "never studied drama and never acted in neighborhood plays," a childhood friend revealed. That may be because by the time Diaz was 16, she had already started on the fast track to fame with a modeling career.

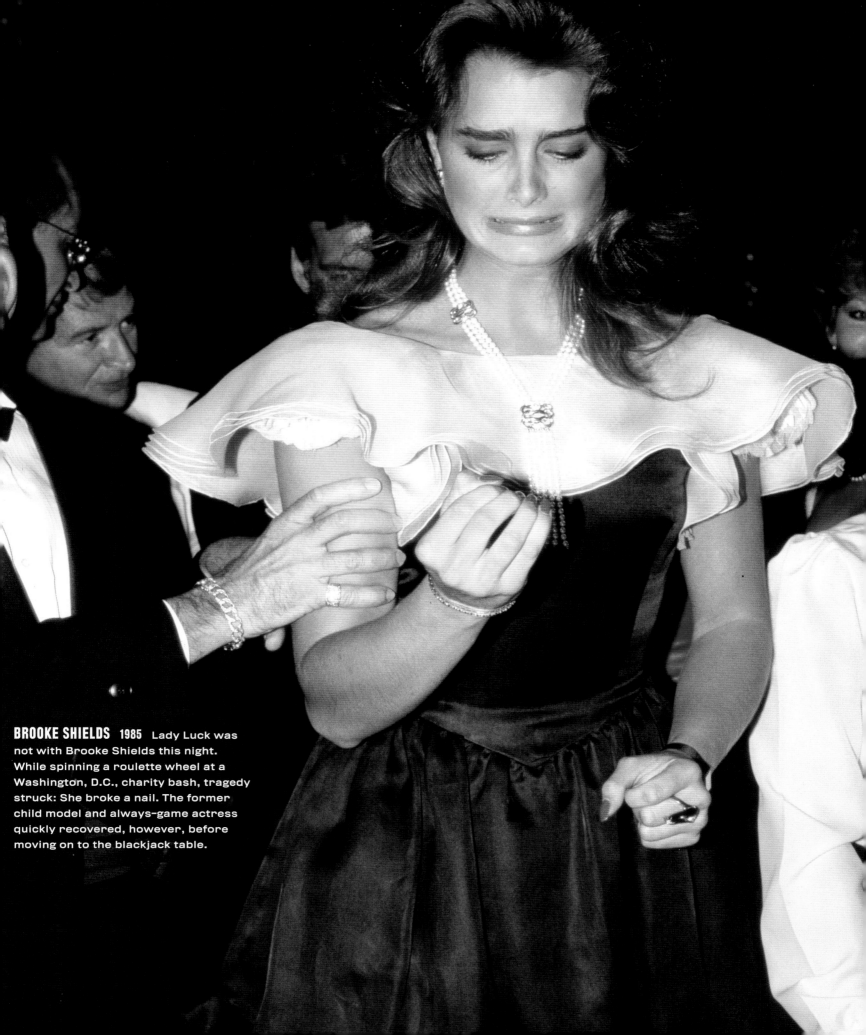

BROOKE SHIELDS 1985 Lady Luck was not with Brooke Shields this night. While spinning a roulette wheel at a Washington, D.C., charity bash, tragedy struck: She broke a nail. The former child model and always-game actress quickly recovered, however, before moving on to the blackjack table.

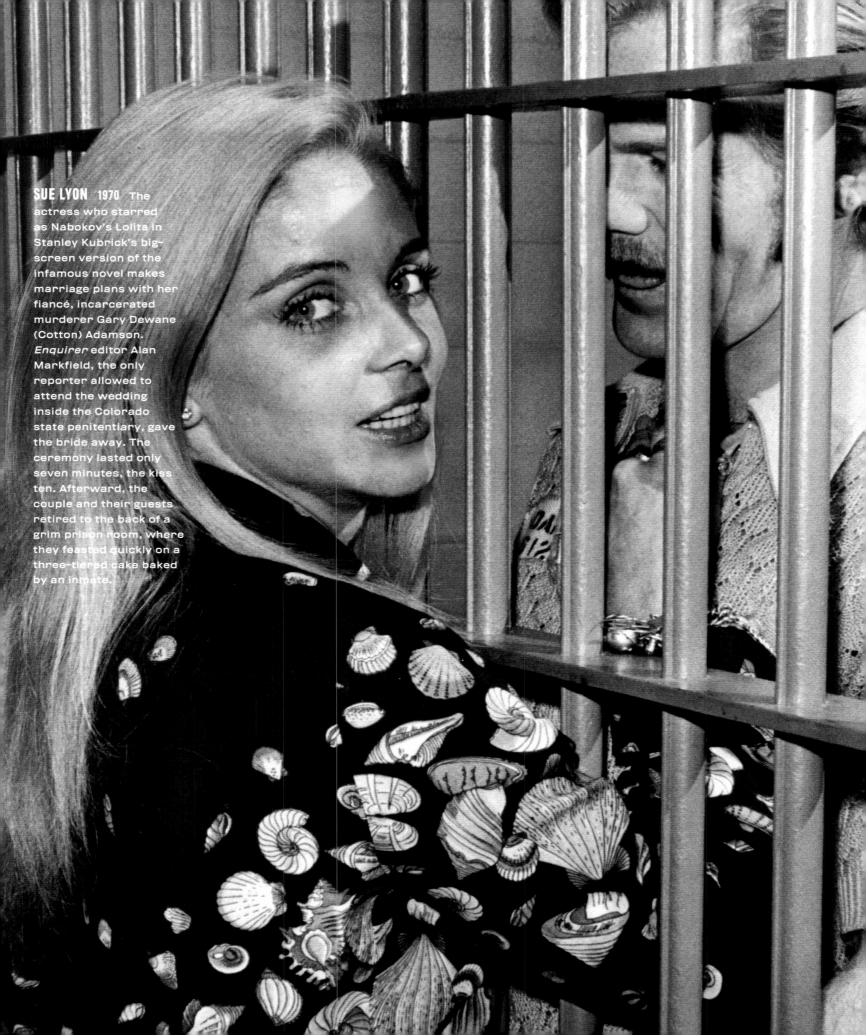

SUE LYON 1970 The actress who starred as Nabokov's Lolita in Stanley Kubrick's big-screen version of the infamous novel makes marriage plans with her fiancé, incarcerated murderer Gary Dewane (Cotton) Adamson. *Enquirer* editor Alan Markfield, the only reporter allowed to attend the wedding inside the Colorado state penitentiary, gave the bride away. The ceremony lasted only seven minutes, the kiss ten. Afterward, the couple and their guests retired to the back of a grim prison room, where they feasted quickly on a three-tiered cake baked by an inmate.

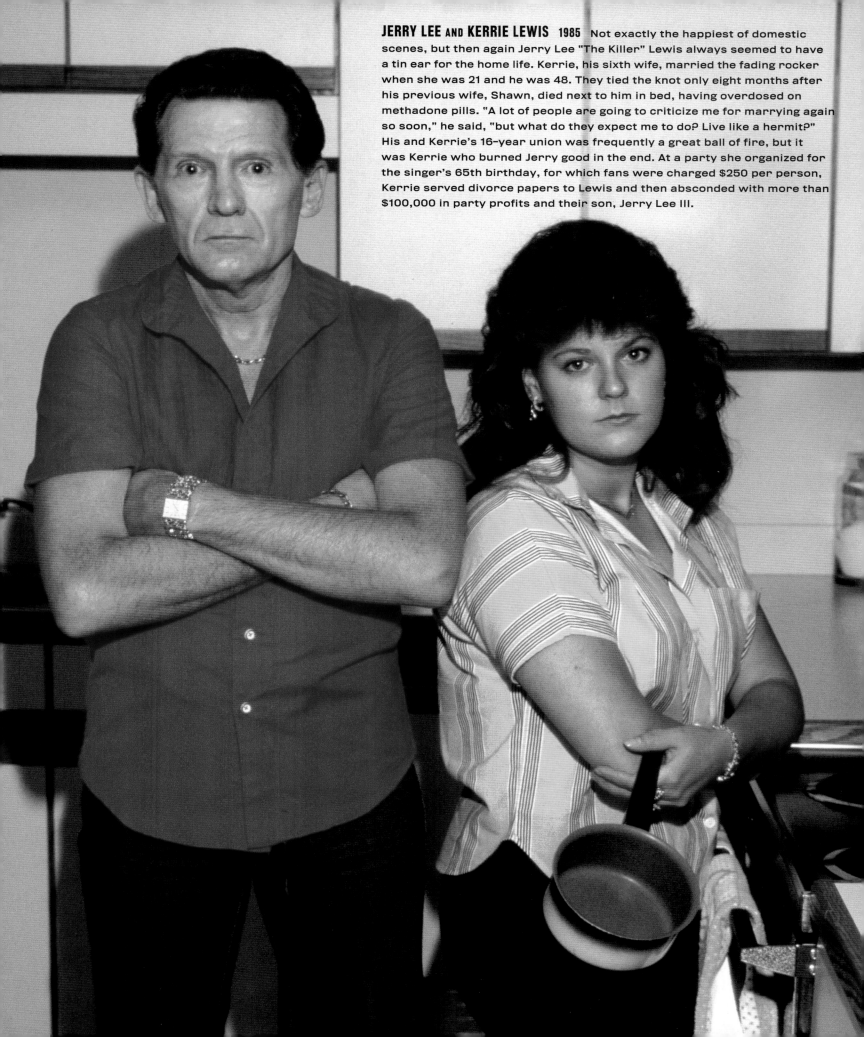

JERRY LEE AND **KERRIE LEWIS** 1985 Not exactly the happiest of domestic scenes, but then again Jerry Lee "The Killer" Lewis always seemed to have a tin ear for the home life. Kerrie, his sixth wife, married the fading rocker when she was 21 and he was 48. They tied the knot only eight months after his previous wife, Shawn, died next to him in bed, having overdosed on methadone pills. "A lot of people are going to criticize me for marrying again so soon," he said, "but what do they expect me to do? Live like a hermit?" His and Kerrie's 16-year union was frequently a great ball of fire, but it was Kerrie who burned Jerry good in the end. At a party she organized for the singer's 65th birthday, for which fans were charged $250 per person, Kerrie served divorce papers to Lewis and then absconded with more than $100,000 in party profits and their son, Jerry Lee III.

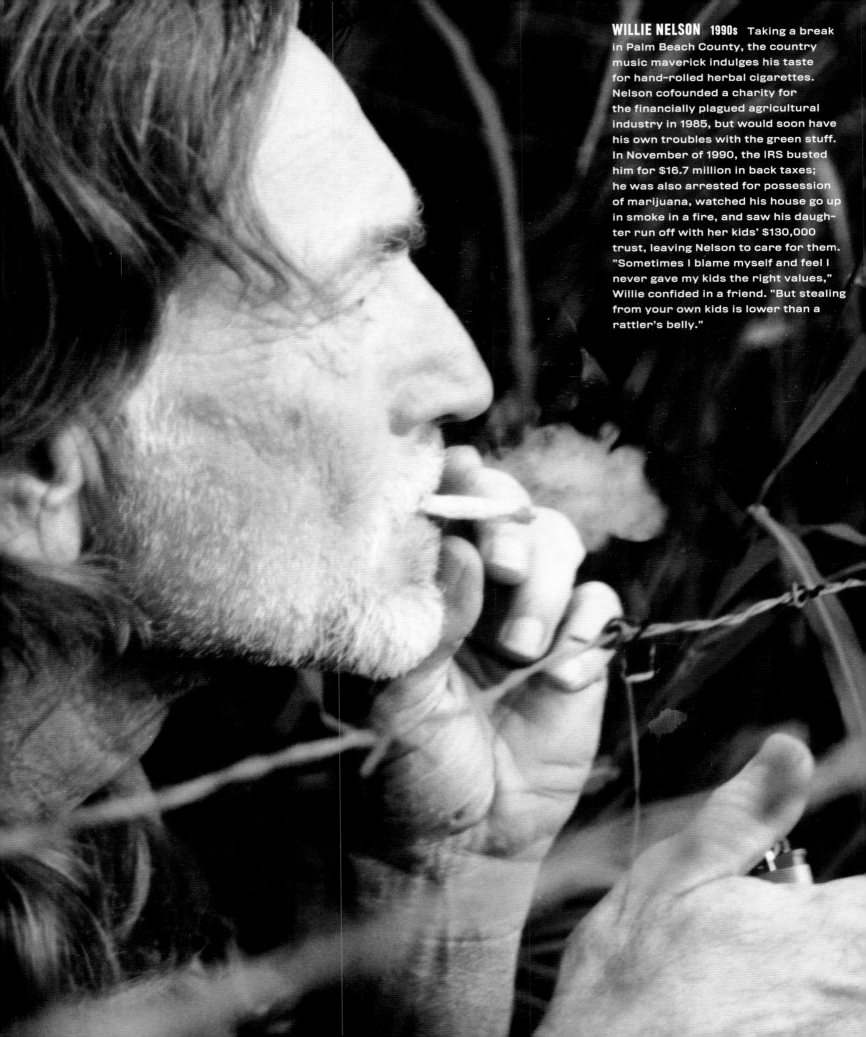

WILLIE NELSON 1990s Taking a break in Palm Beach County, the country music maverick indulges his taste for hand-rolled herbal cigarettes. Nelson cofounded a charity for the financially plagued agricultural industry in 1985, but would soon have his own troubles with the green stuff. In November of 1990, the IRS busted him for $16.7 million in back taxes; he was also arrested for possession of marijuana, watched his house go up in smoke in a fire, and saw his daughter run off with her kids' $130,000 trust, leaving Nelson to care for them. "Sometimes I blame myself and feel I never gave my kids the right values," Willie confided in a friend. "But stealing from your own kids is lower than a rattler's belly."

RICHARD GERE 1995 The 46-year-old American Gigolo and disciple of the Dalai Lama does his part for international relations by skinny-dipping with 24-year-old Stina Norbye, a Swedish student of Chinese medicine. Estranged from supermodel wife Cindy Crawford, Gere had met Stina at a natural food store in Bastad, Sweden, and it wasn't long before they were au naturel in the chilly waters of the North Sea. "It never crossed my mind that there might be a photographer around," Stina said. "But then I don't see him as Richard Gere the movie star. I see him as Richard my boyfriend." He apparently saw her as a summer romance; by the end of 1995 he had started seeing a lot more of model–actress Carey Lowell, who became the mother of his first child, Homer.

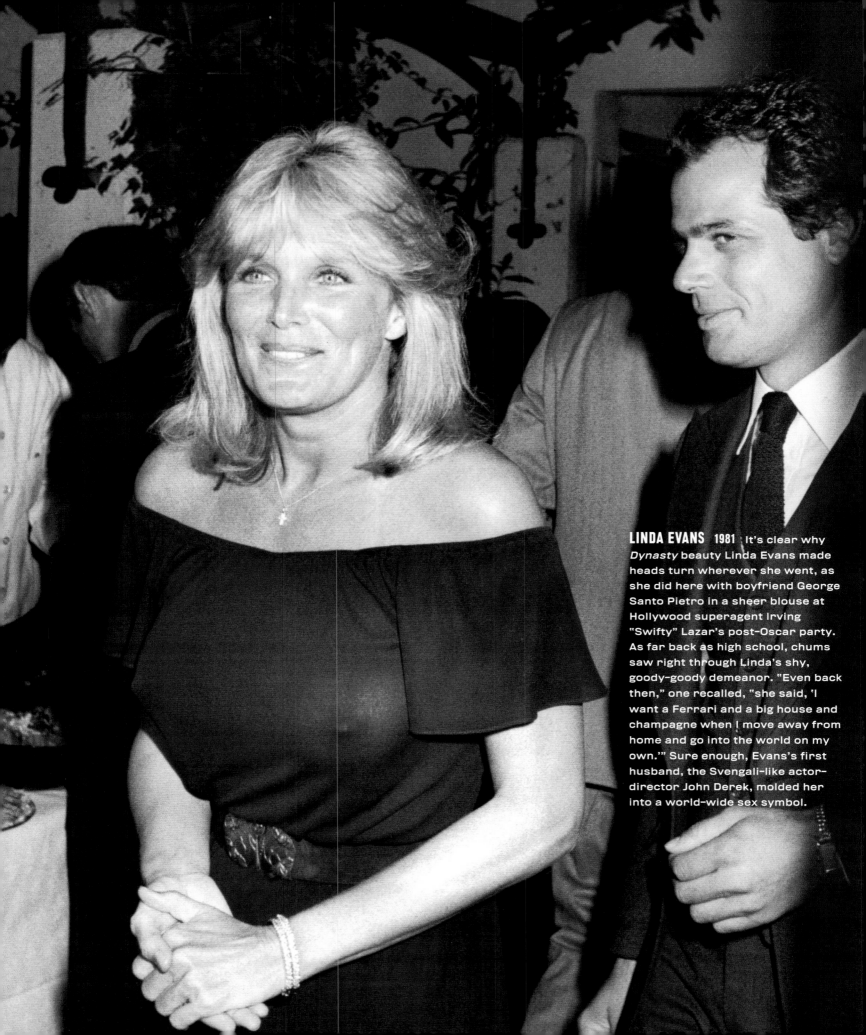

LINDA EVANS 1981 It's clear why *Dynasty* beauty Linda Evans made heads turn wherever she went, as she did here with boyfriend George Santo Pietro in a sheer blouse at Hollywood superagent Irving "Swifty" Lazar's post-Oscar party. As far back as high school, chums saw right through Linda's shy, goody-goody demeanor. "Even back then," one recalled, "she said, 'I want a Ferrari and a big house and champagne when I move away from home and go into the world on my own.'" Sure enough, Evans's first husband, the Svengali-like actor-director John Derek, molded her into a world-wide sex symbol.

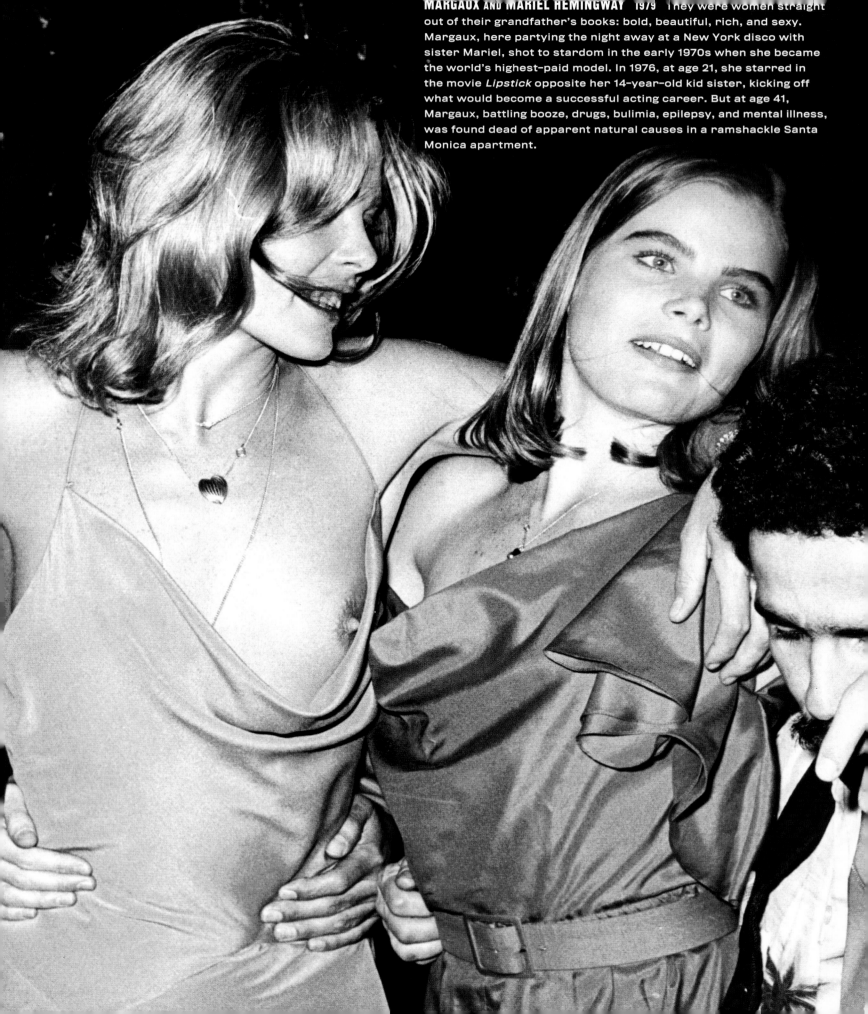

MARGAUX AND **MARIEL HEMINGWAY** 1979 They were women straight out of their grandfather's books: bold, beautiful, rich, and sexy. Margaux, here partying the night away at a New York disco with sister Mariel, shot to stardom in the early 1970s when she became the world's highest-paid model. In 1976, at age 21, she starred in the movie *Lipstick* opposite her 14-year-old kid sister, kicking off what would become a successful acting career. But at age 41, Margaux, battling booze, drugs, bulimia, epilepsy, and mental illness, was found dead of apparent natural causes in a ramshackle Santa Monica apartment.

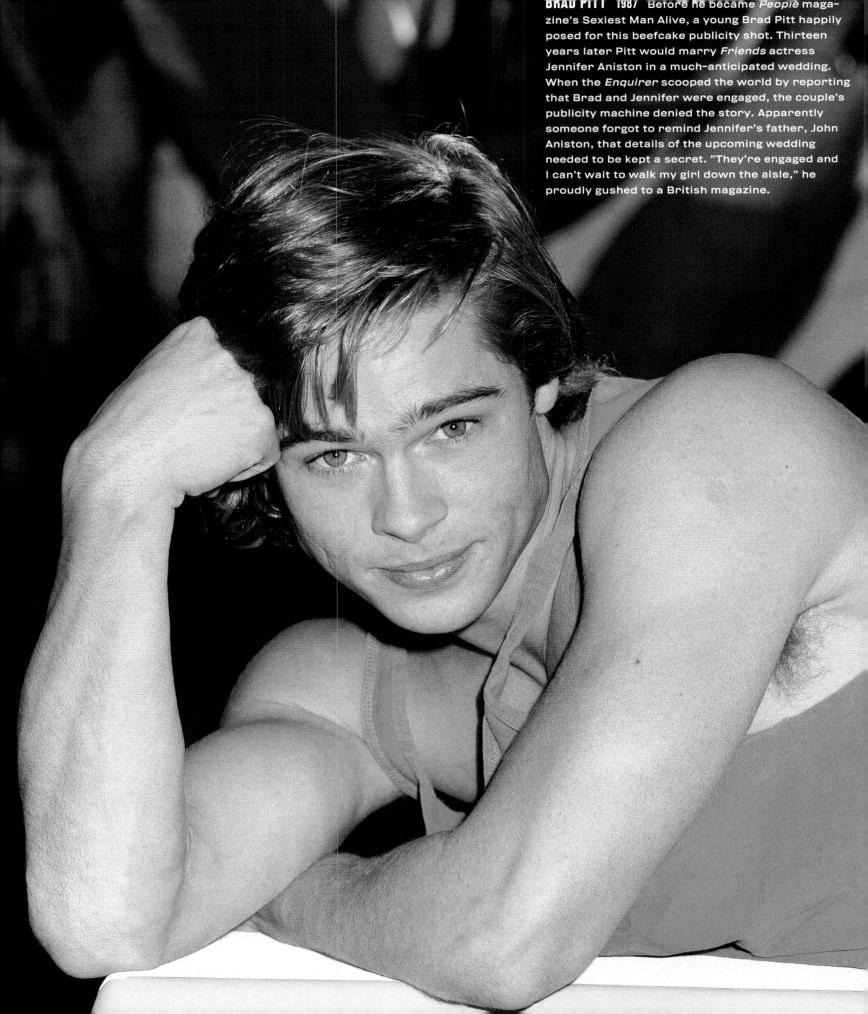

BRAD PITT 1987 Before he became *People* magazine's Sexiest Man Alive, a young Brad Pitt happily posed for this beefcake publicity shot. Thirteen years later Pitt would marry *Friends* actress Jennifer Aniston in a much-anticipated wedding. When the *Enquirer* scooped the world by reporting that Brad and Jennifer were engaged, the couple's publicity machine denied the story. Apparently someone forgot to remind Jennifer's father, John Aniston, that details of the upcoming wedding needed to be kept a secret. "They're engaged and I can't wait to walk my girl down the aisle," he proudly gushed to a British magazine.

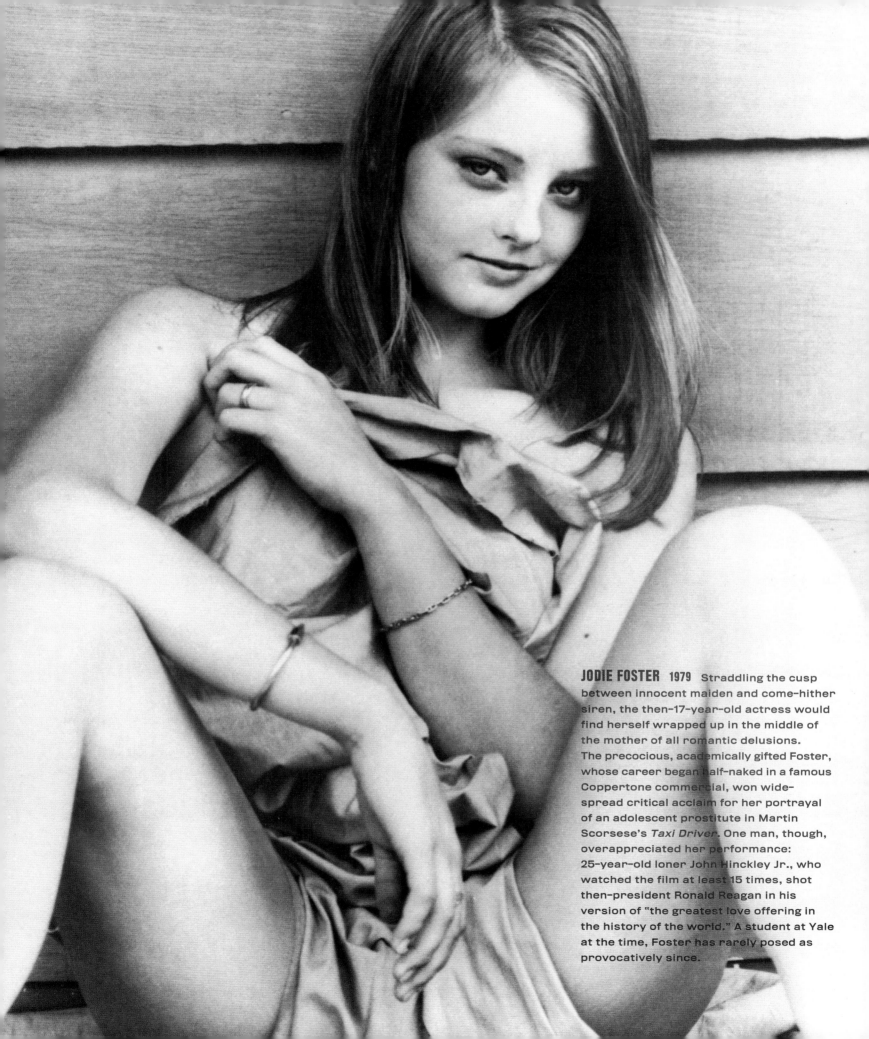

JODIE FOSTER 1979 Straddling the cusp between innocent maiden and come-hither siren, the then–17-year-old actress would find herself wrapped up in the middle of the mother of all romantic delusions. The precocious, academically gifted Foster, whose career began half-naked in a famous Coppertone commercial, won widespread critical acclaim for her portrayal of an adolescent prostitute in Martin Scorsese's *Taxi Driver*. One man, though, overappreciated her performance: 25-year-old loner John Hinckley Jr., who watched the film at least 15 times, shot then-president Ronald Reagan in his version of "the greatest love offering in the history of the world." A student at Yale at the time, Foster has rarely posed as provocatively since.

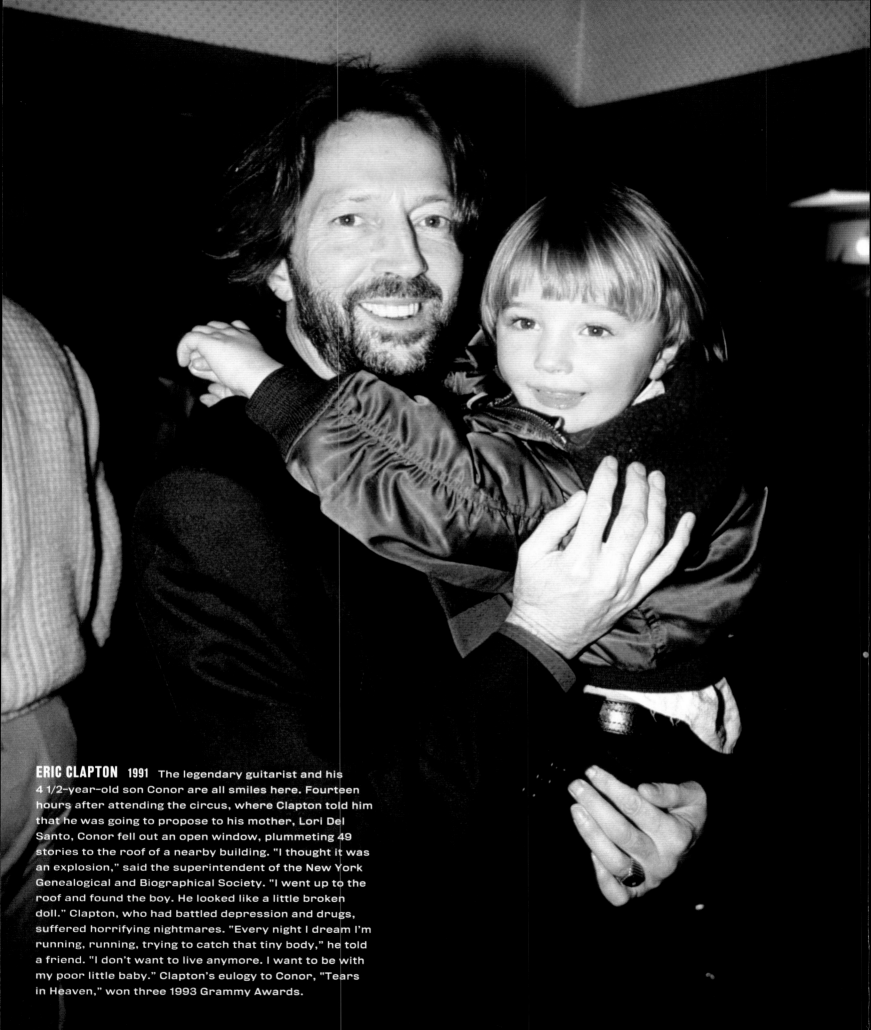

ERIC CLAPTON 1991 The legendary guitarist and his 4 1/2-year-old son Conor are all smiles here. Fourteen hours after attending the circus, where Clapton told him that he was going to propose to his mother, Lori Del Santo, Conor fell out an open window, plummeting 49 stories to the roof of a nearby building. "I thought it was an explosion," said the superintendent of the New York Genealogical and Biographical Society. "I went up to the roof and found the boy. He looked like a little broken doll." Clapton, who had battled depression and drugs, suffered horrifying nightmares. "Every night I dream I'm running, running, trying to catch that tiny body," he told a friend. "I don't want to live anymore. I want to be with my poor little baby." Clapton's eulogy to Conor, "Tears in Heaven," won three 1993 Grammy Awards.

MICHAEL LANDON 1987 He parlayed his leading-man looks into family-man dramas, but it wasn't just an act. Before stoically succumbing to inoperable pancreatic cancer in 1991, the star of *Little House on the Prairie, Highway to Heaven,* and *Bonanza* presided over a family of nine children. "I took this myself," his wife, Cindy, recalled. "It is one of my most cherished photos of my children Jennifer and Sean with their Dad. They were watching TV, and I thought what a lovely photograph it would make." After his death, she and the kids liked to curl up in front of the set to watch Dad on reruns. "Sometimes I see his face on television and there's a pang of pain," said Cindy. "But we still want to see Michael, to hear his voice."

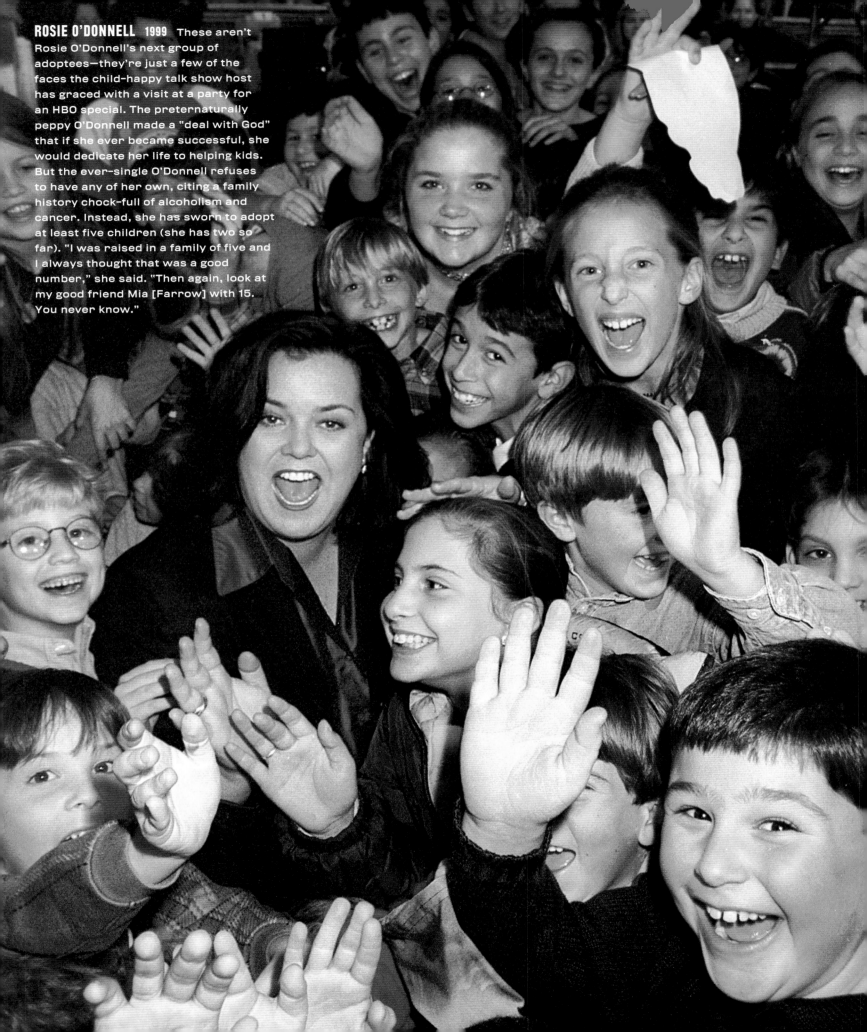

ROSIE O'DONNELL 1999 These aren't Rosie O'Donnell's next group of adoptees—they're just a few of the faces the child-happy talk show host has graced with a visit at a party for an HBO special. The preternaturally peppy O'Donnell made a "deal with God" that if she ever became successful, she would dedicate her life to helping kids. But the ever-single O'Donnell refuses to have any of her own, citing a family history chock-full of alcoholism and cancer. Instead, she has sworn to adopt at least five children (she has two so far). "I was raised in a family of five and I always thought that was a good number," she said. "Then again, look at my good friend Mia [Farrow] with 15. You never know."

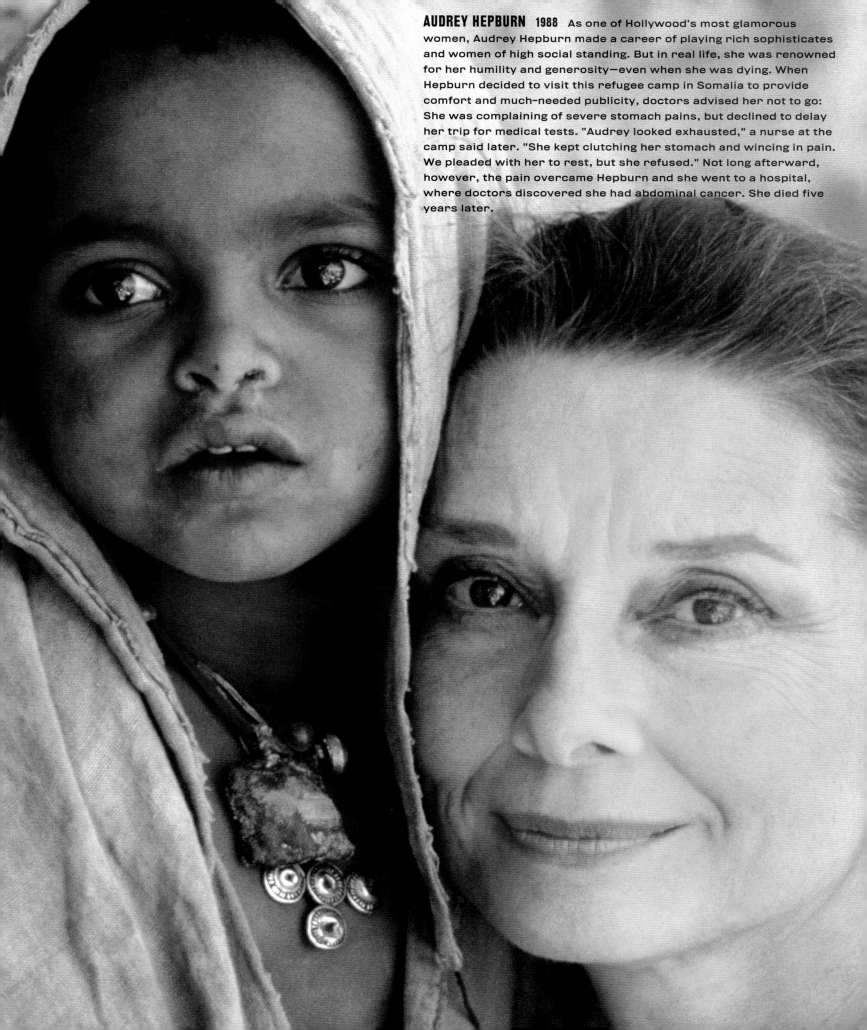

AUDREY HEPBURN 1988 As one of Hollywood's most glamorous women, Audrey Hepburn made a career of playing rich sophisticates and women of high social standing. But in real life, she was renowned for her humility and generosity—even when she was dying. When Hepburn decided to visit this refugee camp in Somalia to provide comfort and much-needed publicity, doctors advised her not to go: She was complaining of severe stomach pains, but declined to delay her trip for medical tests. "Audrey looked exhausted," a nurse at the camp said later. "She kept clutching her stomach and wincing in pain. We pleaded with her to rest, but she refused." Not long afterward, however, the pain overcame Hepburn and she went to a hospital, where doctors discovered she had abdominal cancer. She died five years later.

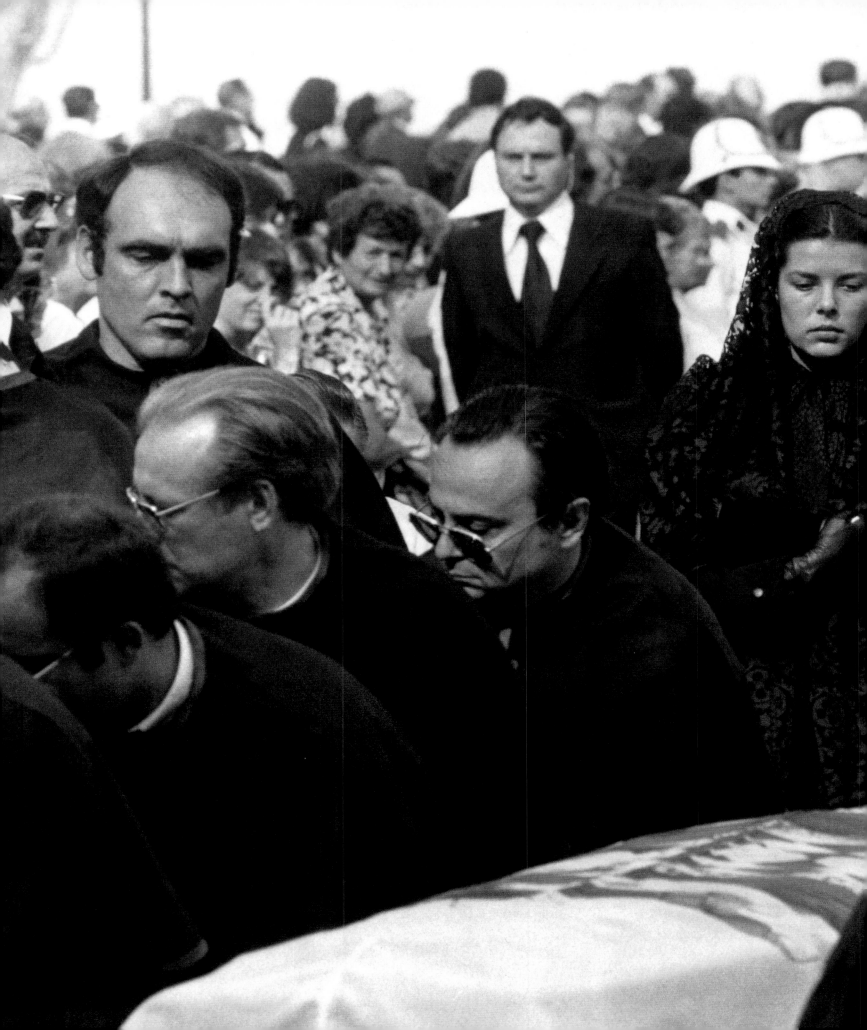

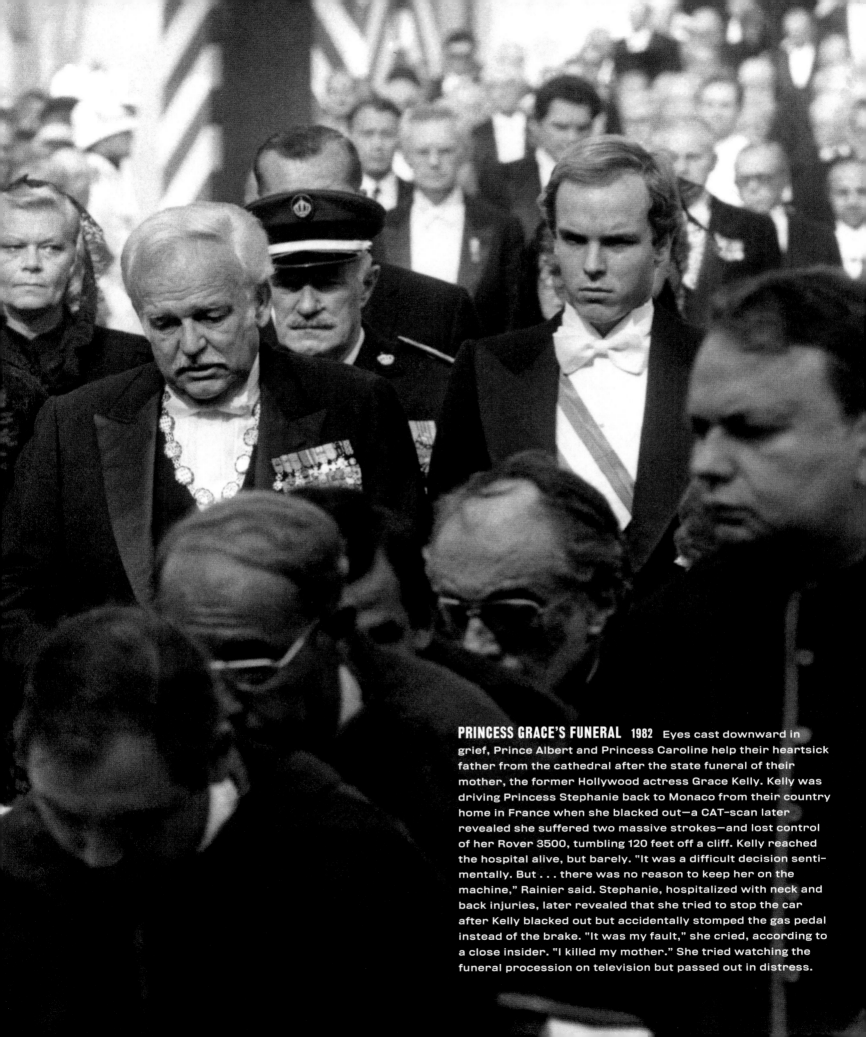

PRINCESS GRACE'S FUNERAL 1982 Eyes cast downward in grief, Prince Albert and Princess Caroline help their heartsick father from the cathedral after the state funeral of their mother, the former Hollywood actress Grace Kelly. Kelly was driving Princess Stephanie back to Monaco from their country home in France when she blacked out—a CAT-scan later revealed she suffered two massive strokes—and lost control of her Rover 3500, tumbling 120 feet off a cliff. Kelly reached the hospital alive, but barely. "It was a difficult decision senti-mentally. But . . . there was no reason to keep her on the machine," Rainier said. Stephanie, hospitalized with neck and back injuries, later revealed that she tried to stop the car after Kelly blacked out but accidentally stomped the gas pedal instead of the brake. "It was my fault," she cried, according to a close insider. "I killed my mother." She tried watching the funeral procession on television but passed out in distress.

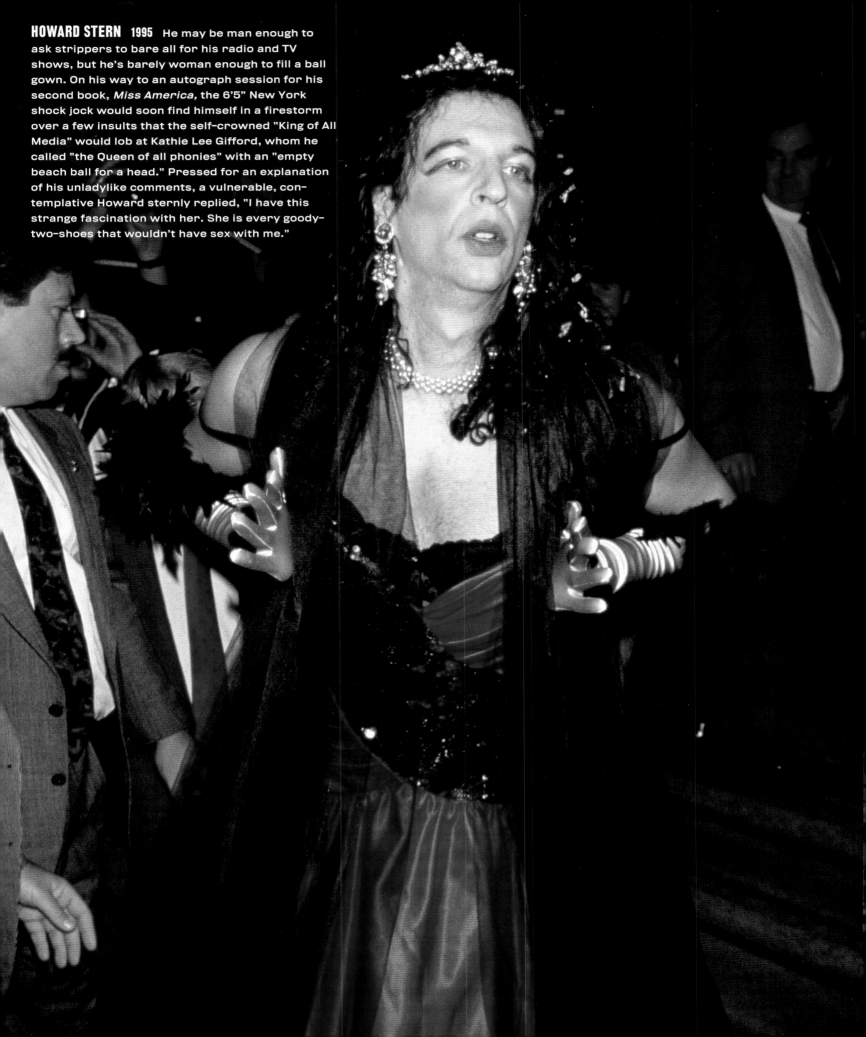

HOWARD STERN 1995 He may be man enough to ask strippers to bare all for his radio and TV shows, but he's barely woman enough to fill a ball gown. On his way to an autograph session for his second book, *Miss America,* the 6'5" New York shock jock would soon find himself in a firestorm over a few insults that the self-crowned "King of All Media" would lob at Kathie Lee Gifford, whom he called "the Queen of all phonies" with an "empty beach ball for a head." Pressed for an explanation of his unladylike comments, a vulnerable, contemplative Howard sternly replied, "I have this strange fascination with her. She is every goody-two-shoes that wouldn't have sex with me."

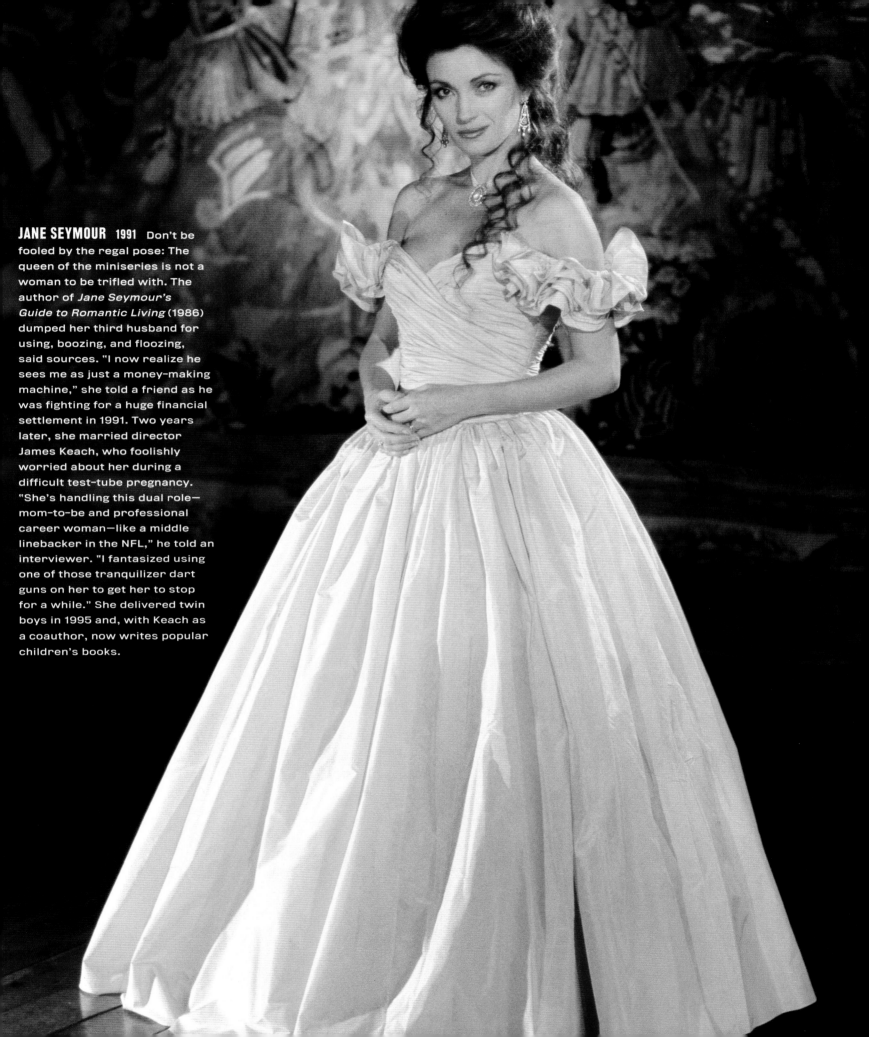

JANE SEYMOUR 1991 Don't be fooled by the regal pose: The queen of the miniseries is not a woman to be trifled with. The author of *Jane Seymour's Guide to Romantic Living* (1986) dumped her third husband for using, boozing, and floozing, said sources. "I now realize he sees me as just a money-making machine," she told a friend as he was fighting for a huge financial settlement in 1991. Two years later, she married director James Keach, who foolishly worried about her during a difficult test-tube pregnancy. "She's handling this dual role—mom-to-be and professional career woman—like a middle linebacker in the NFL," he told an interviewer. "I fantasized using one of those tranquilizer dart guns on her to get her to stop for a while." She delivered twin boys in 1995 and, with Keach as a coauthor, now writes popular children's books.

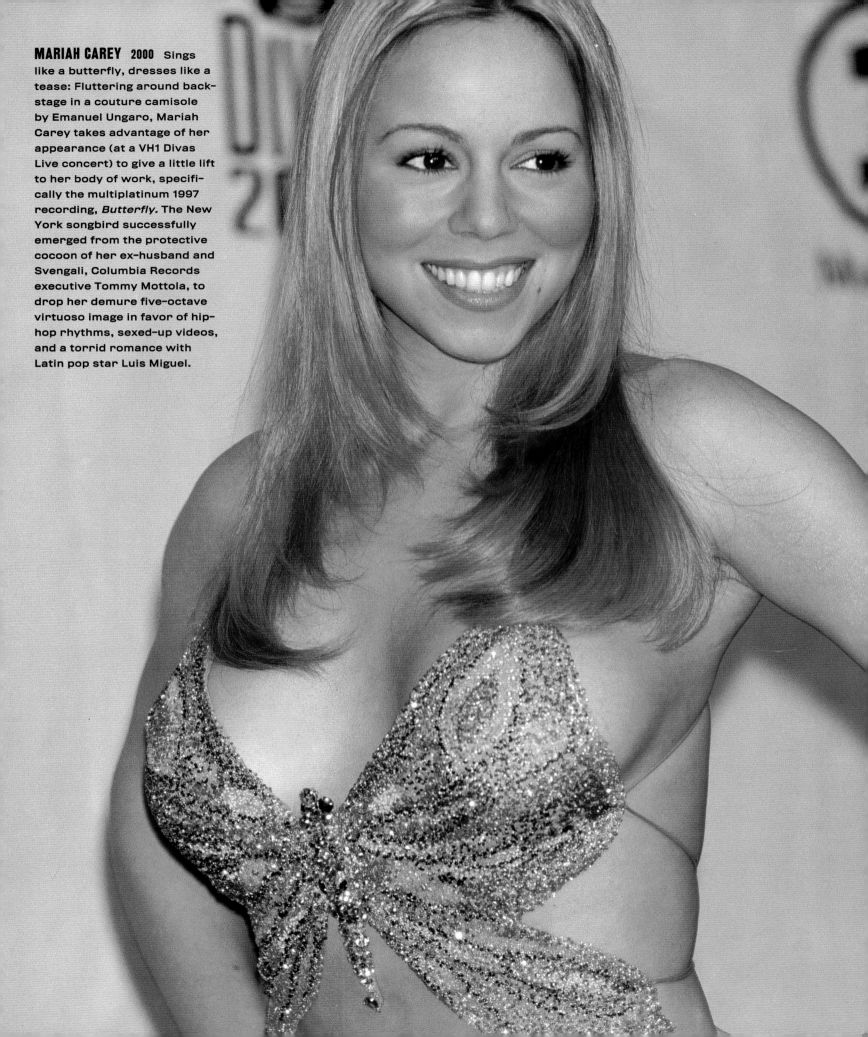

MARIAH CAREY **2000** Sings like a butterfly, dresses like a tease: Fluttering around backstage in a couture camisole by Emanuel Ungaro, Mariah Carey takes advantage of her appearance (at a VH1 Divas Live concert) to give a little lift to her body of work, specifically the multiplatinum 1997 recording, *Butterfly.* The New York songbird successfully emerged from the protective cocoon of her ex-husband and Svengali, Columbia Records executive Tommy Mottola, to drop her demure five-octave virtuoso image in favor of hip-hop rhythms, sexed-up videos, and a torrid romance with Latin pop star Luis Miguel.

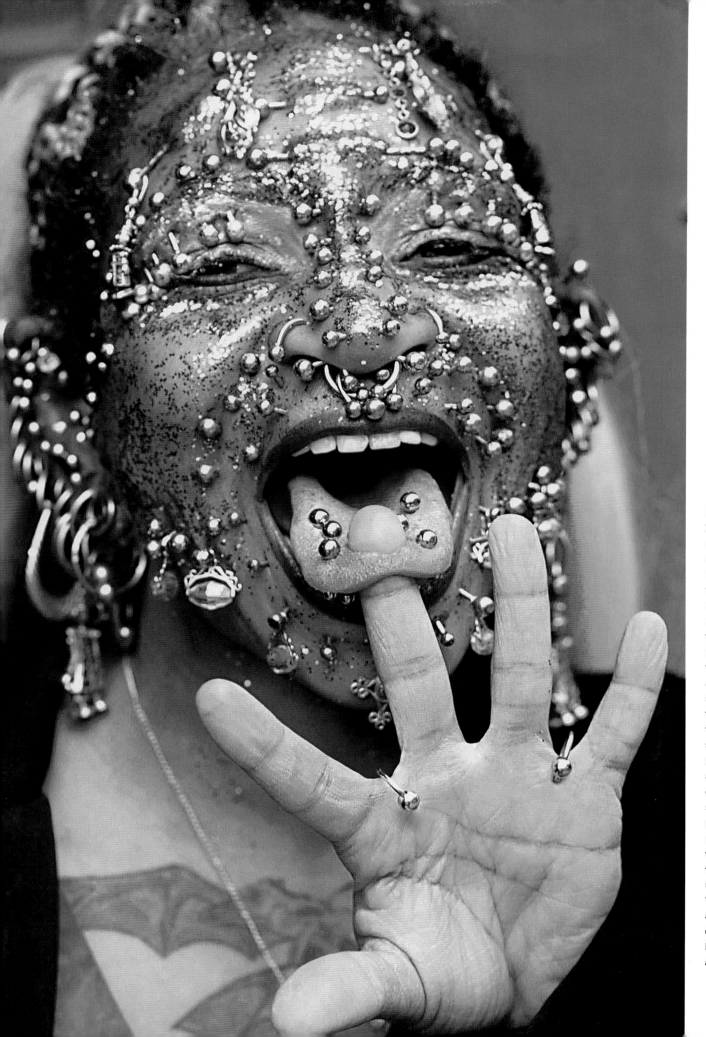

ELAINE DAVIDSON
2001 This 27-year-old-owner of a tattoo and piercing parlor in Glasgow claimed the *Guinness Book*'s most-pierced-person record with 290 holes, which she started piercing only four years ago. But like any top competitor, she didn't let it go to her head—in fact, the 620 piercings she had when this photo was taken are spread over her entire body. So far, she has not gone public with her perforated privates, though she admits they please her unpierced boyfriend. "He gets as much of a thrill out of it as I do," she said. "I like it because it encourages gentle sex."

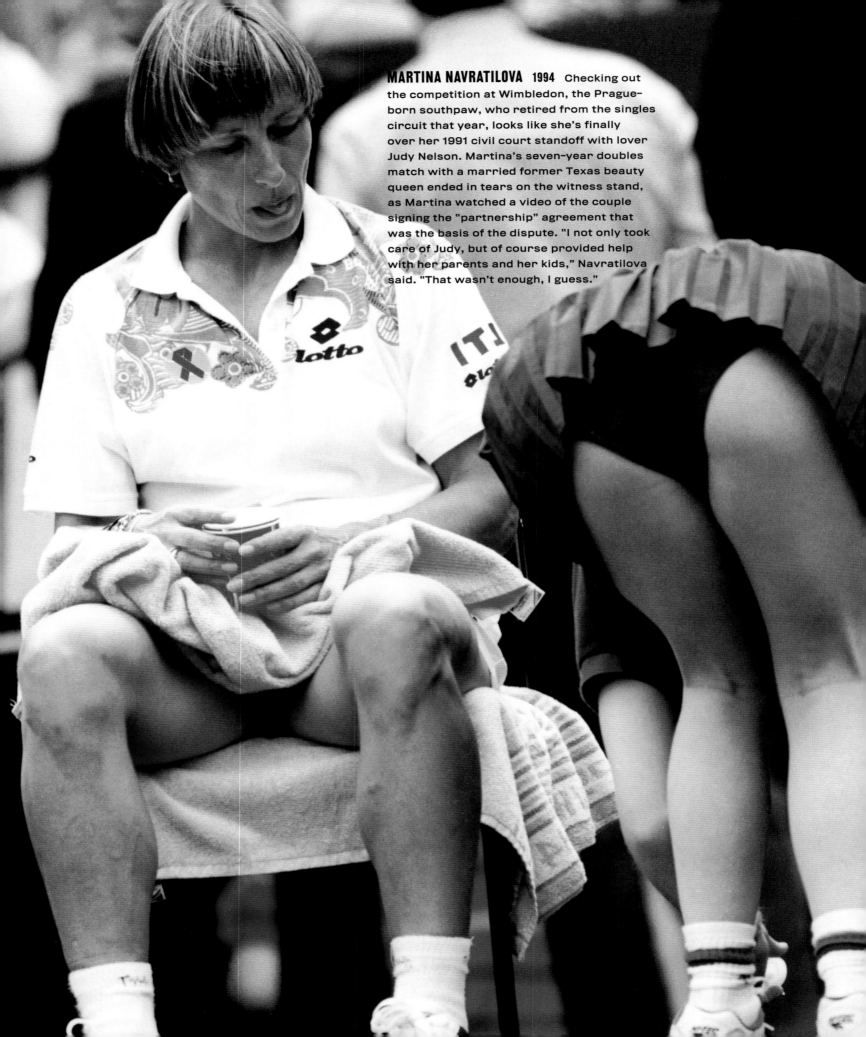

MARTINA NAVRATILOVA 1994 Checking out the competition at Wimbledon, the Prague-born southpaw, who retired from the singles circuit that year, looks like she's finally over her 1991 civil court standoff with lover Judy Nelson. Martina's seven-year doubles match with a married former Texas beauty queen ended in tears on the witness stand, as Martina watched a video of the couple signing the "partnership" agreement that was the basis of the dispute. "I not only took care of Judy, but of course provided help with her parents and her kids," Navratilova said. "That wasn't enough, I guess."

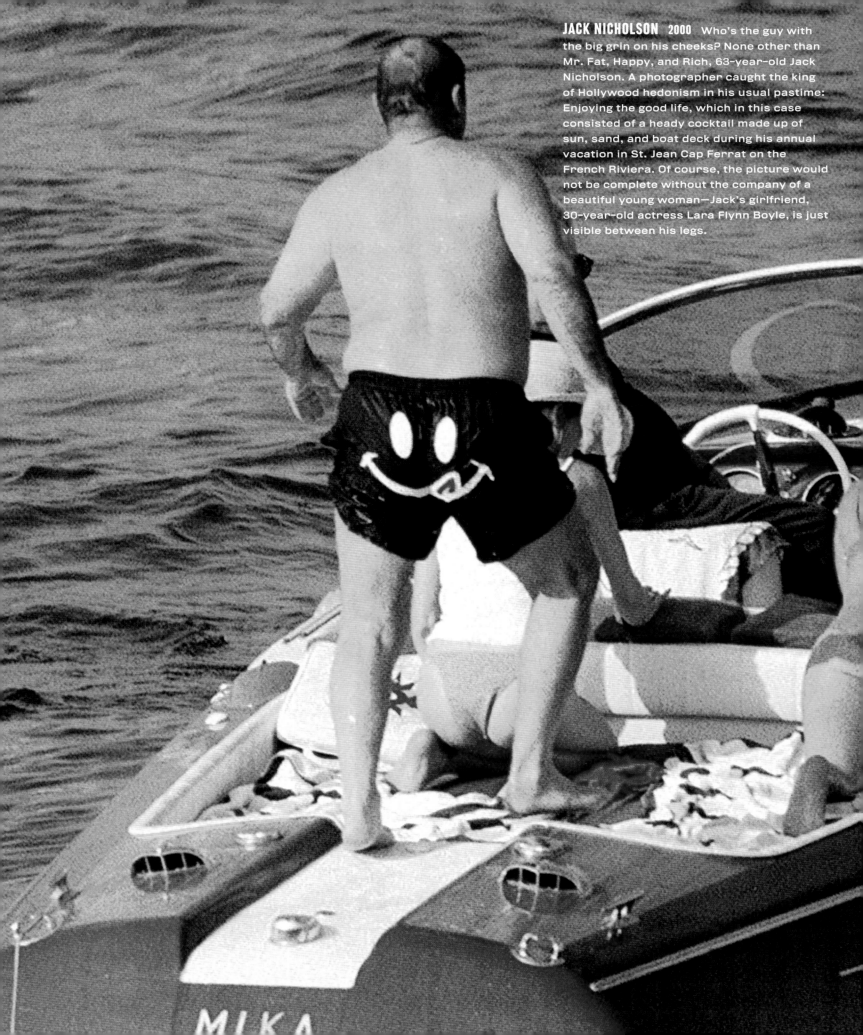

JACK NICHOLSON 2000 Who's the guy with the big grin on his cheeks? None other than Mr. Fat, Happy, and Rich, 63-year-old Jack Nicholson. A photographer caught the king of Hollywood hedonism in his usual pastime: Enjoying the good life, which in this case consisted of a heady cocktail made up of sun, sand, and boat deck during his annual vacation in St. Jean Cap Ferrat on the French Riviera. Of course, the picture would not be complete without the company of a beautiful young woman—Jack's girlfriend, 30-year-old actress Lara Flynn Boyle, is just visible between his legs.

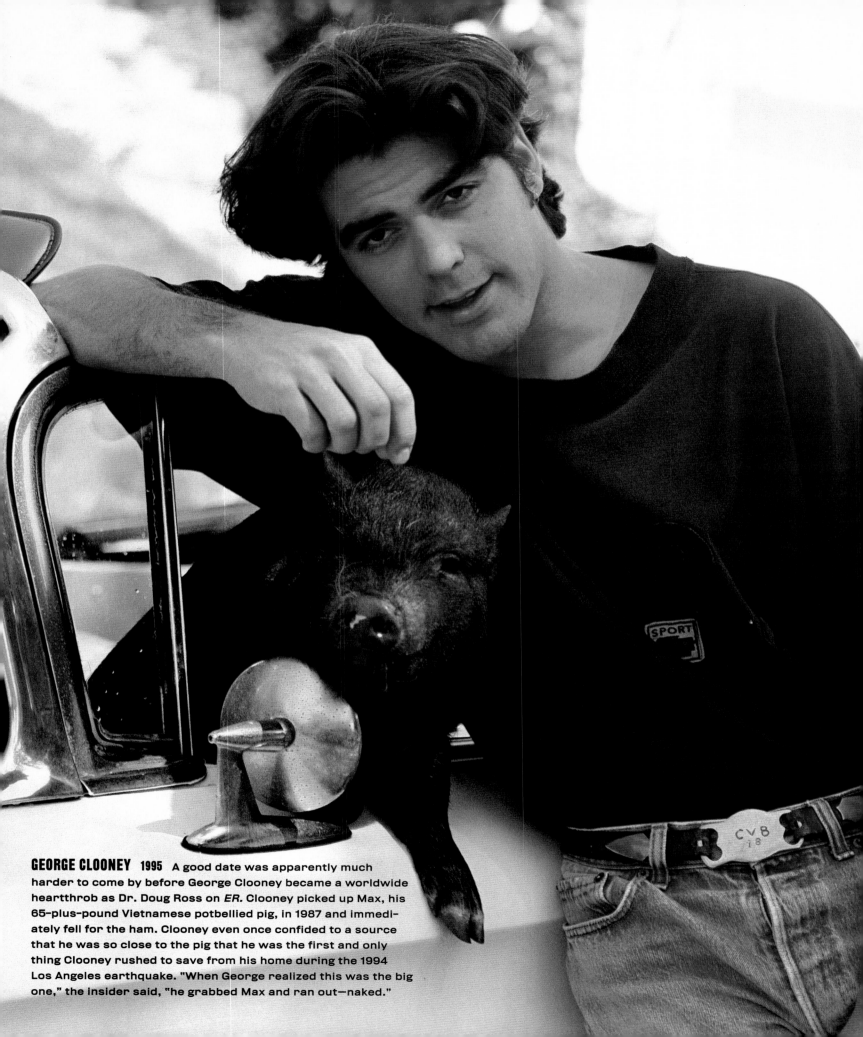

GEORGE CLOONEY 1995 A good date was apparently much harder to come by before George Clooney became a worldwide heartthrob as Dr. Doug Ross on *ER.* Clooney picked up Max, his 65-plus-pound Vietnamese potbellied pig, in 1987 and immediately fell for the ham. Clooney even once confided to a source that he was so close to the pig that he was the first and only thing Clooney rushed to save from his home during the 1994 Los Angeles earthquake. "When George realized this was the big one," the insider said, "he grabbed Max and ran out—naked."

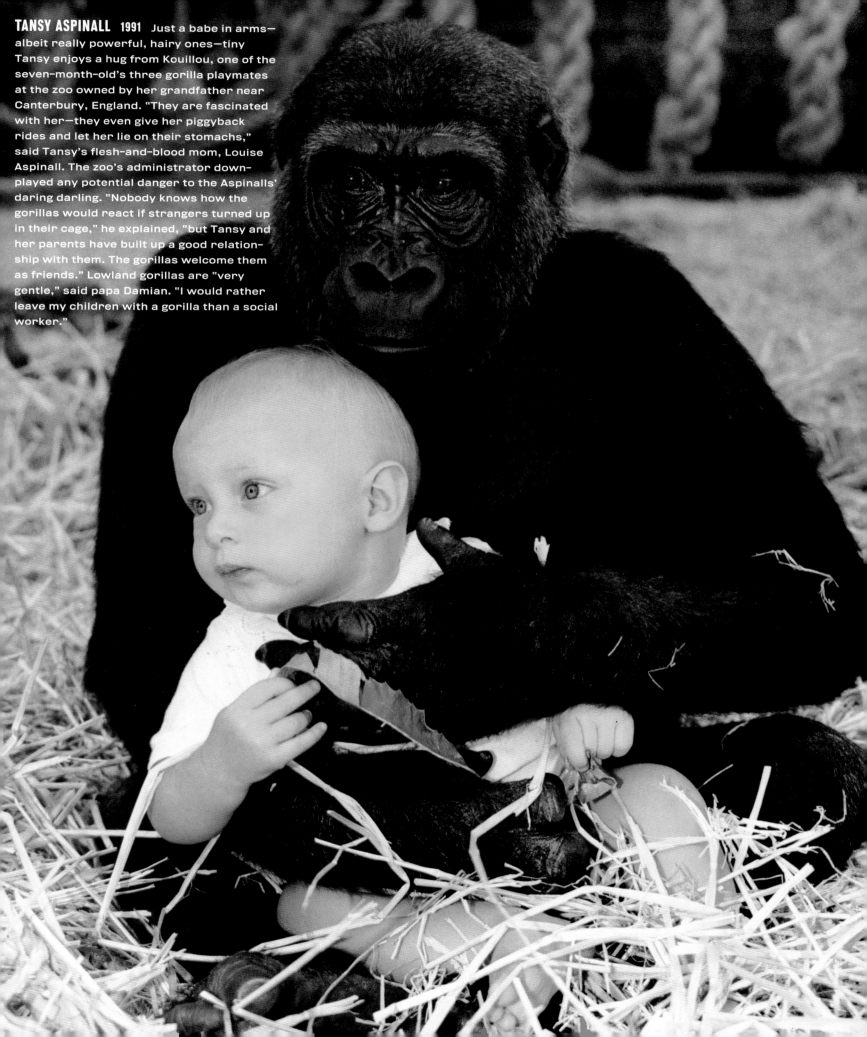

TANSY ASPINALL 1991 Just a babe in arms—albeit really powerful, hairy ones—tiny Tansy enjoys a hug from Kouillou, one of the seven-month-old's three gorilla playmates at the zoo owned by her grandfather near Canterbury, England. "They are fascinated with her—they even give her piggyback rides and let her lie on their stomachs," said Tansy's flesh-and-blood mom, Louise Aspinall. The zoo's administrator downplayed any potential danger to the Aspinalls' daring darling. "Nobody knows how the gorillas would react if strangers turned up in their cage," he explained, "but Tansy and her parents have built up a good relationship with them. The gorillas welcome them as friends." Lowland gorillas are "very gentle," said papa Damian. "I would rather leave my children with a gorilla than a social worker."

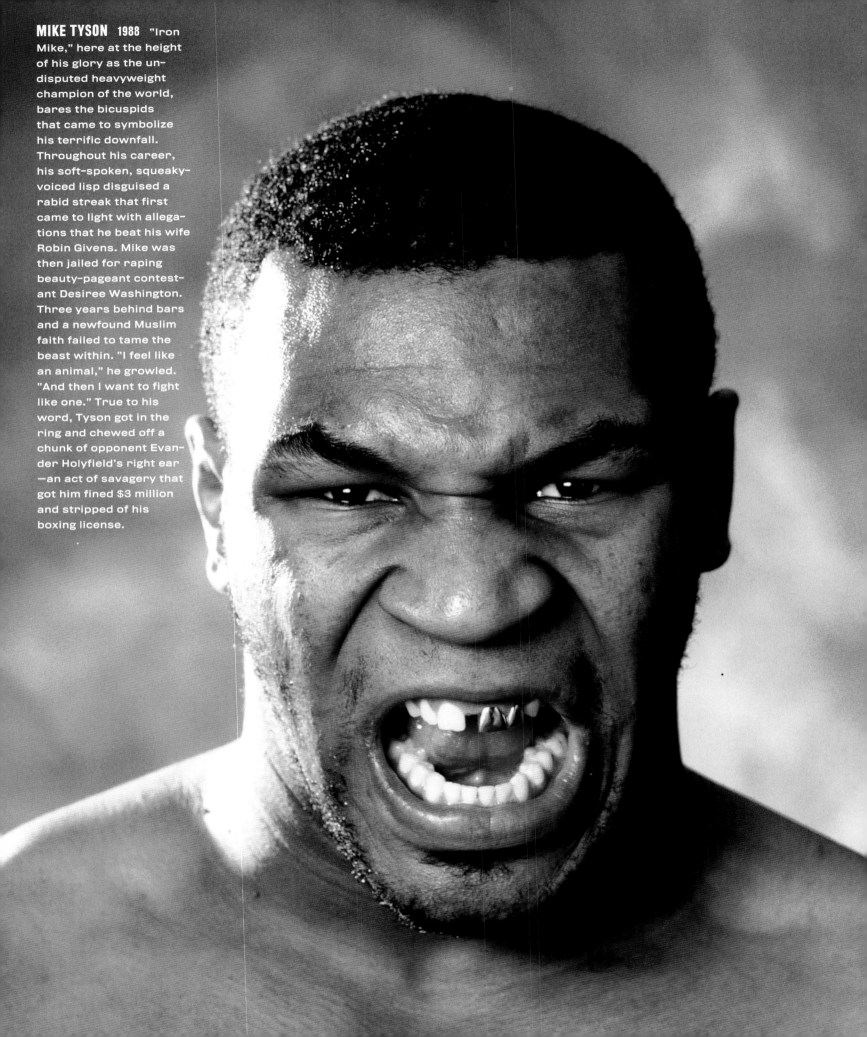

MIKE TYSON 1988 "Iron Mike," here at the height of his glory as the un-disputed heavyweight champion of the world, bares the bicuspids that came to symbolize his terrific downfall. Throughout his career, his soft-spoken, squeaky-voiced lisp disguised a rabid streak that first came to light with allega-tions that he beat his wife Robin Givens. Mike was then jailed for raping beauty-pageant contest-ant Desiree Washington. Three years behind bars and a newfound Muslim faith failed to tame the beast within. "I feel like an animal," he growled. "And then I want to fight like one." True to his word, Tyson got in the ring and chewed off a chunk of opponent Evan-der Holyfield's right ear —an act of savagery that got him fined $3 million and stripped of his boxing license.

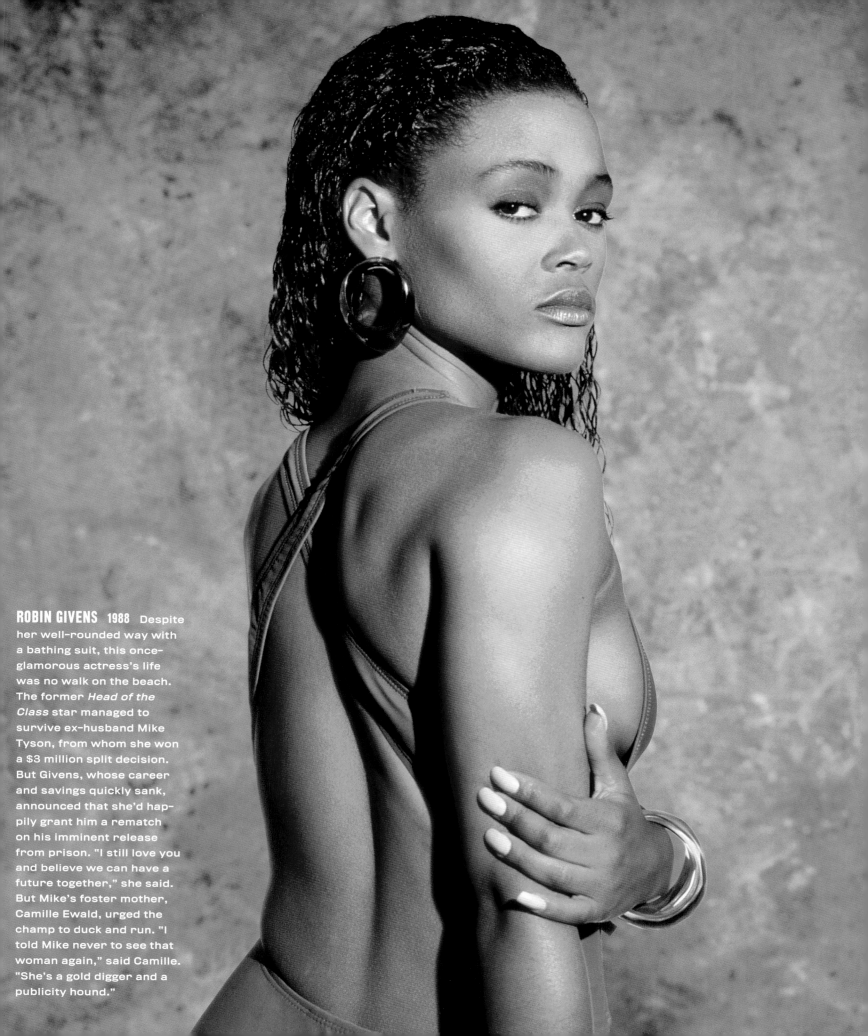

ROBIN GIVENS **1988** Despite her well-rounded way with a bathing suit, this once-glamorous actress's life was no walk on the beach. The former *Head of the Class* star managed to survive ex-husband Mike Tyson, from whom she won a $3 million split decision. But Givens, whose career and savings quickly sank, announced that she'd happily grant him a rematch on his imminent release from prison. "I still love you and believe we can have a future together," she said. But Mike's foster mother, Camille Ewald, urged the champ to duck and run. "I told Mike never to see that woman again," said Camille. "She's a gold digger and a publicity hound."

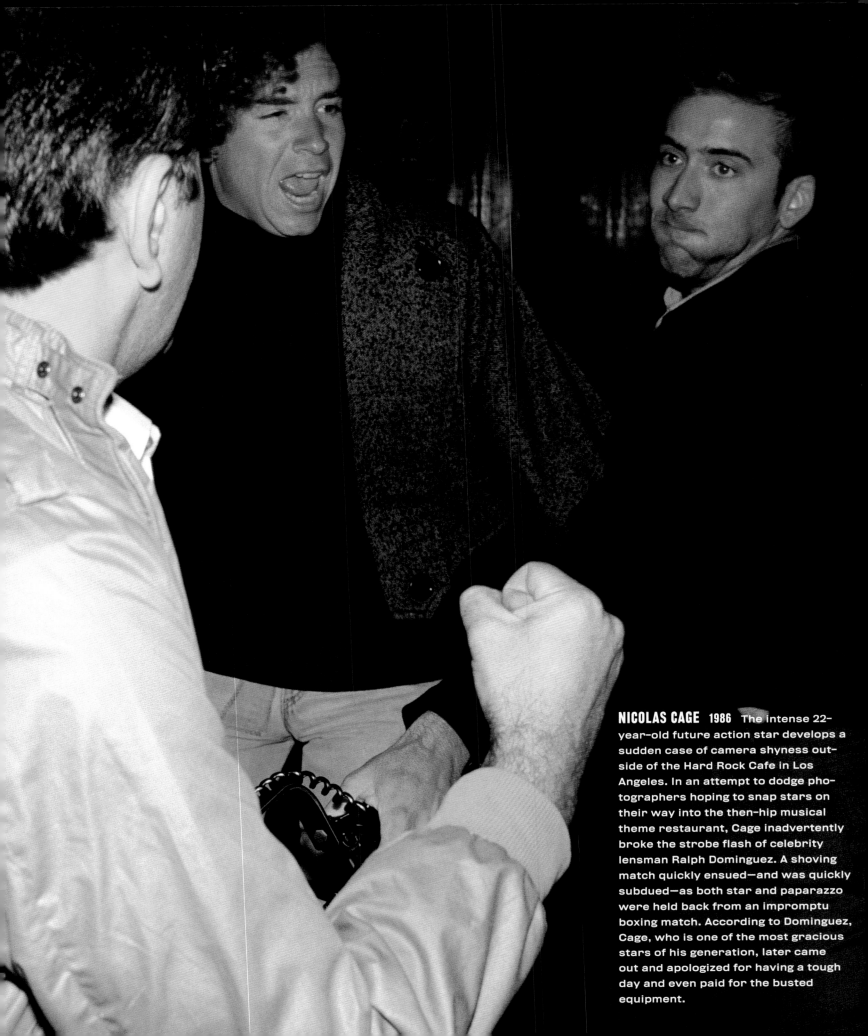

NICOLAS CAGE 1986 The intense 22-year-old future action star develops a sudden case of camera shyness outside of the Hard Rock Cafe in Los Angeles. In an attempt to dodge photographers hoping to snap stars on their way into the then-hip musical theme restaurant, Cage inadvertently broke the strobe flash of celebrity lensman Ralph Dominguez. A shoving match quickly ensued—and was quickly subdued—as both star and paparazzo were held back from an impromptu boxing match. According to Dominguez, Cage, who is one of the most gracious stars of his generation, later came out and apologized for having a tough day and even paid for the busted equipment.

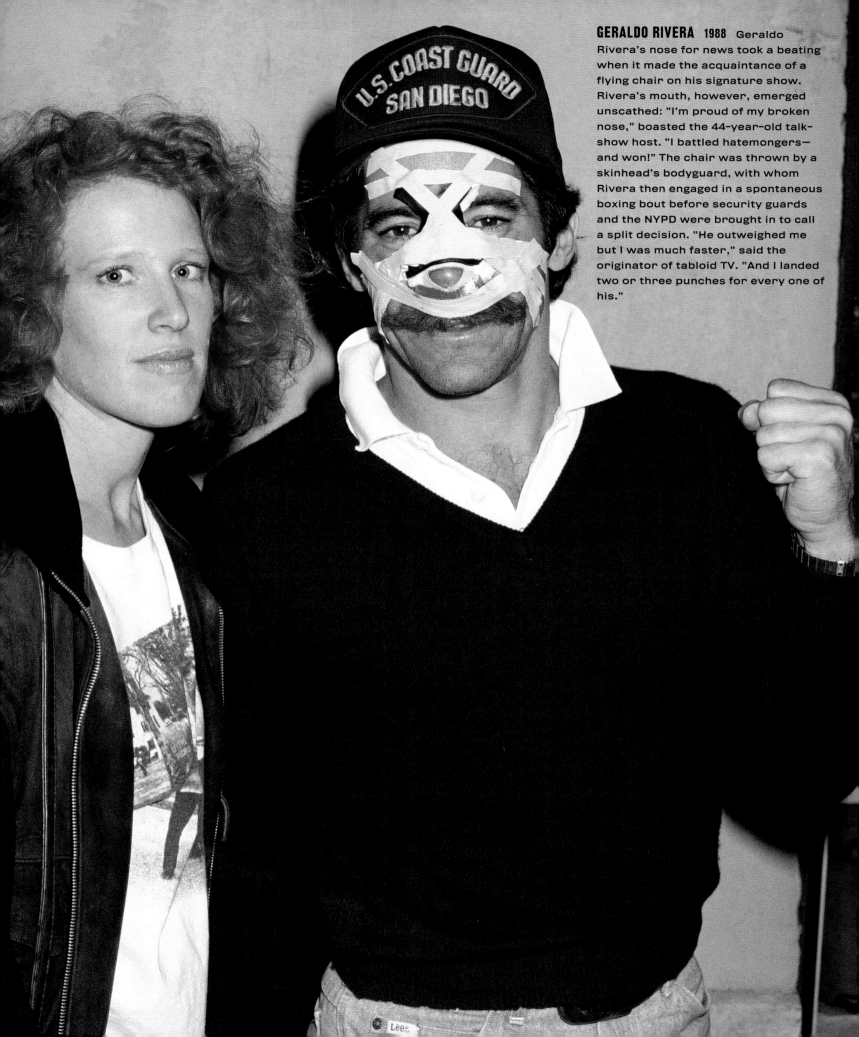

GERALDO RIVERA 1988 Geraldo Rivera's nose for news took a beating when it made the acquaintance of a flying chair on his signature show. Rivera's mouth, however, emerged unscathed: "I'm proud of my broken nose," boasted the 44-year-old talk-show host. "I battled hatemongers—and won!" The chair was thrown by a skinhead's bodyguard, with whom Rivera then engaged in a spontaneous boxing bout before security guards and the NYPD were brought in to call a split decision. "He outweighed me but I was much faster," said the originator of tabloid TV. "And I landed two or three punches for every one of his."

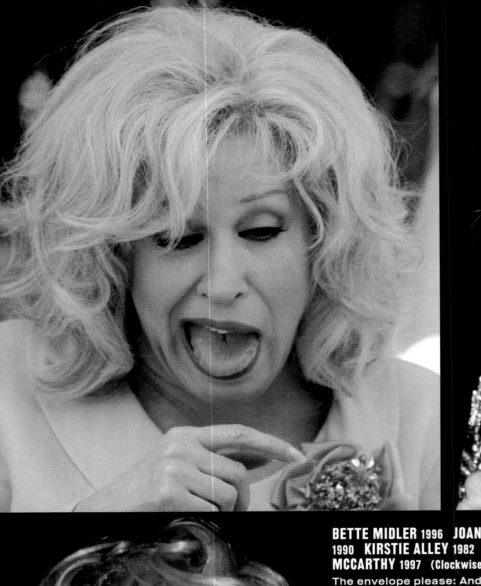

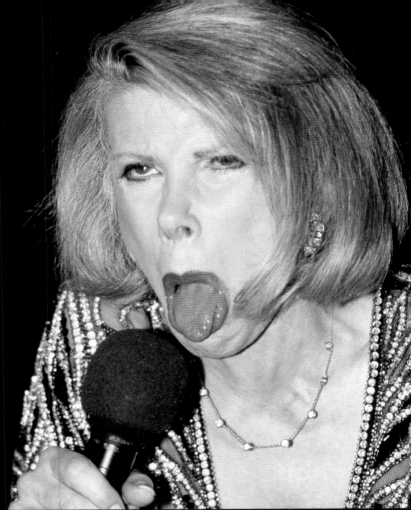

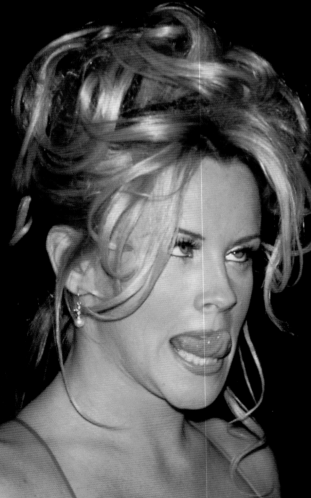

BETTE MIDLER 1996 **JOAN RIVERS** 1990 **KIRSTIE ALLEY** 1982 AND **JENNY MCCARTHY** 1997 **(Clockwise from top left)** The envelope please: And the winner is Jenny McCarthy, whose silly faces have made young men putty in her hands ever since her breakout gig on MTV's *Singled Out.* Bette Midler's knack for the wacky was put into doubt with her recent sitcom flop, while Joan Rivers will always be the Susan Lucci of the category—a perennial contender whose hard work on the red carpet goes unre-warded. Although Scientology is exceedingly loony, Kirstie Alley herself will need a few more prayers before she can outclass this competition.

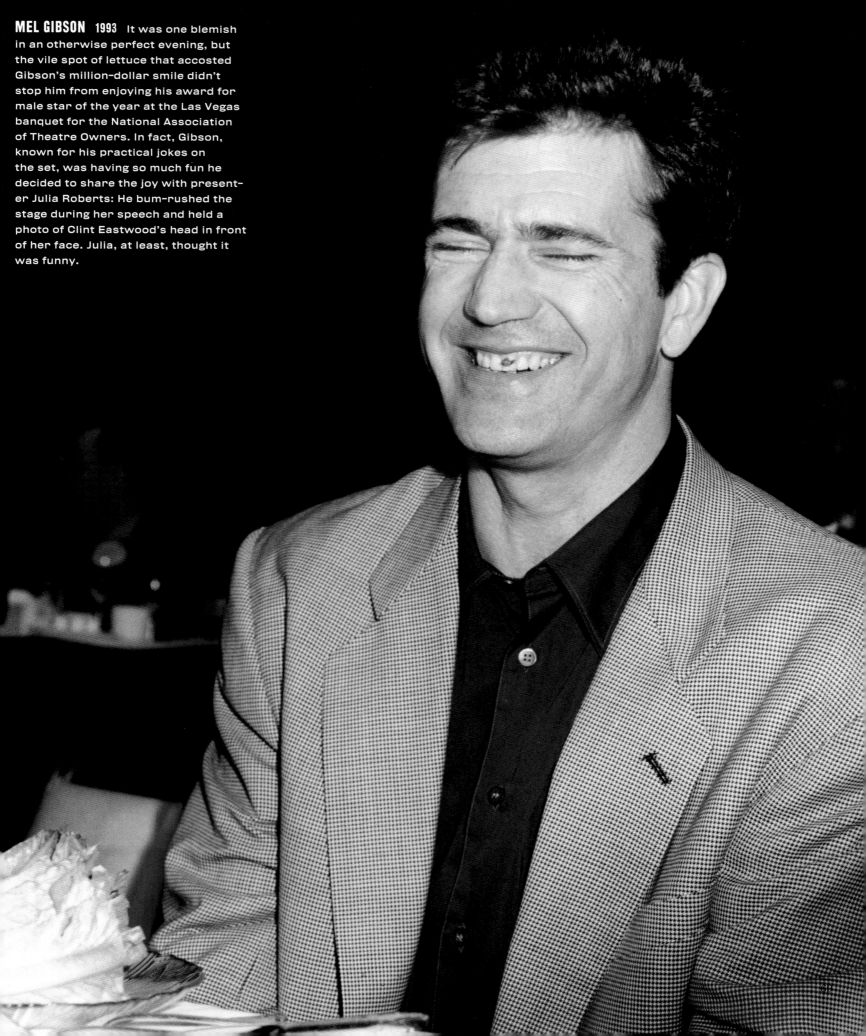

MEL GIBSON **1993** It was one blemish in an otherwise perfect evening, but the vile spot of lettuce that accosted Gibson's million-dollar smile didn't stop him from enjoying his award for male star of the year at the Las Vegas banquet for the National Association of Theatre Owners. In fact, Gibson, known for his practical jokes on the set, was having so much fun he decided to share the joy with presenter Julia Roberts: He bum-rushed the stage during her speech and held a photo of Clint Eastwood's head in front of her face. Julia, at least, thought it was funny.

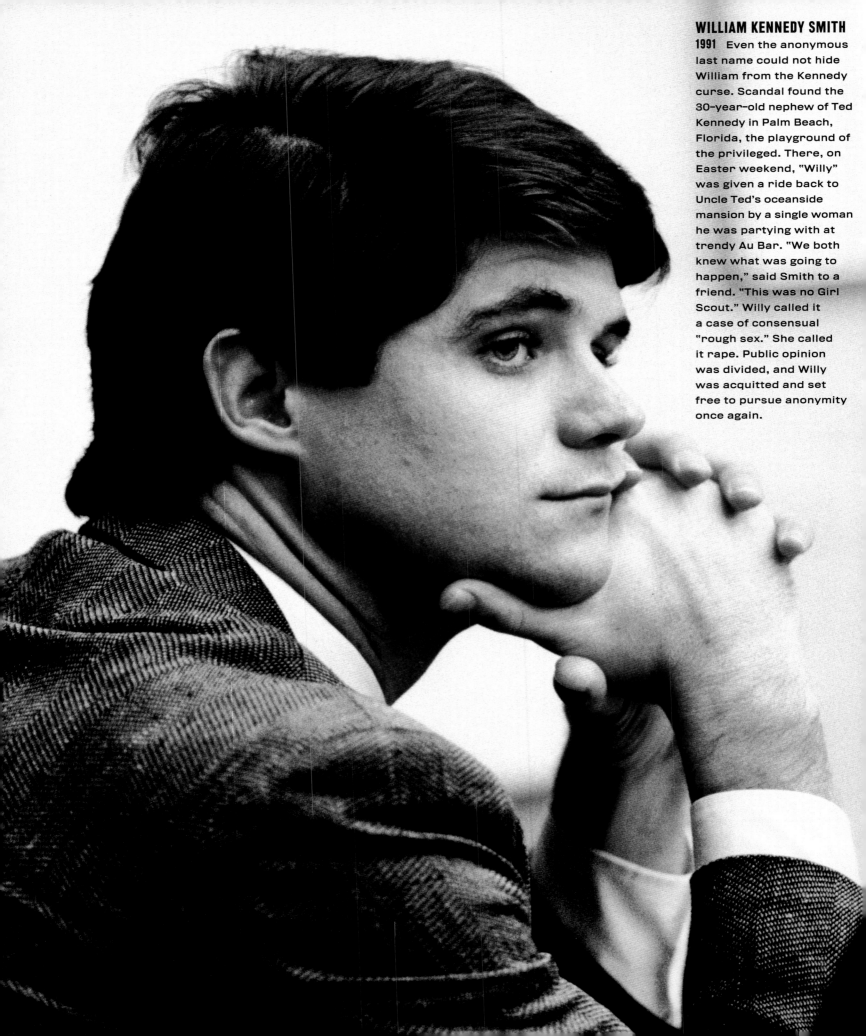

WILLIAM KENNEDY SMITH
1991 Even the anonymous last name could not hide William from the Kennedy curse. Scandal found the 30-year-old nephew of Ted Kennedy in Palm Beach, Florida, the playground of the privileged. There, on Easter weekend, "Willy" was given a ride back to Uncle Ted's oceanside mansion by a single woman he was partying with at trendy Au Bar. "We both knew what was going to happen," said Smith to a friend. "This was no Girl Scout." Willy called it a case of consensual "rough sex." She called it rape. Public opinion was divided, and Willy was acquitted and set free to pursue anonymity once again.

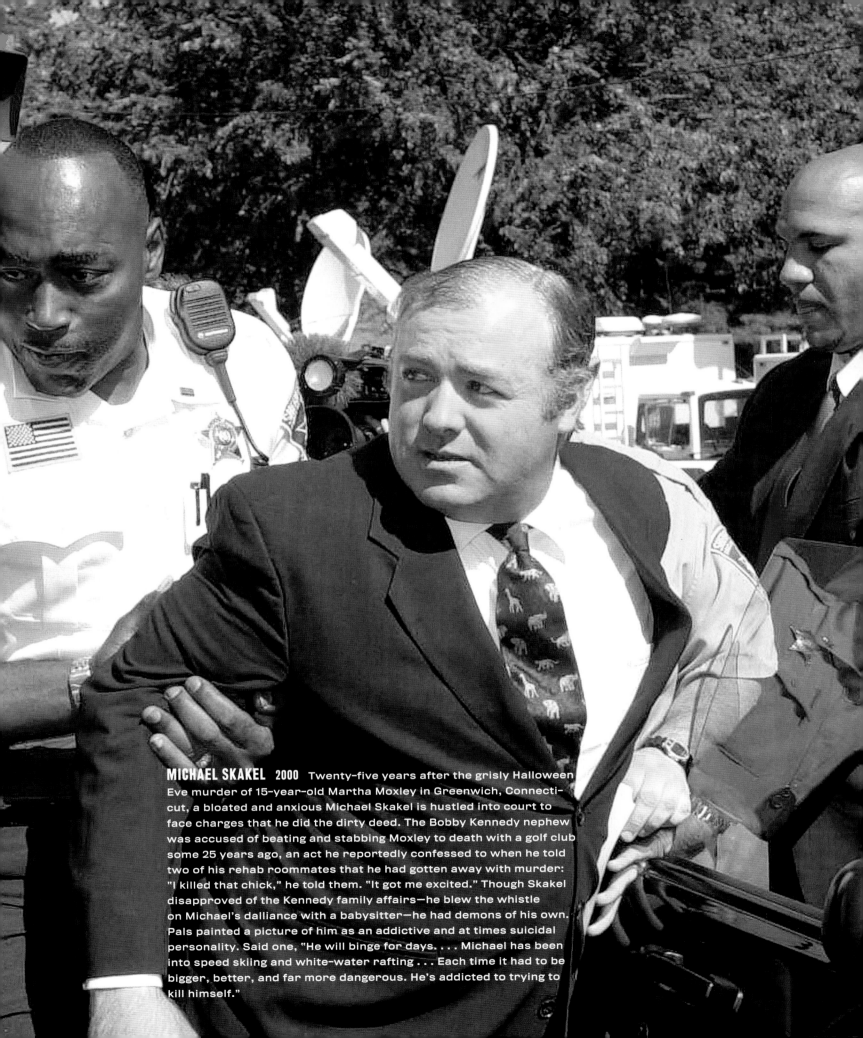

MICHAEL SKAKEL 2000 Twenty-five years after the grisly Halloween Eve murder of 15-year-old Martha Moxley in Greenwich, Connecticut, a bloated and anxious Michael Skakel is hustled into court to face charges that he did the dirty deed. The Bobby Kennedy nephew was accused of beating and stabbing Moxley to death with a golf club some 25 years ago, an act he reportedly confessed to when he told two of his rehab roommates that he had gotten away with murder: "I killed that chick," he told them. "It got me excited." Though Skakel disapproved of the Kennedy family affairs—he blew the whistle on Michael's dalliance with a babysitter—he had demons of his own. Pals painted a picture of him as an addictive and at times suicidal personality. Said one, "He will binge for days. . . . Michael has been into speed skiing and white-water rafting . . . Each time it had to be bigger, better, and far more dangerous. He's addicted to trying to kill himself."

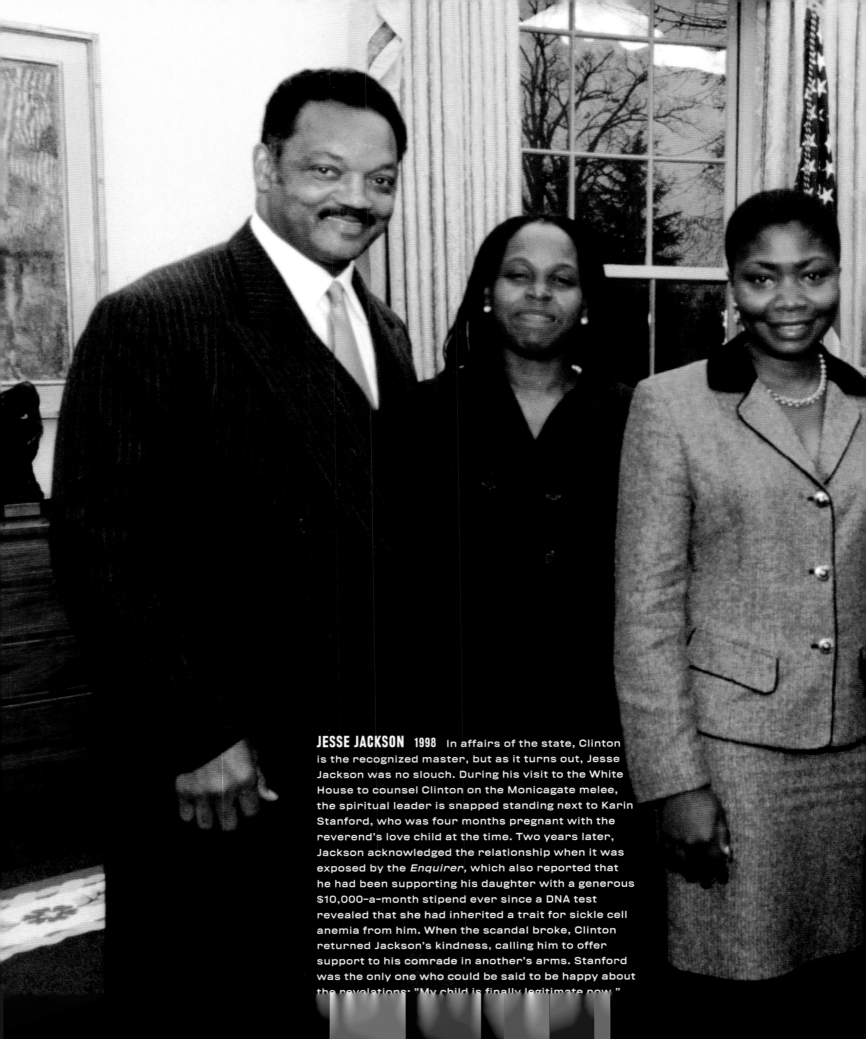

JESSE JACKSON 1998 In affairs of the state, Clinton is the recognized master, but as it turns out, Jesse Jackson was no slouch. During his visit to the White House to counsel Clinton on the Monicagate melee, the spiritual leader is snapped standing next to Karin Stanford, who was four months pregnant with the reverend's love child at the time. Two years later, Jackson acknowledged the relationship when it was exposed by the *Enquirer,* which also reported that he had been supporting his daughter with a generous $10,000-a-month stipend ever since a DNA test revealed that she had inherited a trait for sickle cell anemia from him. When the scandal broke, Clinton returned Jackson's kindness, calling him to offer support to his comrade in another's arms. Stanford was the only one who could be said to be happy about the revelations: "My child is finally legitimate now."

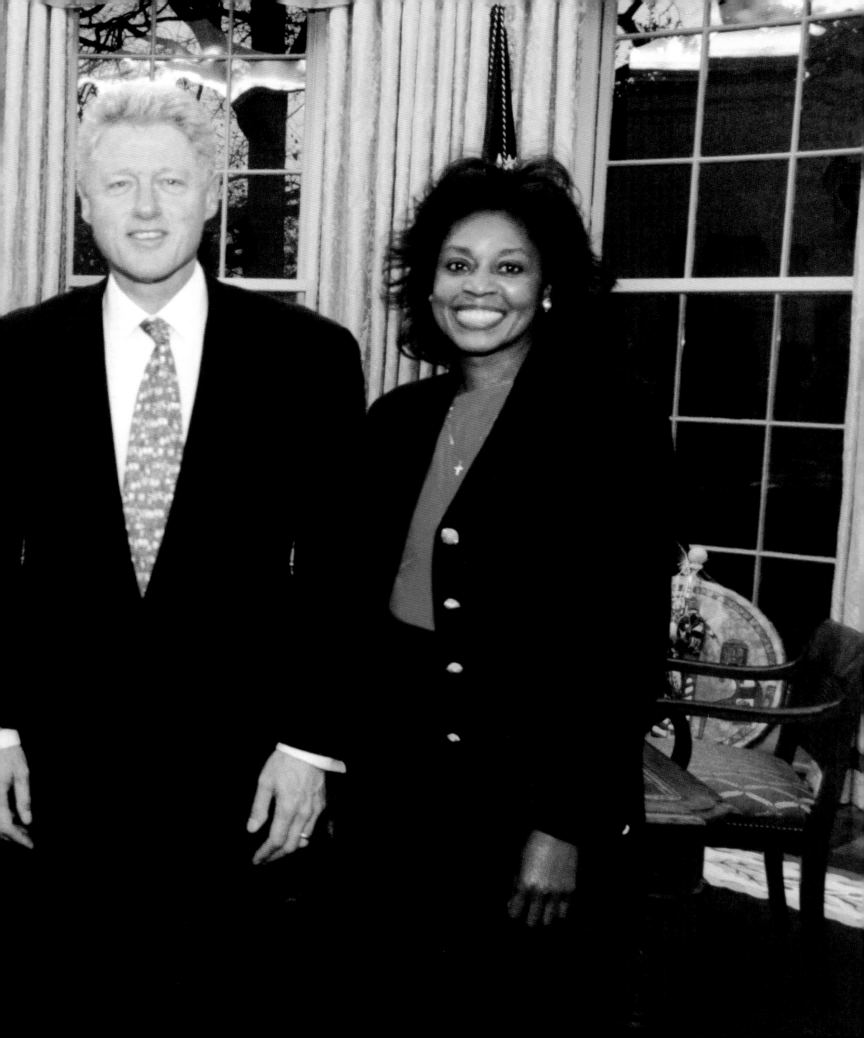

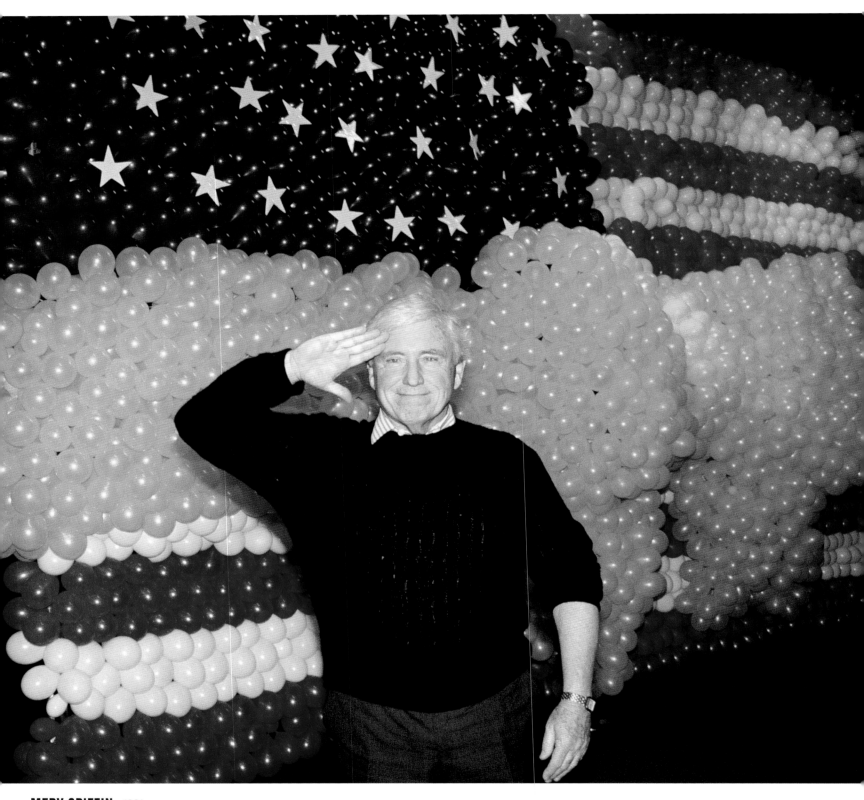

MERV GRIFFIN 1991 The creator of *Jeopardy!* and *Wheel of Fortune* goes head to head with Trump in the casino wars, apparently showing up personally at his Resorts International Atlantic City property to salute arriving customers. Griffin, whose billion-dollar real estate fortune rivals Donald Trump's, saw his own wheel of fortune turn to misfortune when he was diagnosed with prostate cancer in 1996. Upon hearing the news, he took off on his $7 million yacht with a gourmet chef. "I ate like a son of a bitch," he said. "I thought, 'I'll just force that cancer out with a little crème brûlée.'" Indeed, his cancer did go into remission, and two years later he opened the Coconut Club in his Beverly Hilton hotel. "The *National Enquirer* said, 'Merv Griffin bought the Beverly Hilton so he would have a place to work for the rest of his life,'" Merv said in an interview. "A few months later I was singing there, and I thought, 'Hey! They were right!'"

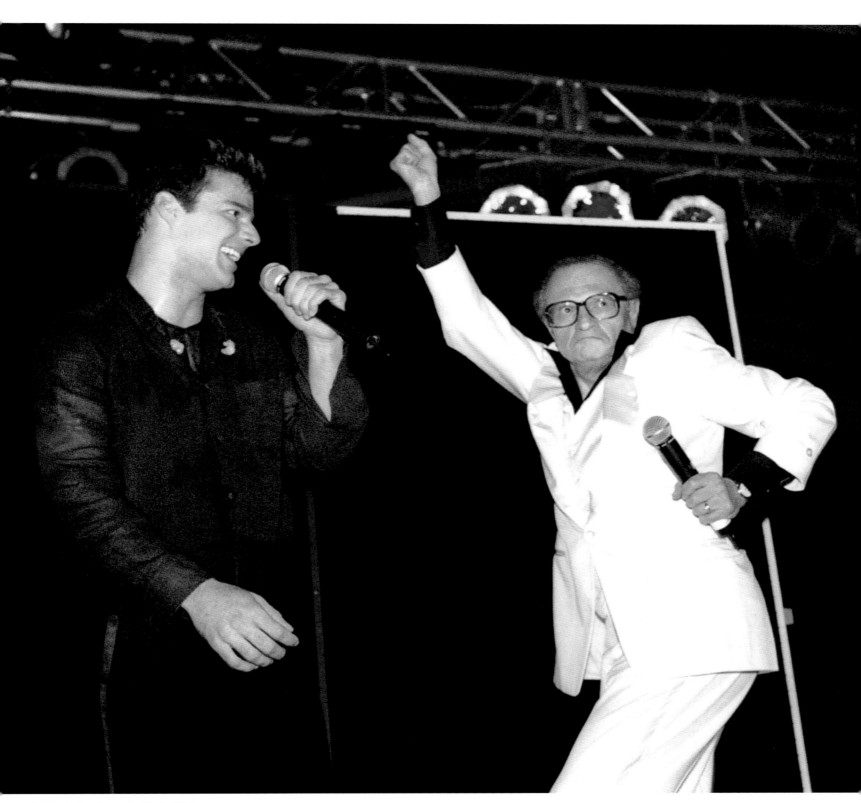

RICKY MARTIN AND **LARRY KING** **1999** The Puerto Rican pop singer plays it straight as Larry King comes down with a "Saturday Night Fever" during a benefit for the Larry King Cardiac Foundation. The TV interviewer, who proved to everyone he could still shake his bonbon when he became a dad at 65, created the foundation after surviving a $65,000 quintuple bypass operation in 1987. "This is the most gratifying thing I do," said King, who donates money from books and lectures to people who need heart surgery. "For me, this is a celebration of life."

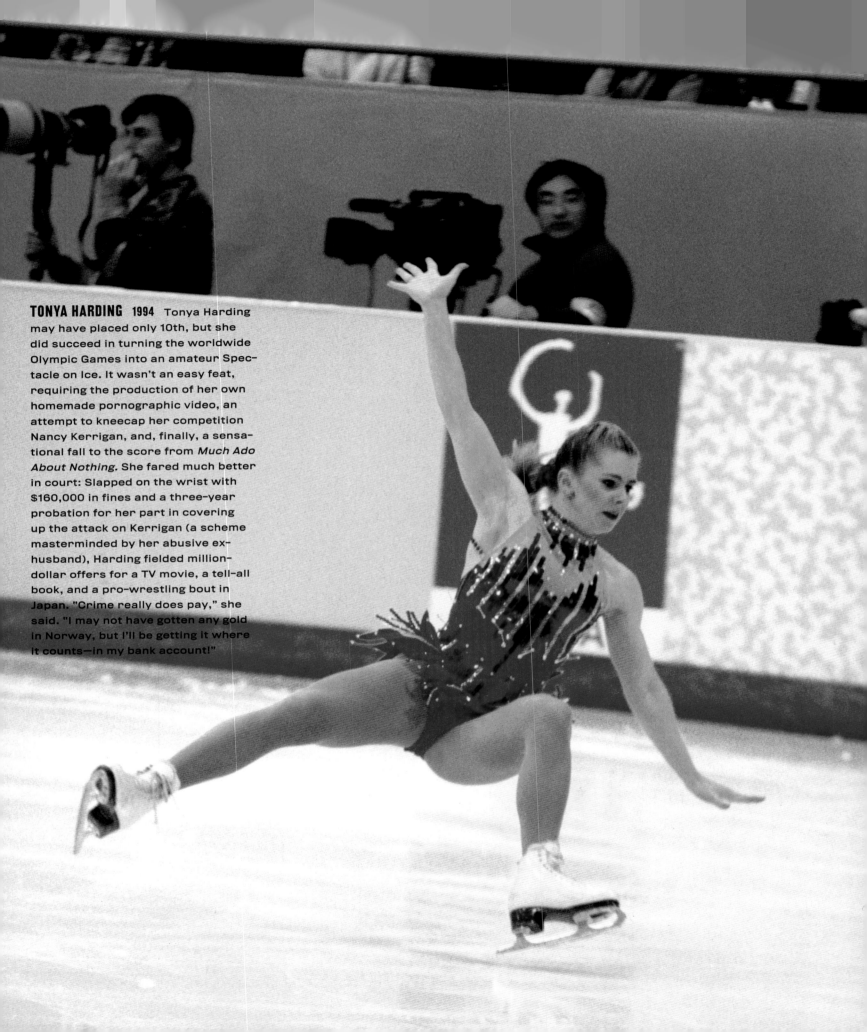

TONYA HARDING 1994 Tonya Harding may have placed only 10th, but she did succeed in turning the worldwide Olympic Games into an amateur Spectacle on Ice. It wasn't an easy feat, requiring the production of her own homemade pornographic video, an attempt to kneecap her competition Nancy Kerrigan, and, finally, a sensational fall to the score from *Much Ado About Nothing.* She fared much better in court: Slapped on the wrist with $160,000 in fines and a three-year probation for her part in covering up the attack on Kerrigan (a scheme masterminded by her abusive ex-husband), Harding fielded million-dollar offers for a TV movie, a tell-all book, and a pro-wrestling bout in Japan. "Crime really does pay," she said. "I may not have gotten any gold in Norway, but I'll be getting it where it counts—in my bank account!"

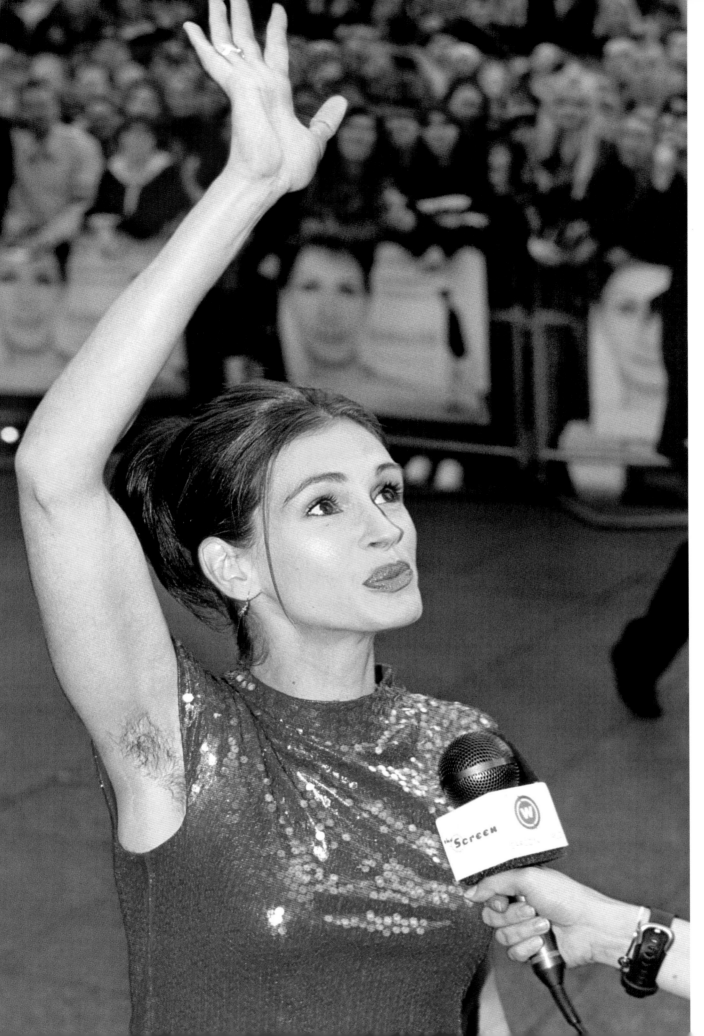

JULIA ROBERTS 1999

Hollywood's highest-paid pretty woman caused a small stink at the London premiere of *Notting Hill* when she exposed her unshaven underarm to the cameras. Perhaps that's because good dirt on the Smyrna, Georgia, peach has always been hard to come by. Even her poor choice in men (she dumped Kiefer Sutherland *Runaway Bride*-style, then briefly married, but never lived with, country crooner Lyle Lovett) hasn't been fertile ground since her apparently healthy relationship with *Law & Order* star Benjamin Bratt (which, however, ended in 2001). "I live a privileged life," Roberts once said. "I'm rich. I'm happy. I'm like a pig in shit."

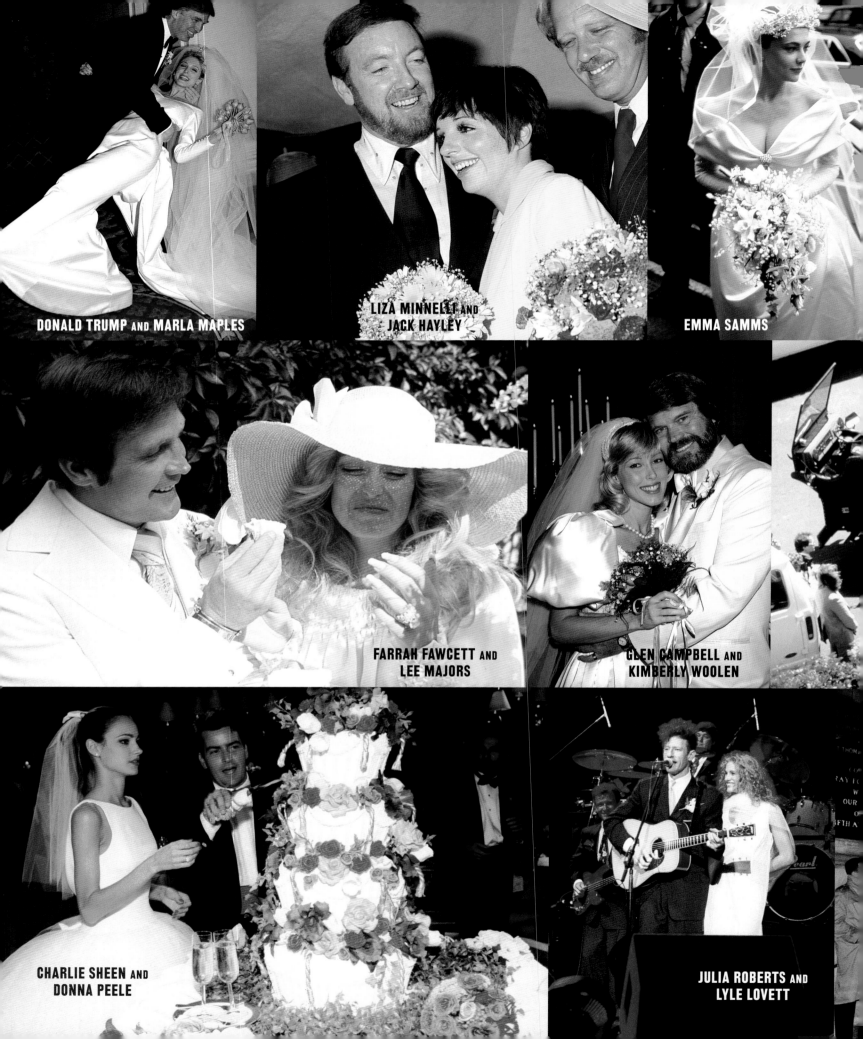

DONALD TRUMP AND MARLA MAPLES

LIZA MINNELLI AND
JACK HAYLEY

EMMA SAMMS

FARRAH FAWCETT AND
LEE MAJORS

GLEN CAMPBELL AND
KIMBERLY WOOLEN

CHARLIE SHEEN AND
DONNA PEELE

JULIA ROBERTS AND
LYLE LOVETT

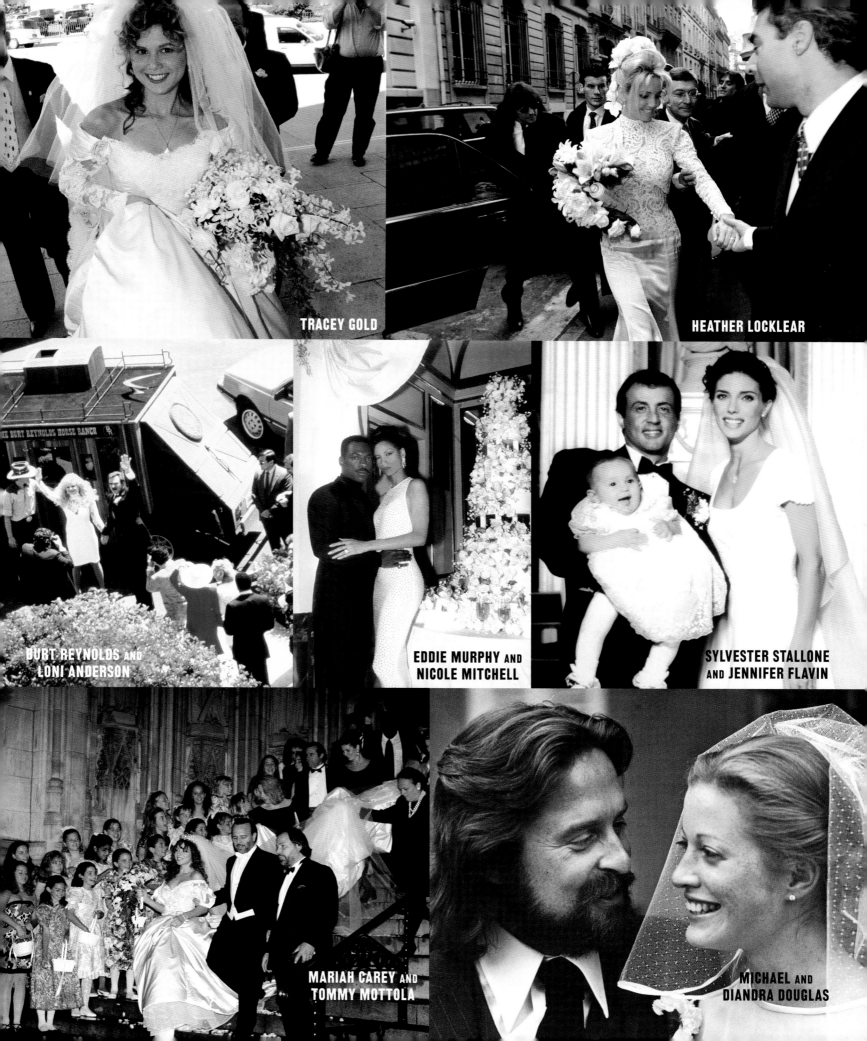

TRACEY GOLD

HEATHER LOCKLEAR

BURT REYNOLDS AND
LONI ANDERSON

EDDIE MURPHY AND
NICOLE MITCHELL

SYLVESTER STALLONE
AND JENNIFER FLAVIN

MARIAH CAREY AND
TOMMY MOTTOLA

MICHAEL AND
DIANDRA DOUGLAS

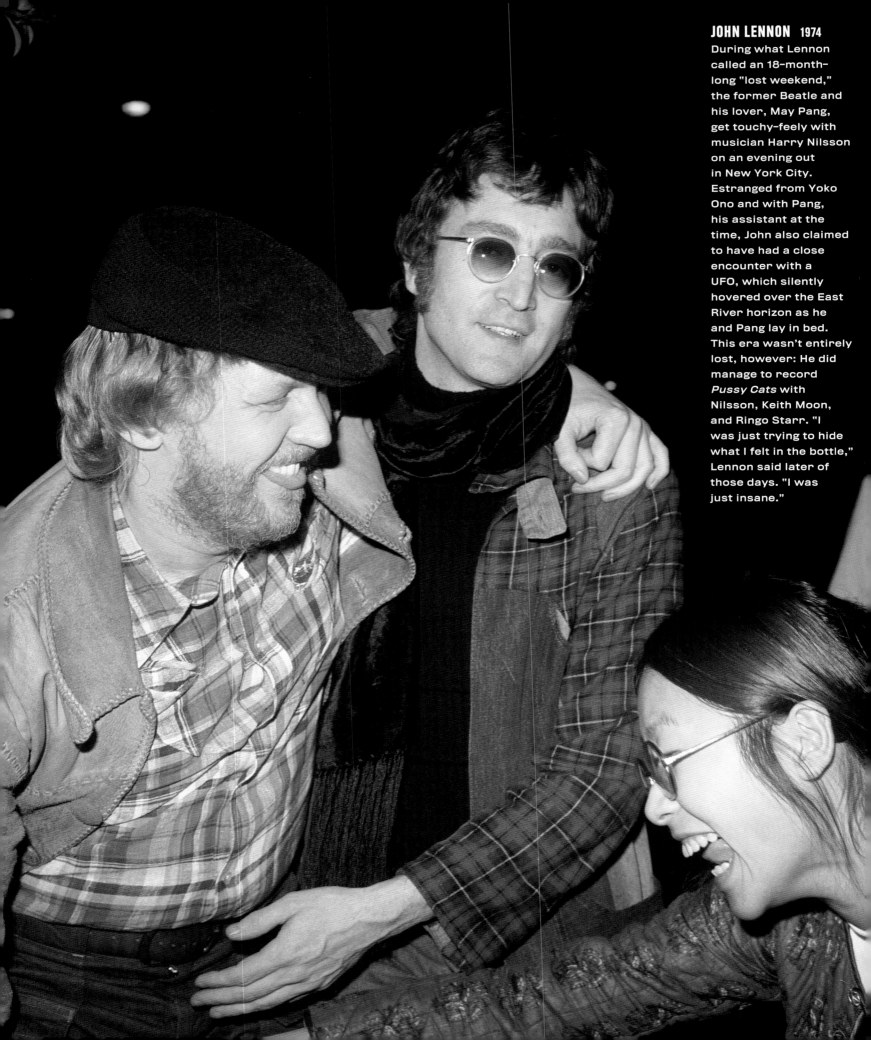

JOHN LENNON 1974

During what Lennon called an 18-month-long "lost weekend," the former Beatle and his lover, May Pang, get touchy-feely with musician Harry Nilsson on an evening out in New York City. Estranged from Yoko Ono and with Pang, his assistant at the time, John also claimed to have had a close encounter with a UFO, which silently hovered over the East River horizon as he and Pang lay in bed. This era wasn't entirely lost, however: He did manage to record *Pussy Cats* with Nilsson, Keith Moon, and Ringo Starr. "I was just trying to hide what I felt in the bottle," Lennon said later of those days. "I was just insane."

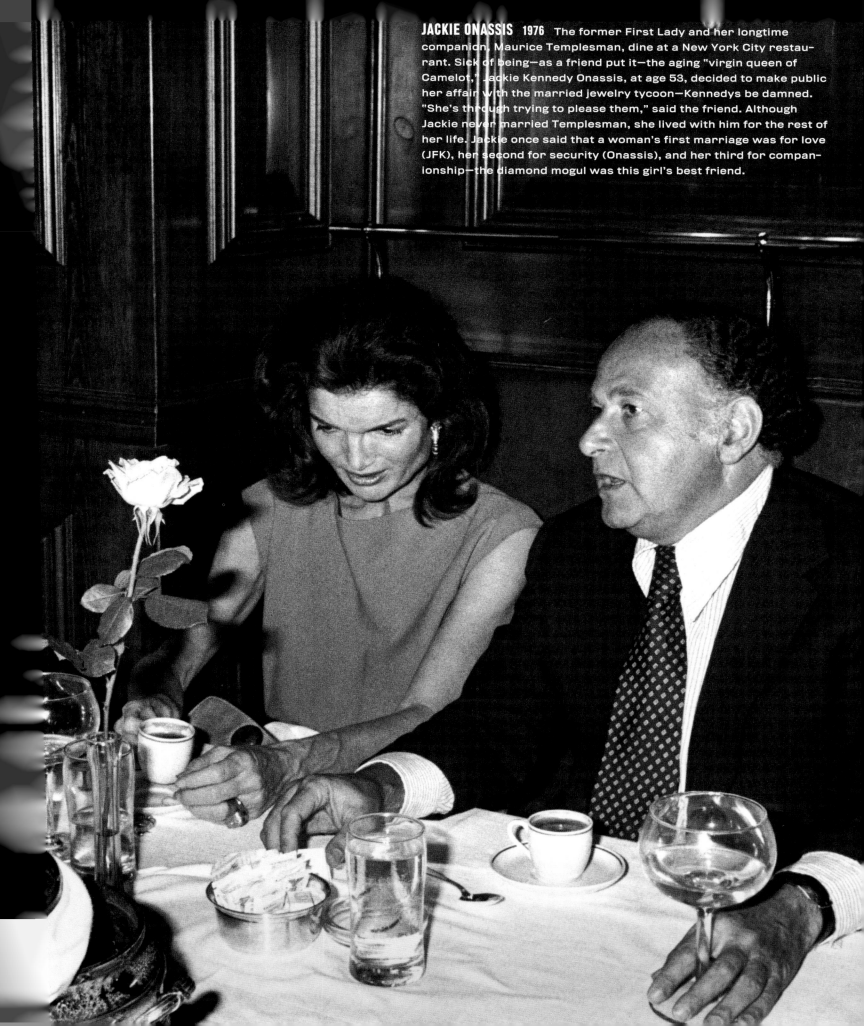

JACKIE ONASSIS 1976 The former First Lady and her longtime companion, Maurice Templesman, dine at a New York City restaurant. Sick of being—as a friend put it—the aging "virgin queen of Camelot," Jackie Kennedy Onassis, at age 53, decided to make public her affair with the married jewelry tycoon—Kennedys be damned. "She's through trying to please them," said the friend. Although Jackie never married Templesman, she lived with him for the rest of her life. Jackie once said that a woman's first marriage was for love (JFK), her second for security (Onassis), and her third for companionship—the diamond mogul was this girl's best friend.

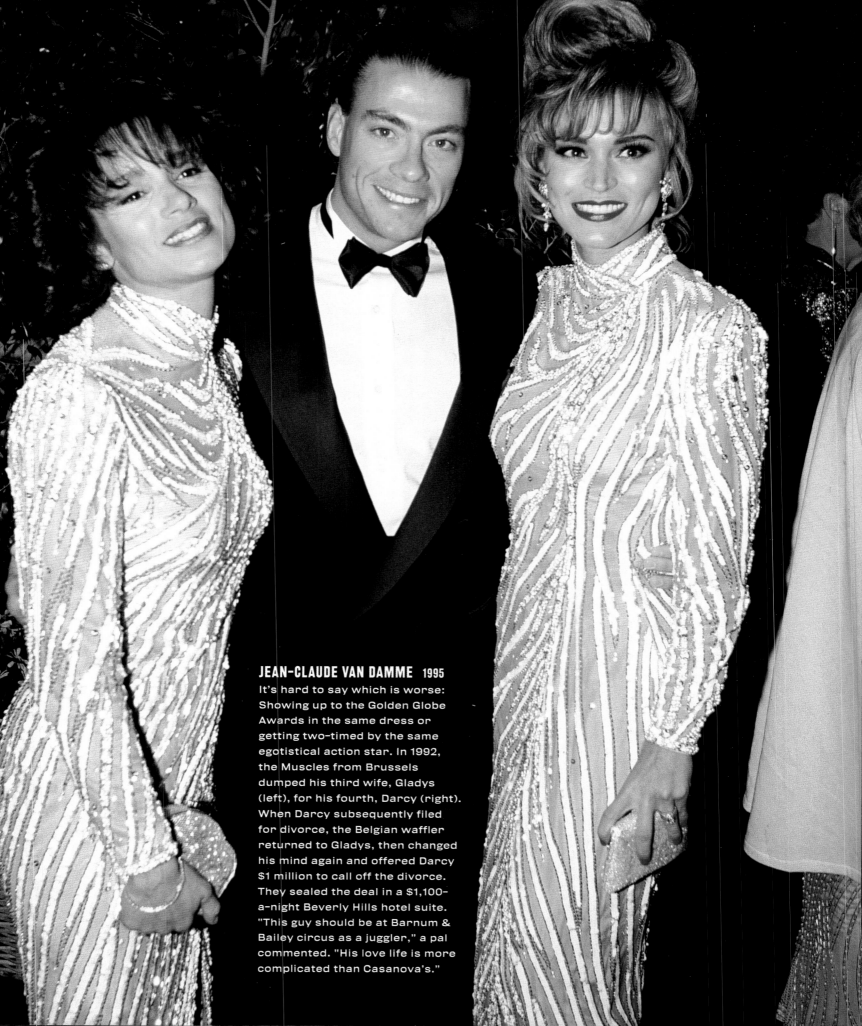

JEAN-CLAUDE VAN DAMME 1995

It's hard to say which is worse: Showing up to the Golden Globe Awards in the same dress or getting two-timed by the same egotistical action star. In 1992, the Muscles from Brussels dumped his third wife, Gladys (left), for his fourth, Darcy (right). When Darcy subsequently filed for divorce, the Belgian waffler returned to Gladys, then changed his mind again and offered Darcy $1 million to call off the divorce. They sealed the deal in a $1,100-a-night Beverly Hills hotel suite. "This guy should be at Barnum & Bailey circus as a juggler," a pal commented. "His love life is more complicated than Casanova's."

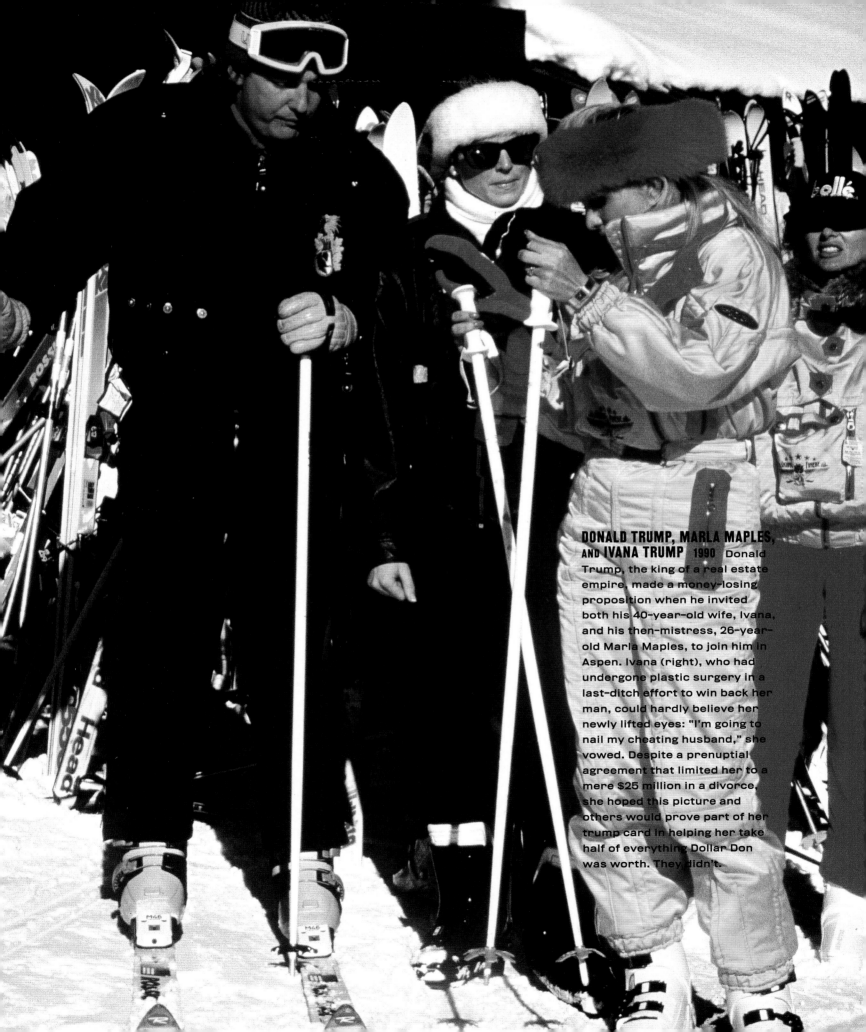

DONALD TRUMP, MARLA MAPLES, AND IVANA TRUMP 1990 Donald Trump, the king of a real estate empire, made a money-losing proposition when he invited both his 40-year-old wife, Ivana, and his then-mistress, 26-year-old Marla Maples, to join him in Aspen. Ivana (right), who had undergone plastic surgery in a last-ditch effort to win back her man, could hardly believe her newly lifted eyes: "I'm going to nail my cheating husband," she vowed. Despite a prenuptial agreement that limited her to a mere $25 million in a divorce, she hoped this picture and others would prove part of her trump card in helping her take half of everything Dollar Don was worth. They didn't.

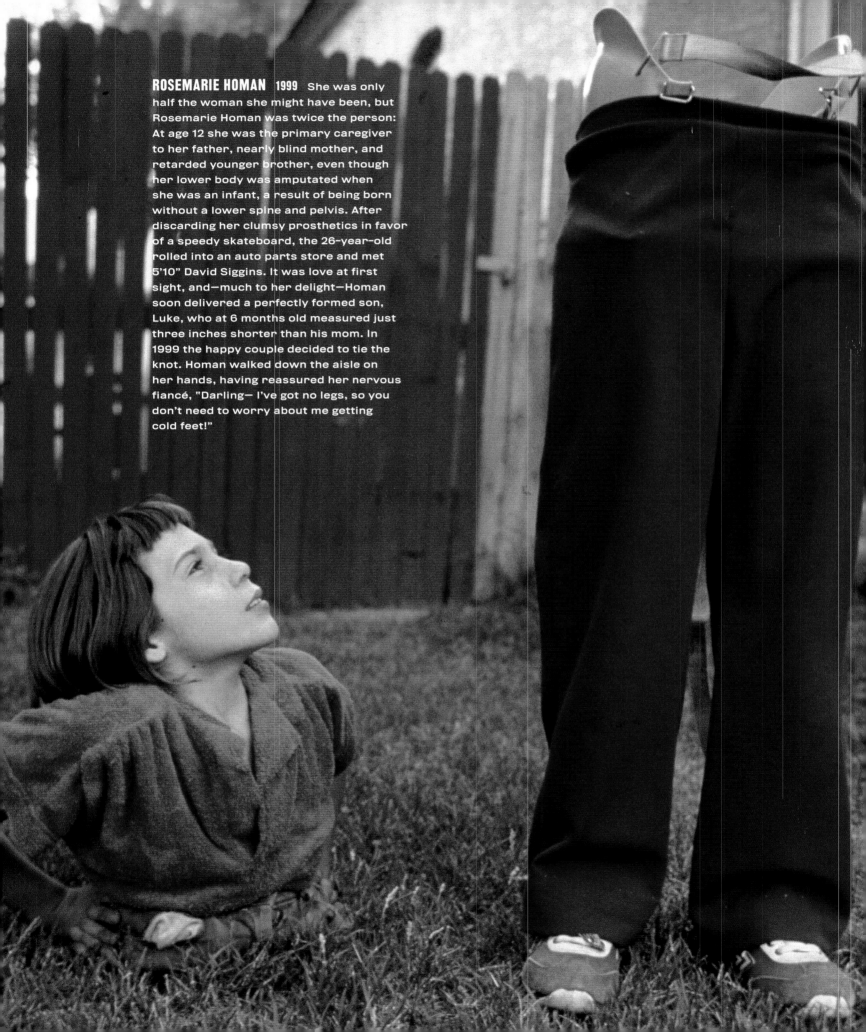

ROSEMARIE HOMAN 1999 She was only half the woman she might have been, but Rosemarie Homan was twice the person: At age 12 she was the primary caregiver to her father, nearly blind mother, and retarded younger brother, even though her lower body was amputated when she was an infant, a result of being born without a lower spine and pelvis. After discarding her clumsy prosthetics in favor of a speedy skateboard, the 26-year-old rolled into an auto parts store and met 5'10" David Siggins. It was love at first sight, and—much to her delight—Homan soon delivered a perfectly formed son, Luke, who at 6 months old measured just three inches shorter than his mom. In 1999 the happy couple decided to tie the knot. Homan walked down the aisle on her hands, having reassured her nervous fiancé, "Darling— I've got no legs, so you don't need to worry about me getting cold feet!"

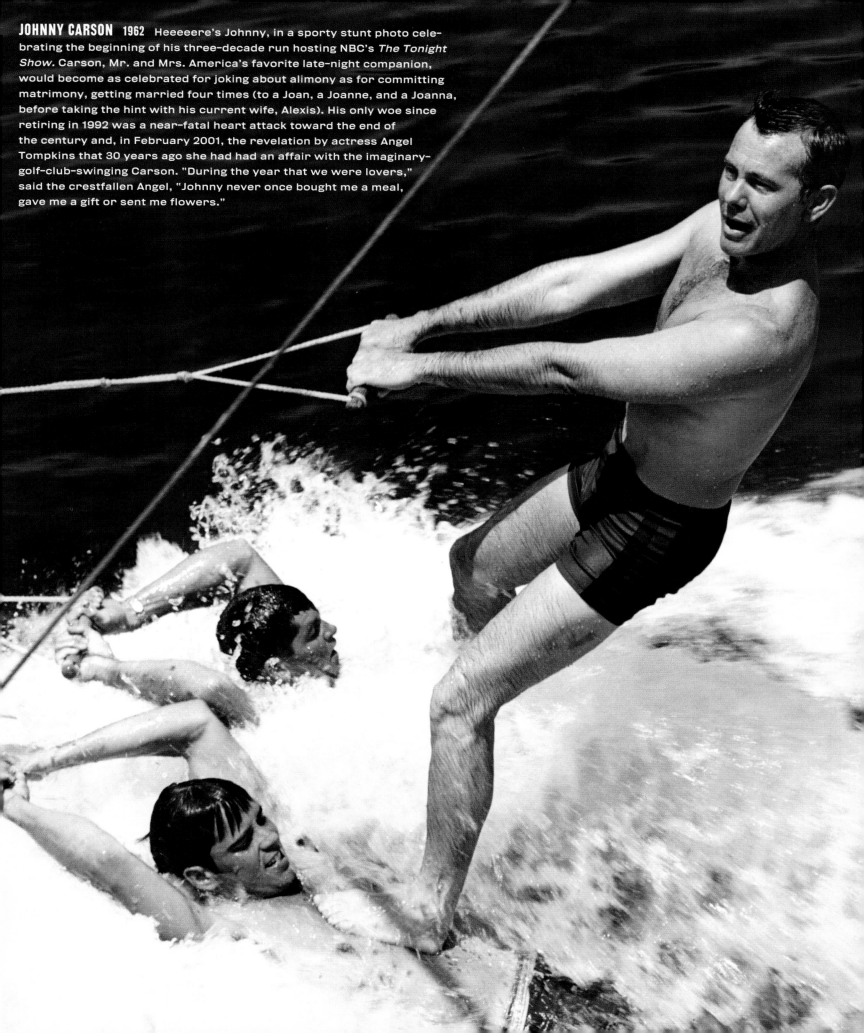

JOHNNY CARSON 1962 Heeeeere's Johnny, in a sporty stunt photo celebrating the beginning of his three-decade run hosting NBC's *The Tonight Show.* Carson, Mr. and Mrs. America's favorite late-night companion, would become as celebrated for joking about alimony as for committing matrimony, getting married four times (to a Joan, a Joanne, and a Joanna, before taking the hint with his current wife, Alexis). His only woe since retiring in 1992 was a near-fatal heart attack toward the end of the century and, in February 2001, the revelation by actress Angel Tompkins that 30 years ago she had had an affair with the imaginary-golf-club-swinging Carson. "During the year that we were lovers," said the crestfallen Angel, "Johnny never once bought me a meal, gave me a gift or sent me flowers."

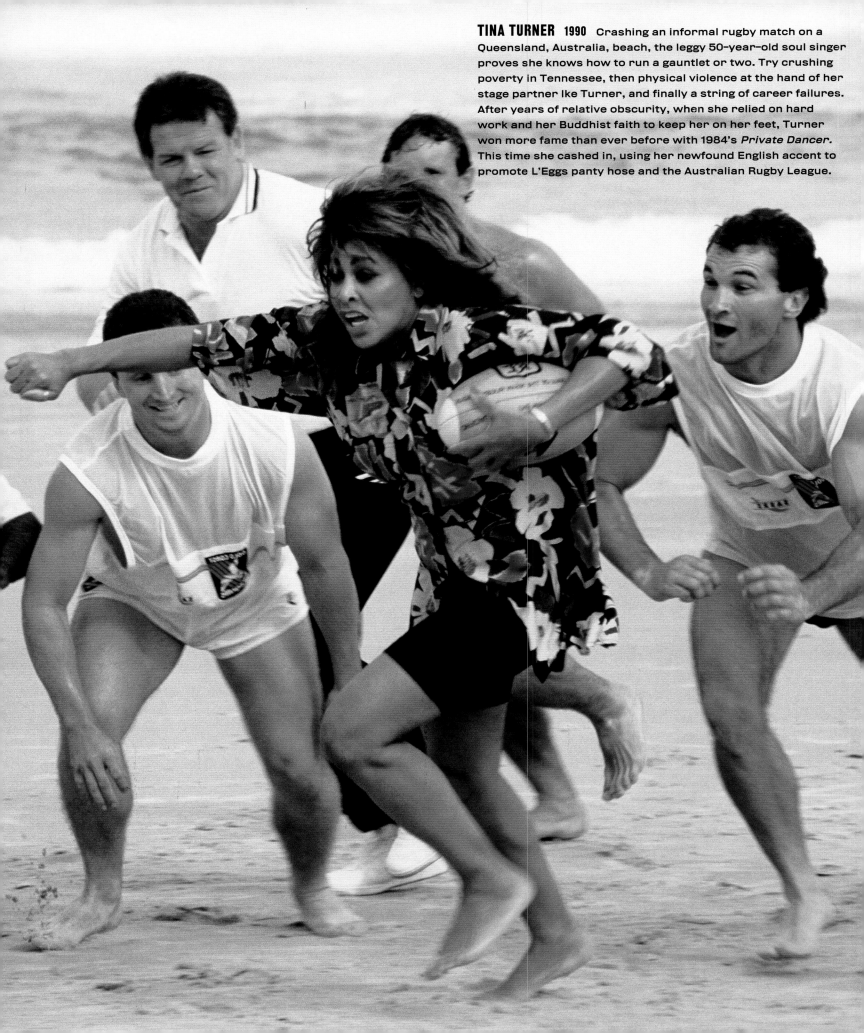

TINA TURNER 1990 Crashing an informal rugby match on a Queensland, Australia, beach, the leggy 50-year-old soul singer proves she knows how to run a gauntlet or two. Try crushing poverty in Tennessee, then physical violence at the hand of her stage partner Ike Turner, and finally a string of career failures. After years of relative obscurity, when she relied on hard work and her Buddhist faith to keep her on her feet, Turner won more fame than ever before with 1984's *Private Dancer*. This time she cashed in, using her newfound English accent to promote L'Eggs panty hose and the Australian Rugby League.

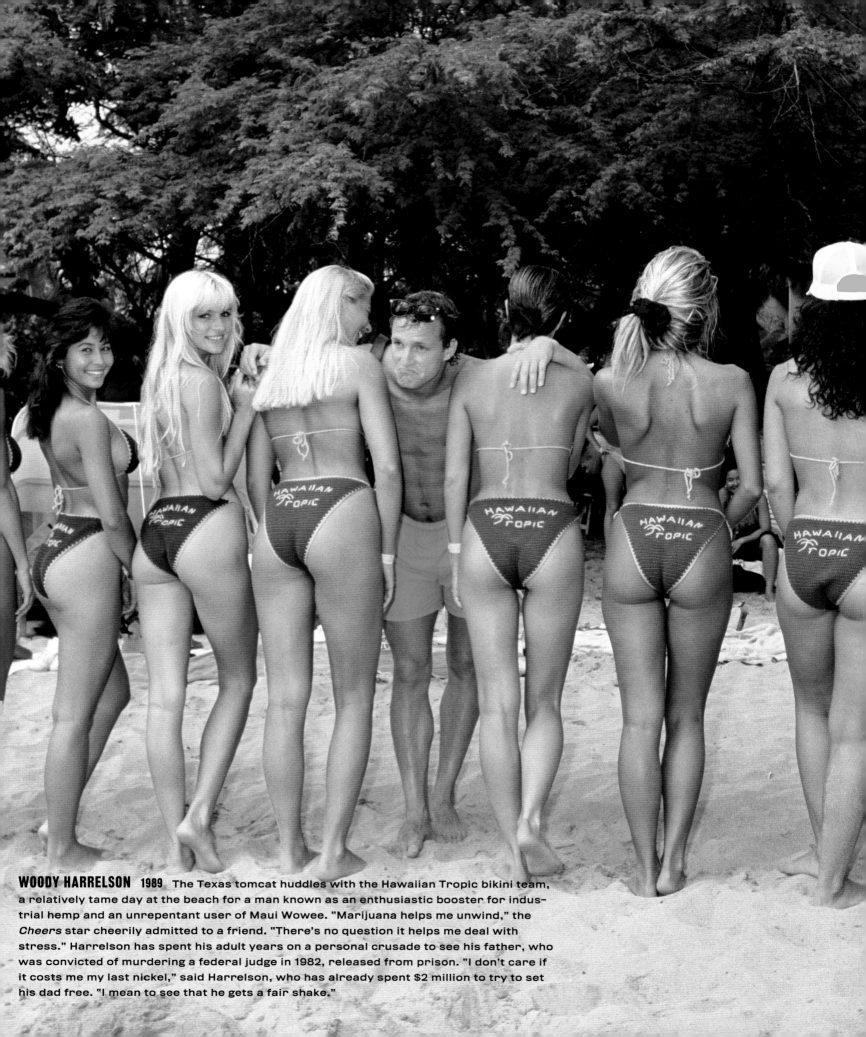

WOODY HARRELSON **1989** The Texas tomcat huddles with the Hawaiian Tropic bikini team, a relatively tame day at the beach for a man known as an enthusiastic booster for industrial hemp and an unrepentant user of Maui Wowee. "Marijuana helps me unwind," the *Cheers* star cheerily admitted to a friend. "There's no question it helps me deal with stress." Harrelson has spent his adult years on a personal crusade to see his father, who was convicted of murdering a federal judge in 1982, released from prison. "I don't care if it costs me my last nickel," said Harrelson, who has already spent $2 million to try to set his dad free. "I mean to see that he gets a fair shake."

MADONNA AND SEAN PENN 1985 It was one small step for Madonna and Sean Penn, and one giant step for tabloid journalism: The short-lived couple's nuptial celebration was the first ever to be captured on film by the "chopperazzi." A phalanx of eight press choppers buzzed the ceremony, blowing back the bride's veil and drowning out the couple's exchange of vows. "A furious Madonna violently jabbed her middle finger at the copter," a guest recalled. Sean "growled, 'If I had a shotgun, I'd blow those jerks right out of the sky.'" Eventually, Penn retreated to the bar with friends as Madonna danced barefoot to Prince, Michael Jackson, and, naturally, Madonna. Around 1 a.m., she confessed to a close friend, "This has been the worst day of my life. The whole thing could have been avoided if Sean . . . had just let the press in for a couple of quick pictures."

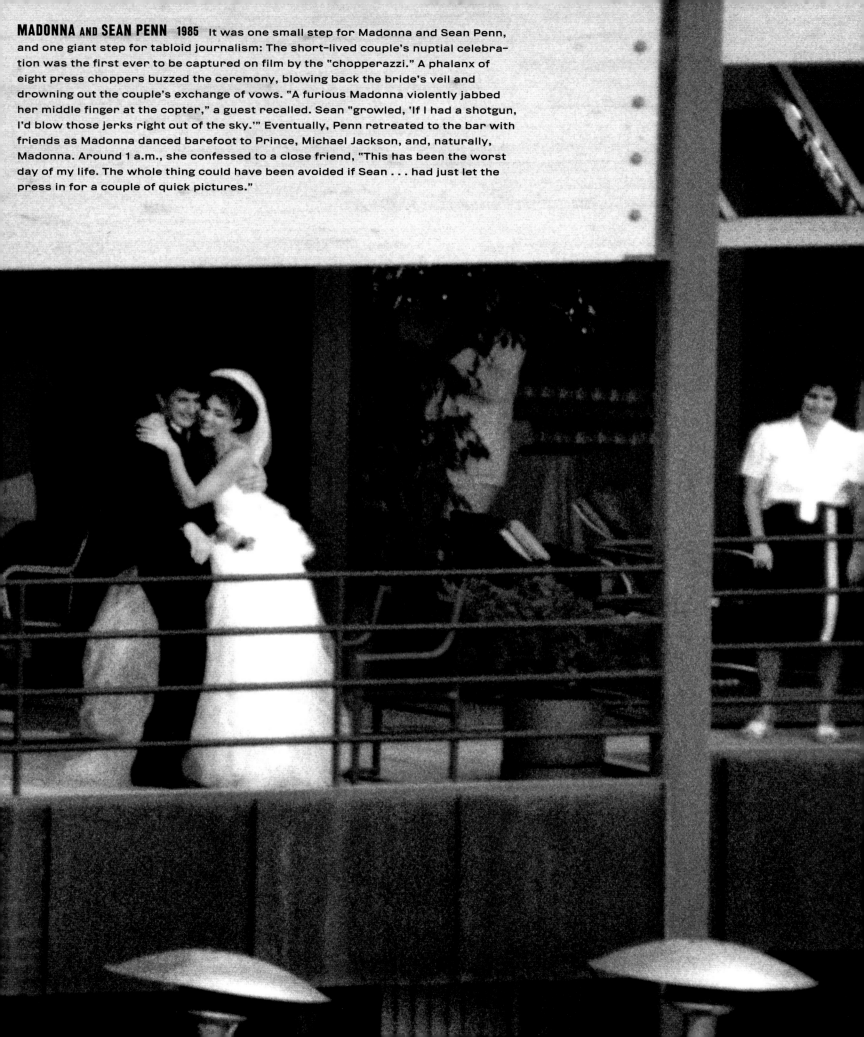

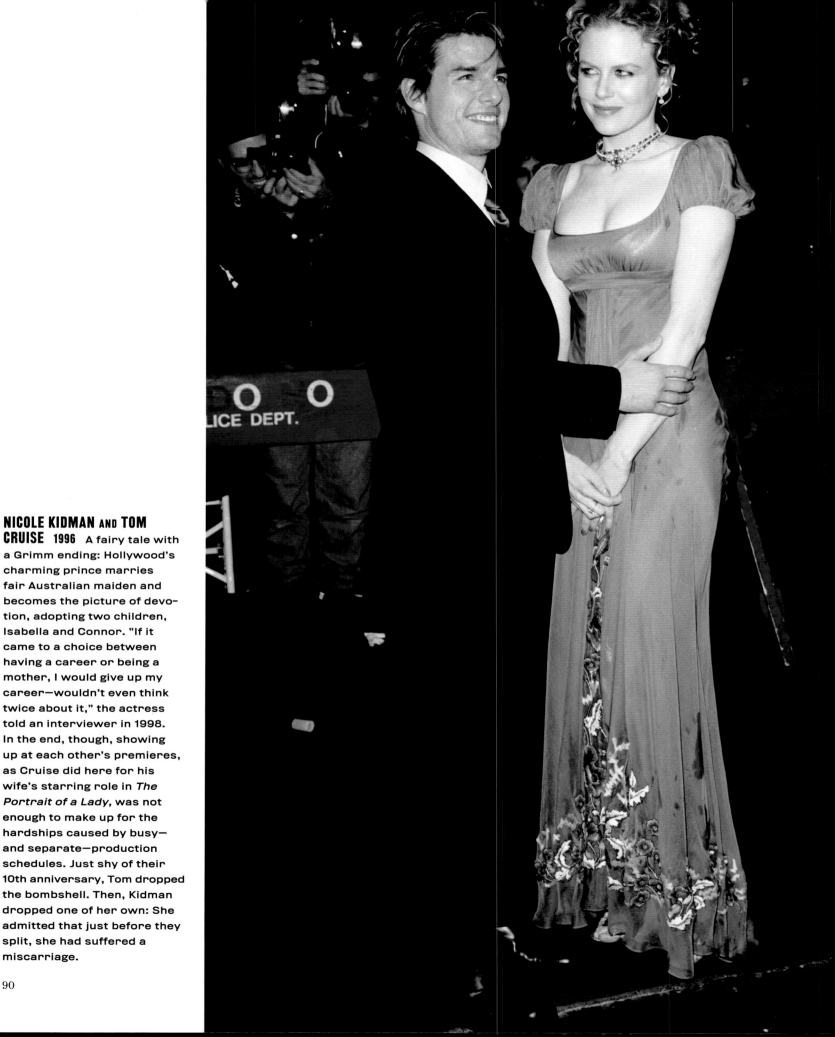

NICOLE KIDMAN AND TOM CRUISE 1996 A fairy tale with a Grimm ending: Hollywood's charming prince marries fair Australian maiden and becomes the picture of devotion, adopting two children, Isabella and Connor. "If it came to a choice between having a career or being a mother, I would give up my career—wouldn't even think twice about it," the actress told an interviewer in 1998. In the end, though, showing up at each other's premieres, as Cruise did here for his wife's starring role in *The Portrait of a Lady,* was not enough to make up for the hardships caused by busy— and separate—production schedules. Just shy of their 10th anniversary, Tom dropped the bombshell. Then, Kidman dropped one of her own: She admitted that just before they split, she had suffered a miscarriage.

HUGH GRANT AND **ELIZABETH HURLEY** 1995 It was warm enough for shorts, but the atmosphere was definitely chilly when the telephoto lens caught the couple in the garden of their Bath, England, house holding a summit after Hugh's Divine Brown sexcapade. During his 13-year relationship with Hurley, Grant was always a bit frisky, but his perverse pursuits really bloomed when he was busted with the Sunset Strip hooker, soiling Hurley's sophisticated Estée Lauder image. "Dirty cheat," she yelled at him when she first heard the news. Hurley froze their wedding plans, and the relationship slowly faded along with the scandal.

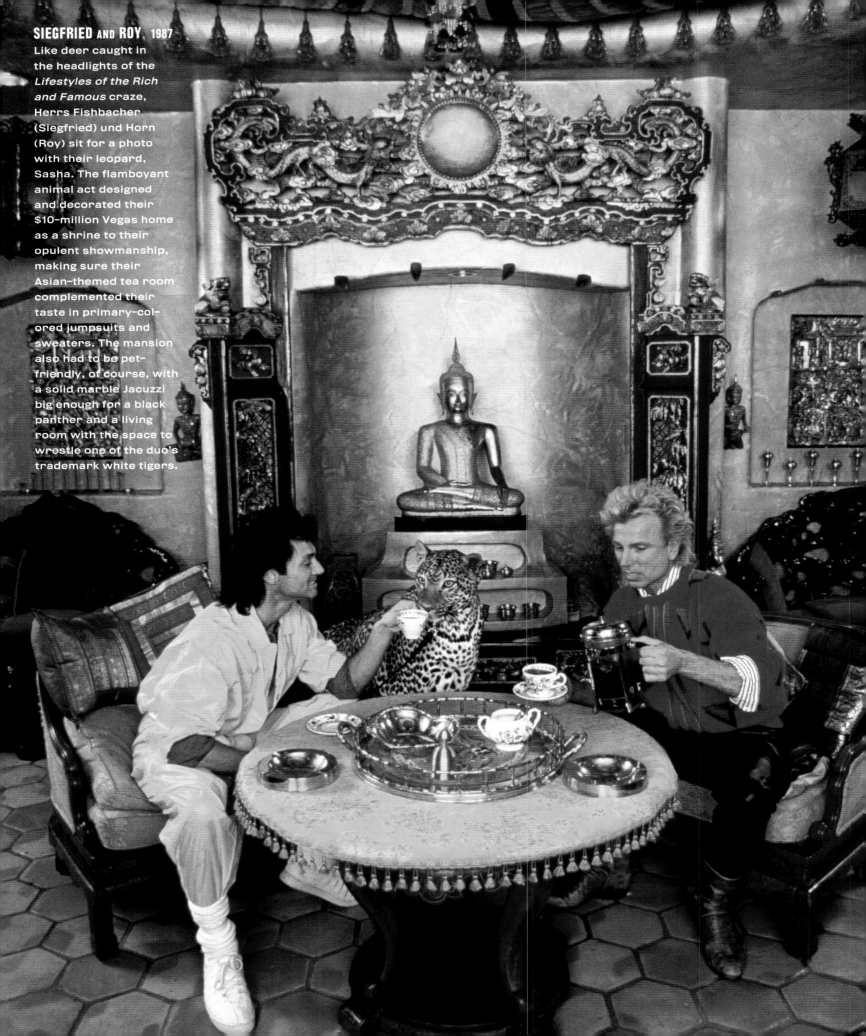

SIEGFRIED AND ROY 1987
Like deer caught in the headlights of the *Lifestyles of the Rich and Famous* craze, Herrs Fishbacher (Siegfried) und Horn (Roy) sit for a photo with their leopard, Sasha. The flamboyant animal act designed and decorated their $10-million Vegas home as a shrine to their opulent showmanship, making sure their Asian-themed tea room complemented their taste in primary-colored jumpsuits and sweaters. The mansion also had to be pet-friendly, of course, with a solid marble Jacuzzi big enough for a black panther and a living room with the space to wrestle one of the duo's trademark white tigers.

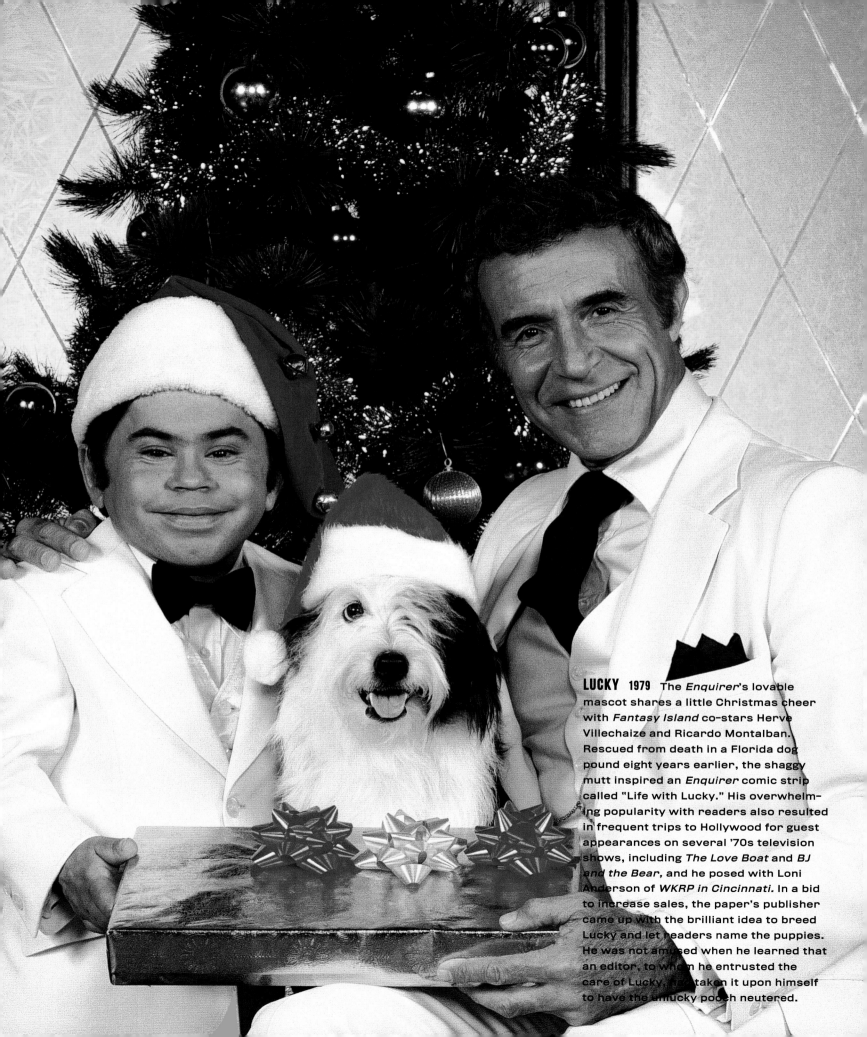

LUCKY 1979 The *Enquirer*'s lovable mascot shares a little Christmas cheer with *Fantasy Island* co-stars Herve Villechaize and Ricardo Montalban. Rescued from death in a Florida dog pound eight years earlier, the shaggy mutt inspired an *Enquirer* comic strip called "Life with Lucky." His overwhelming popularity with readers also resulted in frequent trips to Hollywood for guest appearances on several '70s television shows, including *The Love Boat* and *BJ and the Bear,* and he posed with Loni Anderson of *WKRP in Cincinnati.* In a bid to increase sales, the paper's publisher came up with the brilliant idea to breed Lucky and let readers name the puppies. He was not amused when he learned that an editor, to whom he entrusted the care of Lucky, had taken it upon himself to have the unlucky pooch neutered.

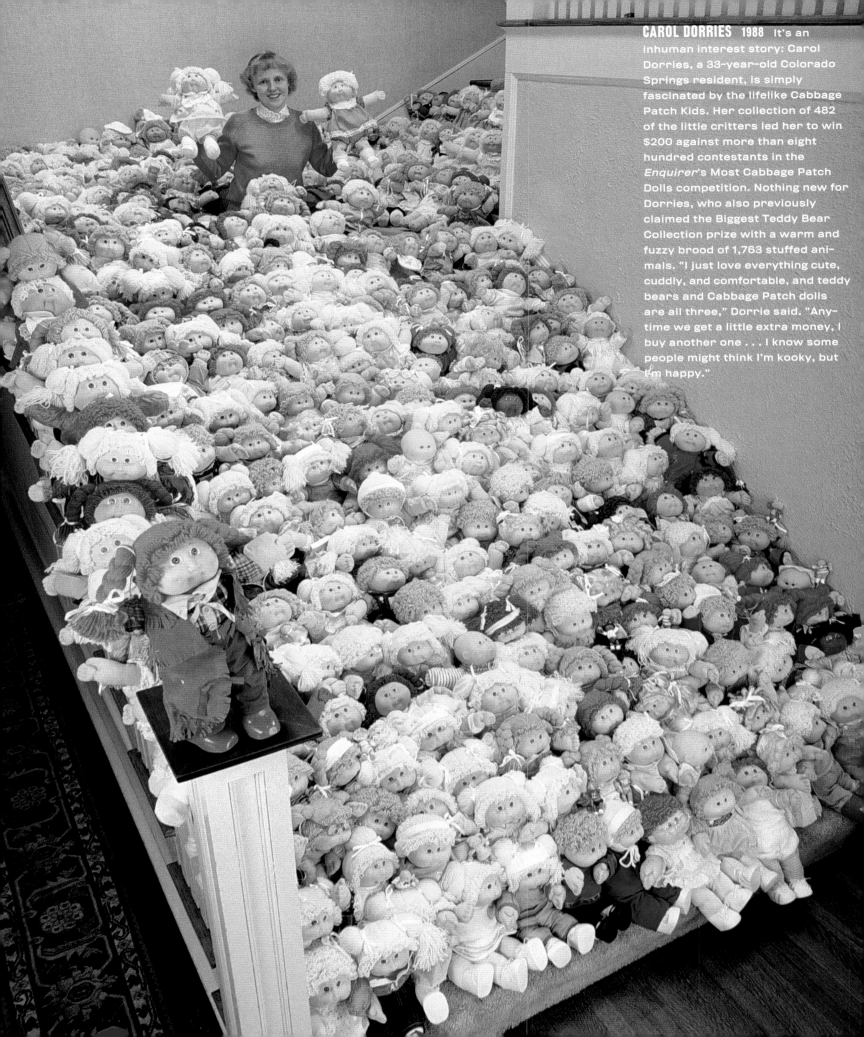

CAROL DORRIES 1988 It's an inhuman interest story: Carol Dorries, a 33-year-old Colorado Springs resident, is simply fascinated by the lifelike Cabbage Patch Kids. Her collection of 482 of the little critters led her to win $200 against more than eight hundred contestants in the *Enquirer*'s Most Cabbage Patch Dolls competition. Nothing new for Dorries, who also previously claimed the Biggest Teddy Bear Collection prize with a warm and fuzzy brood of 1,763 stuffed animals. "I just love everything cute, cuddly, and comfortable, and teddy bears and Cabbage Patch dolls are all three," Dorrie said. "Anytime we get a little extra money, I buy another one . . . I know some people might think I'm kooky, but I'm happy."

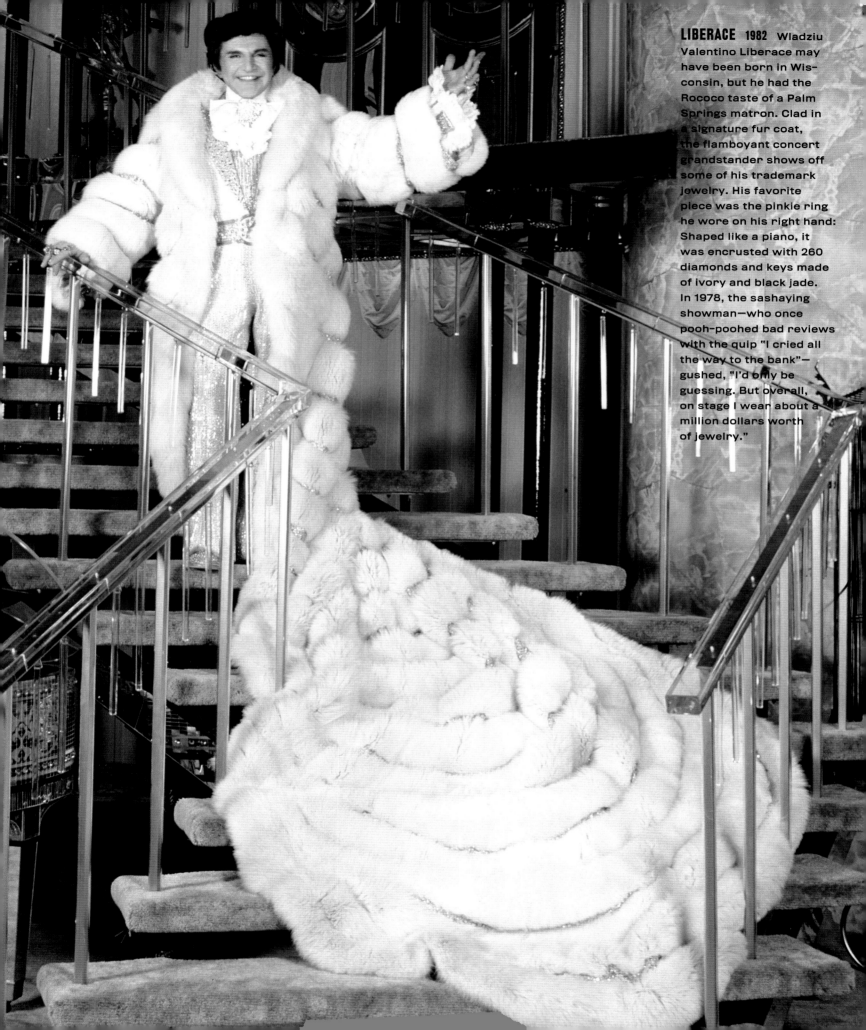

LIBERACE 1982 Wladziu Valentino Liberace may have been born in Wisconsin, but he had the Rococo taste of a Palm Springs matron. Clad in a signature fur coat, the flamboyant concert grandstander shows off some of his trademark jewelry. His favorite piece was the pinkie ring he wore on his right hand: Shaped like a piano, it was encrusted with 260 diamonds and keys made of ivory and black jade. In 1978, the sashaying showman—who once pooh-poohed bad reviews with the quip "I cried all the way to the bank"— gushed, "I'd only be guessing. But overall, on stage I wear about a million dollars worth of jewelry."

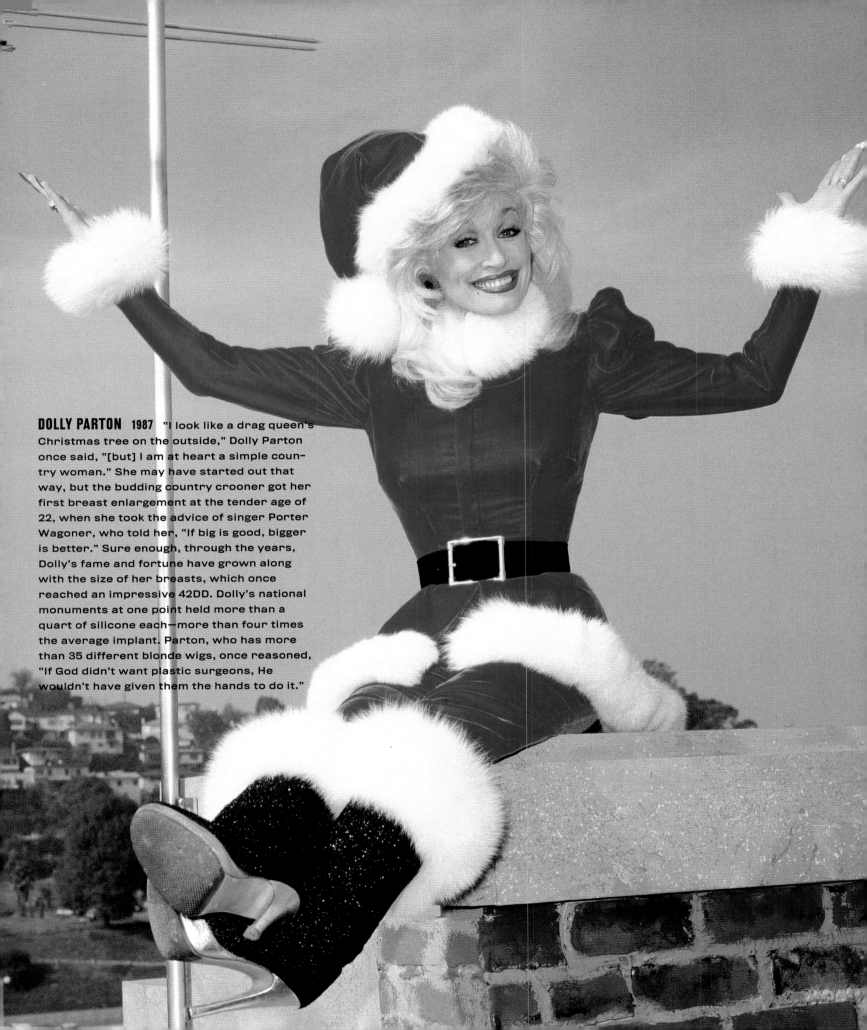

DOLLY PARTON 1987 "I look like a drag queen's Christmas tree on the outside," Dolly Parton once said, "[but] I am at heart a simple country woman." She may have started out that way, but the budding country crooner got her first breast enlargement at the tender age of 22, when she took the advice of singer Porter Wagoner, who told her, "If big is good, bigger is better." Sure enough, through the years, Dolly's fame and fortune have grown along with the size of her breasts, which once reached an impressive 42DD. Dolly's national monuments at one point held more than a quart of silicone each—more than four times the average implant. Parton, who has more than 35 different blonde wigs, once reasoned, "If God didn't want plastic surgeons, He wouldn't have given them the hands to do it."

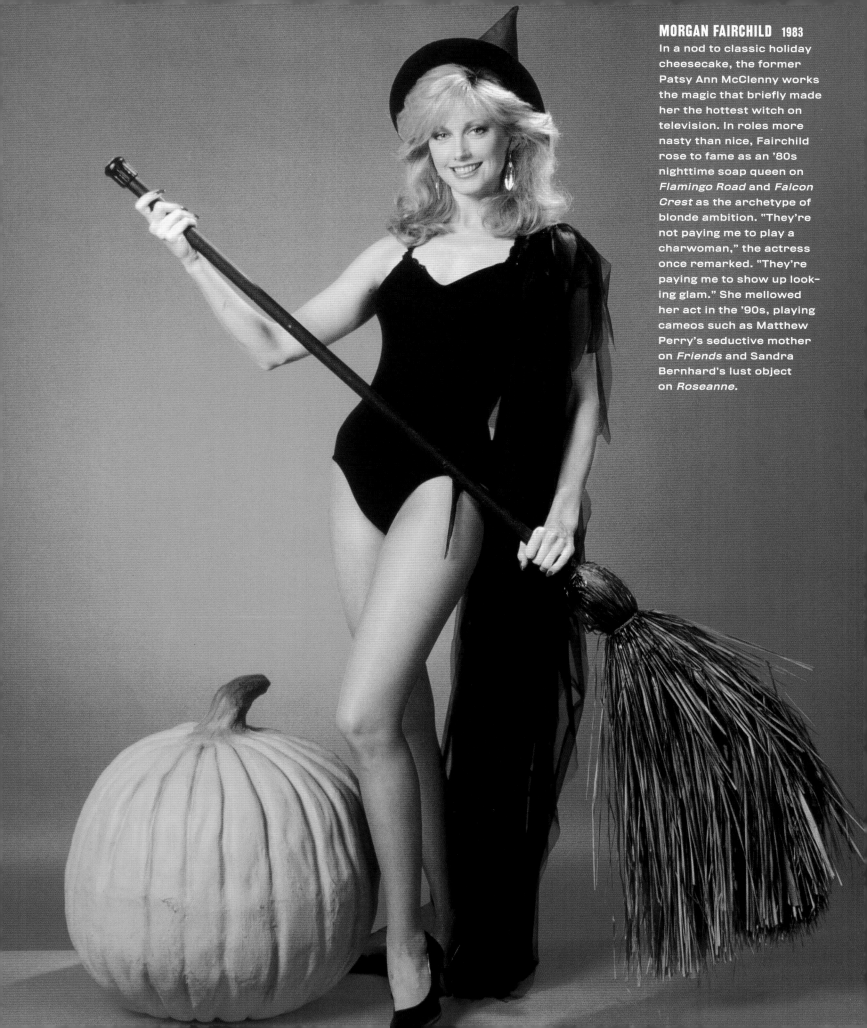

MORGAN FAIRCHILD 1983
In a nod to classic holiday cheesecake, the former Patsy Ann McClenny works the magic that briefly made her the hottest witch on television. In roles more nasty than nice, Fairchild rose to fame as an '80s nighttime soap queen on *Flamingo Road* and *Falcon Crest* as the archetype of blonde ambition. "They're not paying me to play a charwoman," the actress once remarked. "They're paying me to show up looking glam." She mellowed her act in the '90s, playing cameos such as Matthew Perry's seductive mother on *Friends* and Sandra Bernhard's lust object on *Roseanne*.

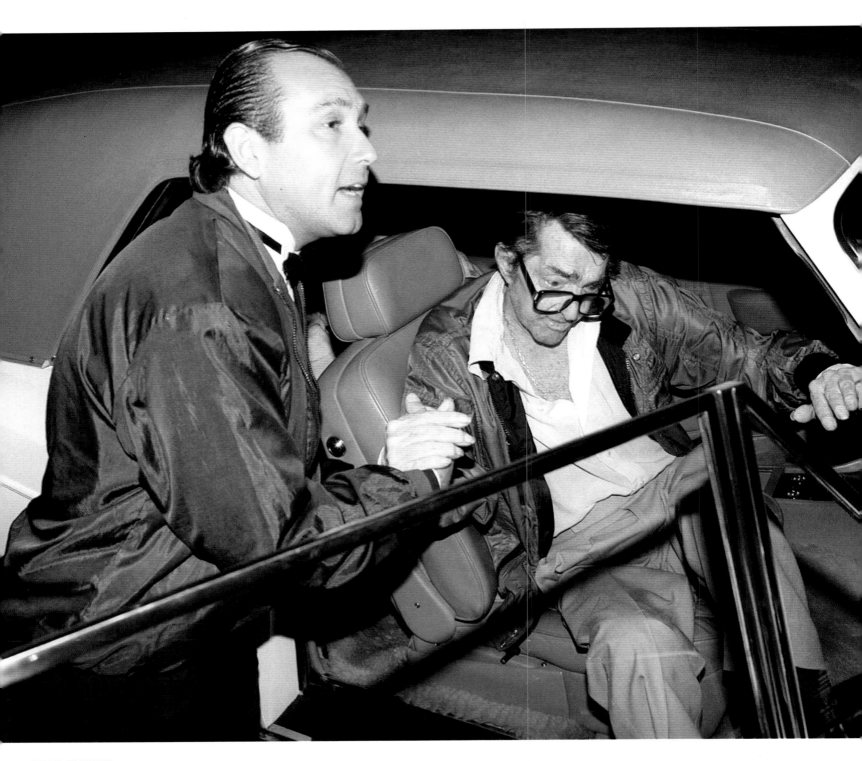

DEAN MARTIN 1994 Dean Martin arrives at his favorite Italian restaurant, La Famiglia, with a little help from the help: The once-robust crooner, now 78 and weighing only 120 pounds, dined alone that night while—just three miles away—former friend Frank Sinatra was celebrating his 80th birthday at a lavish, televised bash. Ol' Blue Eyes had snubbed Deano ever since the legendary boozer pulled out of a 1988 Rat Pack reunion tour due to kidney problems. Sad and lonely, Martin visited La Famiglia often, ordering food but rarely touching it. "I want to die at La Famiglia with a scotch in one hand and a cigarette in the other," he said during his final days. No such luck: In 1995, he succumbed to lung cancer and passed away quietly in his mansion.

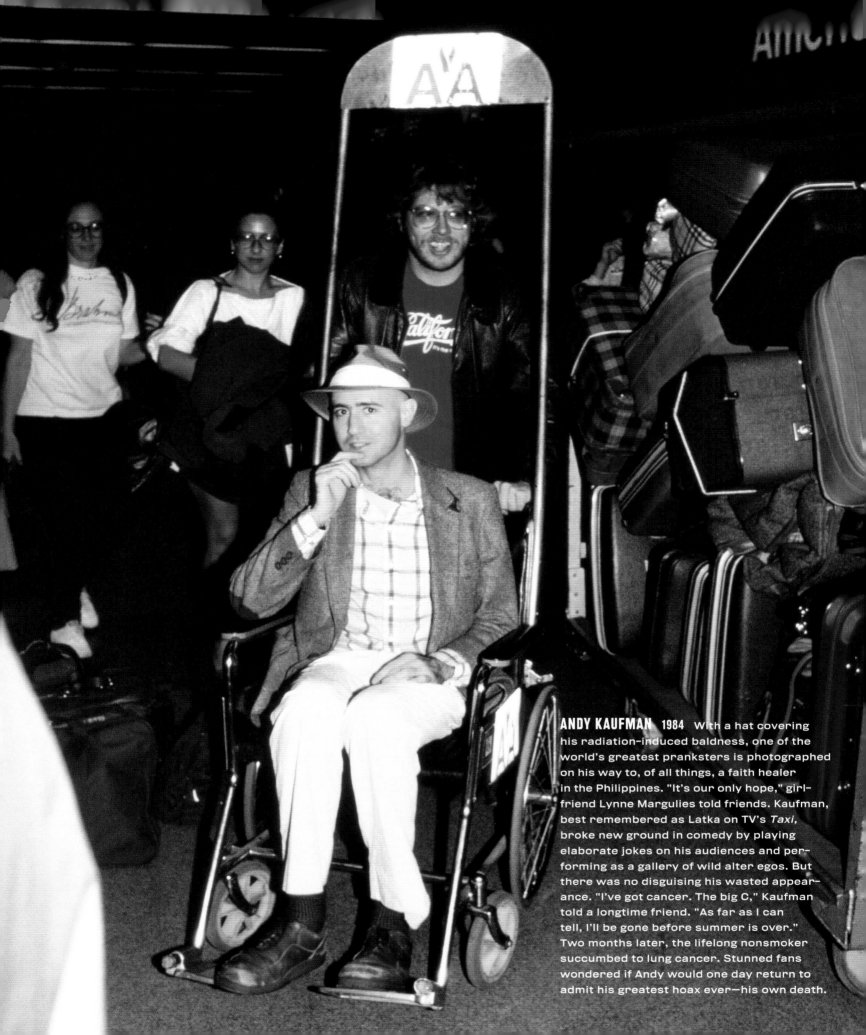

ANDY KAUFMAN 1984 With a hat covering his radiation-induced baldness, one of the world's greatest pranksters is photographed on his way to, of all things, a faith healer in the Philippines. "It's our only hope," girl-friend Lynne Margulies told friends. Kaufman, best remembered as Latka on TV's *Taxi*, broke new ground in comedy by playing elaborate jokes on his audiences and per-forming as a gallery of wild alter egos. But there was no disguising his wasted appear-ance. "I've got cancer. The big C," Kaufman told a longtime friend. "As far as I can tell, I'll be gone before summer is over." Two months later, the lifelong nonsmoker succumbed to lung cancer. Stunned fans wondered if Andy would one day return to admit his greatest hoax ever—his own death.

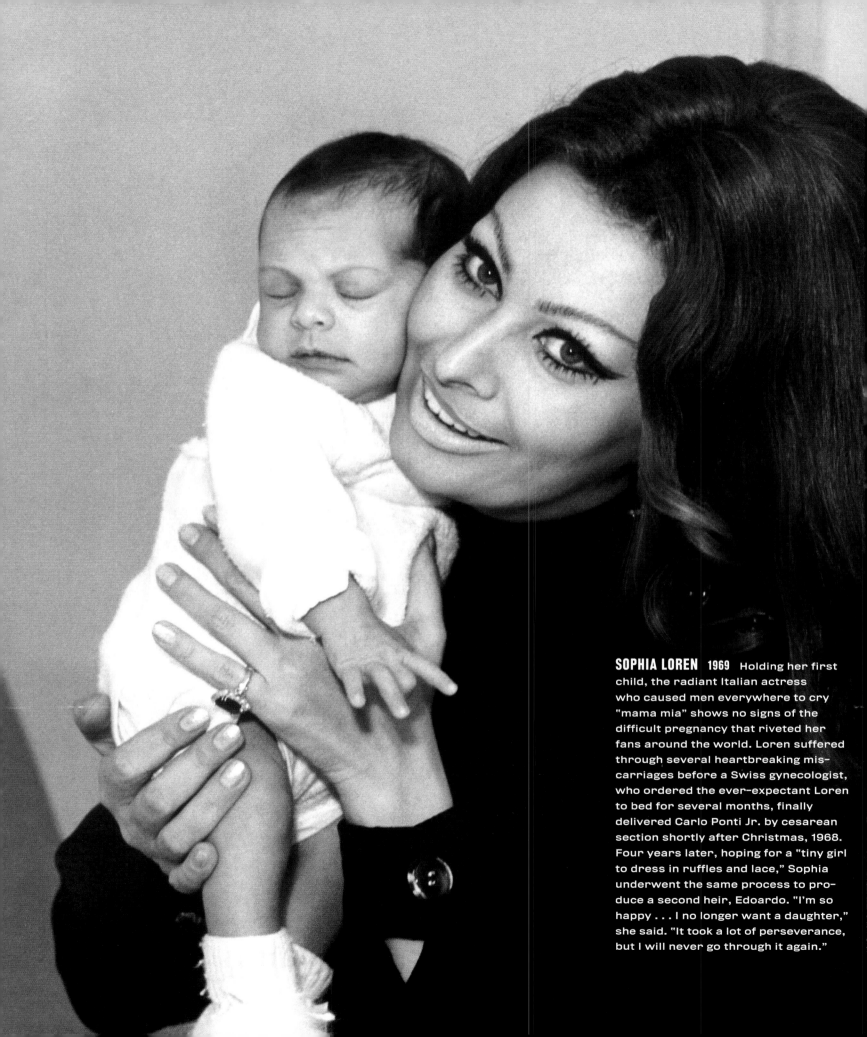

SOPHIA LOREN 1969 Holding her first child, the radiant Italian actress who caused men everywhere to cry "mama mia" shows no signs of the difficult pregnancy that riveted her fans around the world. Loren suffered through several heartbreaking miscarriages before a Swiss gynecologist, who ordered the ever-expectant Loren to bed for several months, finally delivered Carlo Ponti Jr. by cesarean section shortly after Christmas, 1968. Four years later, hoping for a "tiny girl to dress in ruffles and lace," Sophia underwent the same process to produce a second heir, Edoardo. "I'm so happy . . . I no longer want a daughter," she said. "It took a lot of perseverance, but I will never go through it again."

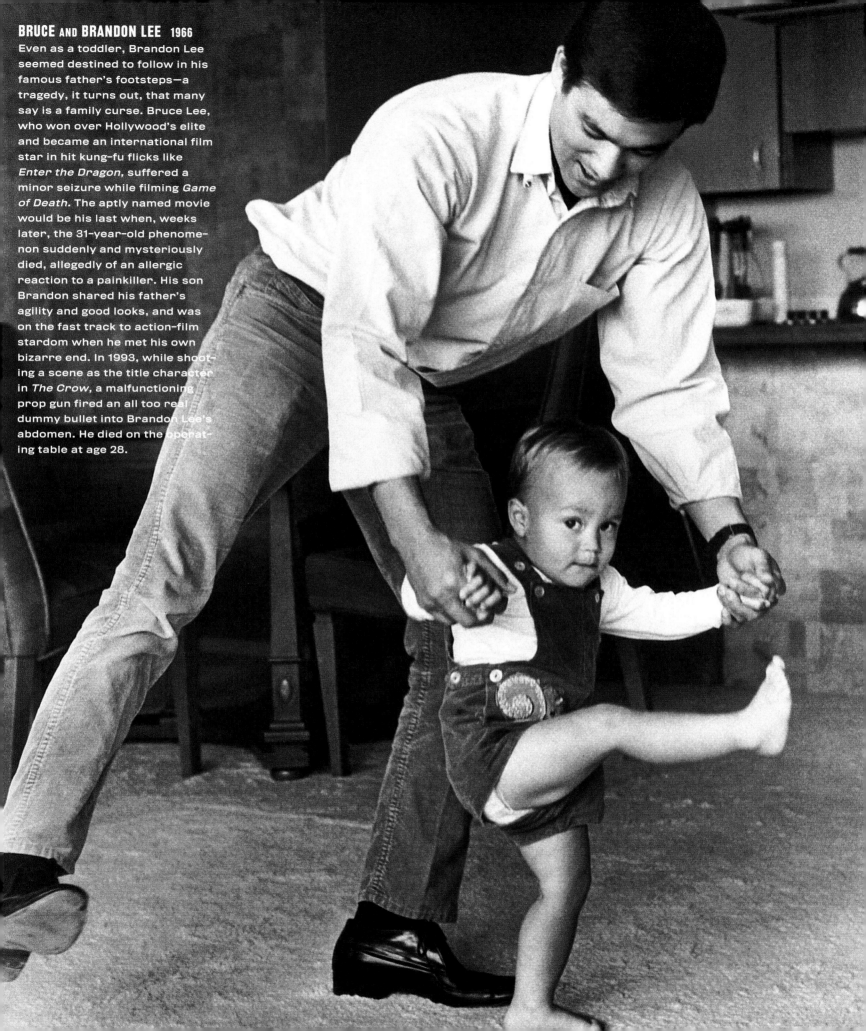

BRUCE AND BRANDON LEE 1966
Even as a toddler, Brandon Lee seemed destined to follow in his famous father's footsteps—a tragedy, it turns out, that many say is a family curse. Bruce Lee, who won over Hollywood's elite and became an international film star in hit kung-fu flicks like *Enter the Dragon*, suffered a minor seizure while filming *Game of Death.* The aptly named movie would be his last when, weeks later, the 31-year-old phenomenon suddenly and mysteriously died, allegedly of an allergic reaction to a painkiller. His son Brandon shared his father's agility and good looks, and was on the fast track to action-film stardom when he met his own bizarre end. In 1993, while shooting a scene as the title character in *The Crow*, a malfunctioning prop gun fired an all too real dummy bullet into Brandon Lee's abdomen. He died on the operating table at age 28.

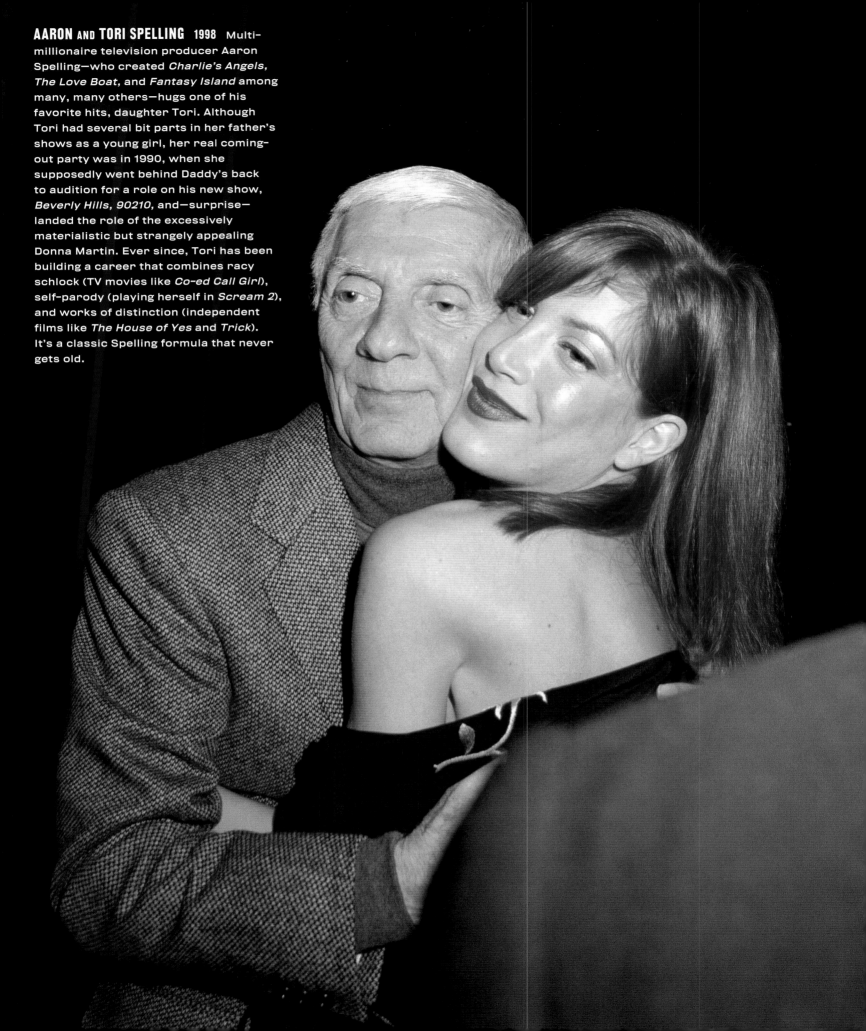

AARON AND TORI SPELLING 1998 Multi-millionaire television producer Aaron Spelling—who created *Charlie's Angels*, *The Love Boat*, and *Fantasy Island* among many, many others—hugs one of his favorite hits, daughter Tori. Although Tori had several bit parts in her father's shows as a young girl, her real coming-out party was in 1990, when she supposedly went behind Daddy's back to audition for a role on his new show, *Beverly Hills, 90210*, and—surprise— landed the role of the excessively materialistic but strangely appealing Donna Martin. Ever since, Tori has been building a career that combines racy schlock (TV movies like *Co-ed Call Girl*), self-parody (playing herself in *Scream 2*), and works of distinction (independent films like *The House of Yes* and *Trick*). It's a classic Spelling formula that never gets old.

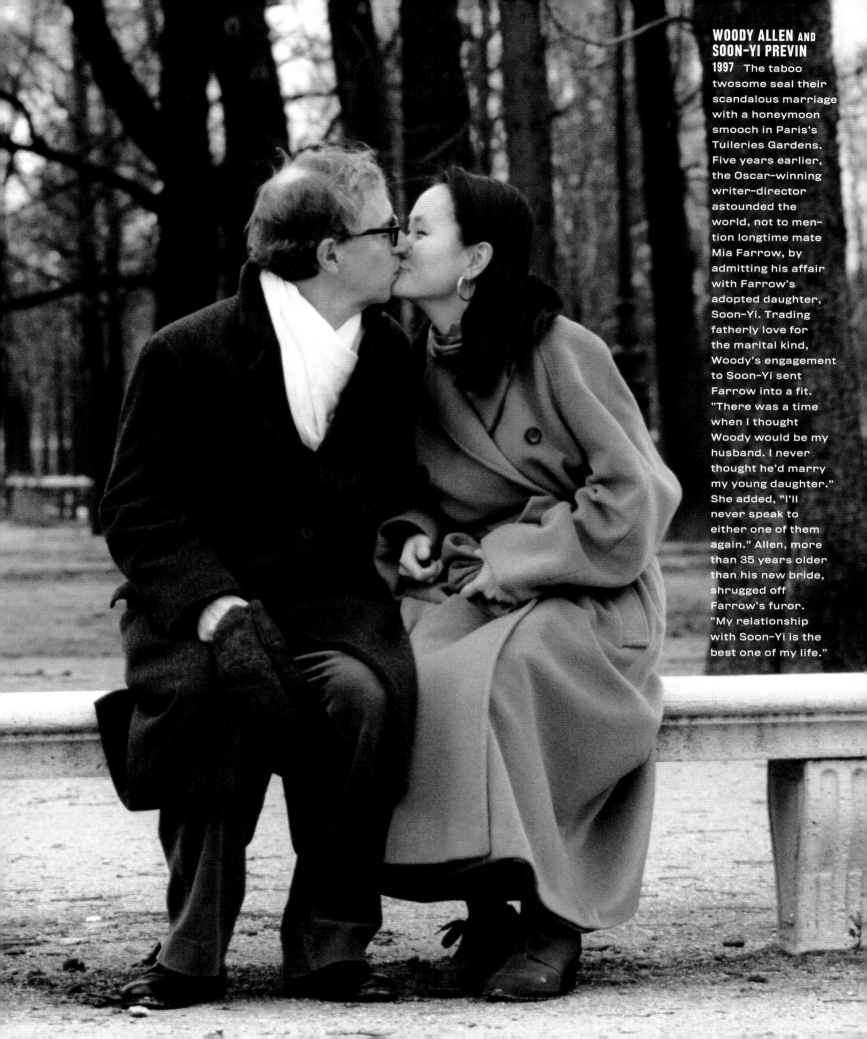

WOODY ALLEN AND SOON-YI PREVIN
1997 The taboo twosome seal their scandalous marriage with a honeymoon smooch in Paris's Tuileries Gardens. Five years earlier, the Oscar-winning writer-director astounded the world, not to mention longtime mate Mia Farrow, by admitting his affair with Farrow's adopted daughter, Soon-Yi. Trading fatherly love for the marital kind, Woody's engagement to Soon-Yi sent Farrow into a fit. "There was a time when I thought Woody would be my husband. I never thought he'd marry my young daughter." She added, "I'll never speak to either one of them again." Allen, more than 35 years older than his new bride, shrugged off Farrow's furor. "My relationship with Soon-Yi is the best one of my life."

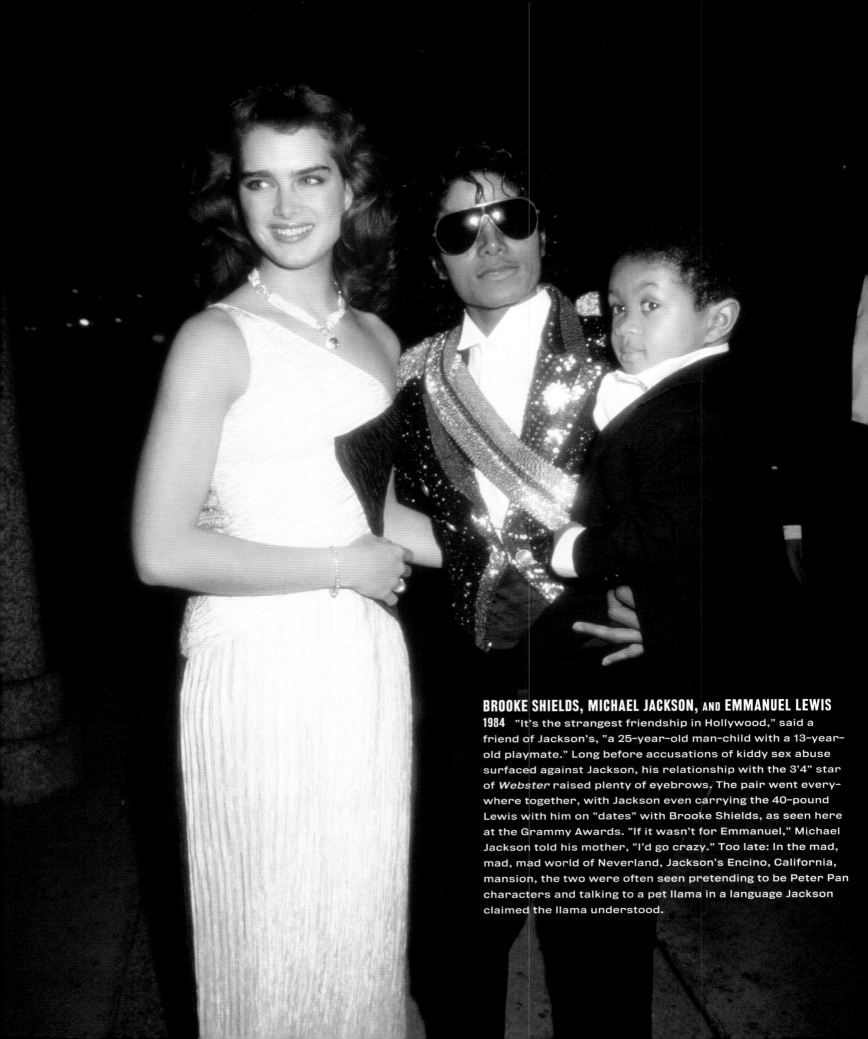

BROOKE SHIELDS, MICHAEL JACKSON, AND EMMANUEL LEWIS
1984 "It's the strangest friendship in Hollywood," said a friend of Jackson's, "a 25-year-old man-child with a 13-year-old playmate." Long before accusations of kiddy sex abuse surfaced against Jackson, his relationship with the 3'4" star of *Webster* raised plenty of eyebrows. The pair went everywhere together, with Jackson even carrying the 40-pound Lewis with him on "dates" with Brooke Shields, as seen here at the Grammy Awards. "If it wasn't for Emmanuel," Michael Jackson told his mother, "I'd go crazy." Too late: In the mad, mad, mad world of Neverland, Jackson's Encino, California, mansion, the two were often seen pretending to be Peter Pan characters and talking to a pet llama in a language Jackson claimed the llama understood.

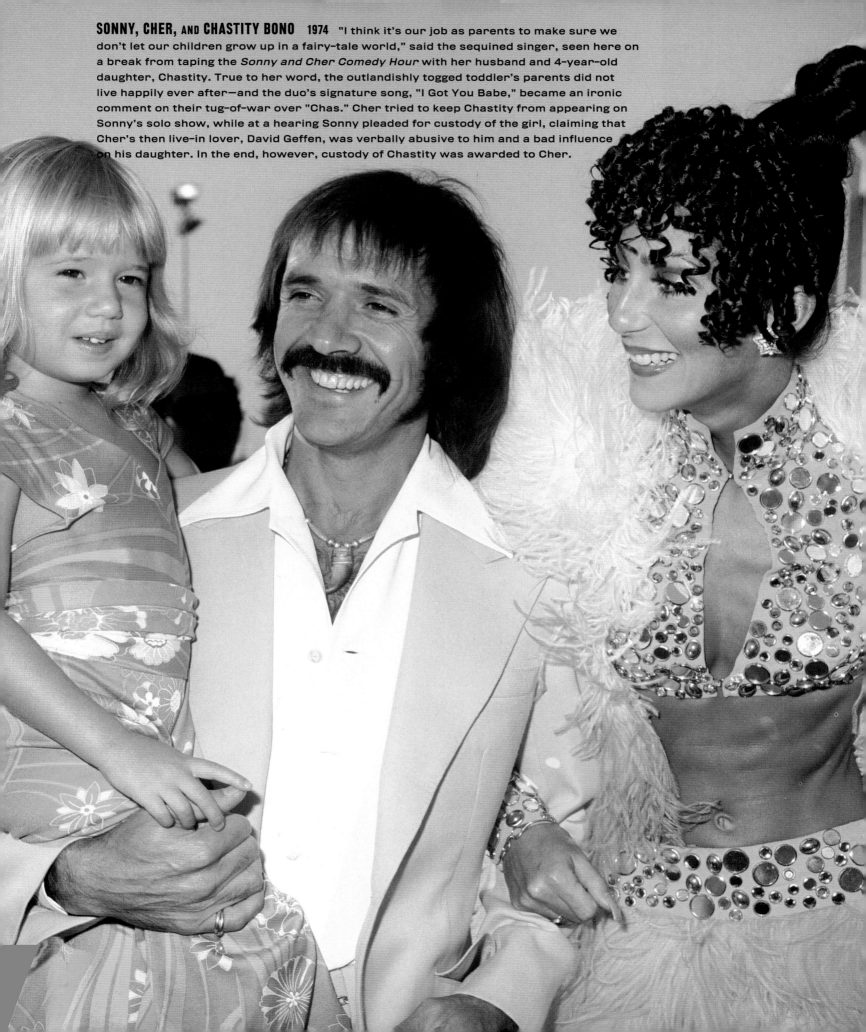

SONNY, CHER, AND CHASTITY BONO 1974 "I think it's our job as parents to make sure we don't let our children grow up in a fairy-tale world," said the sequined singer, seen here on a break from taping the *Sonny and Cher Comedy Hour* with her husband and 4-year-old daughter, Chastity. True to her word, the outlandishly togged toddler's parents did not live happily ever after—and the duo's signature song, "I Got You Babe," became an ironic comment on their tug-of-war over "Chas." Cher tried to keep Chastity from appearing on Sonny's solo show, while at a hearing Sonny pleaded for custody of the girl, claiming that Cher's then live-in lover, David Geffen, was verbally abusive to him and a bad influence on his daughter. In the end, however, custody of Chastity was awarded to Cher.

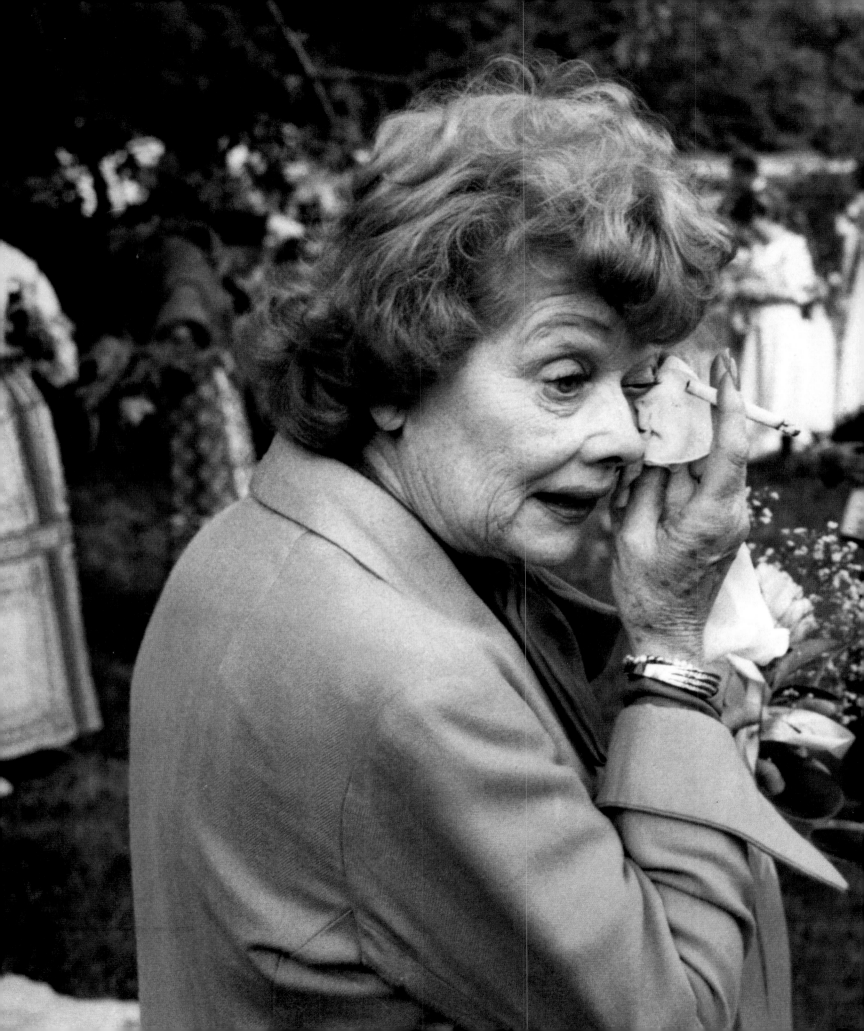

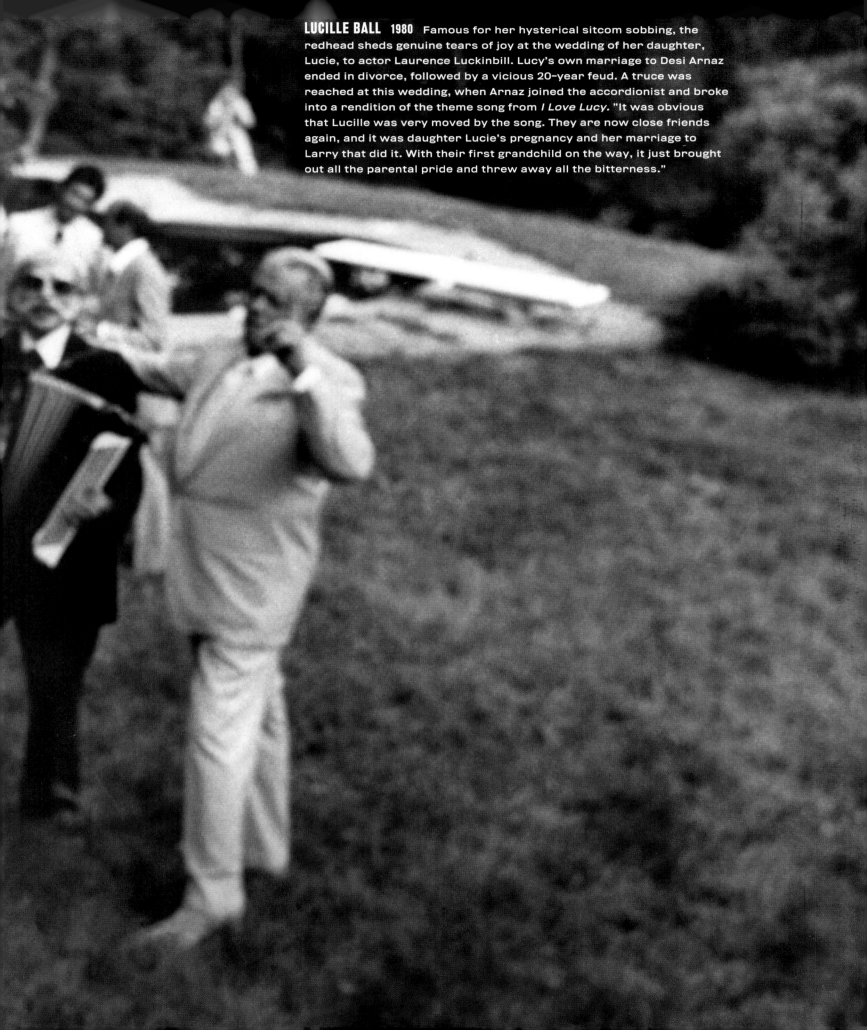

LUCILLE BALL 1980 Famous for her hysterical sitcom sobbing, the redhead sheds genuine tears of joy at the wedding of her daughter, Lucie, to actor Laurence Luckinbill. Lucy's own marriage to Desi Arnaz ended in divorce, followed by a vicious 20-year feud. A truce was reached at this wedding, when Arnaz joined the accordionist and broke into a rendition of the theme song from *I Love Lucy*. "It was obvious that Lucille was very moved by the song. They are now close friends again, and it was daughter Lucie's pregnancy and her marriage to Larry that did it. With their first grandchild on the way, it just brought out all the parental pride and threw away all the bitterness."

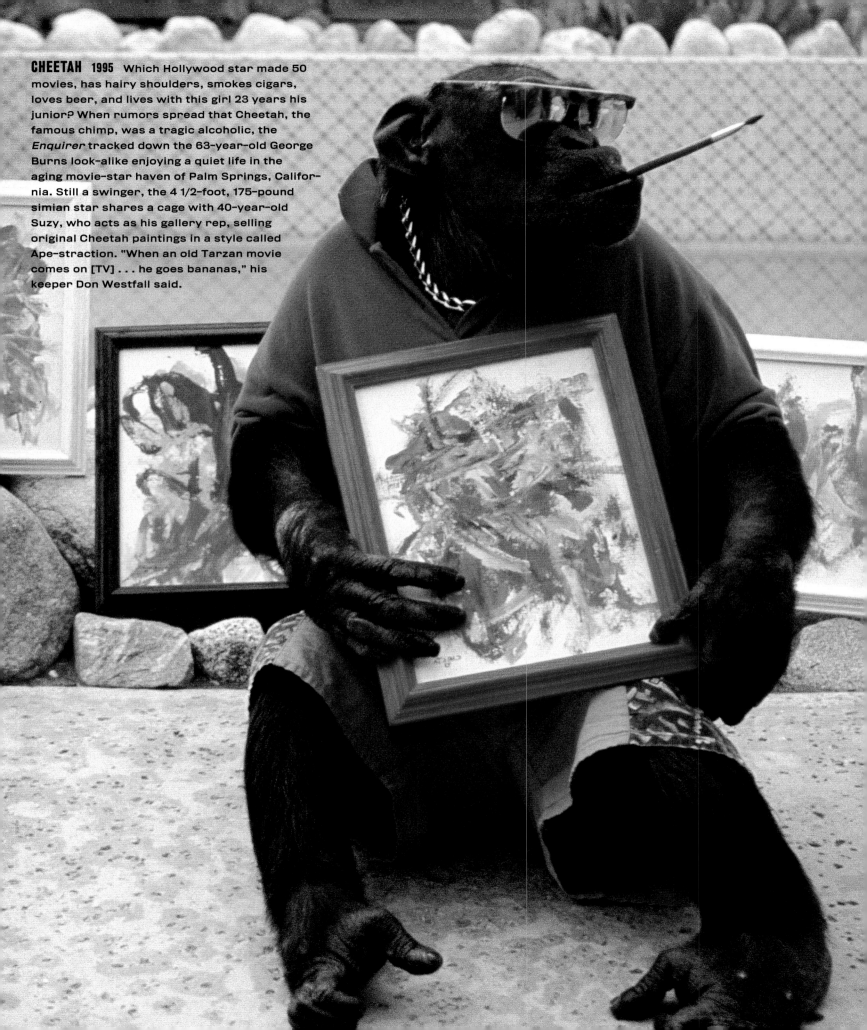

CHEETAH 1995 Which Hollywood star made 50 movies, has hairy shoulders, smokes cigars, loves beer, and lives with this girl 23 years his junior? When rumors spread that Cheetah, the famous chimp, was a tragic alcoholic, the *Enquirer* tracked down the 63-year-old George Burns look-alike enjoying a quiet life in the aging movie-star haven of Palm Springs, California. Still a swinger, the 4 1/2-foot, 175-pound simian star shares a cage with 40-year-old Suzy, who acts as his gallery rep, selling original Cheetah paintings in a style called Ape-straction. "When an old Tarzan movie comes on [TV] . . . he goes bananas," his keeper Don Westfall said.

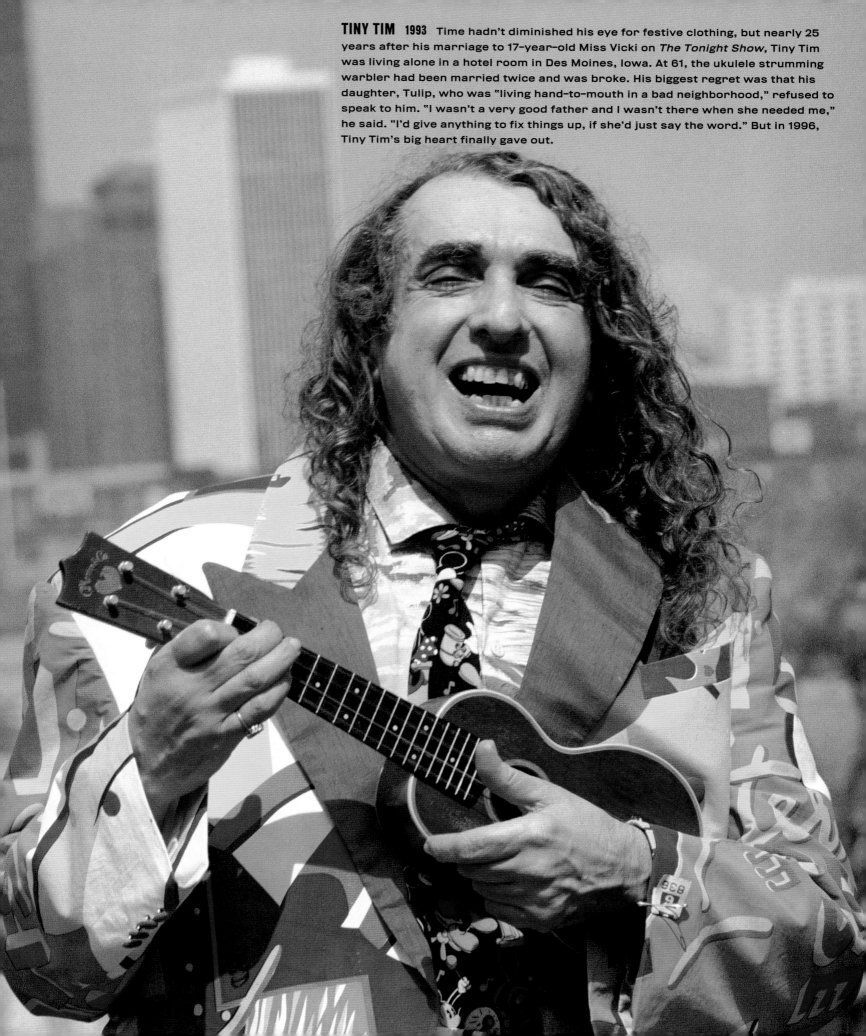

TINY TIM 1993 Time hadn't diminished his eye for festive clothing, but nearly 25 years after his marriage to 17-year-old Miss Vicki on *The Tonight Show*, Tiny Tim was living alone in a hotel room in Des Moines, Iowa. At 61, the ukulele strumming warbler had been married twice and was broke. His biggest regret was that his daughter, Tulip, who was "living hand-to-mouth in a bad neighborhood," refused to speak to him. "I wasn't a very good father and I wasn't there when she needed me," he said. "I'd give anything to fix things up, if she'd just say the word." But in 1996, Tiny Tim's big heart finally gave out.

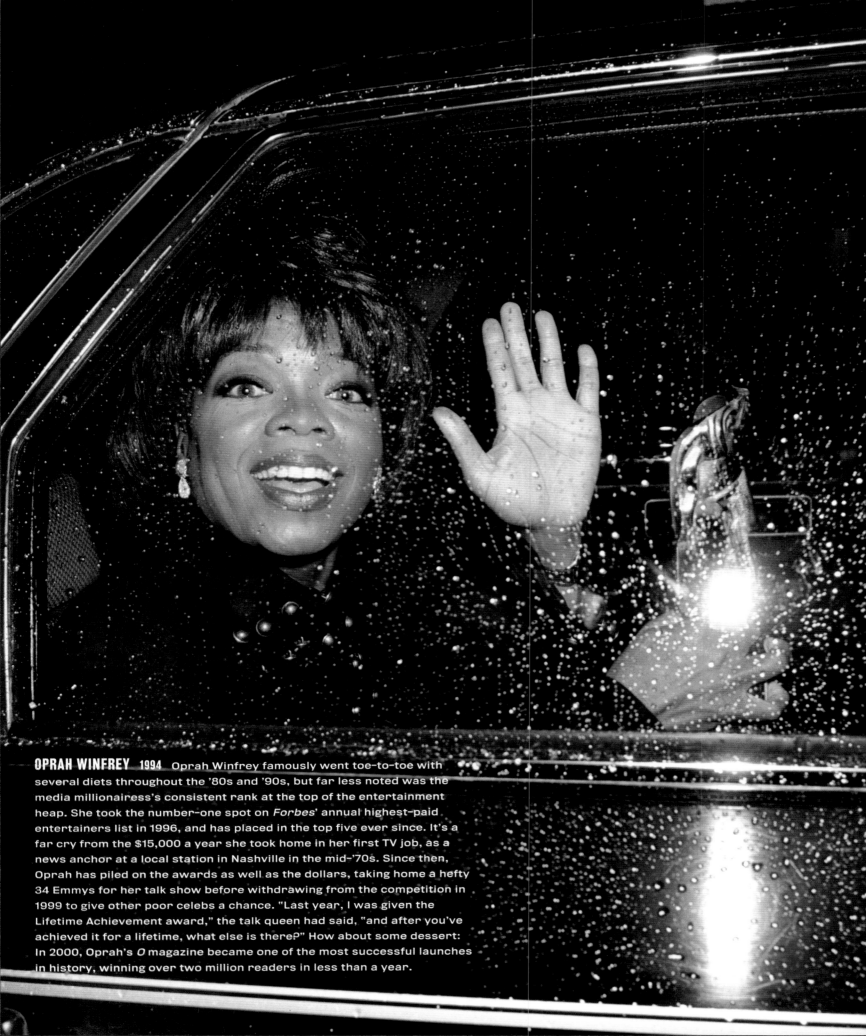

OPRAH WINFREY 1994 Oprah Winfrey famously went toe-to-toe with several diets throughout the '80s and '90s, but far less noted was the media millionairess's consistent rank at the top of the entertainment heap. She took the number-one spot on *Forbes*' annual highest-paid entertainers list in 1996, and has placed in the top five ever since. It's a far cry from the $15,000 a year she took home in her first TV job, as a news anchor at a local station in Nashville in the mid-'70s. Since then, Oprah has piled on the awards as well as the dollars, taking home a hefty 34 Emmys for her talk show before withdrawing from the competition in 1999 to give other poor celebs a chance. "Last year, I was given the Lifetime Achievement award," the talk queen had said, "and after you've achieved it for a lifetime, what else is there?" How about some dessert: In 2000, Oprah's *O* magazine became one of the most successful launches in history, winning over two million readers in less than a year.

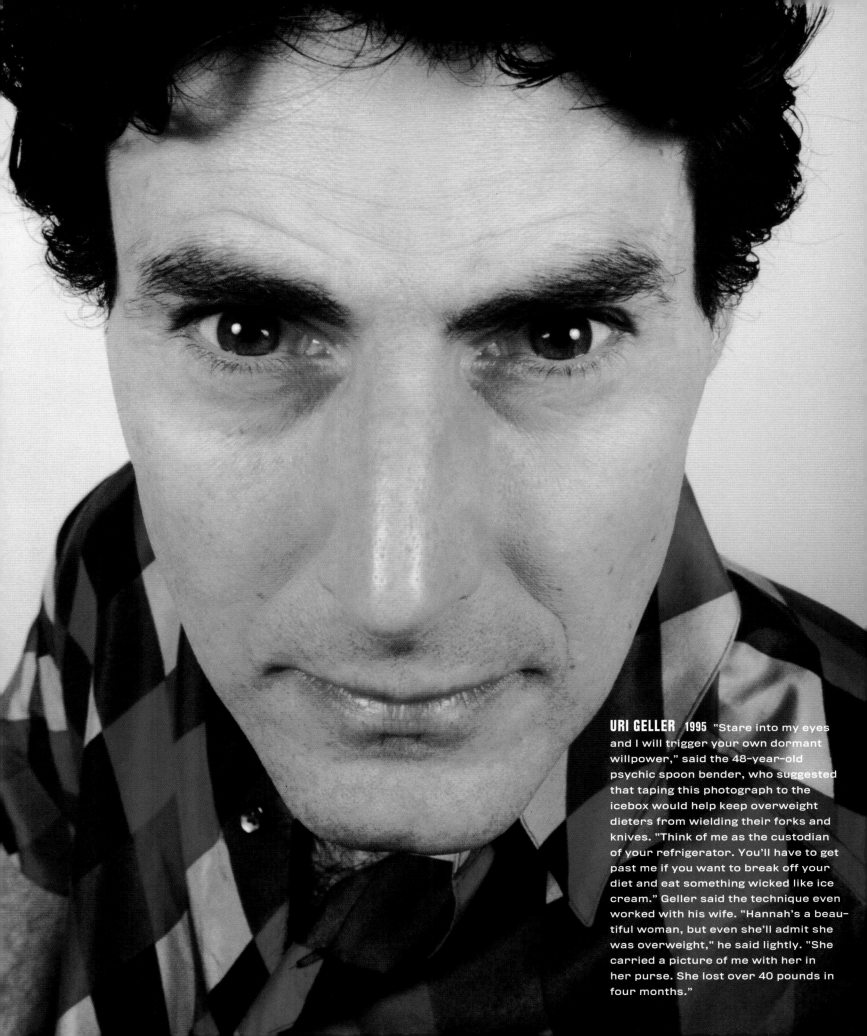

URI GELLER 1995 "Stare into my eyes and I will trigger your own dormant willpower," said the 48-year-old psychic spoon bender, who suggested that taping this photograph to the icebox would help keep overweight dieters from wielding their forks and knives. "Think of me as the custodian of your refrigerator. You'll have to get past me if you want to break off your diet and eat something wicked like ice cream." Geller said the technique even worked with his wife. "Hannah's a beautiful woman, but even she'll admit she was overweight," he said lightly. "She carried a picture of me with her in her purse. She lost over 40 pounds in four months."

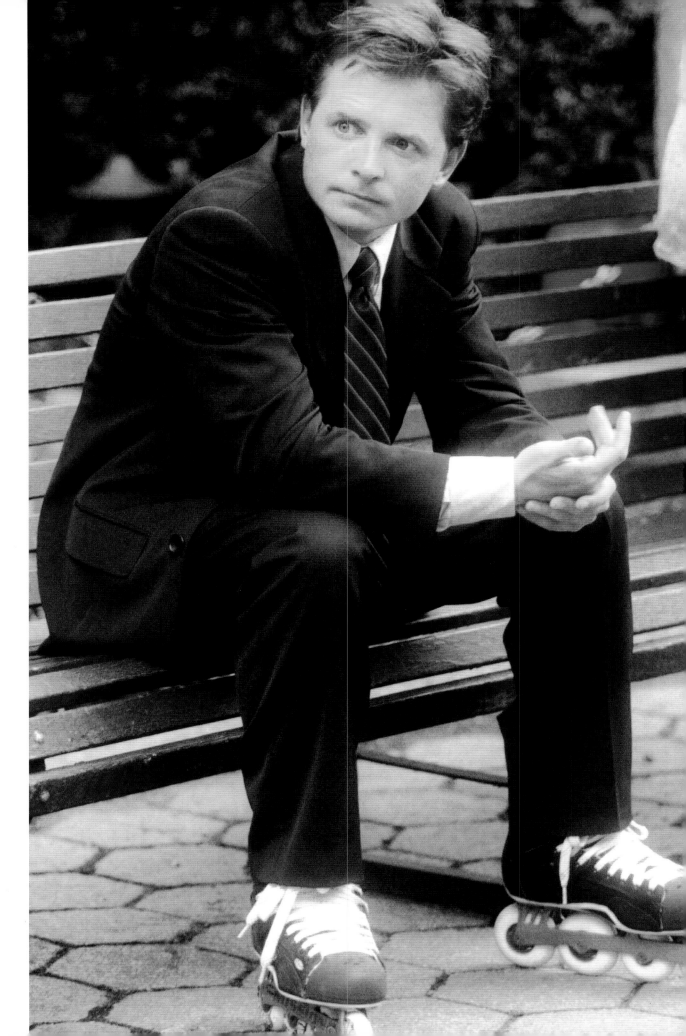

MICHAEL J. FOX 1998
Holding his hand to still the tremors caused by Parkinson's disease, the actor, who once dreamed of being a hockey player, takes a break while filming an inline-skating scene for *Spin City.* Fox has remained stoically upbeat throughout his battle with the neur- ological malady, even though, an insider revealed, "there have been times that the Parkinson's has been so bad that Michael has been unable to walk or talk." Fox hid his condi- tion for seven years, waiting to go public in 1998 until after *Spin City* was sold into syndication for $100 million, guaranteeing the financial security of his wife and three kids. In 2001, he made it clear he had every intention of sticking around, with the announcement of one more family tie, the impending birth of his fourth child.

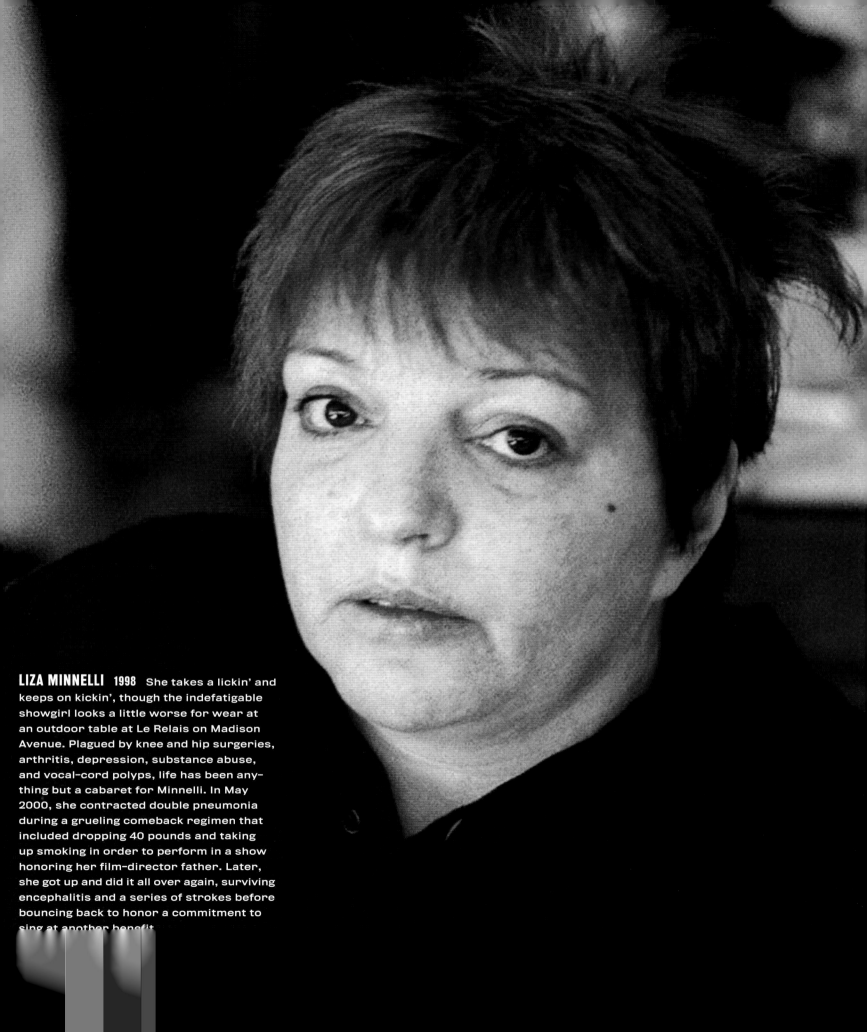

LIZA MINNELLI 1998 She takes a lickin' and keeps on kickin', though the indefatigable showgirl looks a little worse for wear at an outdoor table at Le Relais on Madison Avenue. Plagued by knee and hip surgeries, arthritis, depression, substance abuse, and vocal-cord polyps, life has been any-thing but a cabaret for Minnelli. In May 2000, she contracted double pneumonia during a grueling comeback regimen that included dropping 40 pounds and taking up smoking in order to perform in a show honoring her film-director father. Later, she got up and did it all over again, surviving encephalitis and a series of strokes before bouncing back to honor a commitment to sing at another benefit.

SUZANNE SOMERS 1987

The quintessential ditzy blonde, Suzanne Somers emerged from the fashion faux pas of the '70s and '80s with enough sense to know her biggest assets were her considerable curves. Her ThighMaster devices paid off big time, but she clearly didn't let it go to her head: When she was diagnosed with breast cancer in 2001, she decided to treat herself with an herbal alternative derived from mistletoe, and undergo liposuction on her hips, thighs, abdomen, and upper back "to even things out" after cancer surgery. The 54-year-old apparently thought it would be a good idea to improve her figure before going on a promotional tour to sell her new diet book.

DYAN CANNON 1970 As her pet poodle stands guard, the 39-year-old actress does a shoulder stand to keep her well-groomed body from going to the dogs. Predating even Jane Fonda as a Hollywood fitness freak, the loose Cannon's healthy allure sent Cary Grant, 30-some years her senior, head over heels: She pinned him to the wedding mat in 1965. Known for her knockout figure and trademark curly tresses, the beauty, who was nominated for Academy Awards as an actress and short-film writer-director, said her secret was all in the eyes. "[Eyes are] the most important part of the face because they're the first thing people see when they look at you." Her recommendation: plenty of sleep and even more mascara.

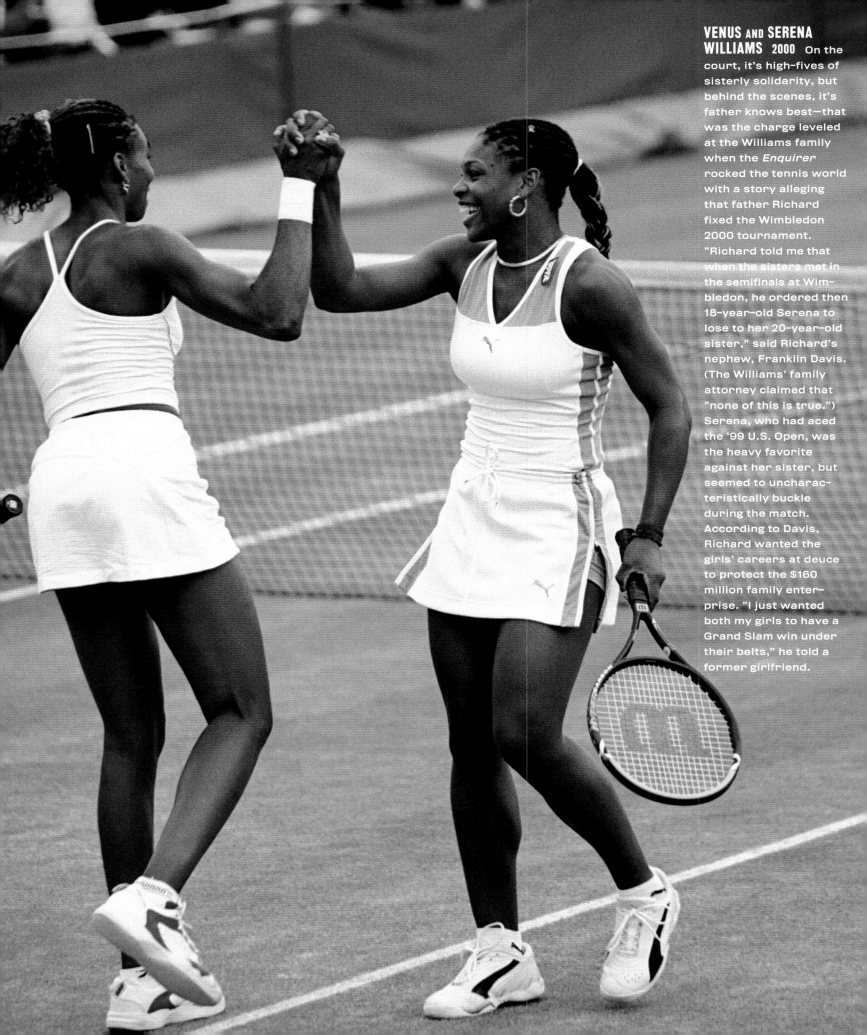

VENUS AND SERENA WILLIAMS 2000 On the court, it's high-fives of sisterly solidarity, but behind the scenes, it's father knows best—that was the charge leveled at the Williams family when the *Enquirer* rocked the tennis world with a story alleging that father Richard fixed the Wimbledon 2000 tournament. "Richard told me that when the sisters met in the semifinals at Wimbledon, he ordered then 18-year-old Serena to lose to her 20-year-old sister," said Richard's nephew, Franklin Davis. (The Williams' family attorney claimed that "none of this is true.") Serena, who had aced the '99 U.S. Open, was the heavy favorite against her sister, but seemed to uncharacteristically buckle during the match. According to Davis, Richard wanted the girls' careers at deuce to protect the $160 million family enterprise. "I just wanted both my girls to have a Grand Slam win under their belts," he told a former girlfriend.

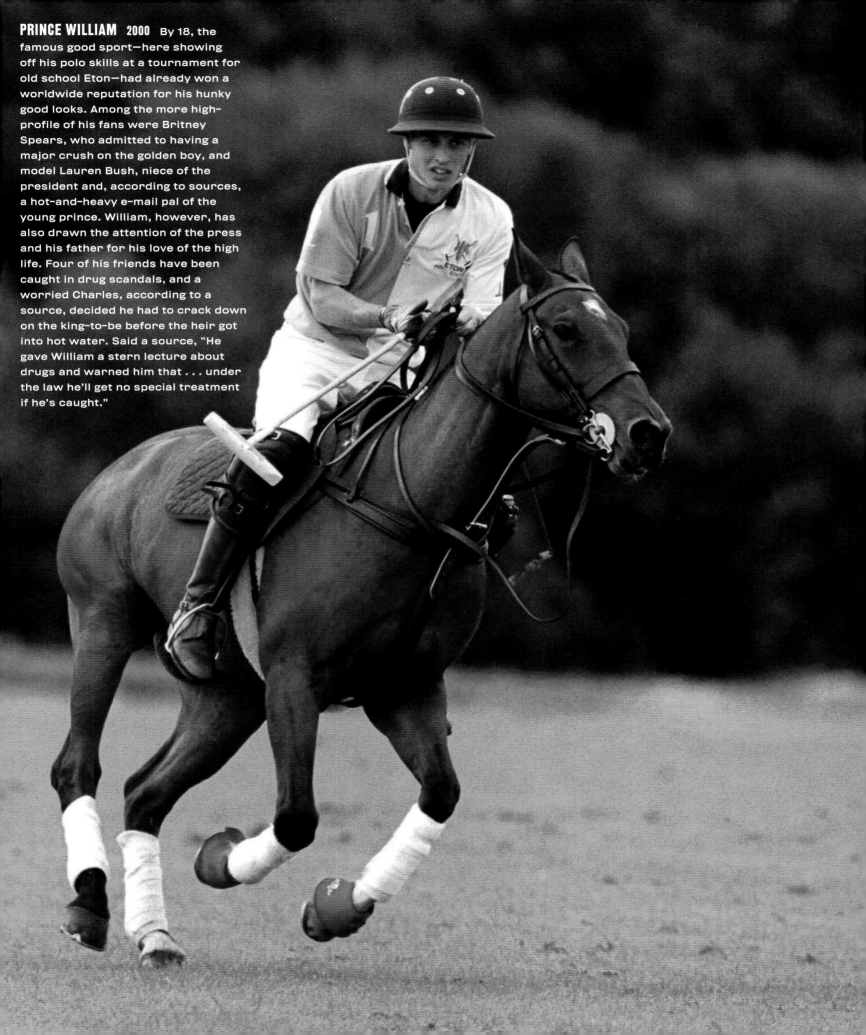

PRINCE WILLIAM 2000 By 18, the famous good sport—here showing off his polo skills at a tournament for old school Eton—had already won a worldwide reputation for his hunky good looks. Among the more high-profile of his fans were Britney Spears, who admitted to having a major crush on the golden boy, and model Lauren Bush, niece of the president and, according to sources, a hot-and-heavy e-mail pal of the young prince. William, however, has also drawn the attention of the press and his father for his love of the high life. Four of his friends have been caught in drug scandals, and a worried Charles, according to a source, decided he had to crack down on the king-to-be before the heir got into hot water. Said a source, "He gave William a stern lecture about drugs and warned him that . . . under the law he'll get no special treatment if he's caught."

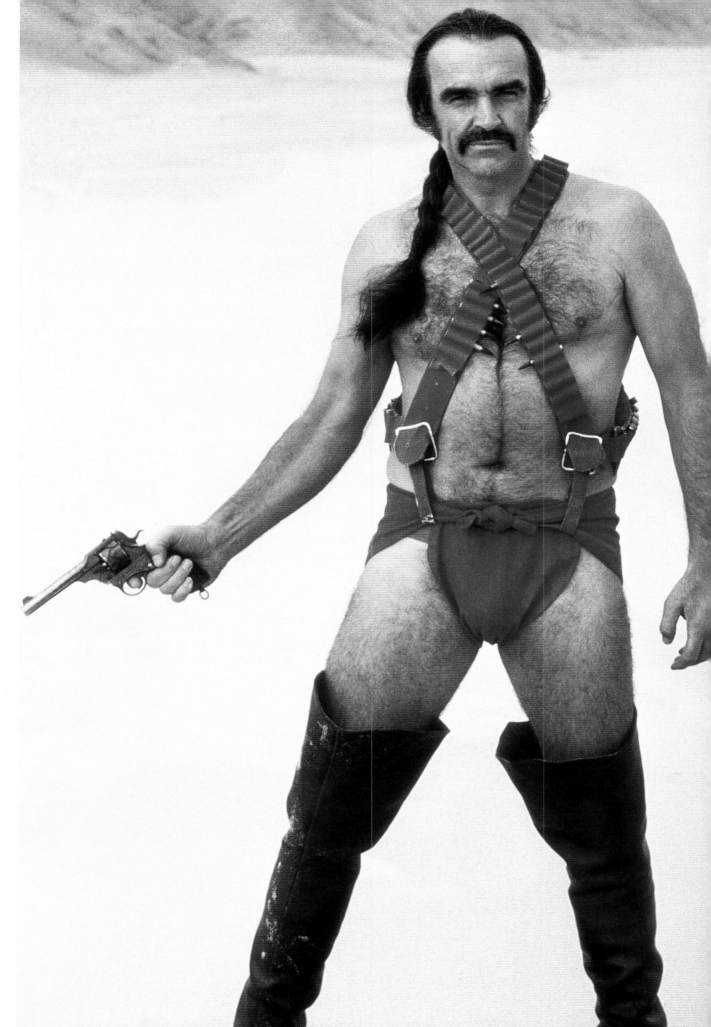

SEAN CONNERY 1974

The public was more shaken than stirred at the sight of Sean Connery in this strange getup for the sci-fi film *Zardoz.* Reportedly weary of suave 007's dinner jackets, the Scottish-born actor, who placed third in the 1953 Mr. Universe body-building contest, repeatedly tried to free himself from his Bonds. He donated his $1.25-million salary from 1971's *Diamonds Are Forever* to charity and signed on for *Zardoz,* growing a mustache and adding a ponytail. Though he'd already made millions, legend has it that Connery, ever mindful of his poor upbringing, drove himself to the set and split the limo and chauffeur allowance with director John Boorman.

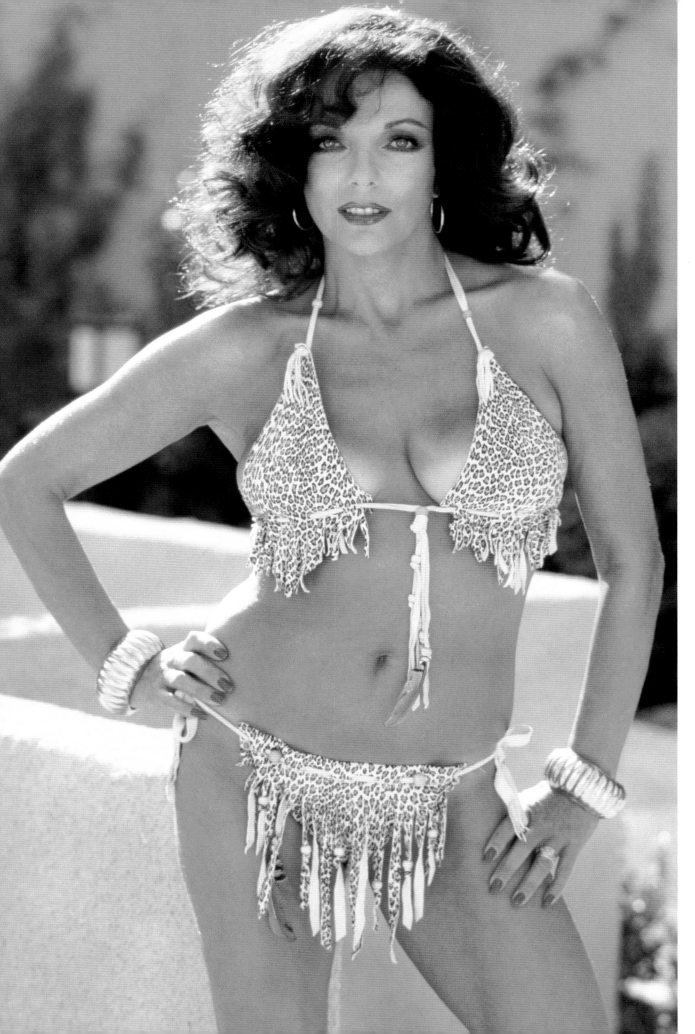

JOAN COLLINS 1981
The cattiest character on prime-time TV has always known how to throw a few curves to the press and public, reinventing herself as a 50-year-old *Playboy* model and a best-selling autobiographer and novelist. Known largely for the company she kept (Harry Belafonte, Ryan O'Neal, one-time fiancé Warren Beatty, and husband Anthony Newley), Collins built her own dynasty, acting in steamy films such as *The Stud* and *The Bitch,* based on her sister Jackie's novels, before immortalizing herself as the over-the-top predatory feline on the small screen, Alexis on *Dynasty.* Particularly adept at playing courtroom scenes, Collins came out on top in real life, too, when Random House foolishly tried to force her to return a $1.3-million book advance.

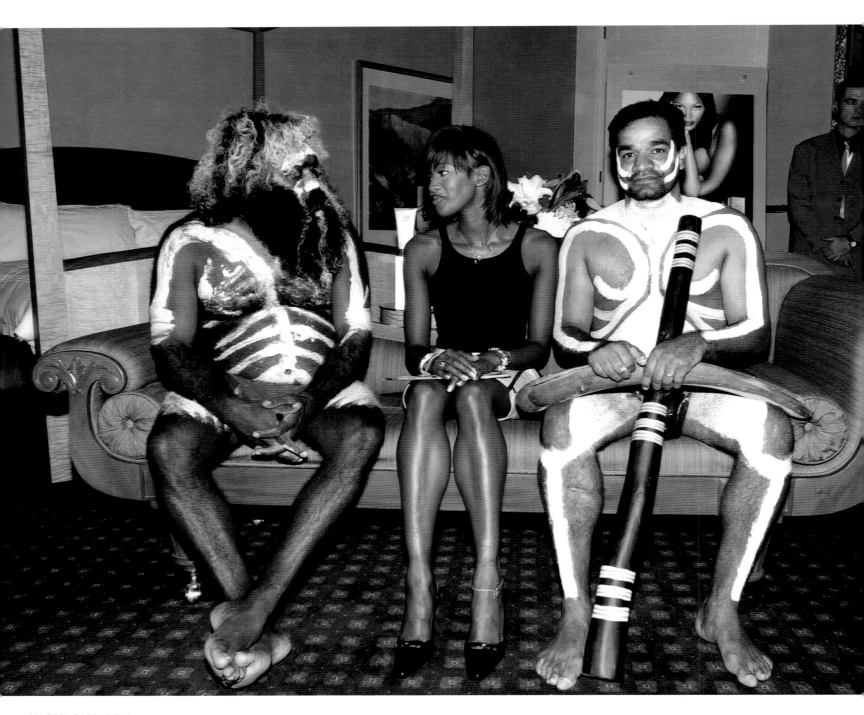

NAOMI CAMPBELL 2000 It is, of course, a supermodel's worst nightmare—showing up underdressed at a public event. Of course, no one told Campbell, in Australia to do a little PR for her new perfume, that the two Aboriginal tribesmen who would welcome her would be attired in nothing but bikini underwear and body paint. The tribesmen, duly impressed with the statuesque beauty, bestowed her with two sou- venirs: a boomerang and a traditional musical instrument called a didgeridoo.

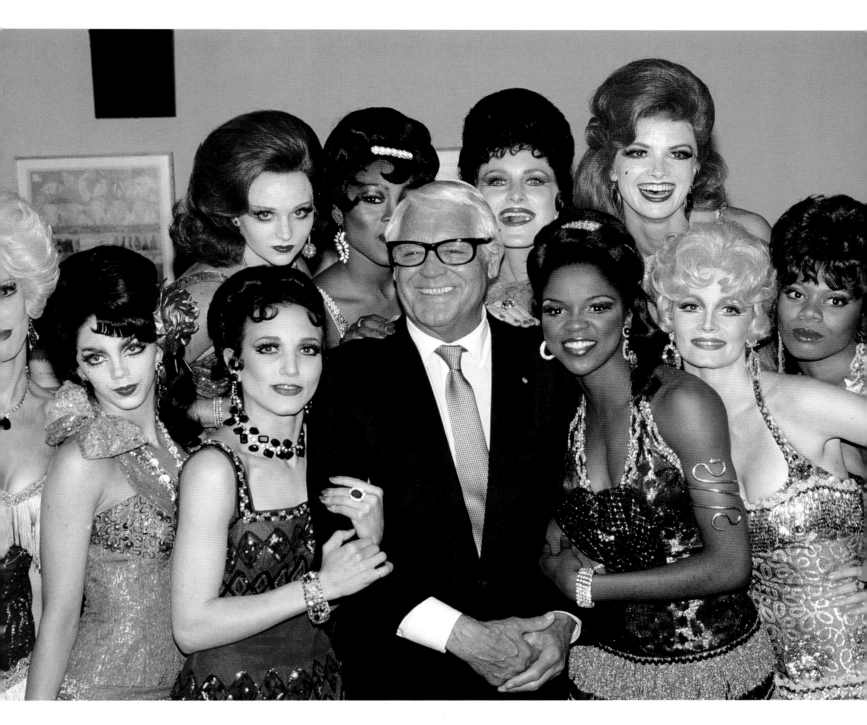

CARY GRANT 1985 White hair and nerdy black glasses didn't dim the appeal of the most suave and assured silver-screen actor of Hollywood's golden age, but the backstage stories of his love life weren't exactly the stuff his romantic movies were made of. Grant stumbled his way through four divorces. He was accused of beating and choking his first wife, Virginia Cherrill, and Grant's three-year marriage to Woolworth heiress Barbara Hutton flopped when it failed to bring up a baby. Actress Dyan Cannon also divorced him after three years. Grant's one seemingly happy marriage, to Betsy Drake, lasted more than a decade. But even before their final curtain, they were often spotted publicly on separate dates. "Look," Grant once told the female companion on his arm, "that's my wife! Isn't she beautiful?"

RICHARD PRYOR 1998 It's been a long, hard road, but Richard Pryor still knows how to run the red carpet in style, as he did here at the premiere of *Lethal Weapon 4,* riding a matching red cart with burled-wood trim. "Do you guys remember when I poured liquor all over my body, lit myself on fire, and ran down the street? How the hell did I survive that?" asked Pryor, referring to the 1980 freebasing incident that nearly killed him. Since his MS diagnosis in the '90s, survival has been a humbling experience for Pryor, who believes his incurable condition might have actually saved his life. As he told a friend, "If I was still out there partying, I'd be in a dope house with a whore. Or in a whorehouse with dope. Either way, I'd be dead."

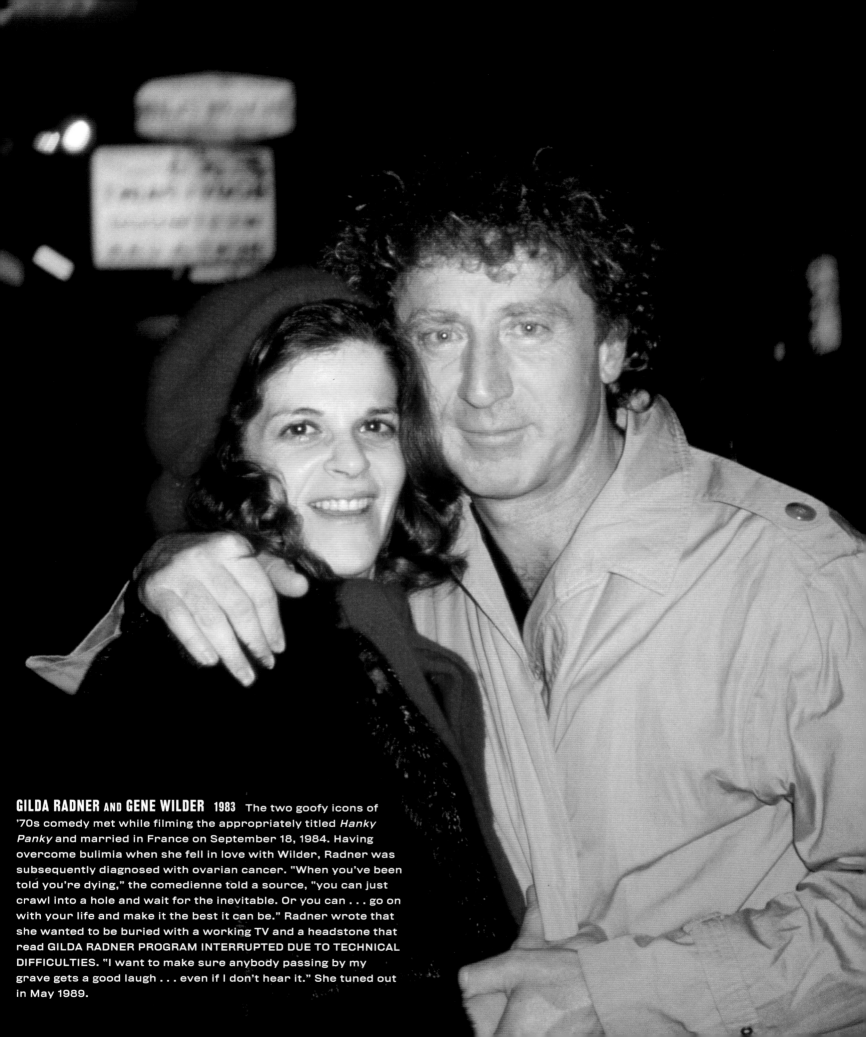

GILDA RADNER AND **GENE WILDER** 1983 The two goofy icons of '70s comedy met while filming the appropriately titled *Hanky Panky* and married in France on September 18, 1984. Having overcome bulimia when she fell in love with Wilder, Radner was subsequently diagnosed with ovarian cancer. "When you've been told you're dying," the comedienne told a source, "you can just crawl into a hole and wait for the inevitable. Or you can . . . go on with your life and make it the best it can be." Radner wrote that she wanted to be buried with a working TV and a headstone that read GILDA RADNER PROGRAM INTERRUPTED DUE TO TECHNICAL DIFFICULTIES. "I want to make sure anybody passing by my grave gets a good laugh . . . even if I don't hear it." She tuned out in May 1989.

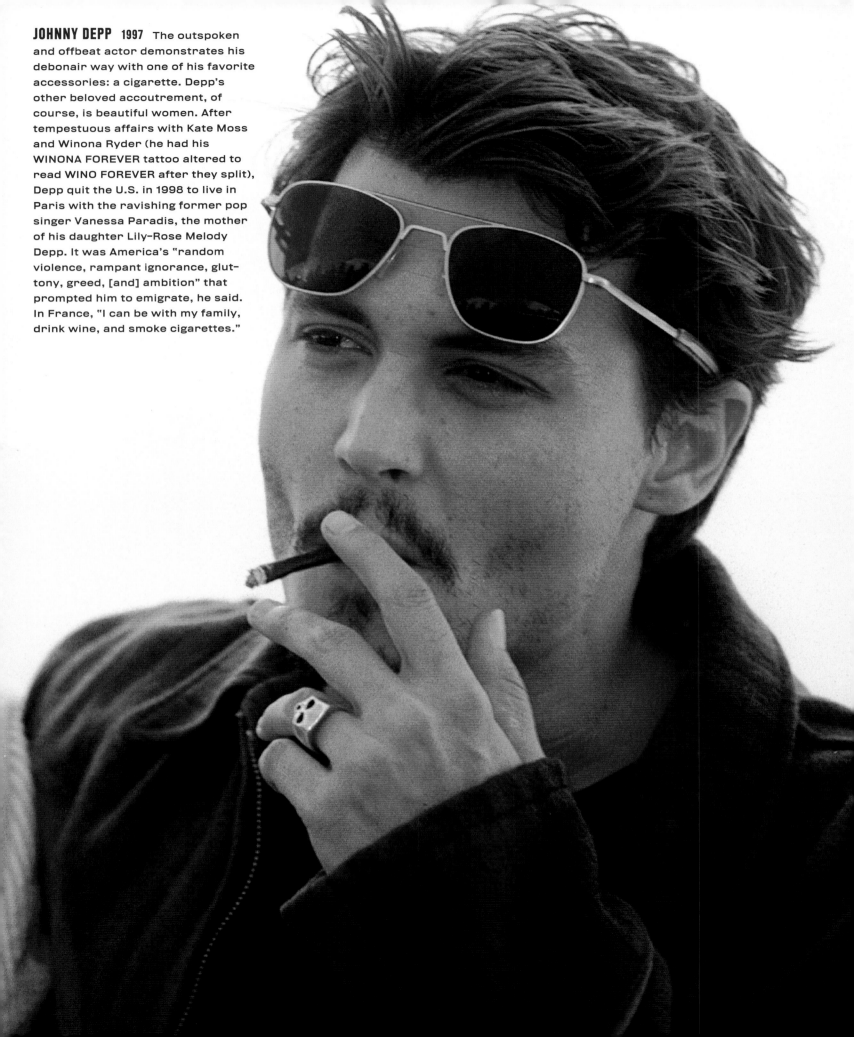

JOHNNY DEPP 1997 The outspoken and offbeat actor demonstrates his debonair way with one of his favorite accessories: a cigarette. Depp's other beloved accoutrement, of course, is beautiful women. After tempestuous affairs with Kate Moss and Winona Ryder (he had his WINONA FOREVER tattoo altered to read WINO FOREVER after they split), Depp quit the U.S. in 1998 to live in Paris with the ravishing former pop singer Vanessa Paradis, the mother of his daughter Lily-Rose Melody Depp. It was America's "random violence, rampant ignorance, glut-tony, greed, [and] ambition" that prompted him to emigrate, he said. In France, "I can be with my family, drink wine, and smoke cigarettes."

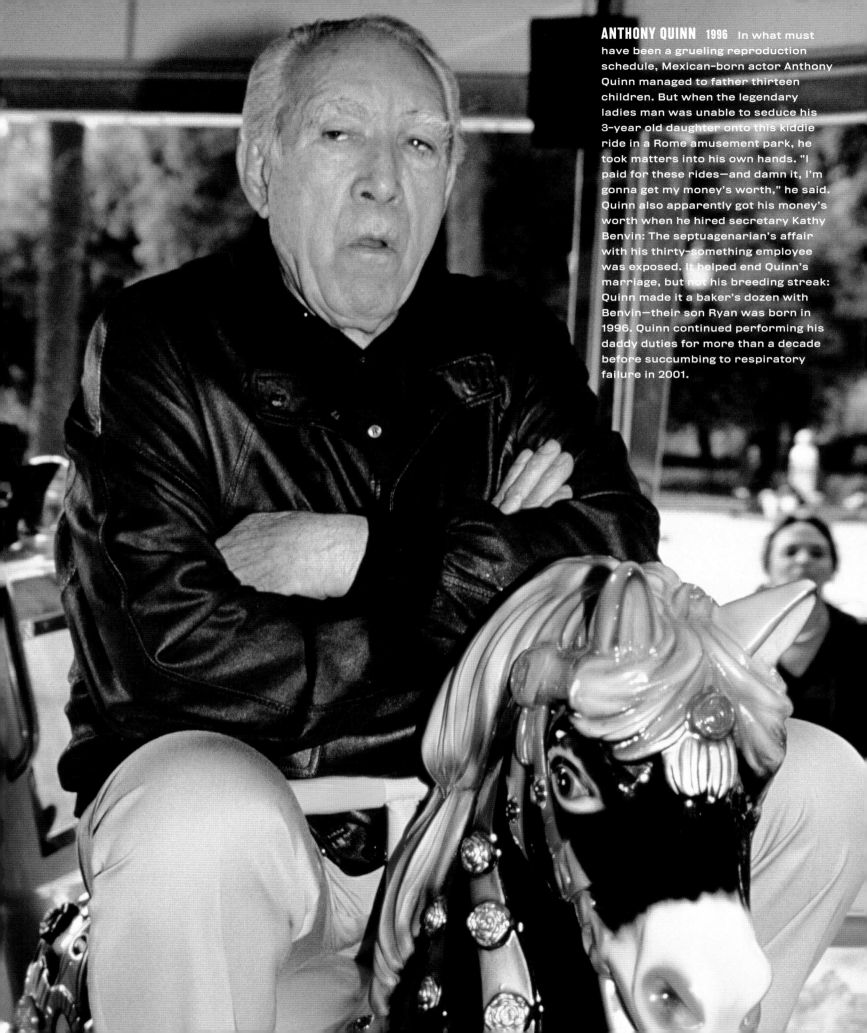

ANTHONY QUINN 1996 In what must have been a grueling reproduction schedule, Mexican-born actor Anthony Quinn managed to father thirteen children. But when the legendary ladies man was unable to seduce his 3-year old daughter onto this kiddie ride in a Rome amusement park, he took matters into his own hands. "I paid for these rides—and damn it, I'm gonna get my money's worth," he said. Quinn also apparently got his money's worth when he hired secretary Kathy Benvin: The septuagenarian's affair with his thirty-something employee was exposed. It helped end Quinn's marriage, but not his breeding streak: Quinn made it a baker's dozen with Benvin—their son Ryan was born in 1996. Quinn continued performing his daddy duties for more than a decade before succumbing to respiratory failure in 2001.

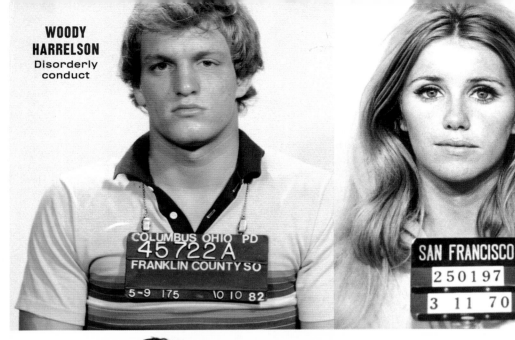

WOODY HARRELSON
Disorderly conduct

COLUMBUS OHIO PD
45722A
FRANKLIN COUNTY SO
5-9 175 10 10 82

SUZANNE SOMERS
Paying rent with a bounced check

SAN FRANCISCO
250197
3 11 70

JANE FONDA
Drug smuggling, assault and battery to a police officer

139813
C LEVELAND
32 5'8 126
NOV 3 1970

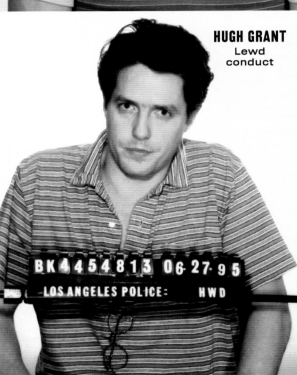

HUGH GRANT
Lewd conduct

BK4454813 06-27-95
LOS ANGELES POLICE HWD

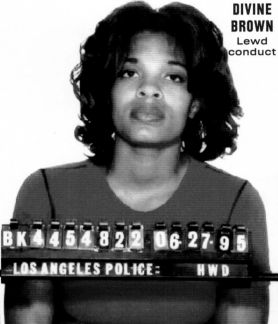

DIVINE BROWN
Lewd conduct

BK4454822 06-27-95
LOS ANGELES POLICE HWD

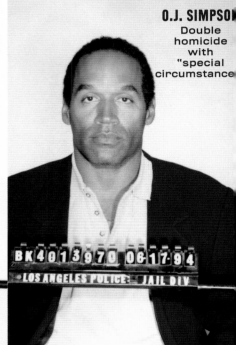

O.J. SIMPSON
Double homicide with "special circumstance"

BK4013970 06-17-94
LOS ANGELES POLICE JAIL DIV

BRETT BUTLER
Drunk driving

AL PACINO
Carrying a concealed weapon in a motor vehicle

ADULT CORR INSTS
18631

MARV ALBERT
Assault and battery

ID NO. DATE
974254 05:27:97
ARLINGTON COUNTY

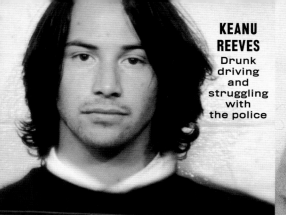

KEANU REEVES
Drunk driving and struggling with the police

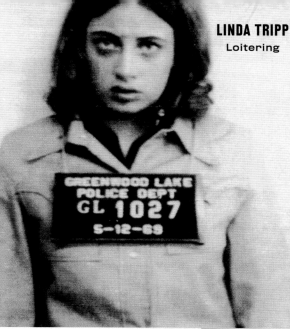

LINDA TRIPP
Loitering

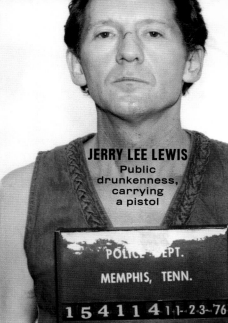

JERRY LEE LEWIS
Public drunkenness, carrying a pistol

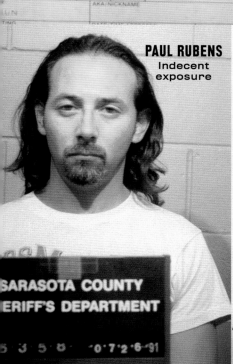

PAUL RUBENS
Indecent exposure

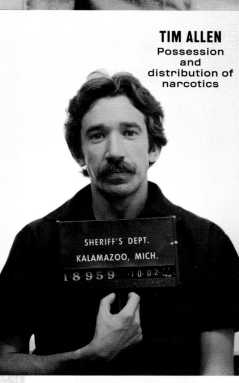

TIM ALLEN
Possession and distribution of narcotics

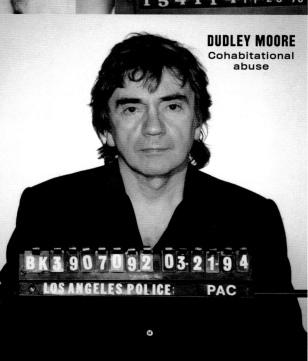

DUDLEY MOORE
Cohabitational abuse

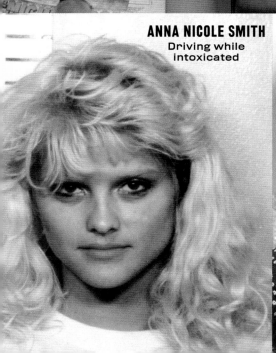

ANNA NICOLE SMITH
Driving while intoxicated

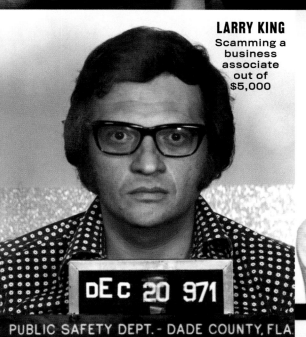

LARRY KING
Scamming a business associate out of $5,000

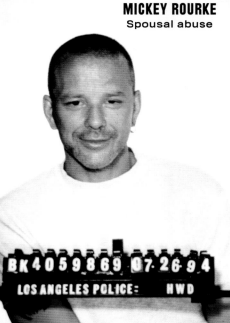

MICKEY ROURKE
Spousal abuse

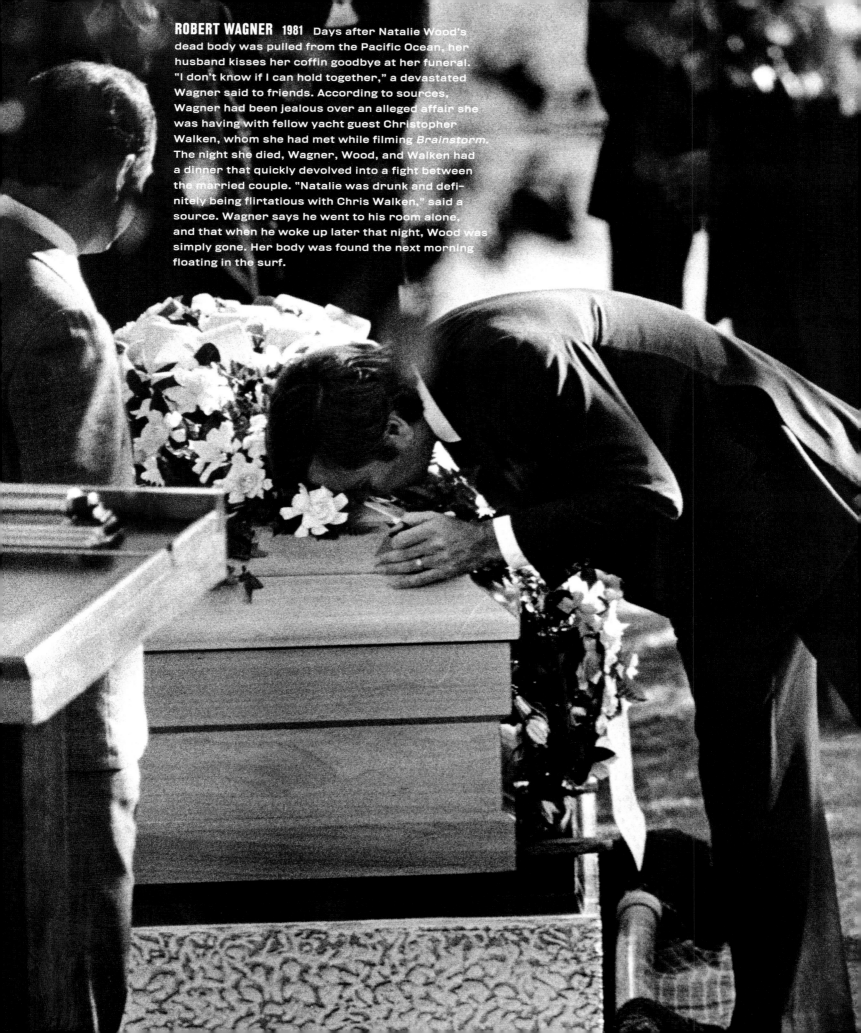

ROBERT WAGNER 1981 Days after Natalie Wood's dead body was pulled from the Pacific Ocean, her husband kisses her coffin goodbye at her funeral. "I don't know if I can hold together," a devastated Wagner said to friends. According to sources, Wagner had been jealous over an alleged affair she was having with fellow yacht guest Christopher Walken, whom she had met while filming *Brainstorm*. The night she died, Wagner, Wood, and Walken had a dinner that quickly devolved into a fight between the married couple. "Natalie was drunk and definitely being flirtatious with Chris Walken," said a source. Wagner says he went to his room alone, and that when he woke up later that night, Wood was simply gone. Her body was found the next morning floating in the surf.

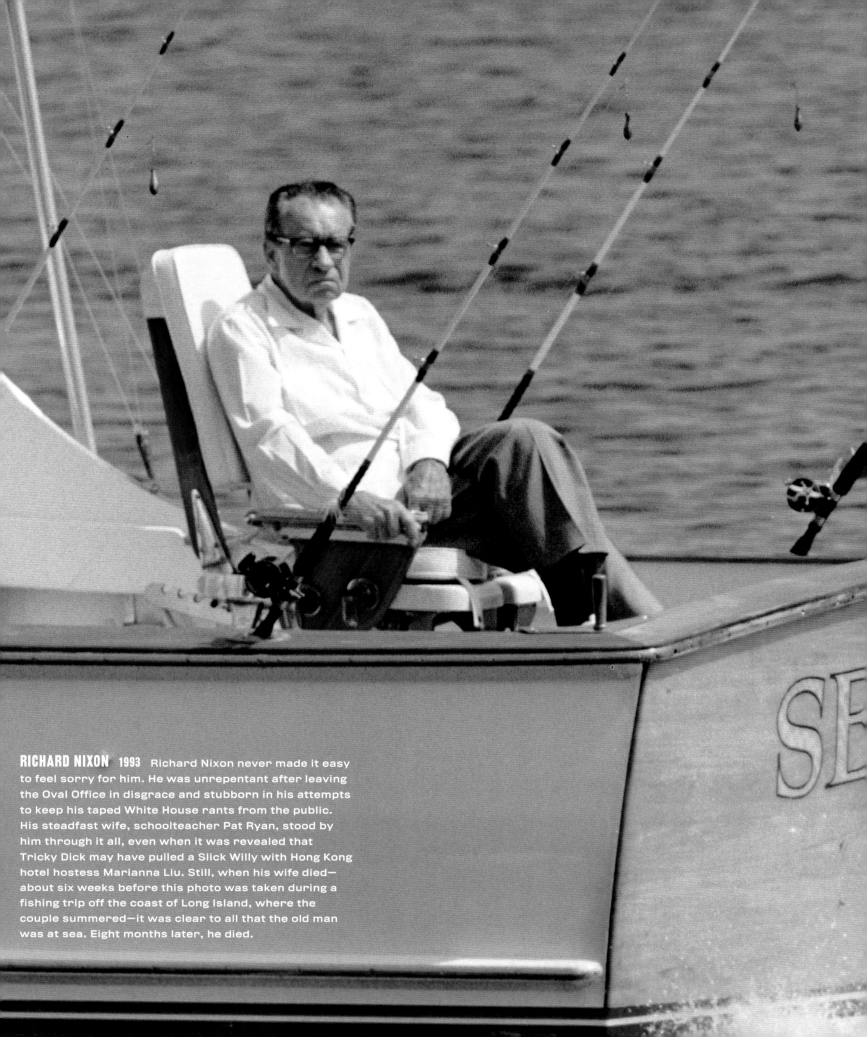

RICHARD NIXON 1993 Richard Nixon never made it easy to feel sorry for him. He was unrepentant after leaving the Oval Office in disgrace and stubborn in his attempts to keep his taped White House rants from the public. His steadfast wife, schoolteacher Pat Ryan, stood by him through it all, even when it was revealed that Tricky Dick may have pulled a Slick Willy with Hong Kong hotel hostess Marianna Liu. Still, when his wife died—about six weeks before this photo was taken during a fishing trip off the coast of Long Island, where the couple summered—it was clear to all that the old man was at sea. Eight months later, he died.

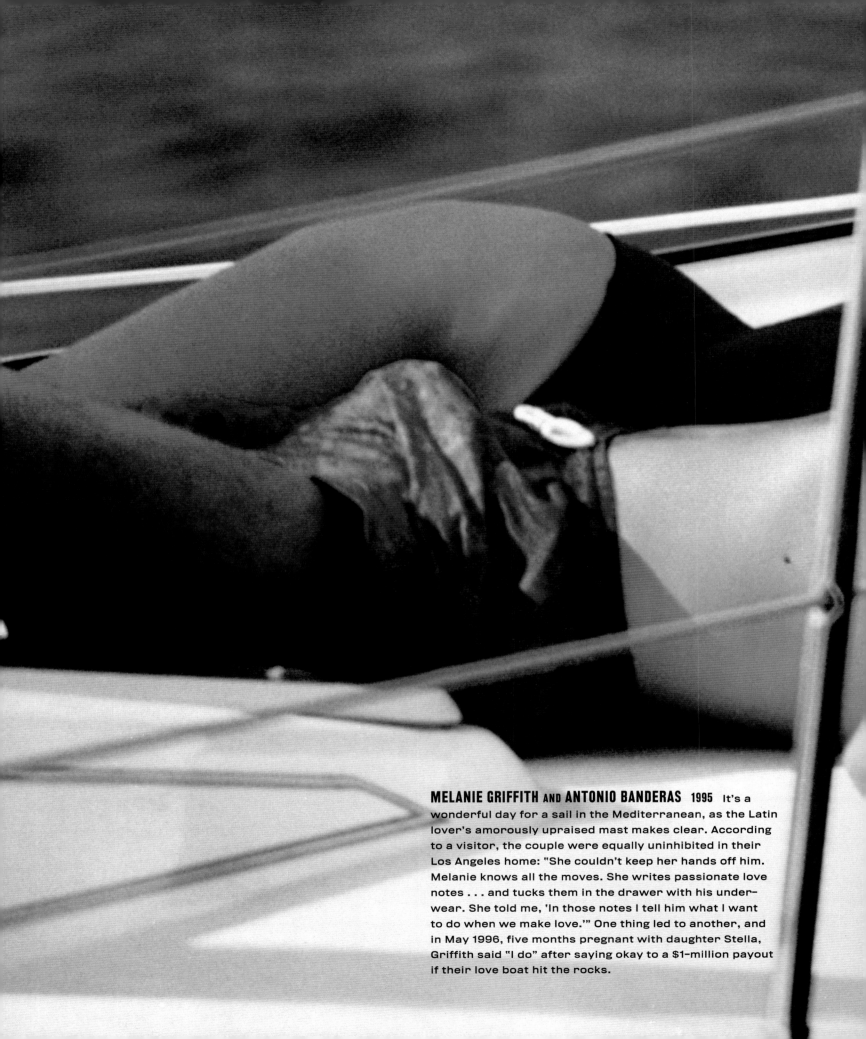

MELANIE GRIFFITH AND **ANTONIO BANDERAS** 1995 It's a wonderful day for a sail in the Mediterranean, as the Latin lover's amorously upraised mast makes clear. According to a visitor, the couple were equally uninhibited in their Los Angeles home: "She couldn't keep her hands off him. Melanie knows all the moves. She writes passionate love notes . . . and tucks them in the drawer with his underwear. She told me, 'In those notes I tell him what I want to do when we make love.'" One thing led to another, and in May 1996, five months pregnant with daughter Stella, Griffith said "I do" after saying okay to a $1-million payout if their love boat hit the rocks.

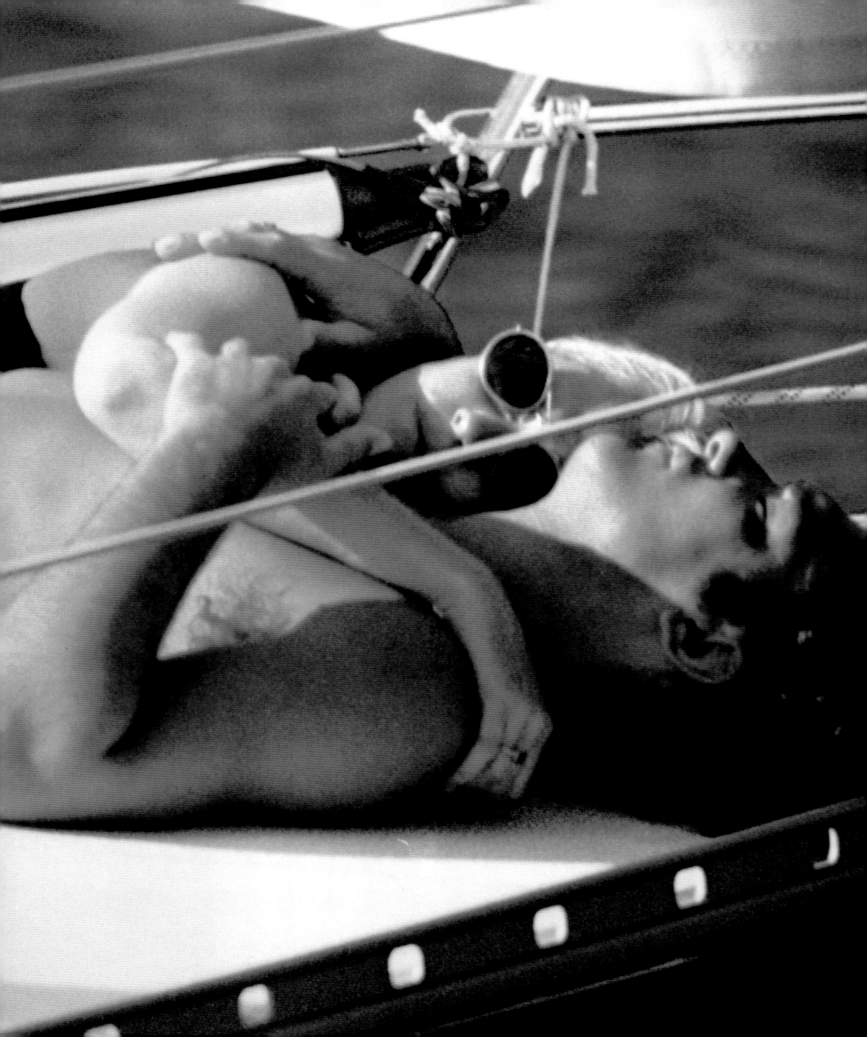

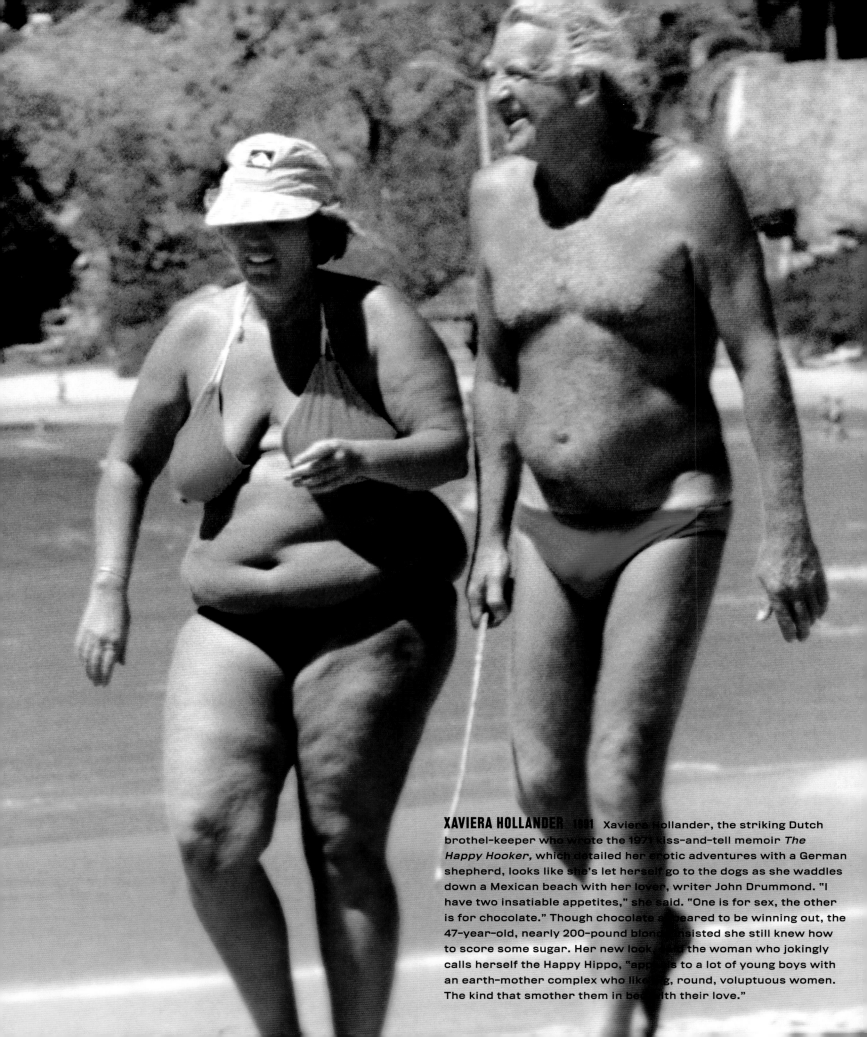

XAVIERA HOLLANDER 1991 Xaviera Hollander, the striking Dutch brothel-keeper who wrote the 1971 kiss-and-tell memoir *The Happy Hooker,* which detailed her erotic adventures with a German shepherd, looks like she's let herself go to the dogs as she waddles down a Mexican beach with her lover, writer John Drummond. "I have two insatiable appetites," she said. "One is for sex, the other is for chocolate." Though chocolate appeared to be winning out, the 47-year-old, nearly 200-pound blonde insisted she still knew how to score some sugar. Her new look, said the woman who jokingly calls herself the Happy Hippo, "appeals to a lot of young boys with an earth-mother complex who like big, round, voluptuous women. The kind that smother them in bed with their love."

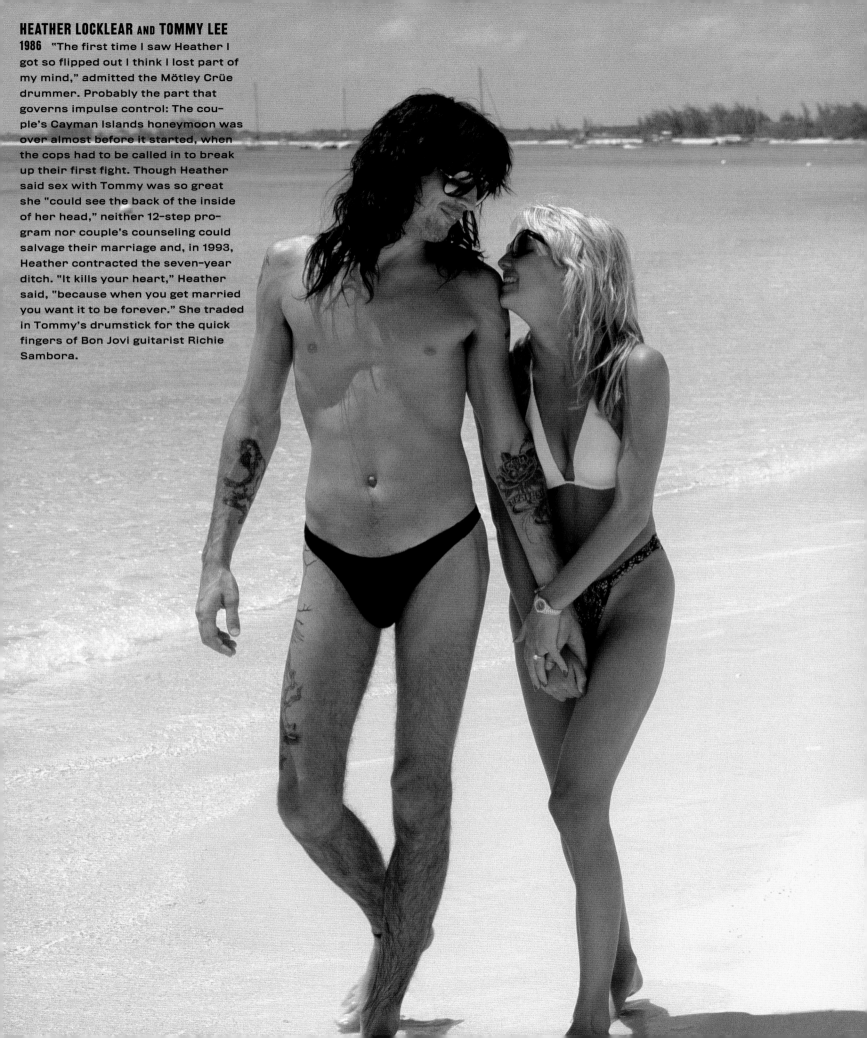

HEATHER LOCKLEAR AND TOMMY LEE

1986 "The first time I saw Heather I got so flipped out I think I lost part of my mind," admitted the Mötley Crüe drummer. Probably the part that governs impulse control: The couple's Cayman Islands honeymoon was over almost before it started, when the cops had to be called in to break up their first fight. Though Heather said sex with Tommy was so great she "could see the back of the inside of her head," neither 12-step program nor couple's counseling could salvage their marriage and, in 1993, Heather contracted the seven-year ditch. "It kills your heart," Heather said, "because when you get married you want it to be forever." She traded in Tommy's drumstick for the quick fingers of Bon Jovi guitarist Richie Sambora.

ELIZABETH TAYLOR 1998 "I can't go on like this much longer," the violet-eyed movie star sobbed, wracked with the pain of a cracked vertebra requiring an ambulance ride to the hospital for X-rays. "I just want to die!" It's a scene Elizabeth Taylor has played many times before. As famous for her near-death illnesses as she is for her movie roles and weddings, the former child actress has become the world's best-loved drama queen. "When she returned home," a friend revealed, "Liz was even more depressed. Because of all the pain medication she's on, she sleeps all day and is up all night. The TV is on practically 24 hours a day. She's become hooked on QVC." Nonetheless, Taylor found the strength to hobble down the stairs of her mansion a few weeks later to greet guests at her annual Memorial Day barbecue.

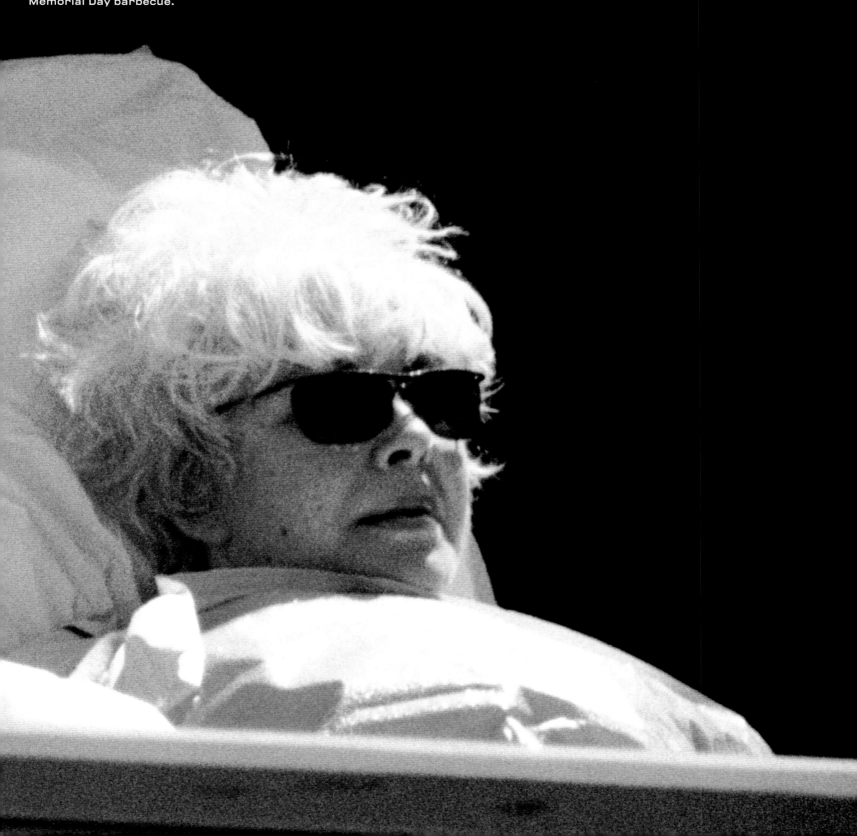

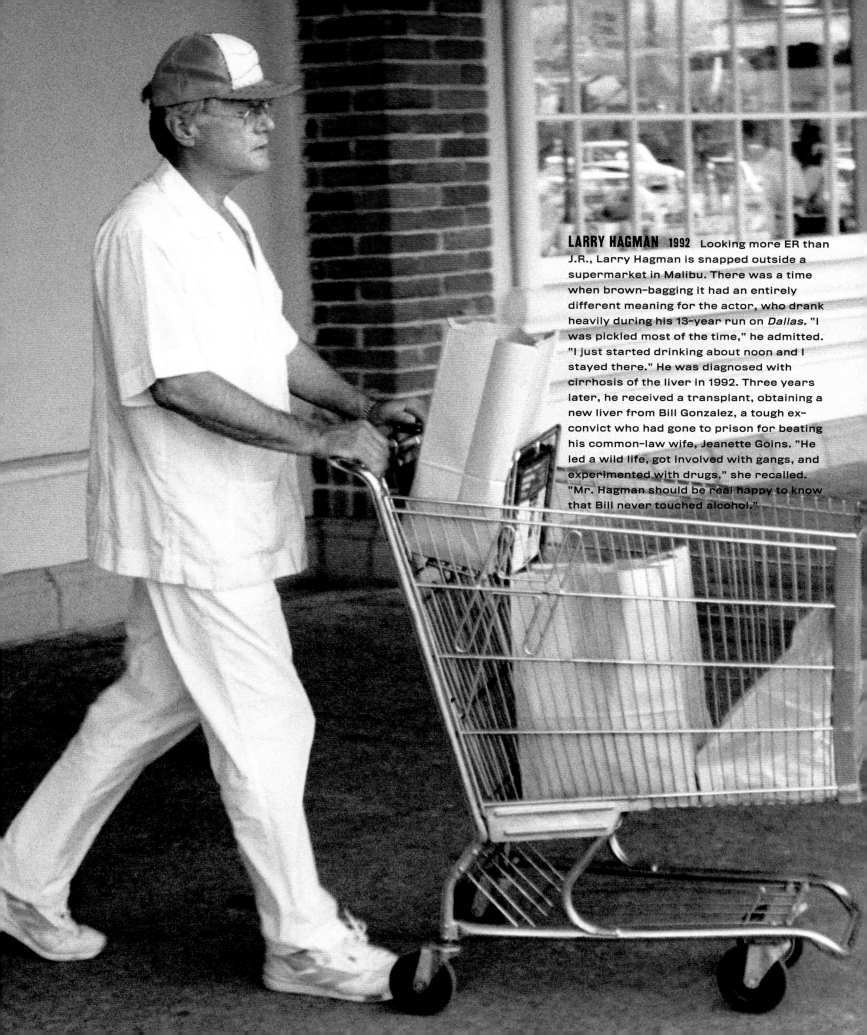

LARRY HAGMAN 1992 Looking more ER than J.R., Larry Hagman is snapped outside a supermarket in Malibu. There was a time when brown-bagging it had an entirely different meaning for the actor, who drank heavily during his 13-year run on *Dallas.* "I was pickled most of the time," he admitted. "I just started drinking about noon and I stayed there." He was diagnosed with cirrhosis of the liver in 1992. Three years later, he received a transplant, obtaining a new liver from Bill Gonzalez, a tough ex-convict who had gone to prison for beating his common-law wife, Jeanette Goins. "He led a wild life, got involved with gangs, and experimented with drugs," she recalled. "Mr. Hagman should be real happy to know that Bill never touched alcohol."

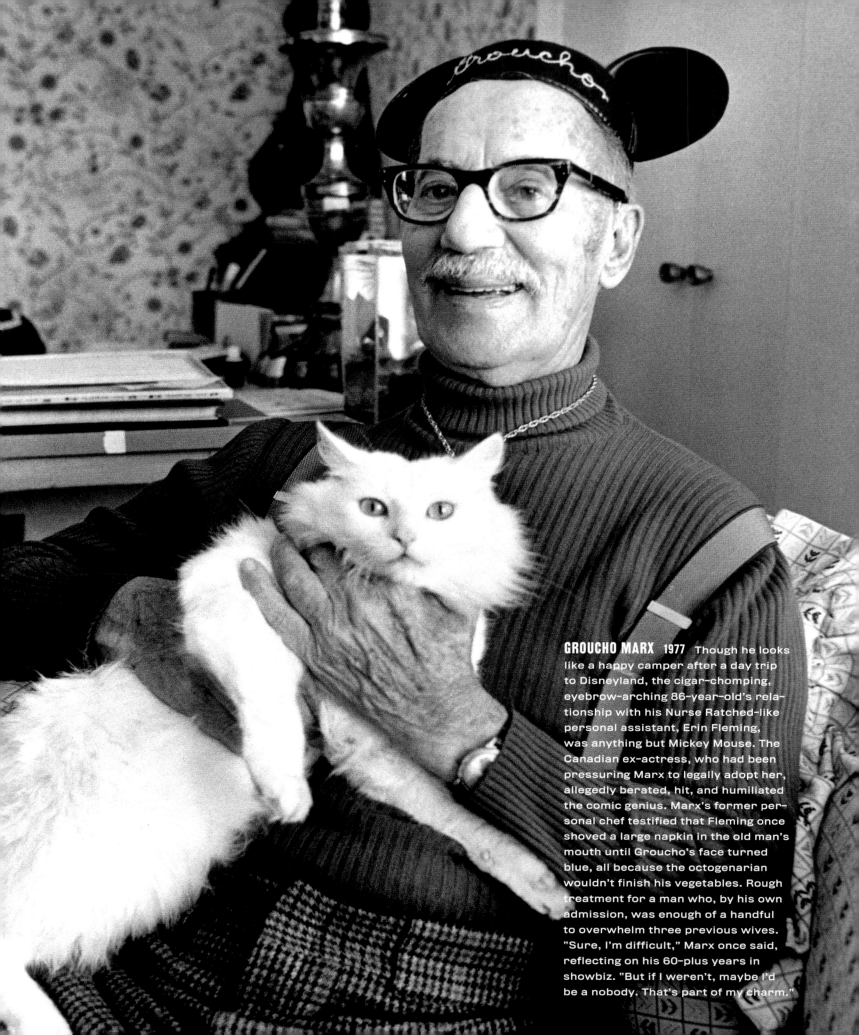

GROUCHO MARX 1977 Though he looks like a happy camper after a day trip to Disneyland, the cigar-chomping, eyebrow-arching 86-year-old's relationship with his Nurse Ratched-like personal assistant, Erin Fleming, was anything but Mickey Mouse. The Canadian ex-actress, who had been pressuring Marx to legally adopt her, allegedly berated, hit, and humiliated the comic genius. Marx's former personal chef testified that Fleming once shoved a large napkin in the old man's mouth until Groucho's face turned blue, all because the octogenarian wouldn't finish his vegetables. Rough treatment for a man who, by his own admission, was enough of a handful to overwhelm three previous wives. "Sure, I'm difficult," Marx once said, reflecting on his 60-plus years in showbiz. "But if I weren't, maybe I'd be a nobody. That's part of my charm."

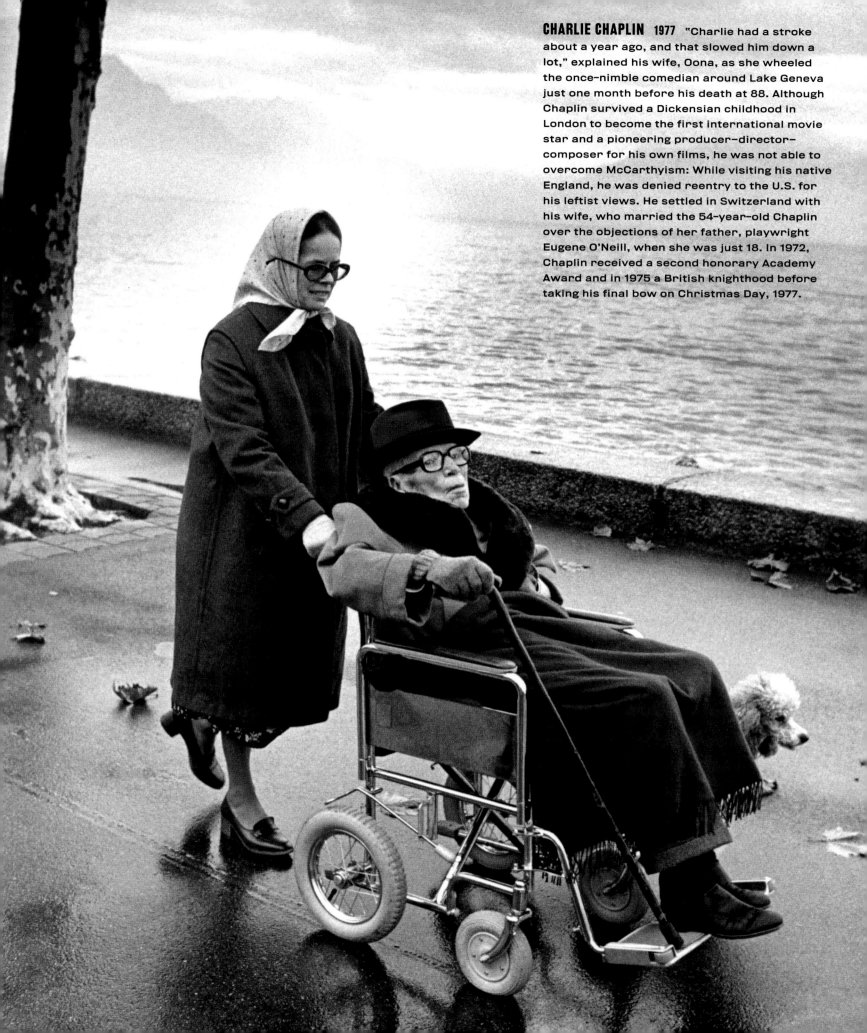

CHARLIE CHAPLIN 1977 "Charlie had a stroke about a year ago, and that slowed him down a lot," explained his wife, Oona, as she wheeled the once-nimble comedian around Lake Geneva just one month before his death at 88. Although Chaplin survived a Dickensian childhood in London to become the first international movie star and a pioneering producer–director–composer for his own films, he was not able to overcome McCarthyism: While visiting his native England, he was denied reentry to the U.S. for his leftist views. He settled in Switzerland with his wife, who married the 54-year-old Chaplin over the objections of her father, playwright Eugene O'Neill, when she was just 18. In 1972, Chaplin received a second honorary Academy Award and in 1975 a British knighthood before taking his final bow on Christmas Day, 1977.

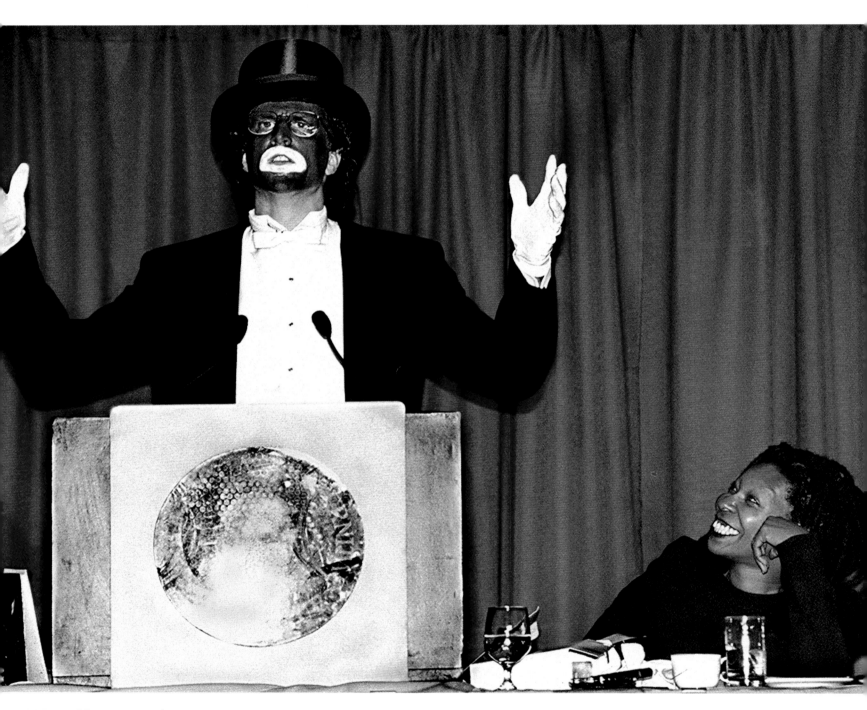

TED DANSON AND WHOOPI GOLDBERG **1993** It was jeers, not cheers, that greeted Ted Danson when he took to the dais of the Friars Club and directed a barrage of race-based "jokes" at his then-girl-friend, Whoopi Goldberg. "I felt like taking Ted Danson and stuffing him into a scotch bottle," said one black guest after the 45-year-old comedian, done up in minstrel blackface, graphically detailed episodes of "hot love" with roast honoree Goldberg. ("Her screaming opened the garage door," he quipped.) "It made me sick," Robert De Niro told a pal afterward. "I think Danson needs psychiatric help." Amazingly, the 37-year-old Whoopi disagreed, laughing and kissing Uncle Ted throughout. "Ted Danson is not a racist," she insisted, telling the press that she, in fact, had written most of her boyfriend's jokes. Nevertheless, the couple broke up their act shortly thereafter.

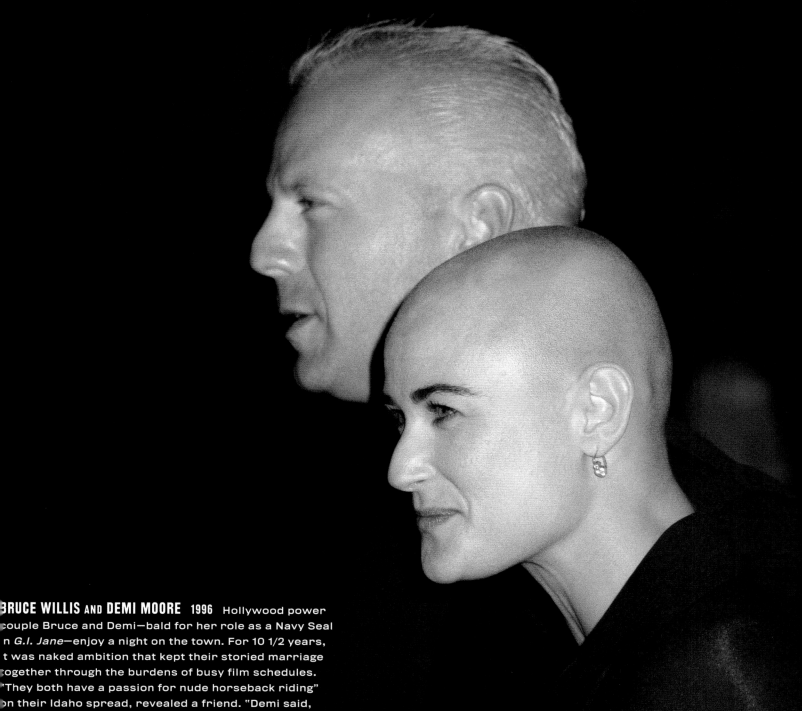

BRUCE WILLIS AND DEMI MOORE 1996 Hollywood power couple Bruce and Demi—bald for her role as a Navy Seal in *G.I. Jane*—enjoy a night on the town. For 10 1/2 years, it was naked ambition that kept their storied marriage together through the burdens of busy film schedules. "They both have a passion for nude horseback riding" on their Idaho spread, revealed a friend. "Demi said, 'We never make it back to the house without having to tie up the horses and make love in the wilderness.'" Boxing as foreplay in their home gym was another favorite pastime, as was paying exotic dancers for private dancing: "Bruce enjoys dressing up like a cowboy in boots, chaps—and nothing else," said the source. "Demi loves to . . . gently tease him with a riding crop!" Still, Willis eventually proved impossible to tame. They split in 1998, when Demi caught him playing the field, though they remain friends.

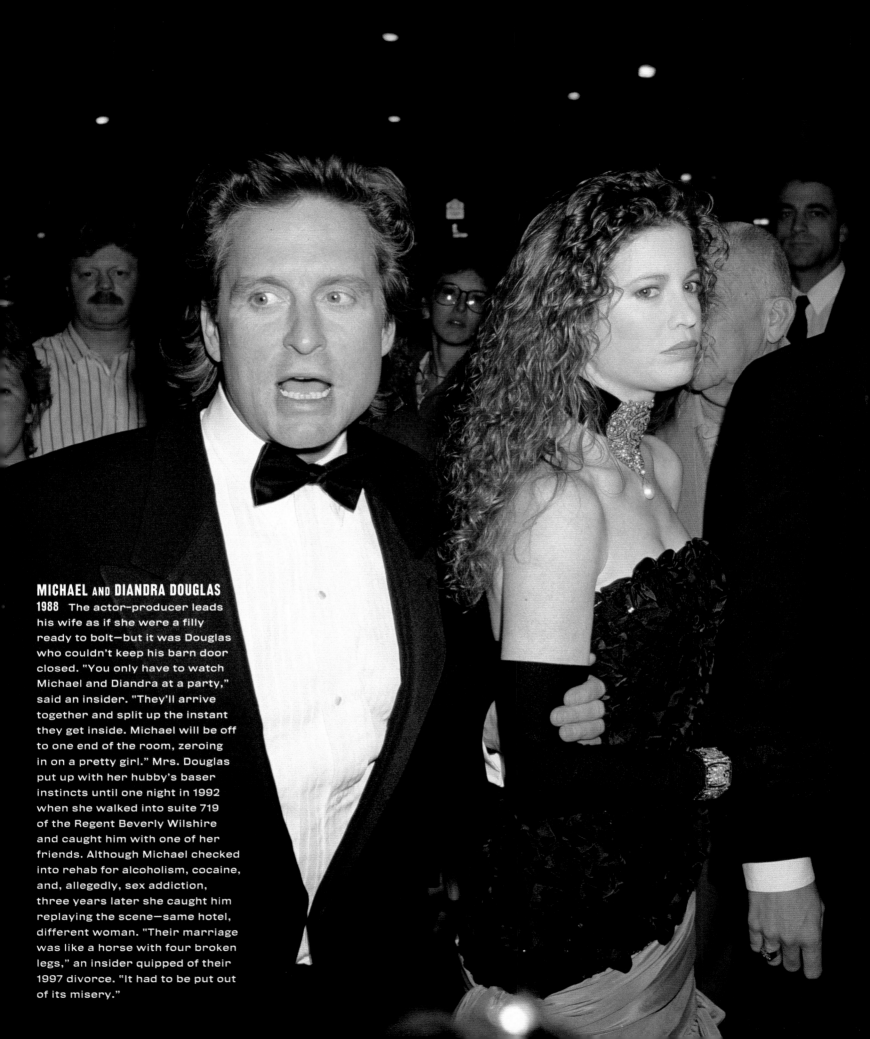

MICHAEL AND DIANDRA DOUGLAS
1988 The actor-producer leads his wife as if she were a filly ready to bolt—but it was Douglas who couldn't keep his barn door closed. "You only have to watch Michael and Diandra at a party," said an insider. "They'll arrive together and split up the instant they get inside. Michael will be off to one end of the room, zeroing in on a pretty girl." Mrs. Douglas put up with her hubby's baser instincts until one night in 1992 when she walked into suite 719 of the Regent Beverly Wilshire and caught him with one of her friends. Although Michael checked into rehab for alcoholism, cocaine, and, allegedly, sex addiction, three years later she caught him replaying the scene—same hotel, different woman. "Their marriage was like a horse with four broken legs," an insider quipped of their 1997 divorce. "It had to be put out of its misery."

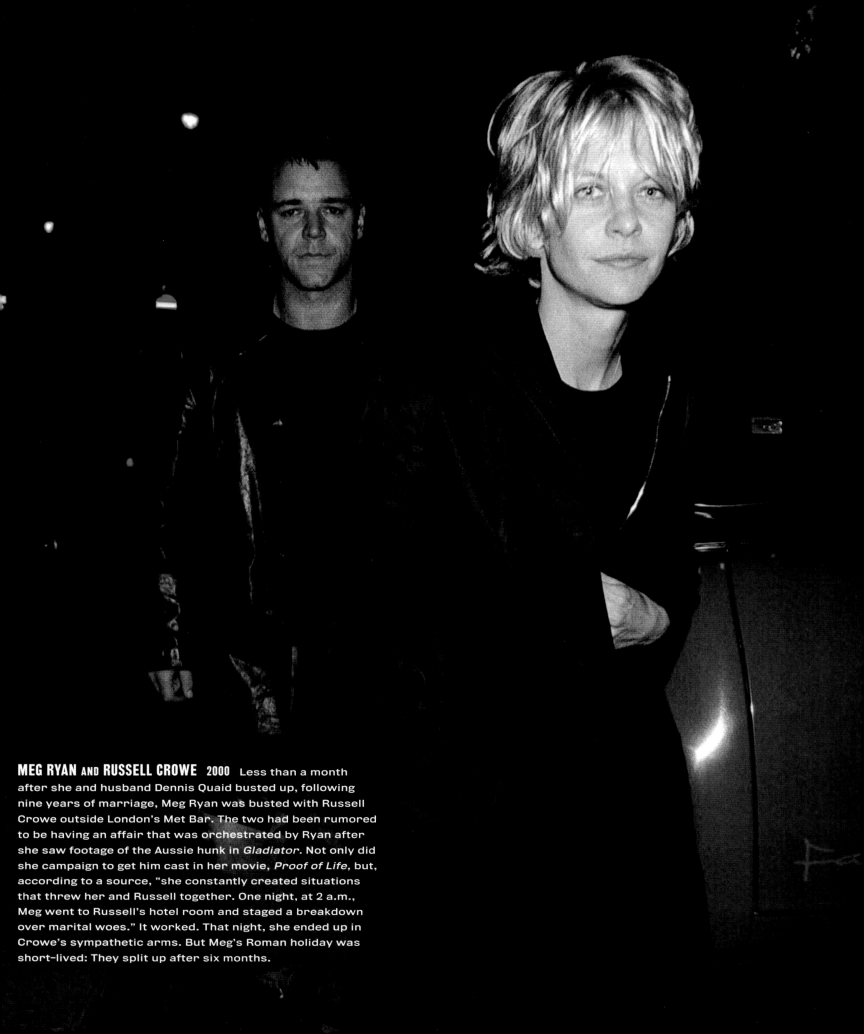

MEG RYAN AND **RUSSELL CROWE** 2000 Less than a month after she and husband Dennis Quaid busted up, following nine years of marriage, Meg Ryan was busted with Russell Crowe outside London's Met Bar. The two had been rumored to be having an affair that was orchestrated by Ryan after she saw footage of the Aussie hunk in *Gladiator*. Not only did she campaign to get him cast in her movie, *Proof of Life*, but, according to a source, "she constantly created situations that threw her and Russell together. One night, at 2 a.m., Meg went to Russell's hotel room and staged a breakdown over marital woes." It worked. That night, she ended up in Crowe's sympathetic arms. But Meg's Roman holiday was short-lived: They split up after six months.

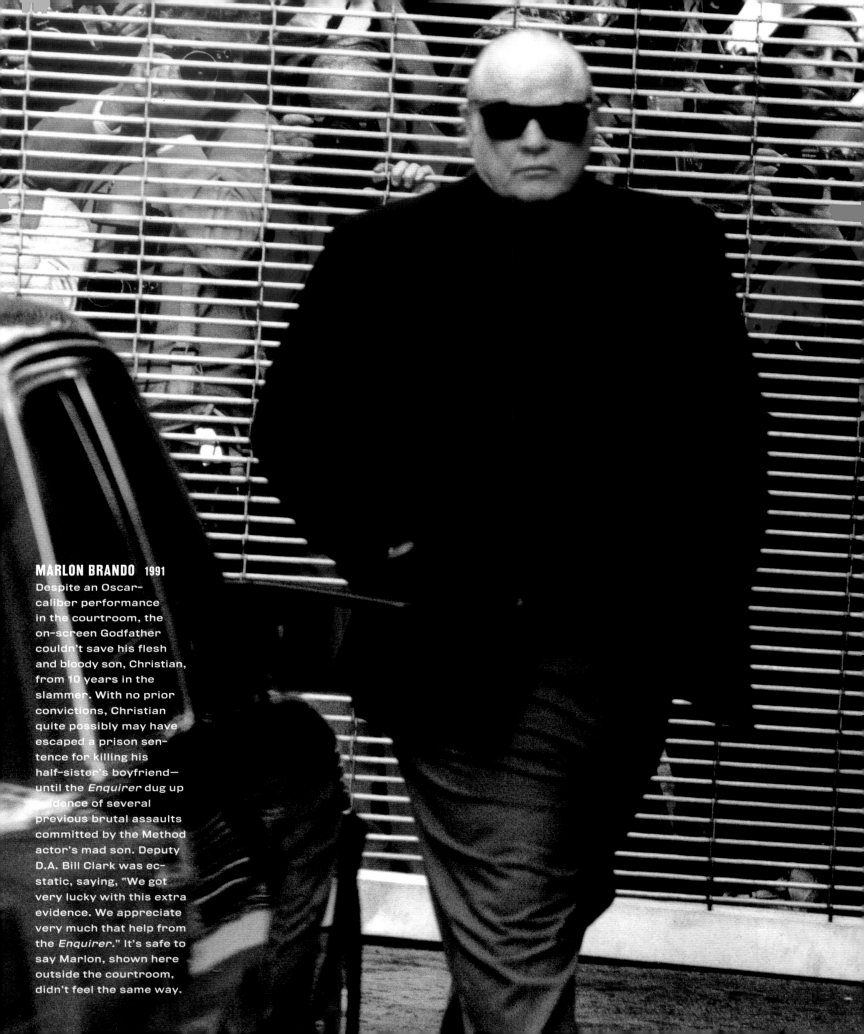

MARLON BRANDO 1991
Despite an Oscar-caliber performance in the courtroom, the on-screen Godfather couldn't save his flesh and bloody son, Christian, from 10 years in the slammer. With no prior convictions, Christian quite possibly may have escaped a prison sentence for killing his half-sister's boyfriend—until the *Enquirer* dug up evidence of several previous brutal assaults committed by the Method actor's mad son. Deputy D.A. Bill Clark was ecstatic, saying, "We got very lucky with this extra evidence. We appreciate very much that help from the *Enquirer*." It's safe to say Marlon, shown here outside the courtroom, didn't feel the same way.

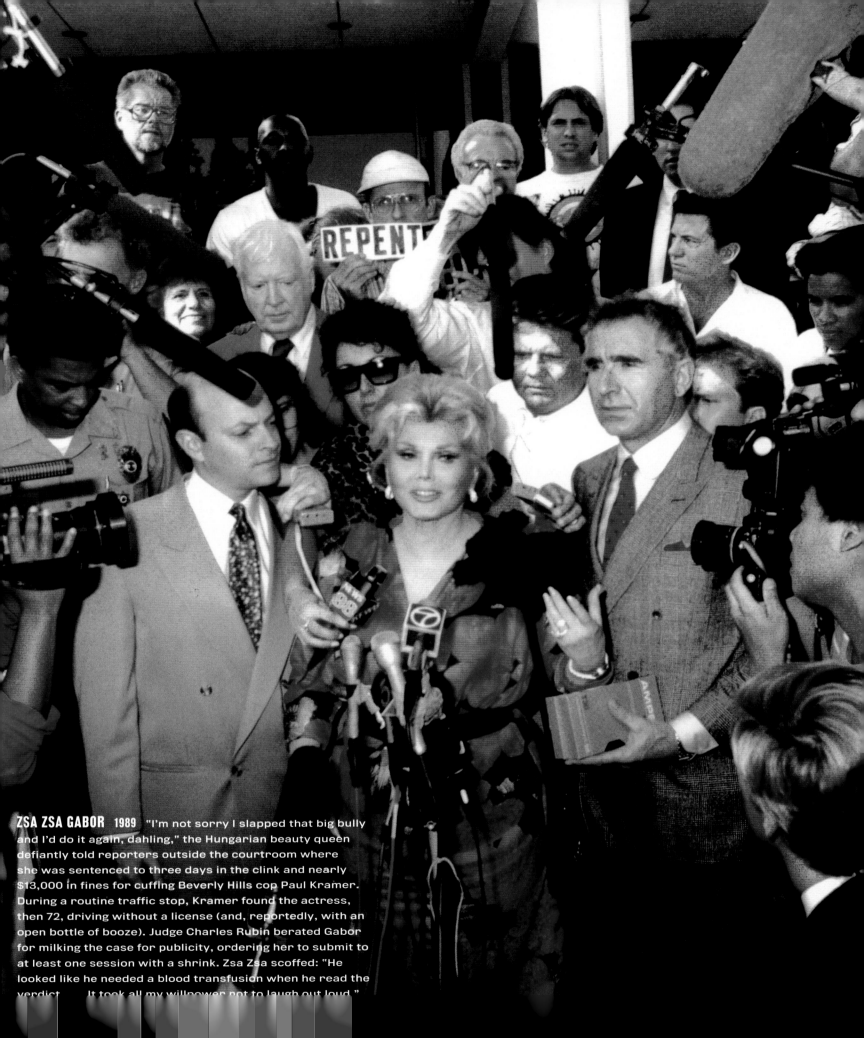

ZSA ZSA GABOR 1989 "I'm not sorry I slapped that big bully and I'd do it again, dahling," the Hungarian beauty queen defiantly told reporters outside the courtroom where she was sentenced to three days in the clink and nearly $13,000 in fines for cuffing Beverly Hills cop Paul Kramer. During a routine traffic stop, Kramer found the actress, then 72, driving without a license (and, reportedly, with an open bottle of booze). Judge Charles Rubin berated Gabor for milking the case for publicity, ordering her to submit to at least one session with a shrink. Zsa Zsa scoffed: "He looked like he needed a blood transfusion when he read the verdict. . . . It took all my willpower not to laugh out loud."

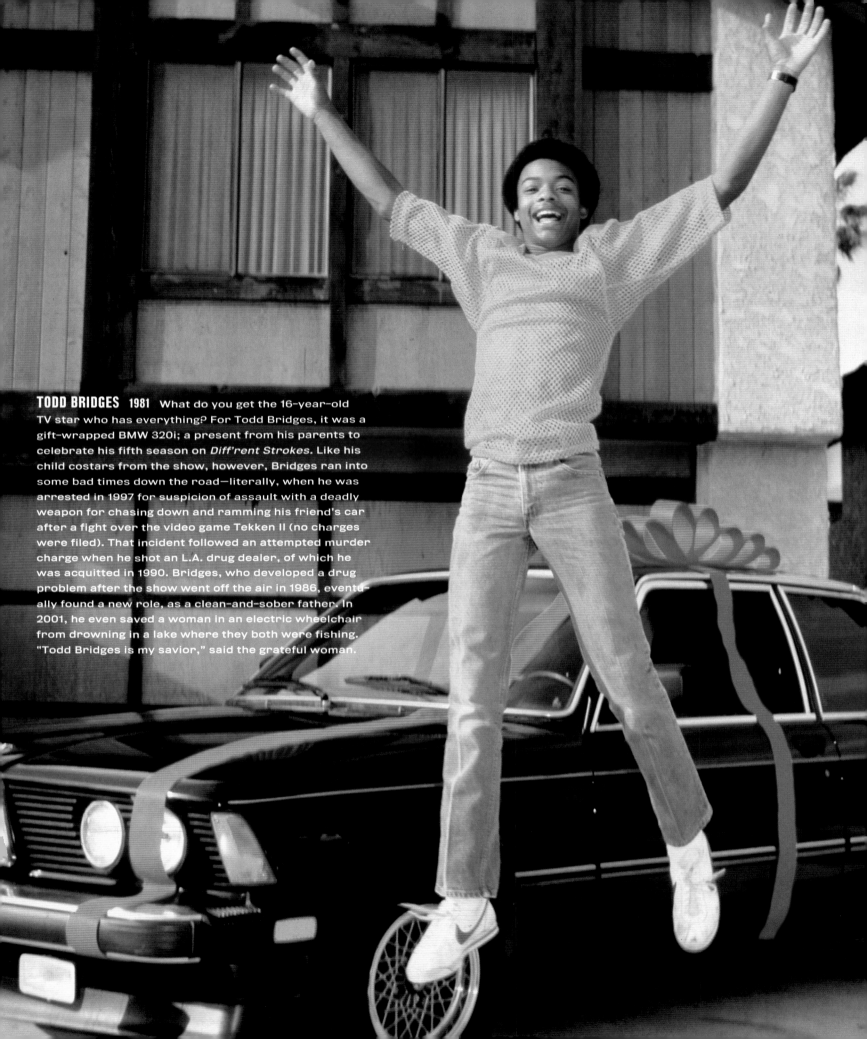

TODD BRIDGES **1981** What do you get the 16-year-old TV star who has everything? For Todd Bridges, it was a gift-wrapped BMW 320i; a present from his parents to celebrate his fifth season on *Diff'rent Strokes*. Like his child costars from the show, however, Bridges ran into some bad times down the road—literally, when he was arrested in 1997 for suspicion of assault with a deadly weapon for chasing down and ramming his friend's car after a fight over the video game Tekken II (no charges were filed). That incident followed an attempted murder charge when he shot an L.A. drug dealer, of which he was acquitted in 1990. Bridges, who developed a drug problem after the show went off the air in 1986, eventually found a new role, as a clean-and-sober father. In 2001, he even saved a woman in an electric wheelchair from drowning in a lake where they both were fishing. "Todd Bridges is my savior," said the grateful woman.

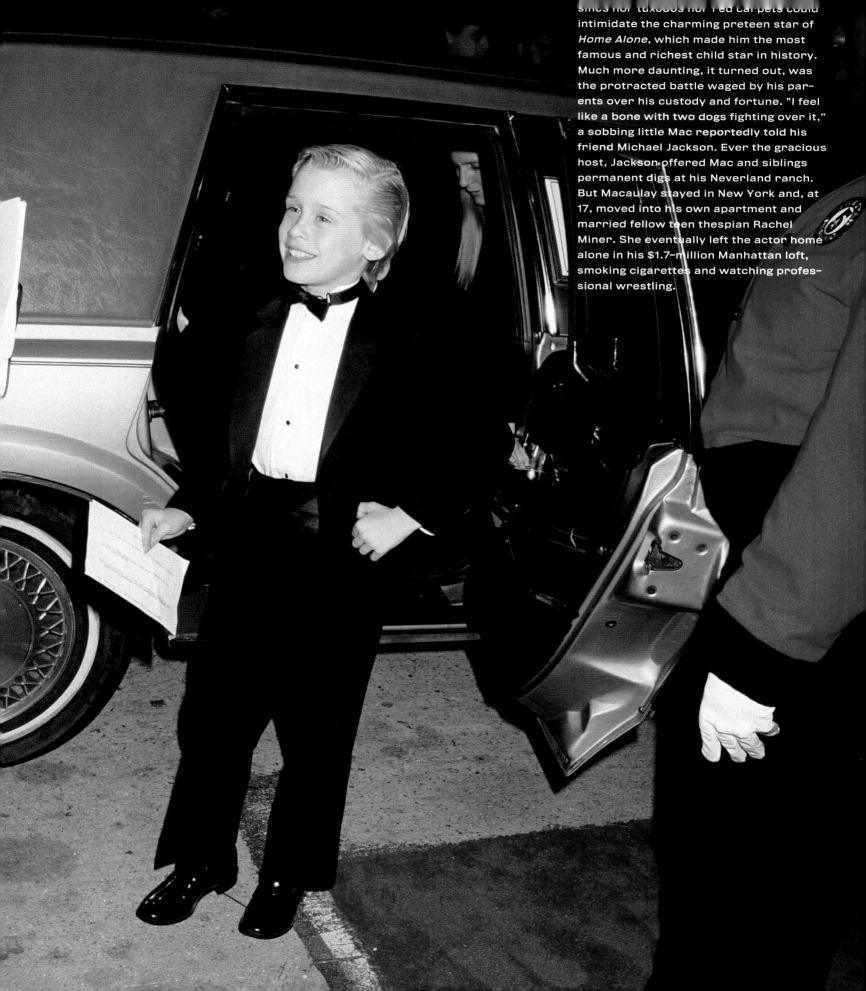

since nor tuxedos nor red carpets could intimidate the charming preteen star of *Home Alone*, which made him the most famous and richest child star in history. Much more daunting, it turned out, was the protracted battle waged by his parents over his custody and fortune. "I feel like a bone with two dogs fighting over it," a sobbing little Mac reportedly told his friend Michael Jackson. Ever the gracious host, Jackson offered Mac and siblings permanent digs at his Neverland ranch. But Macaulay stayed in New York and, at 17, moved into his own apartment and married fellow teen thespian Rachel Miner. She eventually left the actor home alone in his $1.7-million Manhattan loft, smoking cigarettes and watching professional wrestling.

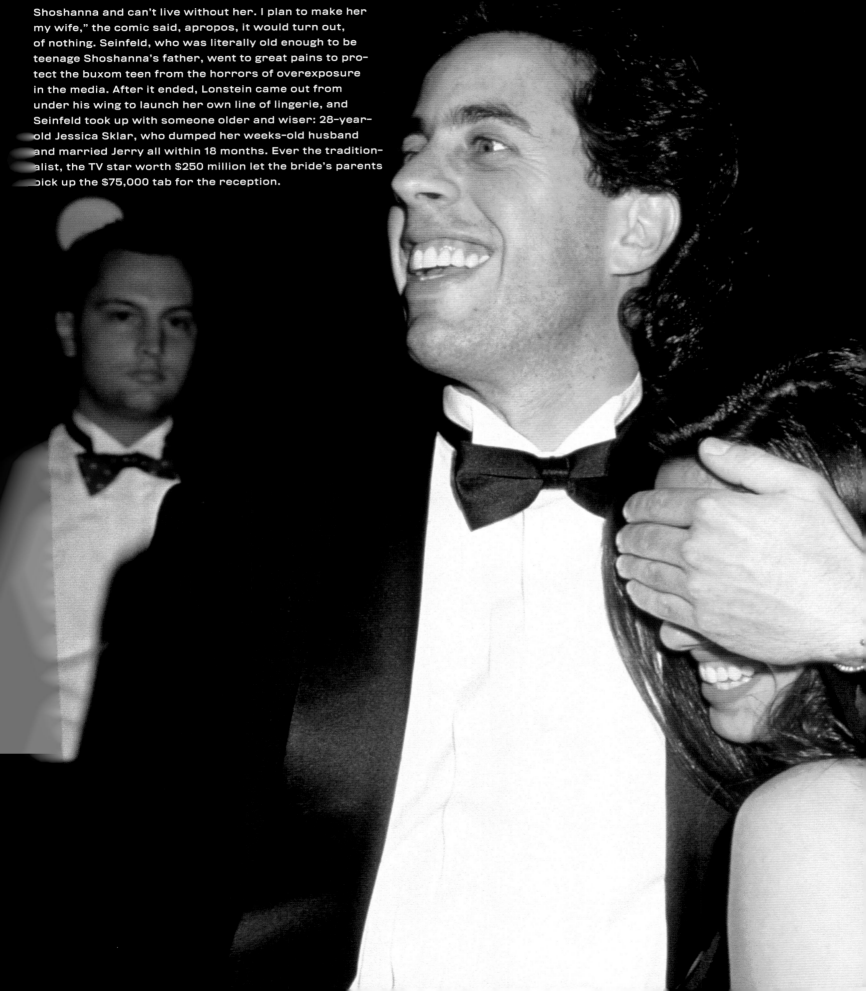

Shoshanna and can't live without her. I plan to make her my wife," the comic said, apropos, it would turn out, of nothing. Seinfeld, who was literally old enough to be teenage Shoshanna's father, went to great pains to protect the buxom teen from the horrors of overexposure in the media. After it ended, Lonstein came out from under his wing to launch her own line of lingerie, and Seinfeld took up with someone older and wiser: 28-year-old Jessica Sklar, who dumped her weeks-old husband and married Jerry all within 18 months. Ever the traditionalist, the TV star worth $250 million let the bride's parents pick up the $75,000 tab for the reception.

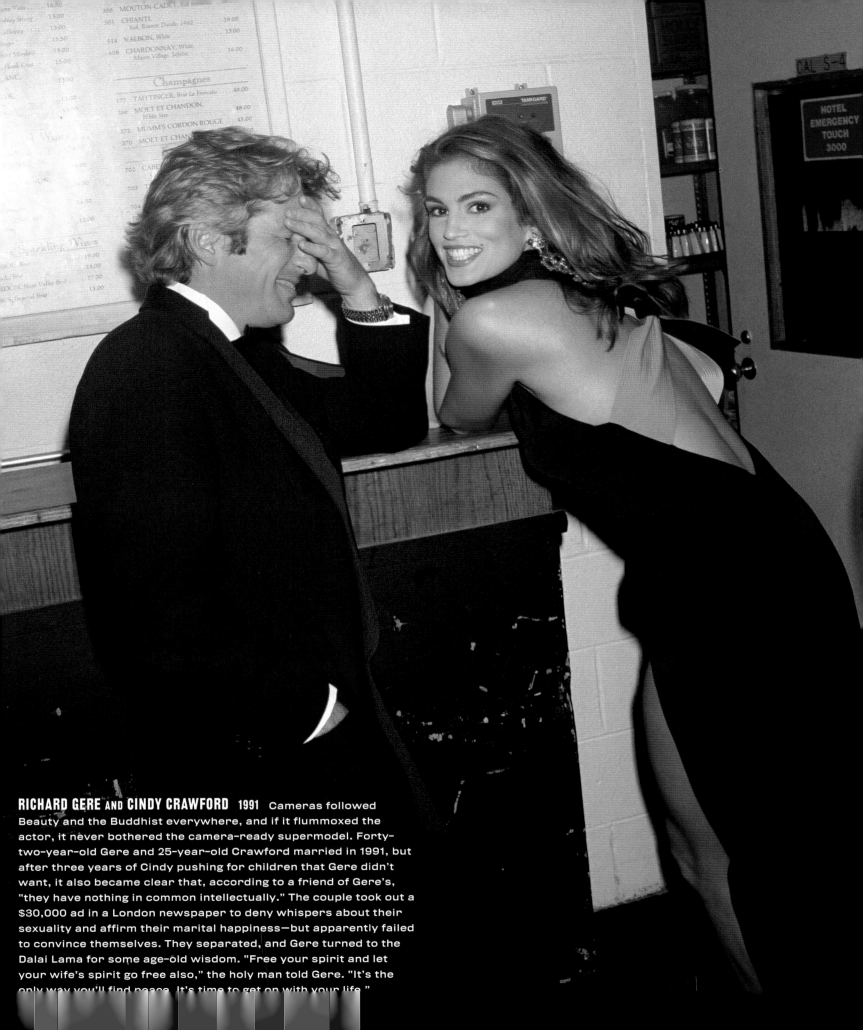

RICHARD GERE and **CINDY CRAWFORD** 1991 Cameras followed Beauty and the Buddhist everywhere, and if it flummoxed the actor, it never bothered the camera-ready supermodel. Forty-two-year-old Gere and 25-year-old Crawford married in 1991, but after three years of Cindy pushing for children that Gere didn't want, it also became clear that, according to a friend of Gere's, "they have nothing in common intellectually." The couple took out a $30,000 ad in a London newspaper to deny whispers about their sexuality and affirm their marital happiness—but apparently failed to convince themselves. They separated, and Gere turned to the Dalai Lama for some age-old wisdom. "Free your spirit and let your wife's spirit go free also," the holy man told Gere. "It's the only way you'll find peace. It's time to get on with your life."

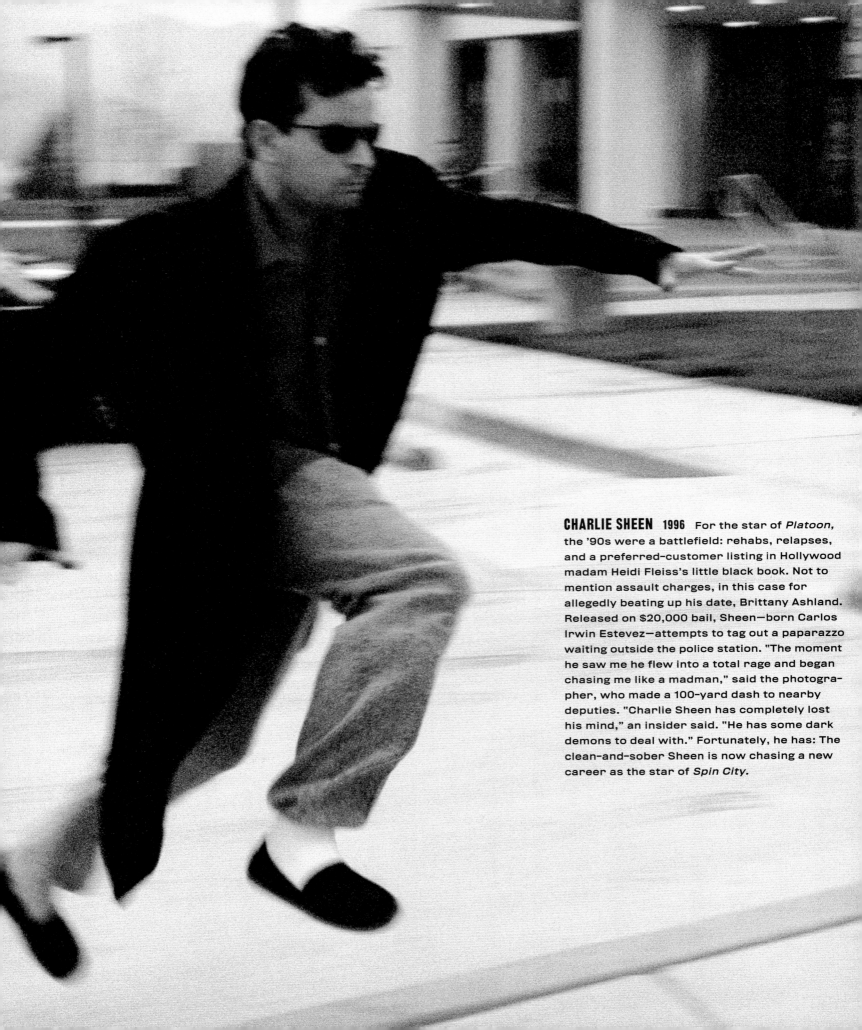

CHARLIE SHEEN 1996 For the star of *Platoon,* the '90s were a battlefield: rehabs, relapses, and a preferred-customer listing in Hollywood madam Heidi Fleiss's little black book. Not to mention assault charges, in this case for allegedly beating up his date, Brittany Ashland. Released on $20,000 bail, Sheen—born Carlos Irwin Estevez—attempts to tag out a paparazzo waiting outside the police station. "The moment he saw me he flew into a total rage and began chasing me like a madman," said the photographer, who made a 100-yard dash to nearby deputies. "Charlie Sheen has completely lost his mind," an insider said. "He has some dark demons to deal with." Fortunately, he has: The clean-and-sober Sheen is now chasing a new career as the star of *Spin City.*

MARKIE POST 1993 The barbarians weren't just at the White House gate; they had already barged through it. "We made it! We're in the White House now!" shouted the 43-year-old star of *Night Court,* snapped with TV producer Linda Bloodworth-Thomason in this unseemly celebration of Clinton's inauguration. After breaking bread with the Clintons, Post—who during her White House visit reportedly enjoyed "closed-door meetings" with Bill and also helped hook him up with Hollywood hair-and-makeup artists—joined Bloodworth-Thomason in the historic Lincoln bedroom. "Bill went to his room to change clothes," said a Washington insider, "Markie made a beeline for the Lincoln bedroom . . . [and] began jumping up and down on the bed like a wild child."

PAULA JONES 1998 "I was terrified . . . all those lights, the table, the equipment,"
said Paula Jones, referring not to her grand jury testimony in her sexual harassment
suit against President Clinton, but to the operating room where she had her prodi-
gious proboscis downsized so that it wouldn't catch so much of the spotlight. Five
days after her nose job, holed up in a hotel room waiting for the bruising to fade, Jones
financed the operation with $9,000 provided by a mystery donor. "For the first time
in my life I had a normal, natural nose. It'll be a little swollen for the next six months,
but it was well worth the pain," Jones said. "Before, people always used to stop and
grill me about being 'the Paula Jones.' Now I go out and nobody knows me."

CHUCK NORRIS 1998

The 58-year-old TV tough guy drops to one knee to reenact one of his smoothest moves, proposing marriage to model-actress Gena O'Kelley. "I had my hair up in a ponytail," the future bride blushed, recalling the impromptu betrothal. "He half-sat on my lap and told me, 'I've been . . . waiting for the right romantic time, but we don't seem to have those, so I'll ask you now—will you marry me?'" The 35-year-old blonde beauty met the bearded martial-arts actor through his best friend and later won a part on his show, *Walker, Texas Ranger,* not to mention a big chunk of the he-man's heart. Not long after, "Walker" walked her down the aisle.

152

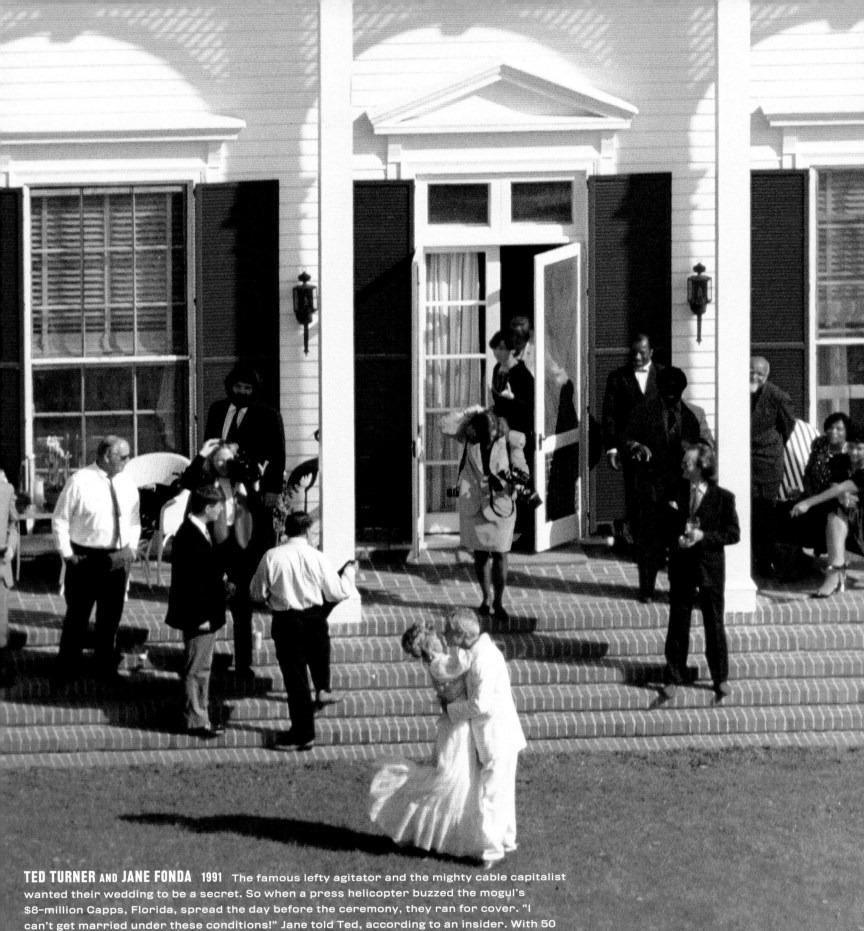

TED TURNER AND **JANE FONDA** 1991 The famous lefty agitator and the mighty cable capitalist wanted their wedding to be a secret. So when a press helicopter buzzed the mogul's $8-million Capps, Florida, spread the day before the ceremony, they ran for cover. "I can't get married under these conditions!" Jane told Ted, according to an insider. With 50 guests in attendance, the ceremony was hastily moved from a local chapel to Turner's plantation. However, it was all to no avail, and the bride, who wore off-white and was given away by her 18-year-old son, even waved to the photographers hovering overhead. "This is the third marriage for both of us," she said, "but this one is going to work." In April 2001, however, Fonda filed one last protest—against Turner, in her petition for divorce.

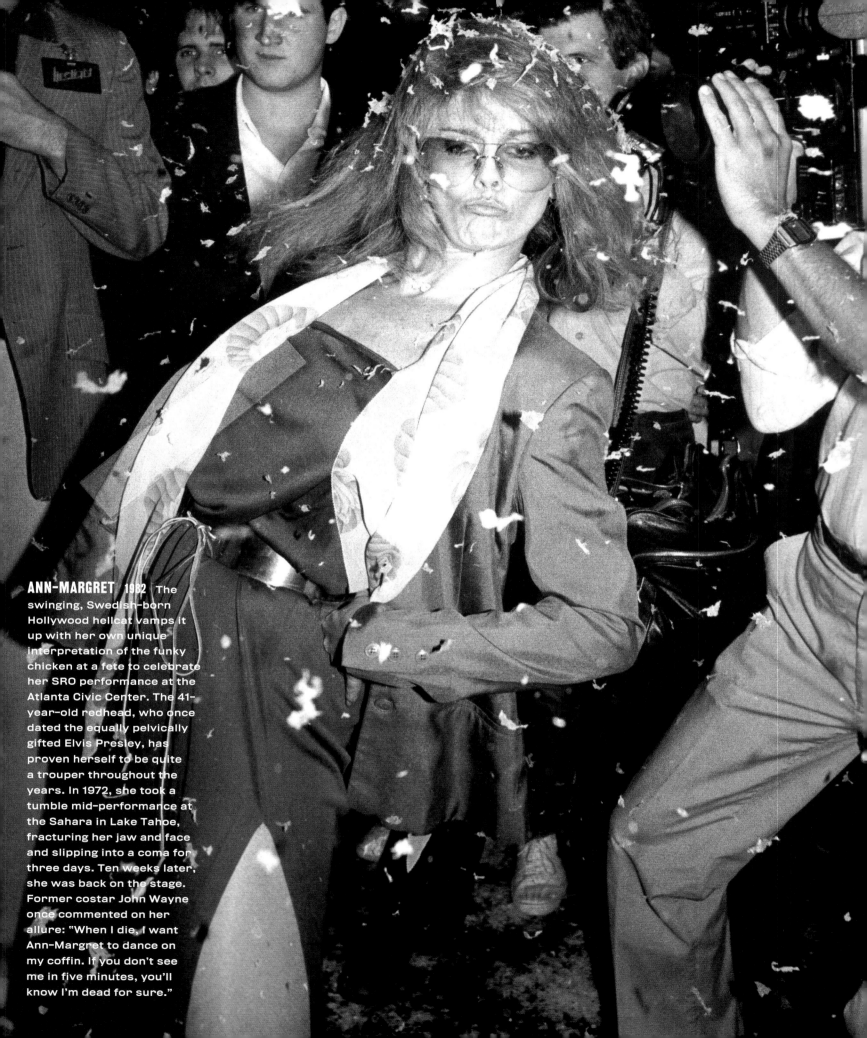

ANN-MARGRET 1982 The swinging, Swedish-born Hollywood hellcat vamps it up with her own unique interpretation of the funky chicken at a fete to celebrate her SRO performance at the Atlanta Civic Center. The 41-year-old redhead, who once dated the equally pelvically gifted Elvis Presley, has proven herself to be quite a trouper throughout the years. In 1972, she took a tumble mid-performance at the Sahara in Lake Tahoe, fracturing her jaw and face and slipping into a coma for three days. Ten weeks later, she was back on the stage. Former costar John Wayne once commented on her allure: "When I die, I want Ann-Margret to dance on my coffin. If you don't see me in five minutes, you'll know I'm dead for sure."

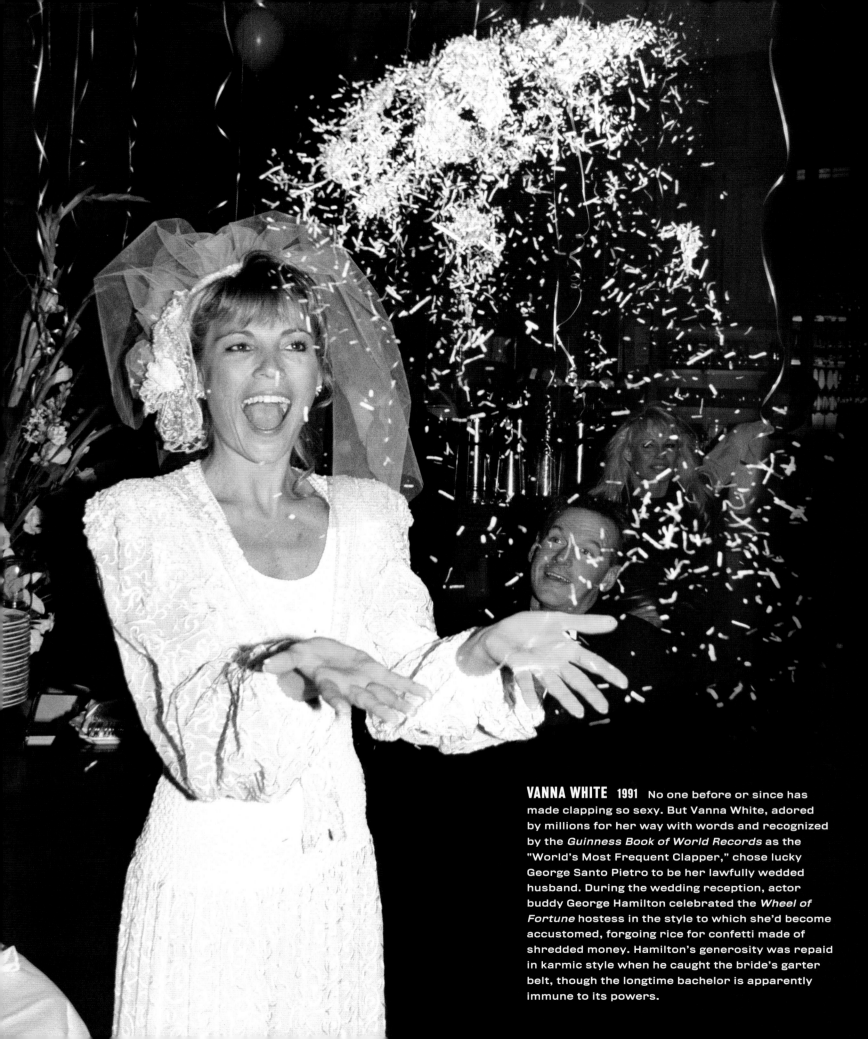

VANNA WHITE 1991 No one before or since has made clapping so sexy. But Vanna White, adored by millions for her way with words and recognized by the *Guinness Book of World Records* as the "World's Most Frequent Clapper," chose lucky George Santo Pietro to be her lawfully wedded husband. During the wedding reception, actor buddy George Hamilton celebrated the *Wheel of Fortune* hostess in the style to which she'd become accustomed, forgoing rice for confetti made of shredded money. Hamilton's generosity was repaid in karmic style when he caught the bride's garter belt, though the longtime bachelor is apparently immune to its powers.

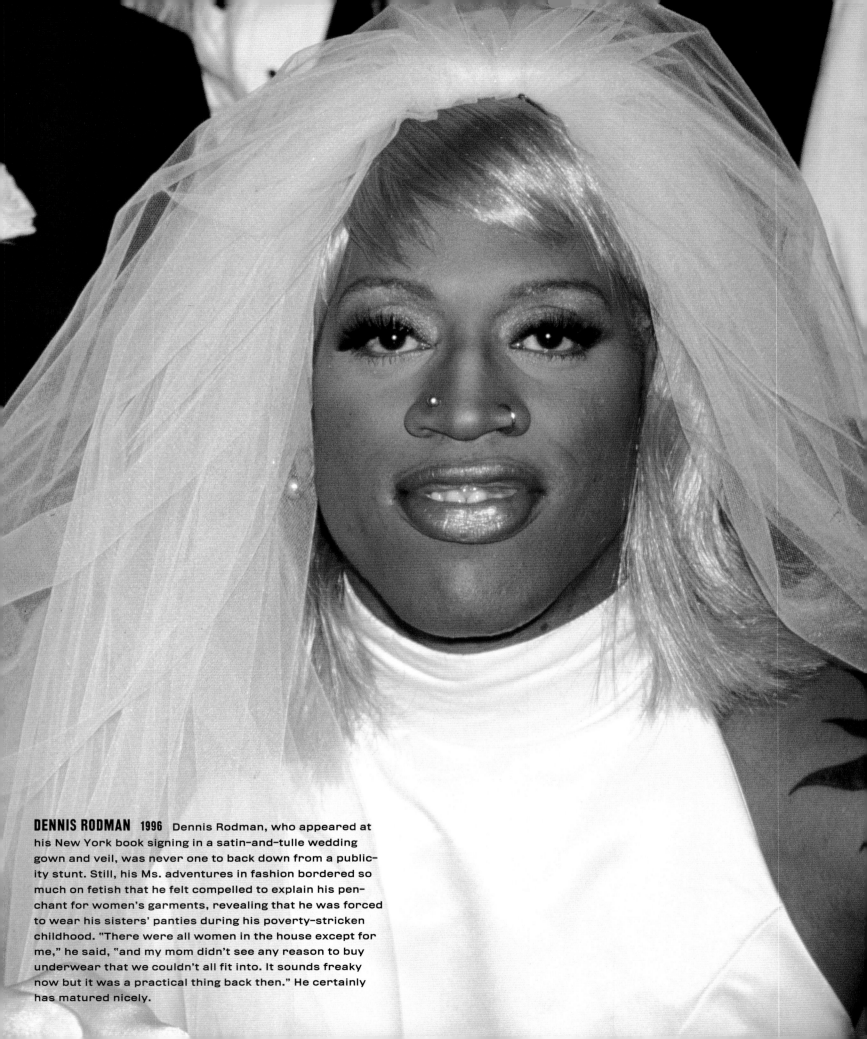

DENNIS RODMAN 1996 Dennis Rodman, who appeared at his New York book signing in a satin-and-tulle wedding gown and veil, was never one to back down from a publicity stunt. Still, his Ms. adventures in fashion bordered so much on fetish that he felt compelled to explain his penchant for women's garments, revealing that he was forced to wear his sisters' panties during his poverty-stricken childhood. "There were all women in the house except for me," he said, "and my mom didn't see any reason to buy underwear that we couldn't all fit into. It sounds freaky now but it was a practical thing back then." He certainly has matured nicely.

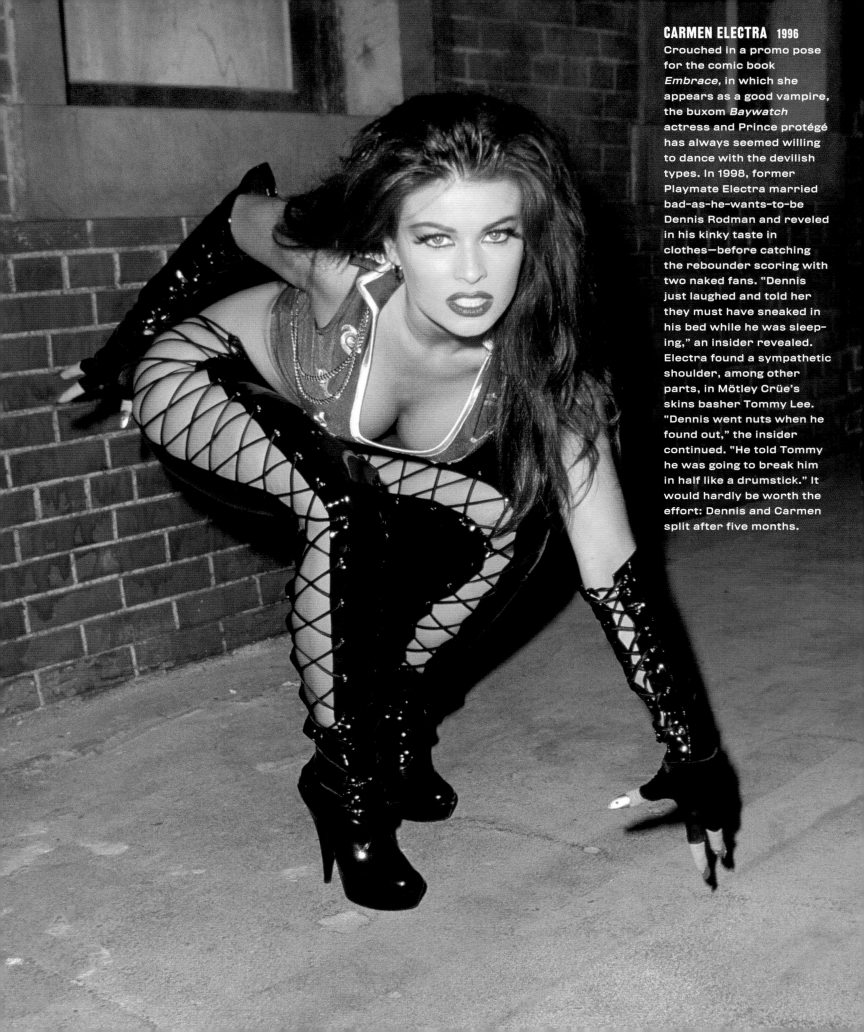

CARMEN ELECTRA 1996
Crouched in a promo pose for the comic book *Embrace*, in which she appears as a good vampire, the buxom *Baywatch* actress and Prince protégé has always seemed willing to dance with the devilish types. In 1998, former Playmate Electra married bad-as-he-wants-to-be Dennis Rodman and reveled in his kinky taste in clothes—before catching the rebounder scoring with two naked fans. "Dennis just laughed and told her they must have sneaked in his bed while he was sleeping," an insider revealed. Electra found a sympathetic shoulder, among other parts, in Mötley Crüe's skins basher Tommy Lee. "Dennis went nuts when he found out," the insider continued. "He told Tommy he was going to break him in half like a drumstick." It would hardly be worth the effort: Dennis and Carmen split after five months.

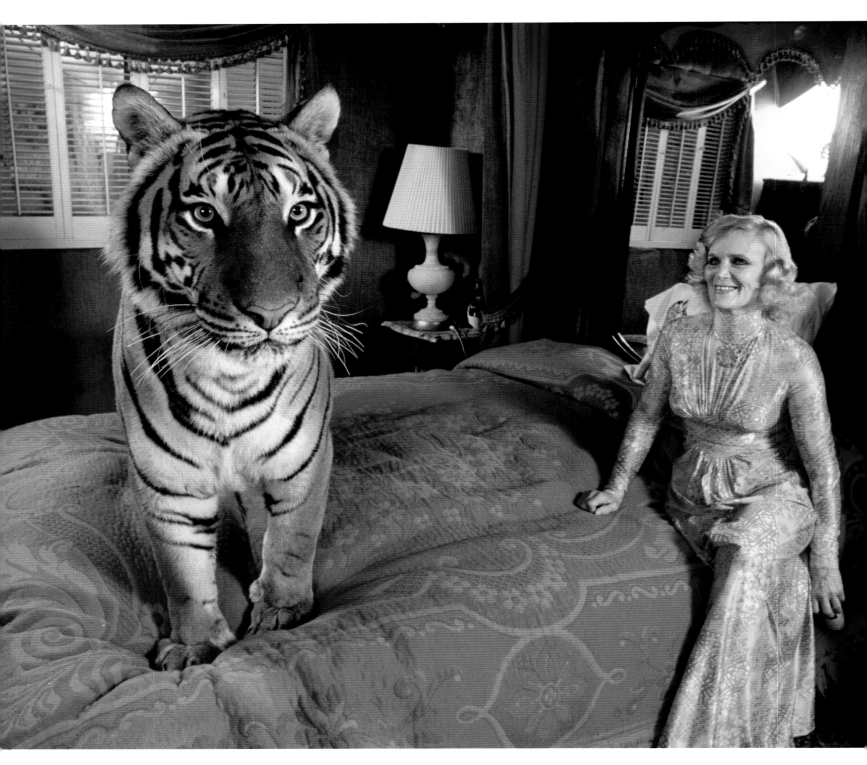

DEE ARLEN 1993 A lady in the parlor and a tiger in the boudoir: Babe, the 300-pound wild cat, has the run of the entire Dee Arlen household, and even gets along with the family dog. "We even sleep in the same bedroom. She's no different from a regular house cat," claimed the 62-year-old former actress, who was a regular on TV's *Truth or Consequences.* Perhaps a little different: When Babe escaped Arlen's Oregon compound, the city fathers took Dee to court to reimburse the town for a nine-day tiger hunt, a bill to the tune of more than $5,000.

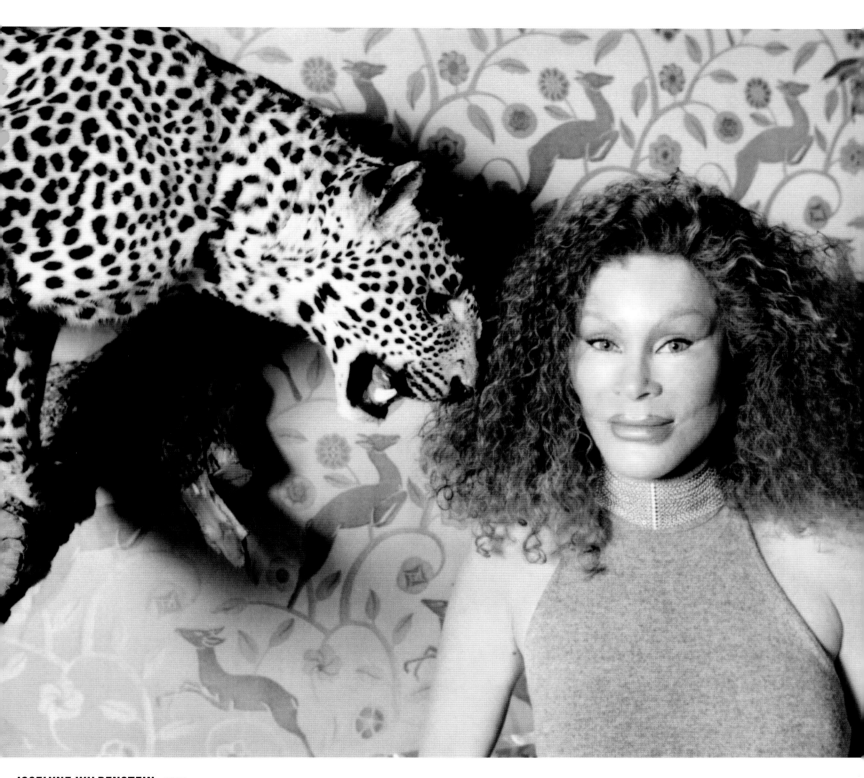

JOCELYNE WILDENSTEIN 1997 The 52-year-old wife of billionaire art dealer Alec Wildenstein shows the catastrophic results of a 10-year addiction to cosmetic surgery. After finding Mr. Wildenstein, 57, in bed with a 19-year-old model, the once-attractive Jocelyne tried to win him back by attempting to reconstruct herself as a younger woman with, bizarrely, distinctly feline features. Though she claimed to have had only one procedure, New York cosmetic surgeon Dr. Victor Rosenberg declared that it was all too obvious she'd had forehead, eye, and eyelid lifts; chin and cheek implants; a nose job; and lip augmentation. Although Jocelyne thought her facial renovation was purr-fect, during the ensuing divorce, her husband requested that photographers be banned from the courtroom to avoid embarrassing their two teenage children.

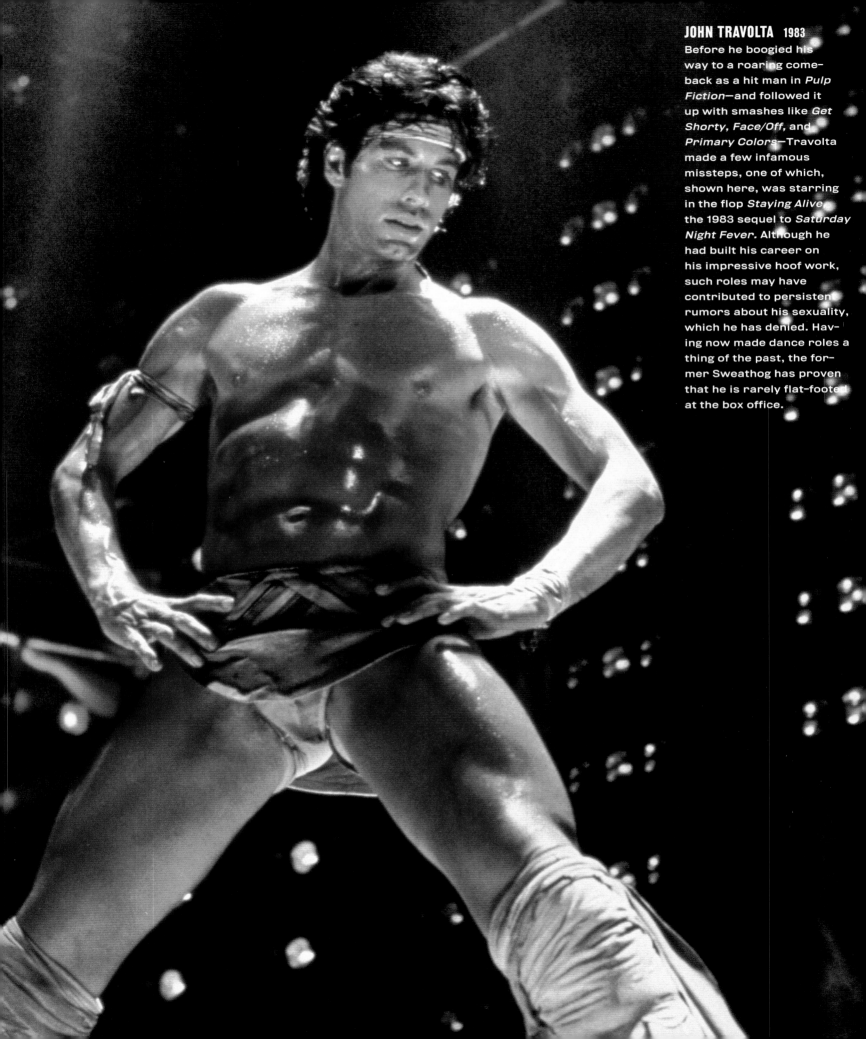

JOHN TRAVOLTA 1983
Before he boogied his way to a roaring comeback as a hit man in *Pulp Fiction*—and followed it up with smashes like *Get Shorty*, *Face/Off*, and *Primary Colors*—Travolta made a few infamous missteps, one of which, shown here, was starring in the flop *Staying Alive*, the 1983 sequel to *Saturday Night Fever*. Although he had built his career on his impressive hoof work, such roles may have contributed to persistent rumors about his sexuality, which he has denied. Having now made dance roles a thing of the past, the former Sweathog has proven that he is rarely flat-footed at the box office.

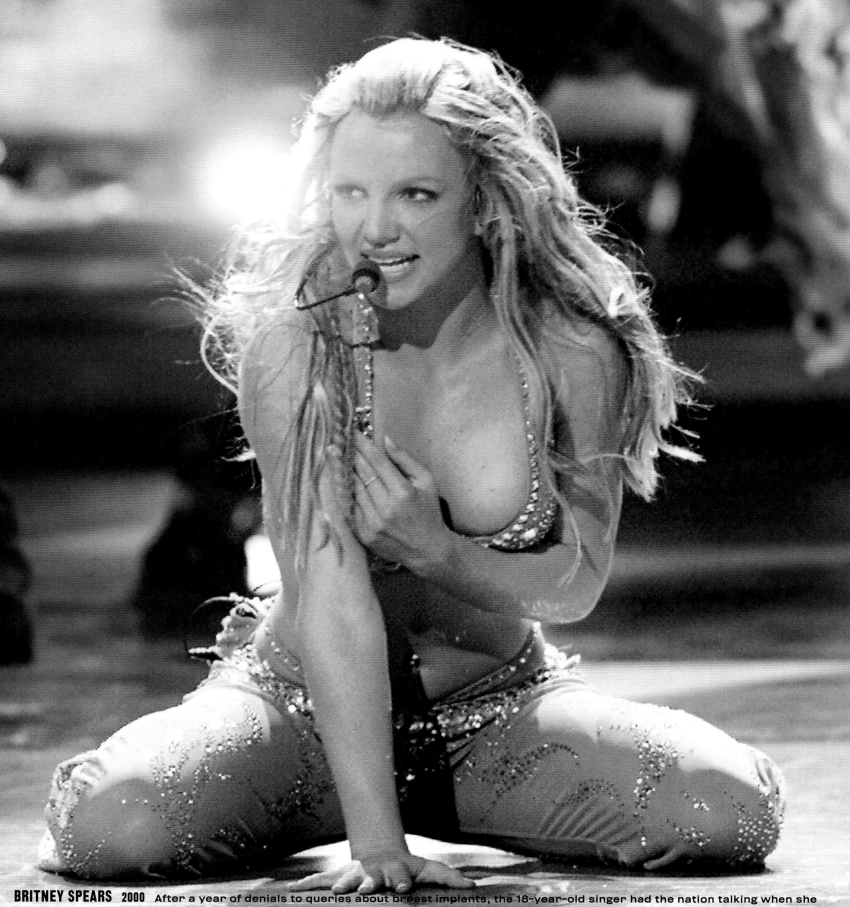

BRITNEY SPEARS 2000 After a year of denials to queries about breast implants, the 18-year-old singer had the nation talking when she stripped down and nearly bust out of her nearly nude bodysuit during the MTV Video Awards. Spears, who has built her success on the conflicting image of herself as a luscious sexpot with childlike innocence, belted out "Oops! . . . I Did It Again," though of course the virginal Spears has never done "it" at all. Nevertheless, this hasn't stopped the chaste teen pop tart from chasing Ben Affleck and Brad Pitt, and she was even politely asked to stop sending letters to Prince William. "If it's a title she's looking for," sniffed a Buckingham Palace insider, "perhaps she can hook up with Michael Jackson . . . the King of Pop." She finally settled for a prince of pop instead, 'N Sync's Justin Timberlake.

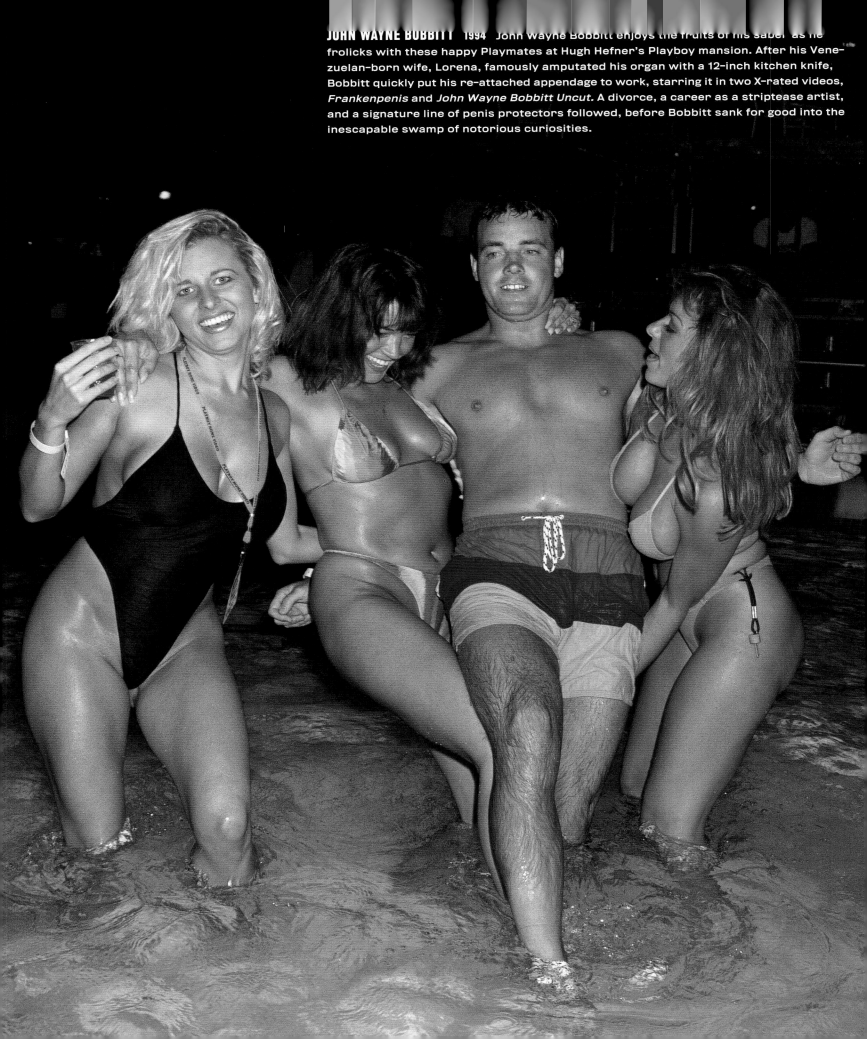

JOHN WAYNE BOBBITT 1994 John Wayne Bobbitt enjoys the fruits of his saber as he frolicks with these happy Playmates at Hugh Hefner's Playboy mansion. After his Venezuelan-born wife, Lorena, famously amputated his organ with a 12-inch kitchen knife, Bobbitt quickly put his re-attached appendage to work, starring it in two X-rated videos, *Frankenpenis* and *John Wayne Bobbitt Uncut.* A divorce, a career as a striptease artist, and a signature line of penis protectors followed, before Bobbitt sank for good into the inescapable swamp of notorious curiosities.

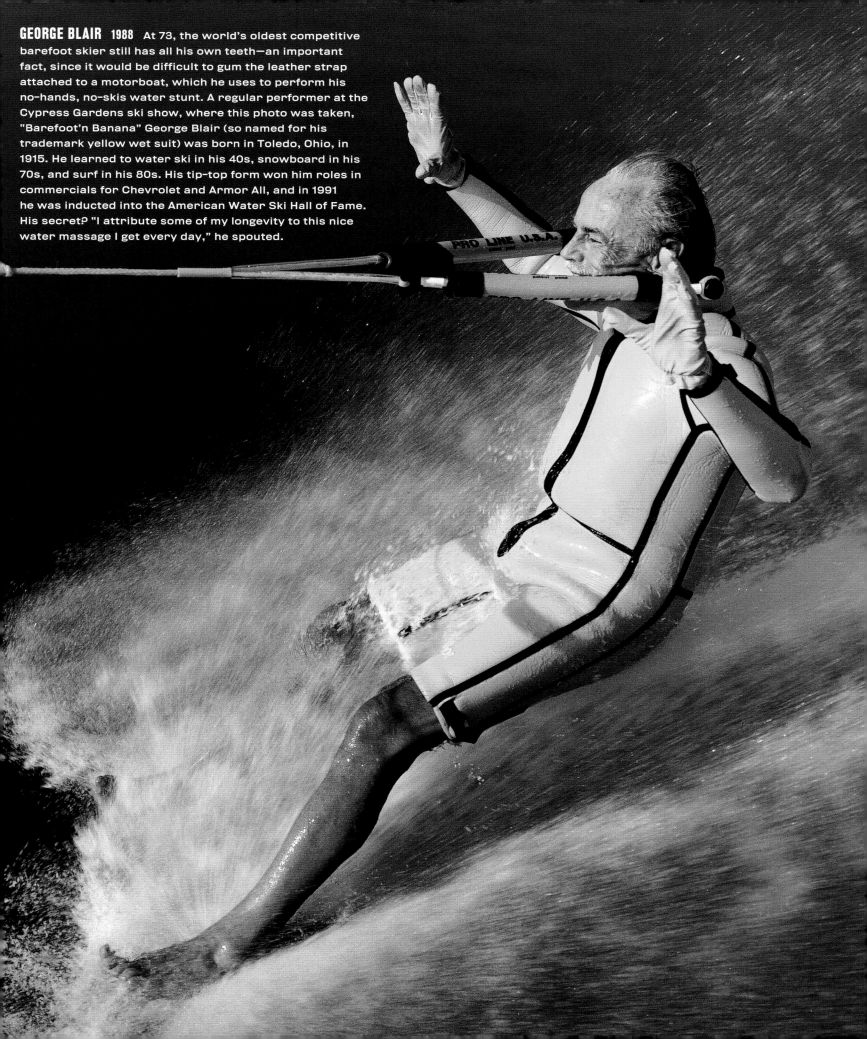

GEORGE BLAIR 1988 At 73, the world's oldest competitive barefoot skier still has all his own teeth—an important fact, since it would be difficult to gum the leather strap attached to a motorboat, which he uses to perform his no-hands, no-skis water stunt. A regular performer at the Cypress Gardens ski show, where this photo was taken, "Barefoot'n Banana" George Blair (so named for his trademark yellow wet suit) was born in Toledo, Ohio, in 1915. He learned to water ski in his 40s, snowboard in his 70s, and surf in his 80s. His tip-top form won him roles in commercials for Chevrolet and Armor All, and in 1991 he was inducted into the American Water Ski Hall of Fame. His secret? "I attribute some of my longevity to this nice water massage I get every day," he spouted.

PRINCE ALBERT **1999** The only son of Prince Rainier and the late Princess Grace Kelly, the never-been-married heir to the throne of Monaco has acquired a reputation as the randiest of royals, a confirmed bachelor who is as likely to be seen judging an Elite model contest in Paris as frolicking on the beaches of the Caribbean with a bevy of beautiful women. Taking full advantage of his lush perch on the ever-glamorous French Riviera, Prince Albert has earned the local nickname "The Prince of Partying." But living the life of a carefree playboy prince isn't as effortless as it looks—keeping absolutely all of the royal parts in good working order must be accomplished by any means necessary, as this shot of Albert in a Monaco gym reveals.

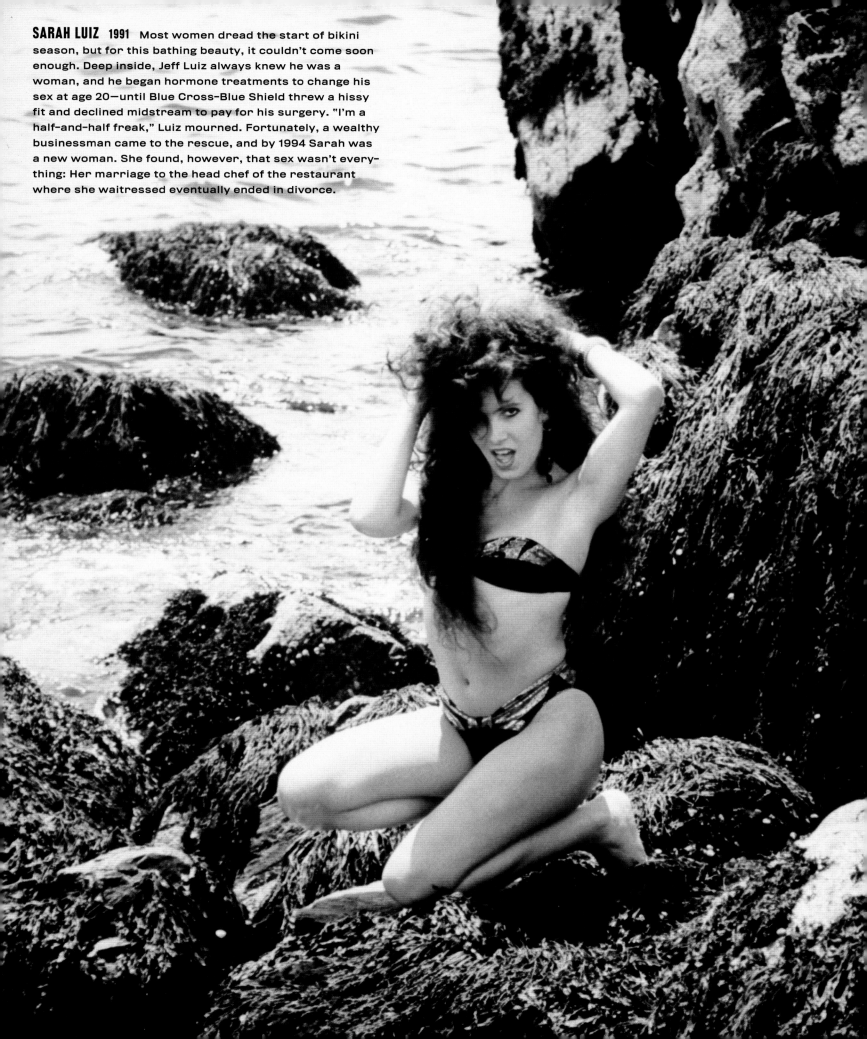

SARAH LUIZ **1991** Most women dread the start of bikini season, but for this bathing beauty, it couldn't come soon enough. Deep inside, Jeff Luiz always knew he was a woman, and he began hormone treatments to change his sex at age 20—until Blue Cross-Blue Shield threw a hissy fit and declined midstream to pay for his surgery. "I'm a half-and-half freak," Luiz mourned. Fortunately, a wealthy businessman came to the rescue, and by 1994 Sarah was a new woman. She found, however, that sex wasn't every-thing: Her marriage to the head chef of the restaurant where she waitressed eventually ended in divorce.

WILLIAM SHATNER 1988

William Shatner, who never shied from plunging into relationships with alien women, was uncharacteristically nervous on his first date with Vigga, his 3-ton costar on the quickly forgotten cable TV series *The Voice of the Planet.* "I was shaking when I went into the pool," he said. "She dived like a great black-and-white submarine and came shooting back out of the water, tons of surging whale rocketing over my head." However, the alluring orca soon worked her charms on the enterprising actor-director-author-singer: When it was over, an exhilarated Shatner sealed the deal with a kiss. "It was with real love and gratitude," he said. The humpback from *Star Trek IV: The Voyage Home* could not be reached for comment.

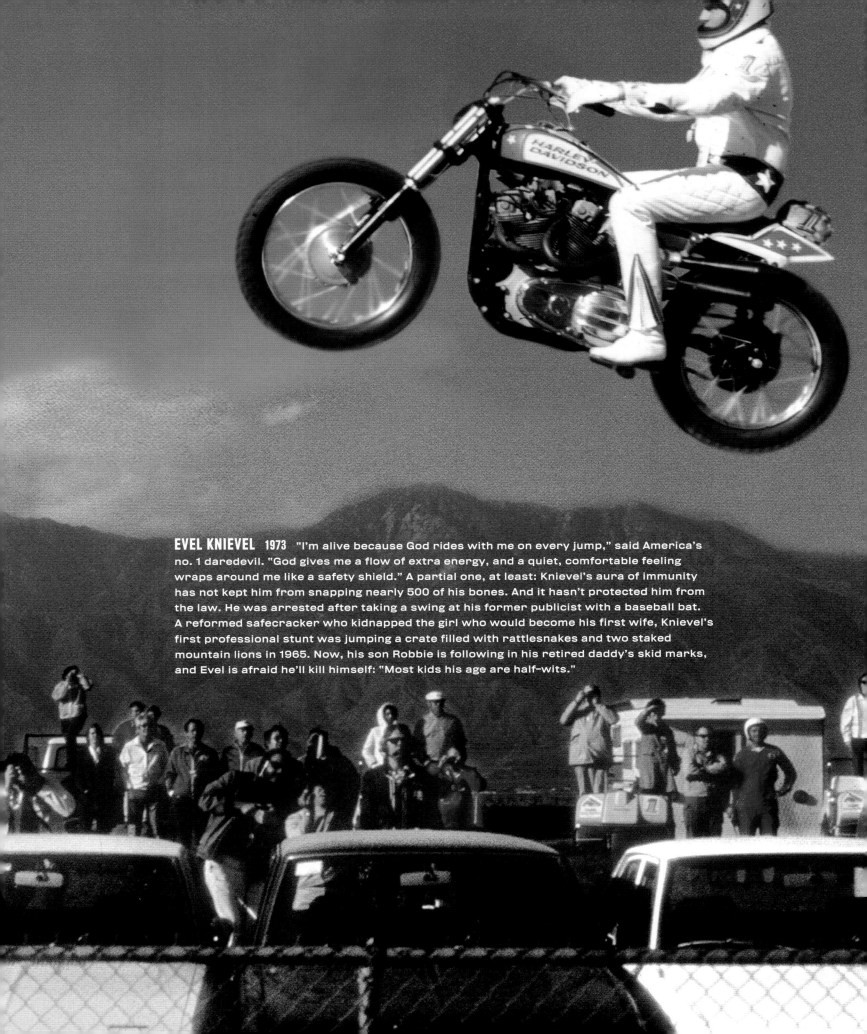

EVEL KNIEVEL 1973 "I'm alive because God rides with me on every jump," said America's no. 1 daredevil. "God gives me a flow of extra energy, and a quiet, comfortable feeling wraps around me like a safety shield." A partial one, at least: Knievel's aura of immunity has not kept him from snapping nearly 500 of his bones. And it hasn't protected him from the law. He was arrested after taking a swing at his former publicist with a baseball bat. A reformed safecracker who kidnapped the girl who would become his first wife, Knievel's first professional stunt was jumping a crate filled with rattlesnakes and two staked mountain lions in 1965. Now, his son Robbie is following in his retired daddy's skid marks, and Evel is afraid he'll kill himself: "Most kids his age are half-wits."

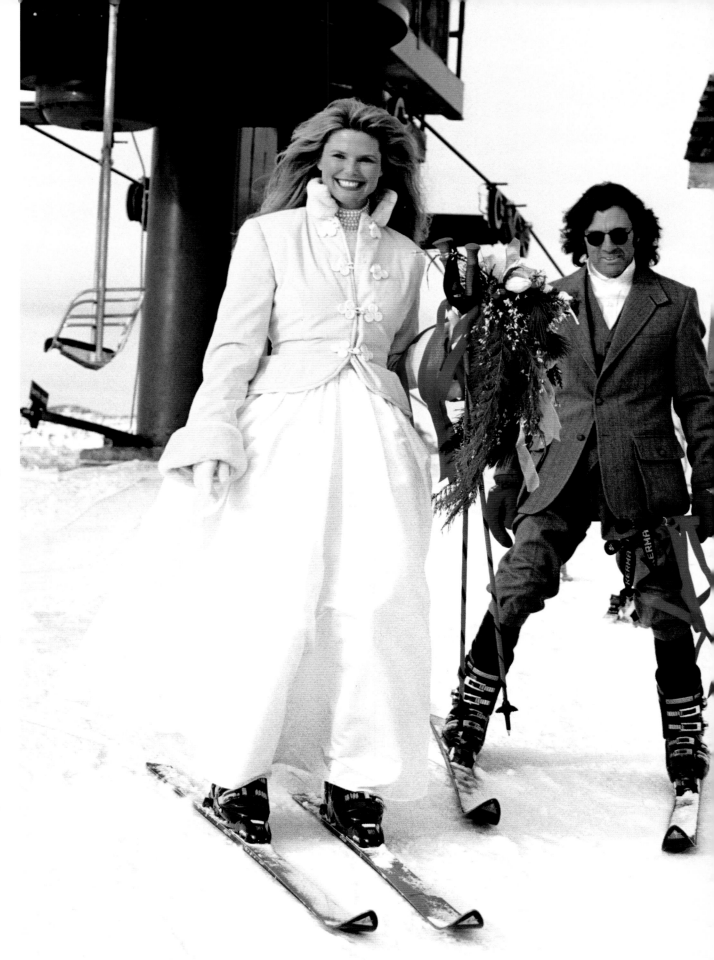

CHRISTIE BRINKLEY AND RICKY TAUBMAN 1994 After the end of her marriage to Billy Joel, the uptown girl's love life takes a downhill turn for the better as she marries real-estate developer Ricky Taubman on a Colorado ski mountain. Several months earlier, the couple spent a day on another Colorado mountainside—trapped for nine hours, along with other people, after a terrifying helicopter crash. Although they survived with only minor injuries, the same would not be true of their union. Christie dumped her new husband seven months after they wed, realizing that she had gotten married on a mogul but not to one—a cash-strapped Taubman, it turned out, had to rely on her to pay the bills.

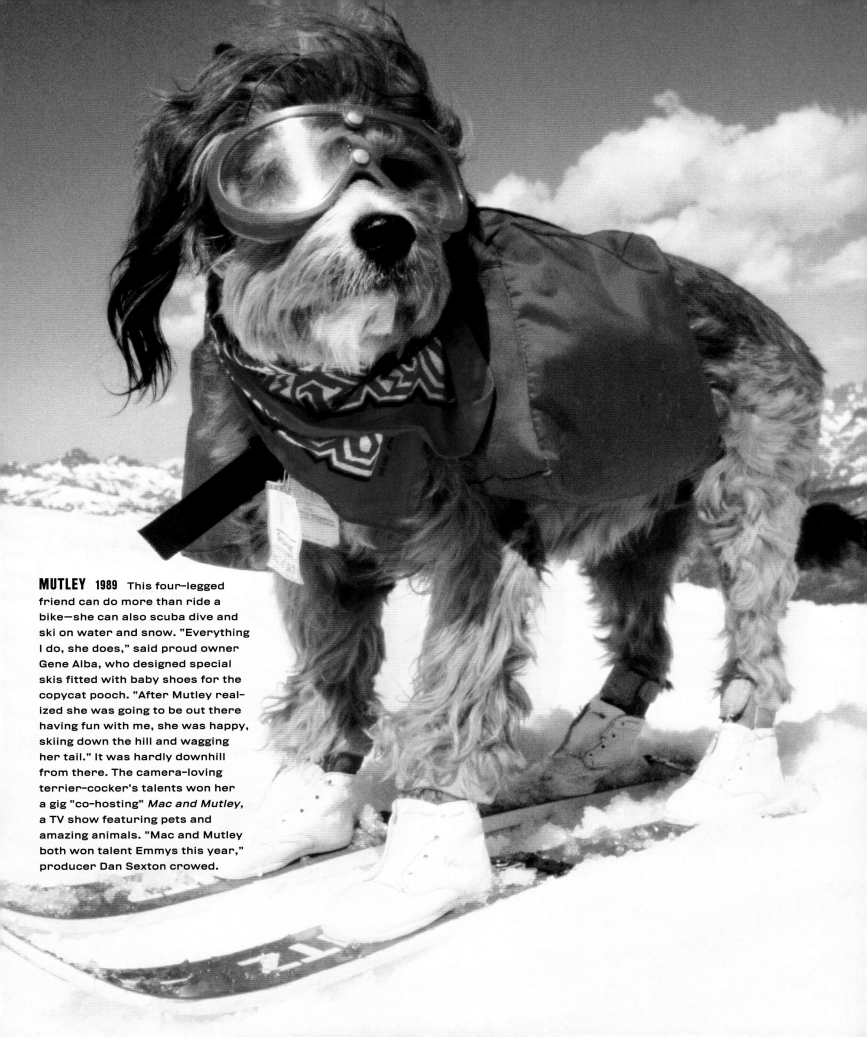

MUTLEY 1989 This four-legged friend can do more than ride a bike—she can also scuba dive and ski on water and snow. "Everything I do, she does," said proud owner Gene Alba, who designed special skis fitted with baby shoes for the copycat pooch. "After Mutley realized she was going to be out there having fun with me, she was happy, skiing down the hill and wagging her tail." It was hardly downhill from there. The camera-loving terrier-cocker's talents won her a gig "co-hosting" *Mac and Mutley*, a TV show featuring pets and amazing animals. "Mac and Mutley both won talent Emmys this year," producer Dan Sexton crowed.

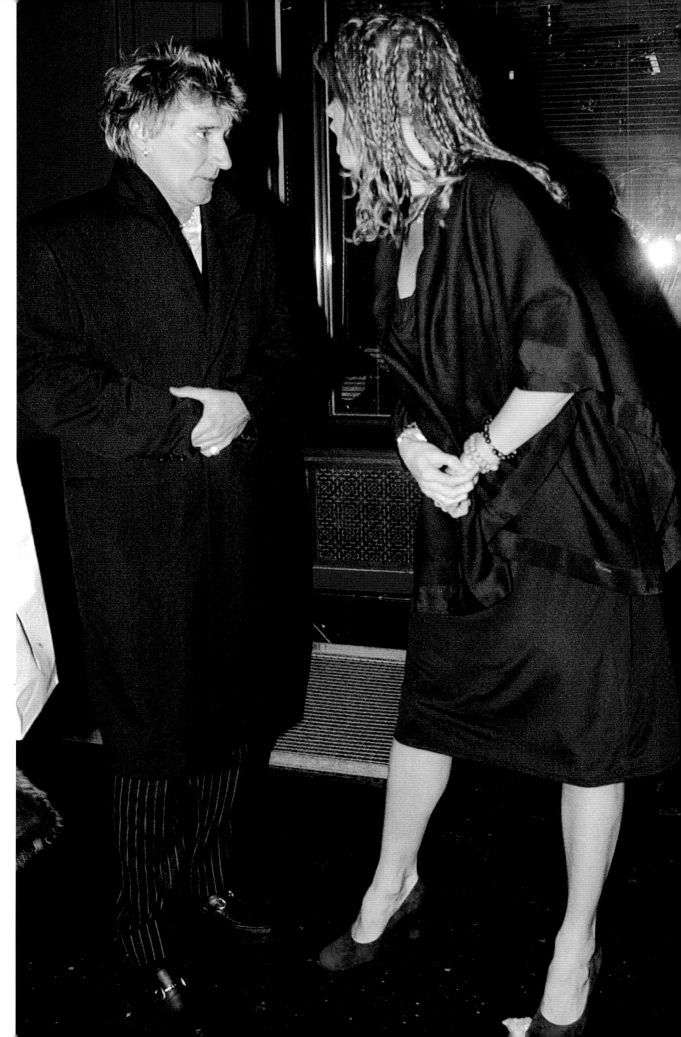

ROD STEWART AND RACHEL HUNTER 1999

The rooster-haired English rock star and soccer nut gets kicked to the curb by his towering New Zealand missus, who dragged him out of the London restaurant where Stewart had just dared to openly flirt with another woman during their anniversary dinner. After eight years of marriage, Stewart was devastated when Hunter initiated divorce proceedings, and vowed to do anything to win her back. "If she needs time alone, I can respect that. I'm willing to go into therapy," he told a friend. "If Rachel doesn't come back, I'm going to fall apart." She didn't, and ever since, Stewart has apparently been trying to find a woman who measures up to Hunter.

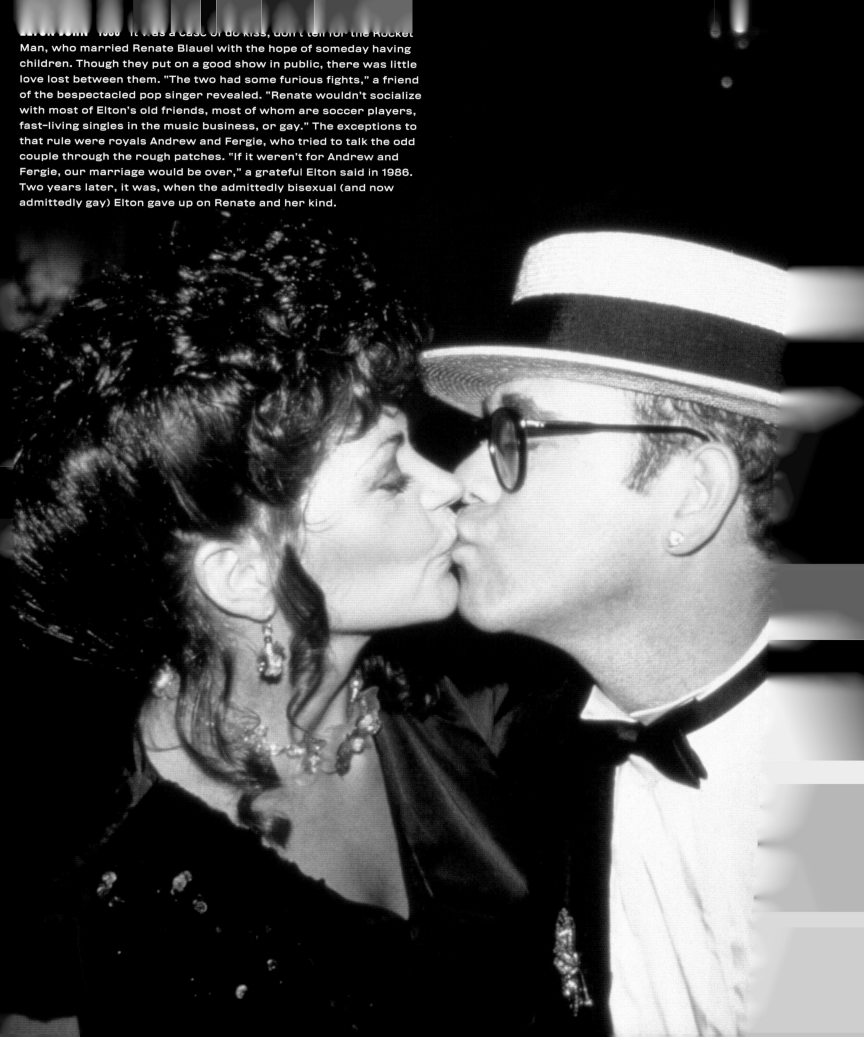

ELTON JOHN 1986 It was a case of do kiss, don't tell for the Rocket Man, who married Renate Blauel with the hope of someday having children. Though they put on a good show in public, there was little love lost between them. "The two had some furious fights," a friend of the bespectacled pop singer revealed. "Renate wouldn't socialize with most of Elton's old friends, most of whom are soccer players, fast-living singles in the music business, or gay." The exceptions to that rule were royals Andrew and Fergie, who tried to talk the odd couple through the rough patches. "If it weren't for Andrew and Fergie, our marriage would be over," a grateful Elton said in 1986. Two years later, it was, when the admittedly bisexual (and now admittedly gay) Elton gave up on Renate and her kind.

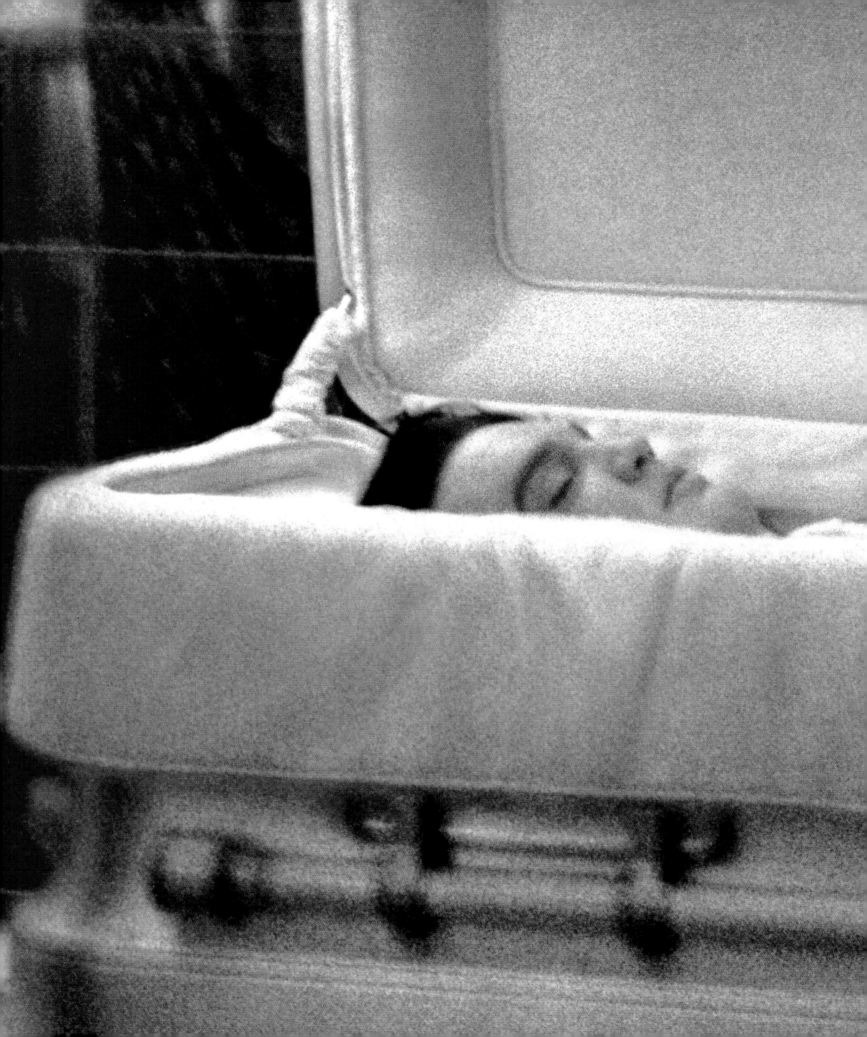

ELVIS PRESLEY 1977 The *Enquirer* put itself on the national map for the first time when it scored this photo—in its biggest selling issue ever—of Elvis in his copper coffin in the music room of Graceland. Snapped by a willing relative who was supplied with an Instamatic camera, the picture was considered so sensational that a senior editor and a security guard were detailed to accompany it at all times. Indeed, even after the picture ran, it was still a hot enough property to tempt a traitorous staffer into trying to sell it to another paper—he was busted in a sting and fired along with two other employees.

PHIL AND BRYNN HARTMAN 1998

Brynn Hartman, shown here with a smile that disguised her habit of mixing Zoloft with booze and coke, would soon end the life of *Saturday Night Live* and *NewsRadio* star Phil Hartman with a bullet to the head on May 28. Brynn then drove to the home of ex-boyfriend Ron Douglas, where she dropped the gun and let him pick it up, leaving his prints on the murder weapon. When he returned with her to the Hartman home, she locked him in a room with her husband's corpse and went off to get another gun. He phoned 911. Fortunately, the Hartmans' 9-year-old son Sean unlocked the door and freed Douglas. When the police arrived, Brynn ended the ordeal the way it began, turning the gun on herself.

CHRIS FARLEY 1997 Chris Farley was fresh out of rehab and approaching 400 pounds when he was snapped partying with Luke Perry and Stephen Baldwin at a Planet Hollywood opening in Indianapolis. "We're all concerned that Chris is going to end up like Belushi: dead at 33 of an overdose or heart attack," said a friend. The prediction came true five months later, on December 18, when the 33-year-old giant of comedy collapsed in his 60th-floor Hancock Towers apartment in Chicago after a four-day binge. The prostitute who was with him said she thought he'd simply passed out when she left him lying on the floor. But that's where he stayed, until his brother John found him, clutching a rosary under the gaze of the sad-faced clown paintings on the wall.

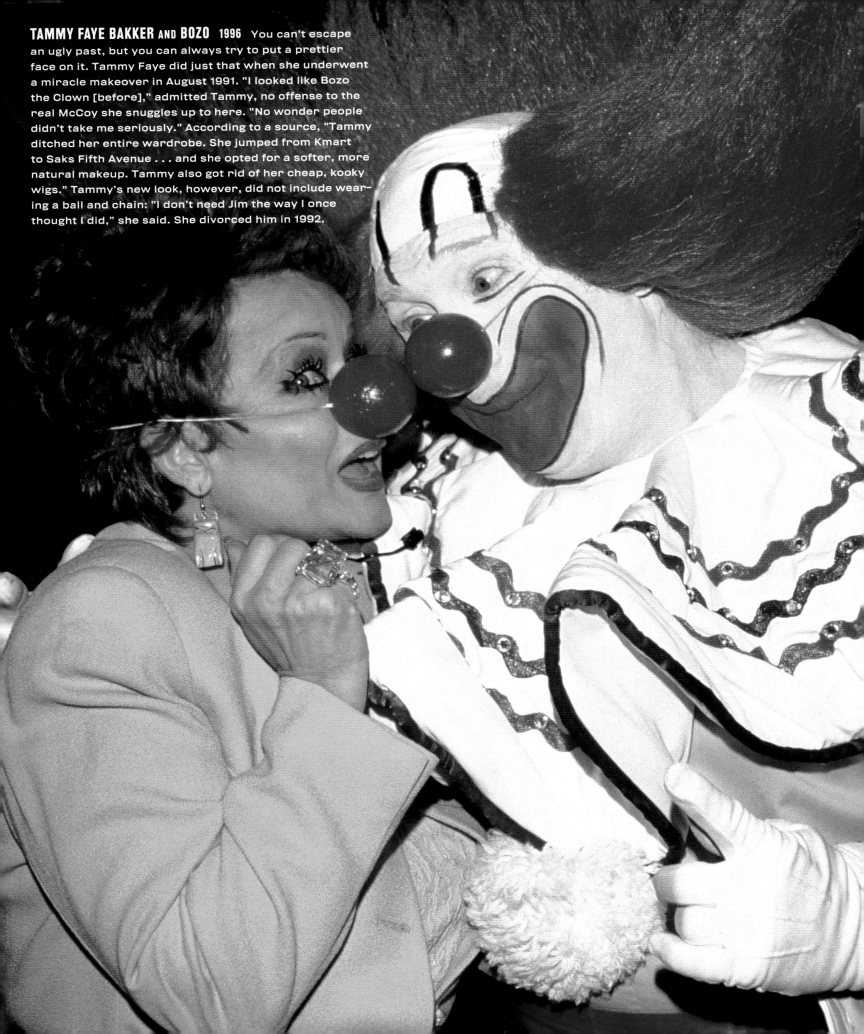

TAMMY FAYE BAKKER AND **BOZO** 1996 You can't escape an ugly past, but you can always try to put a prettier face on it. Tammy Faye did just that when she underwent a miracle makeover in August 1991. "I looked like Bozo the Clown [before]," admitted Tammy, no offense to the real McCoy she snuggles up to here. "No wonder people didn't take me seriously." According to a source, "Tammy ditched her entire wardrobe. She jumped from Kmart to Saks Fifth Avenue . . . and she opted for a softer, more natural makeup. Tammy also got rid of her cheap, kooky wigs." Tammy's new look, however, did not include wearing a ball and chain: "I don't need Jim the way I once thought I did," she said. She divorced him in 1992.

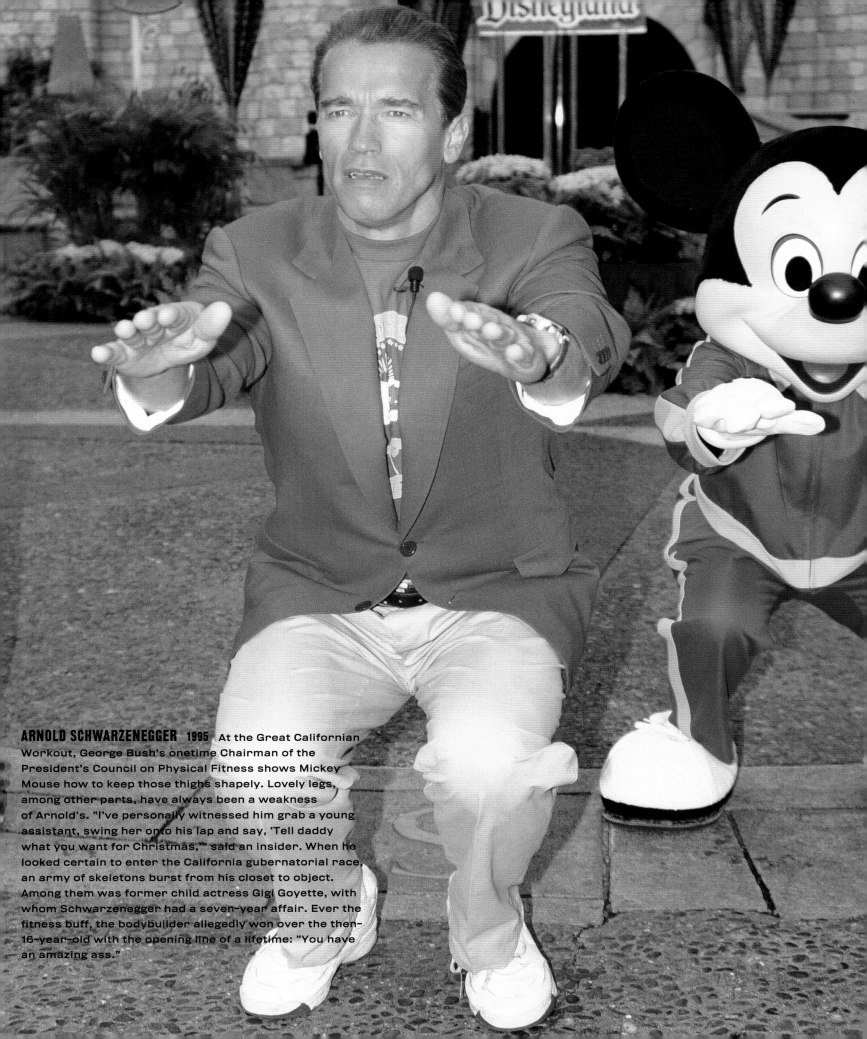

ARNOLD SCHWARZENEGGER 1995 At the Great Californian Workout, George Bush's onetime Chairman of the President's Council on Physical Fitness shows Mickey Mouse how to keep those thighs shapely. Lovely legs, among other parts, have always been a weakness of Arnold's. "I've personally witnessed him grab a young assistant, swing her onto his lap and say, 'Tell daddy what you want for Christmas,'" said an insider. When he looked certain to enter the California gubernatorial race, an army of skeletons burst from his closet to object. Among them was former child actress Gigi Goyette, with whom Schwarzenegger had a seven-year affair. Ever the fitness buff, the bodybuilder allegedly won over the then-16-year-old with the opening line of a lifetime: "You have an amazing ass."

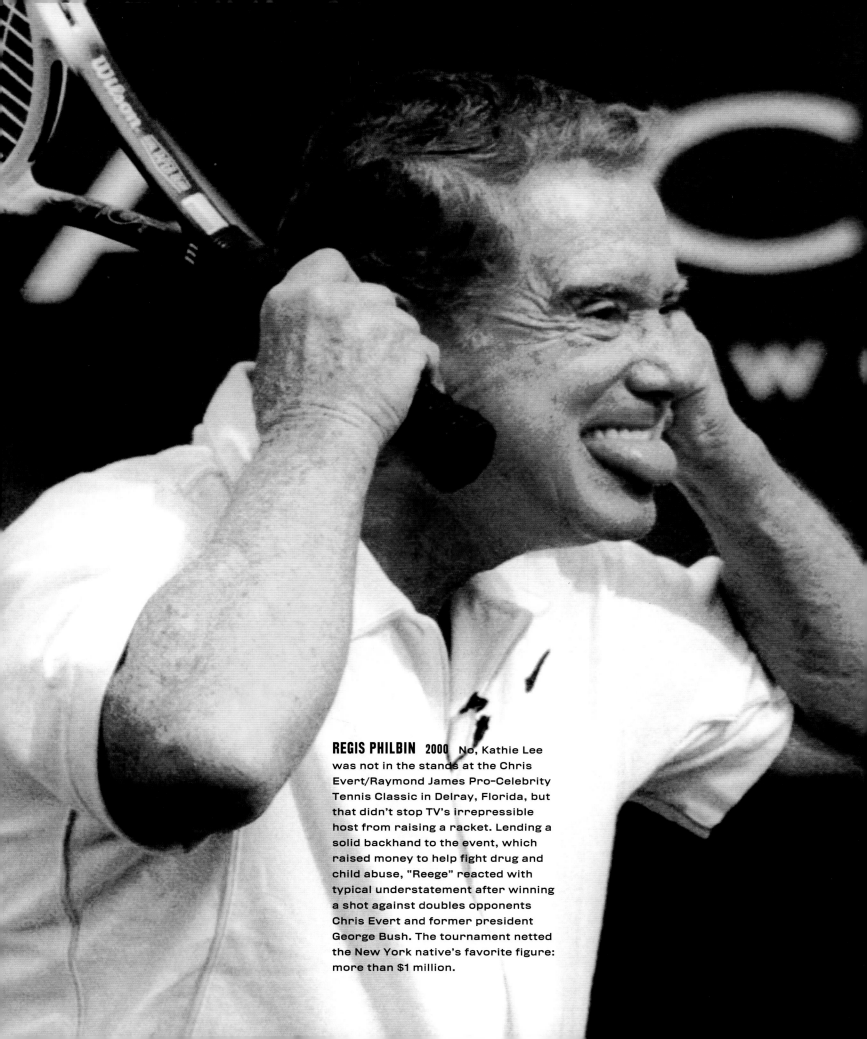

REGIS PHILBIN 2000 No, Kathie Lee was not in the stands at the Chris Evert/Raymond James Pro-Celebrity Tennis Classic in Delray, Florida, but that didn't stop TV's irrepressible host from raising a racket. Lending a solid backhand to the event, which raised money to help fight drug and child abuse, "Reege" reacted with typical understatement after winning a shot against doubles opponents Chris Evert and former president George Bush. The tournament netted the New York native's favorite figure: more than $1 million.

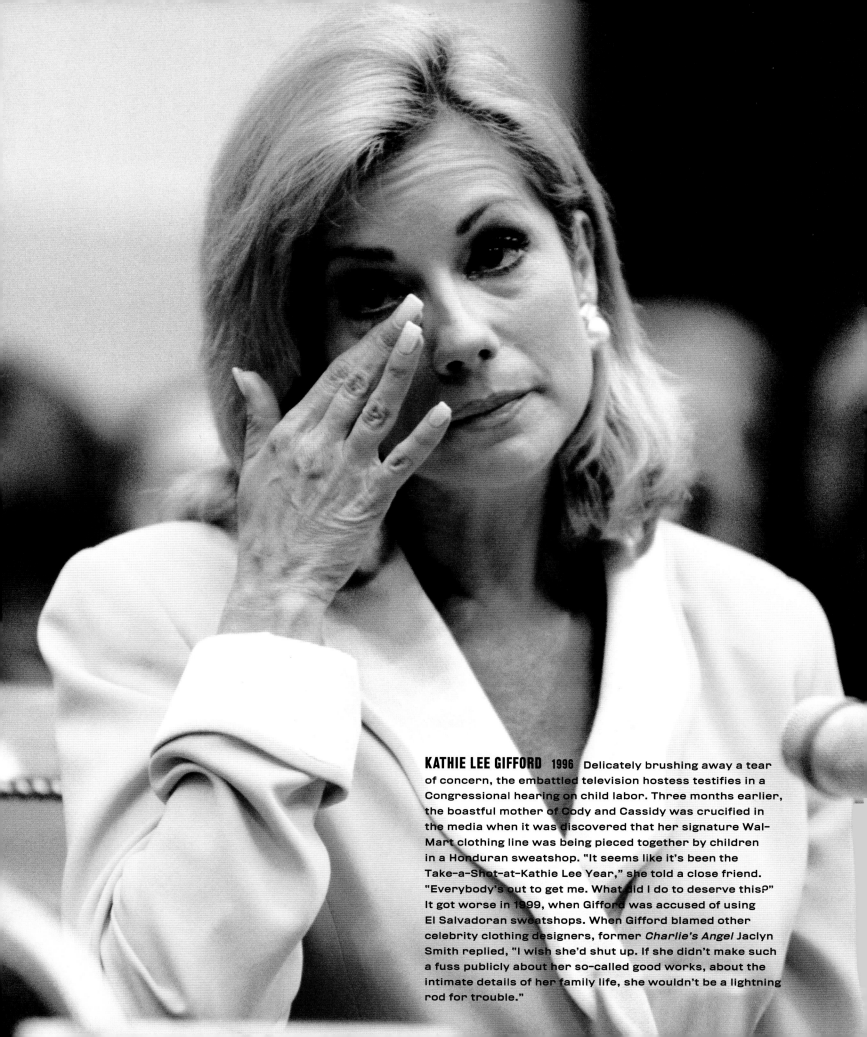

KATHIE LEE GIFFORD 1996 Delicately brushing away a tear of concern, the embattled television hostess testifies in a Congressional hearing on child labor. Three months earlier, the boastful mother of Cody and Cassidy was crucified in the media when it was discovered that her signature Wal-Mart clothing line was being pieced together by children in a Honduran sweatshop. "It seems like it's been the Take-a-Shot-at-Kathie Lee Year," she told a close friend. "Everybody's out to get me. What did I do to deserve this?" It got worse in 1999, when Gifford was accused of using El Salvadoran sweatshops. When Gifford blamed other celebrity clothing designers, former *Charlie's Angel* Jaclyn Smith replied, "I wish she'd shut up. If she didn't make such a fuss publicly about her so-called good works, about the intimate details of her family life, she wouldn't be a lightning rod for trouble."

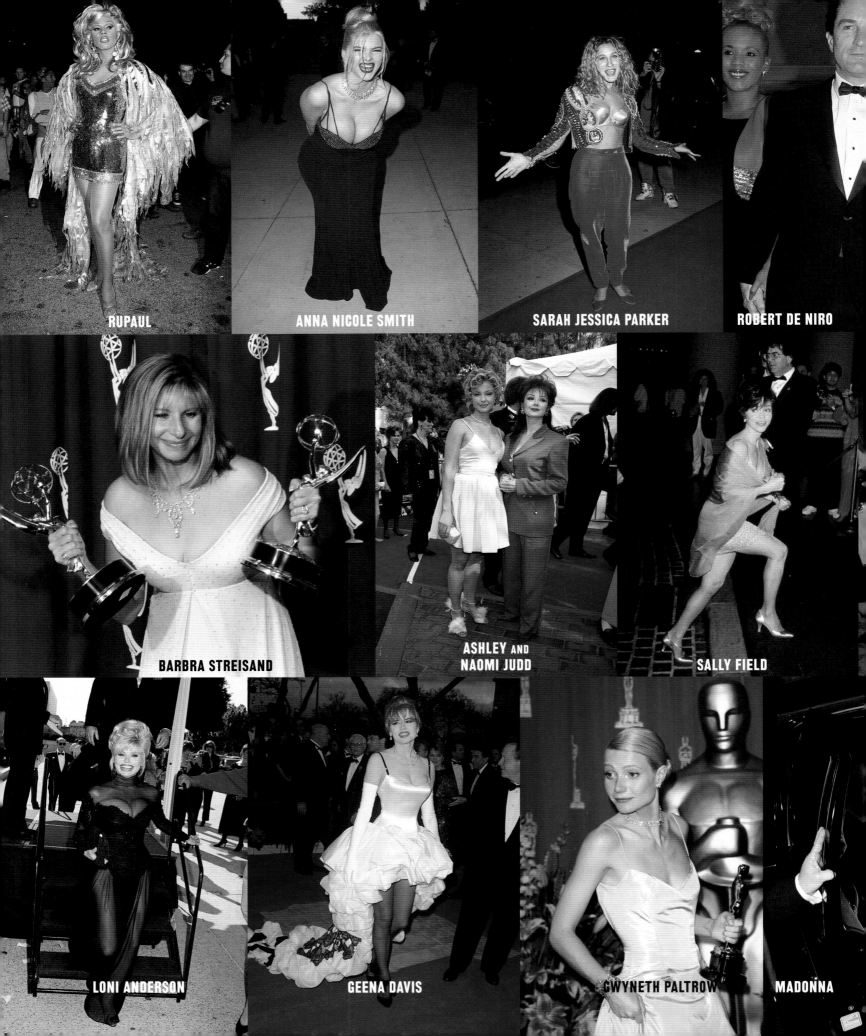

RUPAUL

ANNA NICOLE SMITH

SARAH JESSICA PARKER

ROBERT DE NIRO

BARBRA STREISAND

ASHLEY AND NAOMI JUDD

SALLY FIELD

LONI ANDERSON

GEENA DAVIS

GWYNETH PALTROW

MADONNA

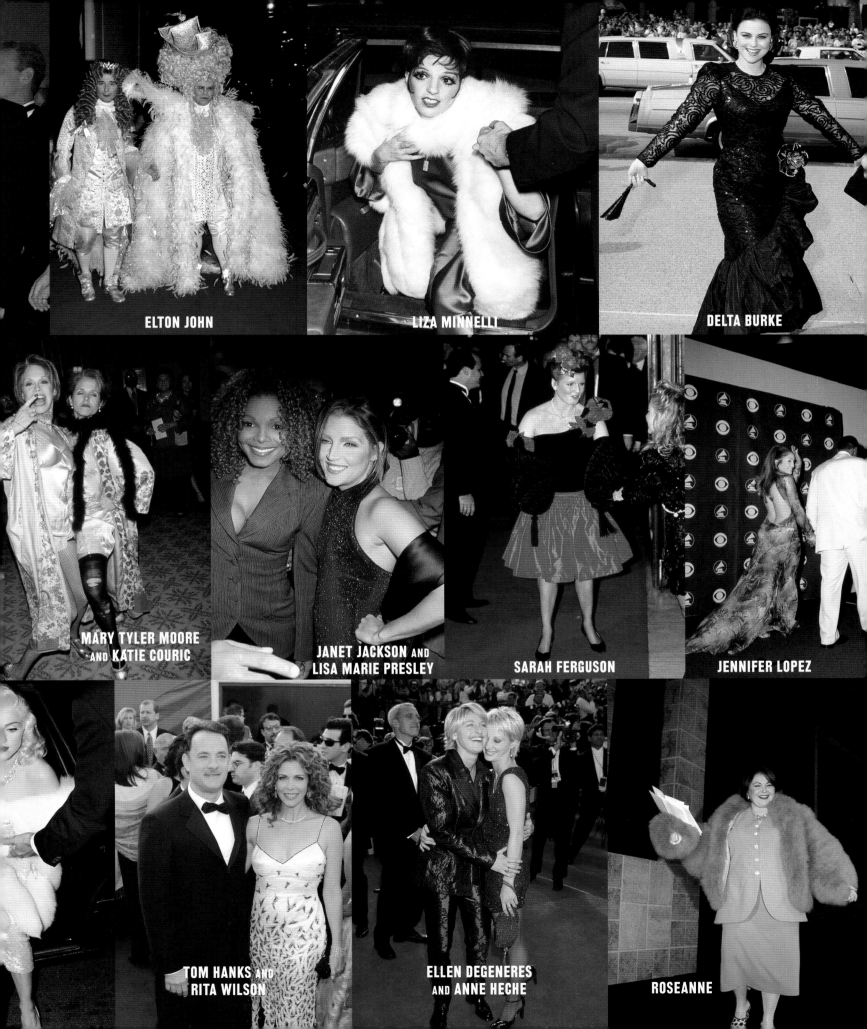

ELTON JOHN

LIZA MINNELLI

DELTA BURKE

MARY TYLER MOORE AND KATIE COURIC

JANET JACKSON AND LISA MARIE PRESLEY

SARAH FERGUSON

JENNIFER LOPEZ

TOM HANKS AND RITA WILSON

ELLEN DEGENERES AND ANNE HECHE

ROSEANNE

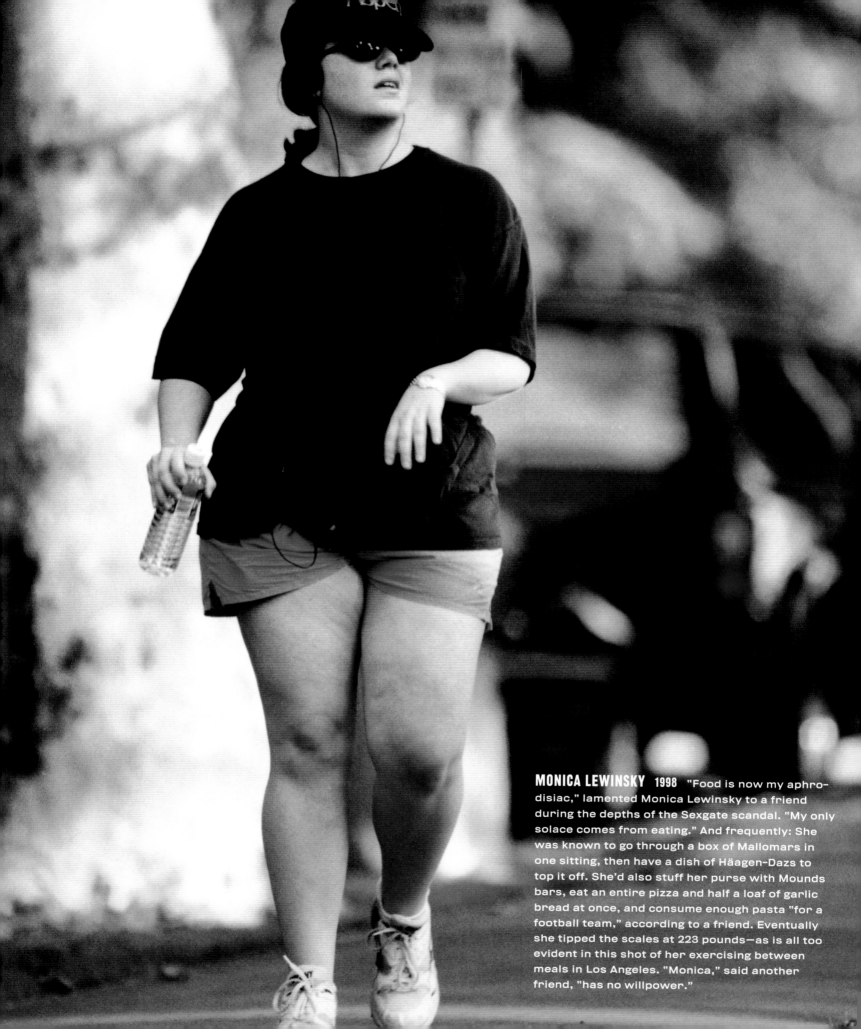

MONICA LEWINSKY 1998 "Food is now my aphrodisiac," lamented Monica Lewinsky to a friend during the depths of the Sexgate scandal. "My only solace comes from eating." And frequently: She was known to go through a box of Mallomars in one sitting, then have a dish of Häagen-Dazs to top it off. She'd also stuff her purse with Mounds bars, eat an entire pizza and half a loaf of garlic bread at once, and consume enough pasta "for a football team," according to a friend. Eventually she tipped the scales at 223 pounds—as is all too evident in this shot of her exercising between meals in Los Angeles. "Monica," said another friend, "has no willpower."

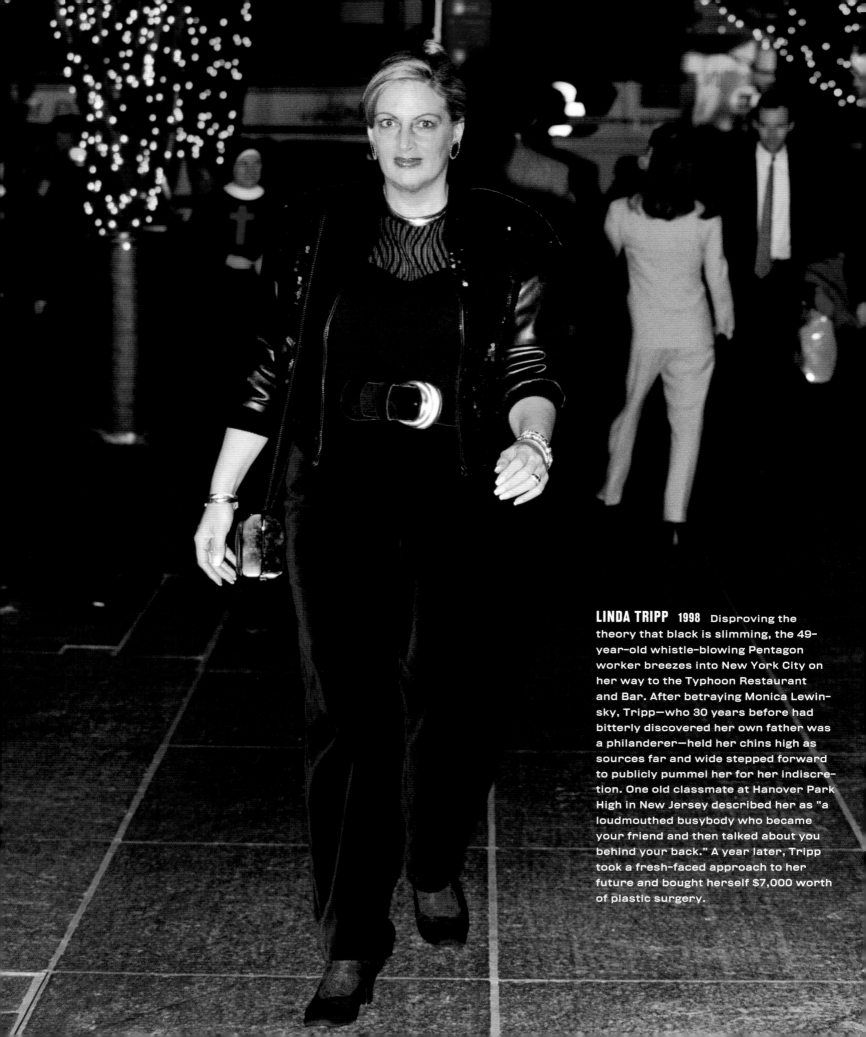

LINDA TRIPP 1998 Disproving the theory that black is slimming, the 49-year-old whistle-blowing Pentagon worker breezes into New York City on her way to the Typhoon Restaurant and Bar. After betraying Monica Lewinsky, Tripp—who 30 years before had bitterly discovered her own father was a philanderer—held her chins high as sources far and wide stepped forward to publicly pummel her for her indiscretion. One old classmate at Hanover Park High in New Jersey described her as "a loudmouthed busybody who became your friend and then talked about you behind your back." A year later, Tripp took a fresh-faced approach to her future and bought herself $7,000 worth of plastic surgery.

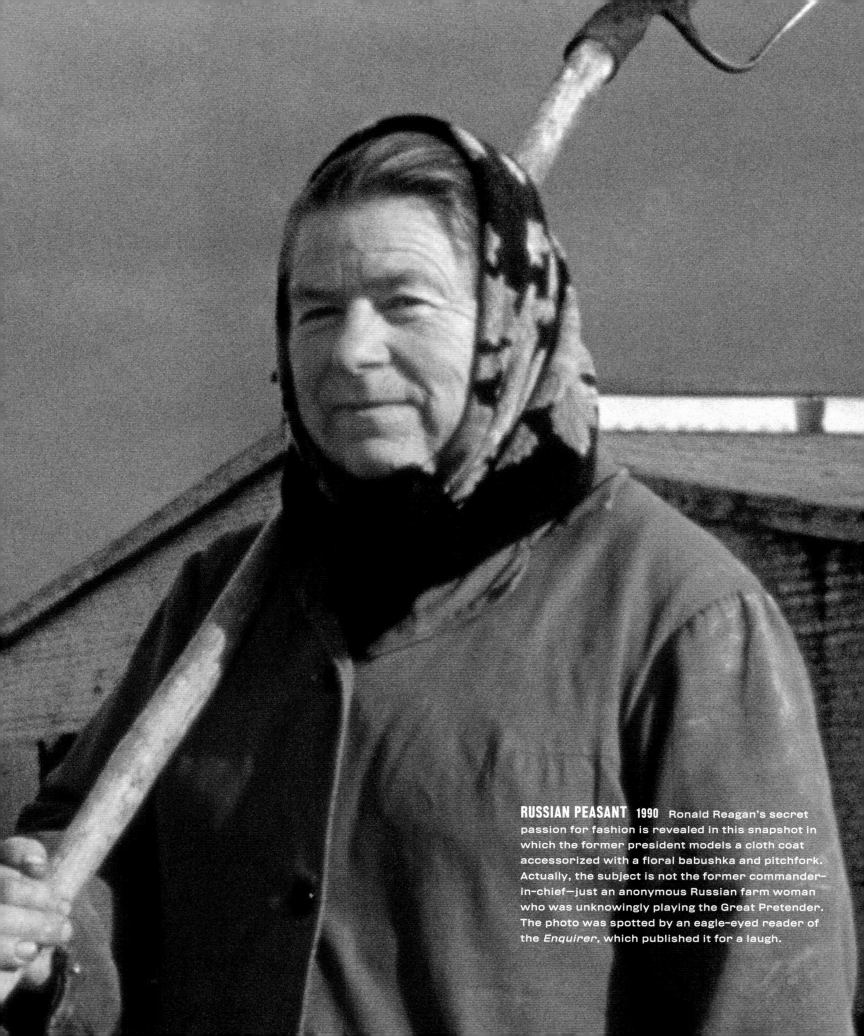

RUSSIAN PEASANT 1990 Ronald Reagan's secret passion for fashion is revealed in this snapshot in which the former president models a cloth coat accessorized with a floral babushka and pitchfork. Actually, the subject is not the former commander-in-chief—just an anonymous Russian farm woman who was unknowingly playing the Great Pretender. The photo was spotted by an eagle-eyed reader of the *Enquirer*, which published it for a laugh.

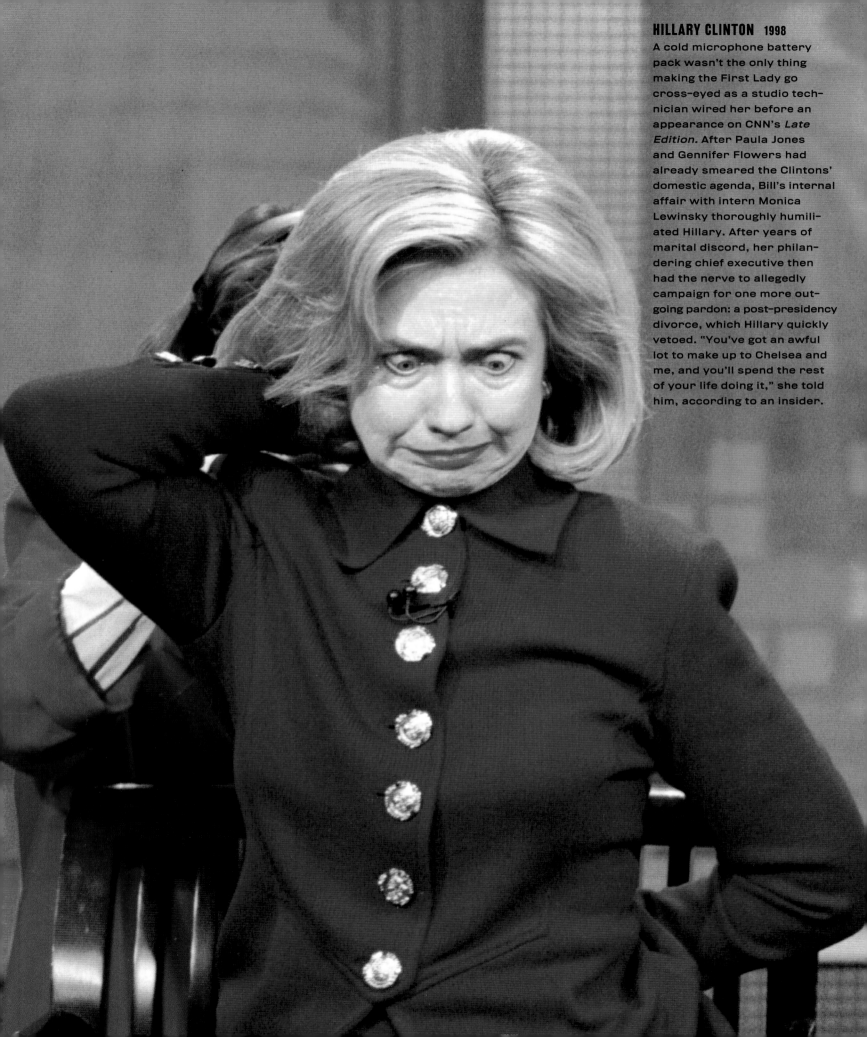

HILLARY CLINTON 1998
A cold microphone battery pack wasn't the only thing making the First Lady go cross-eyed as a studio technician wired her before an appearance on CNN's *Late Edition*. After Paula Jones and Gennifer Flowers had already smeared the Clintons' domestic agenda, Bill's internal affair with intern Monica Lewinsky thoroughly humiliated Hillary. After years of marital discord, her philandering chief executive then had the nerve to allegedly campaign for one more outgoing pardon: a post-presidency divorce, which Hillary quickly vetoed. "You've got an awful lot to make up to Chelsea and me, and you'll spend the rest of your life doing it," she told him, according to an insider.

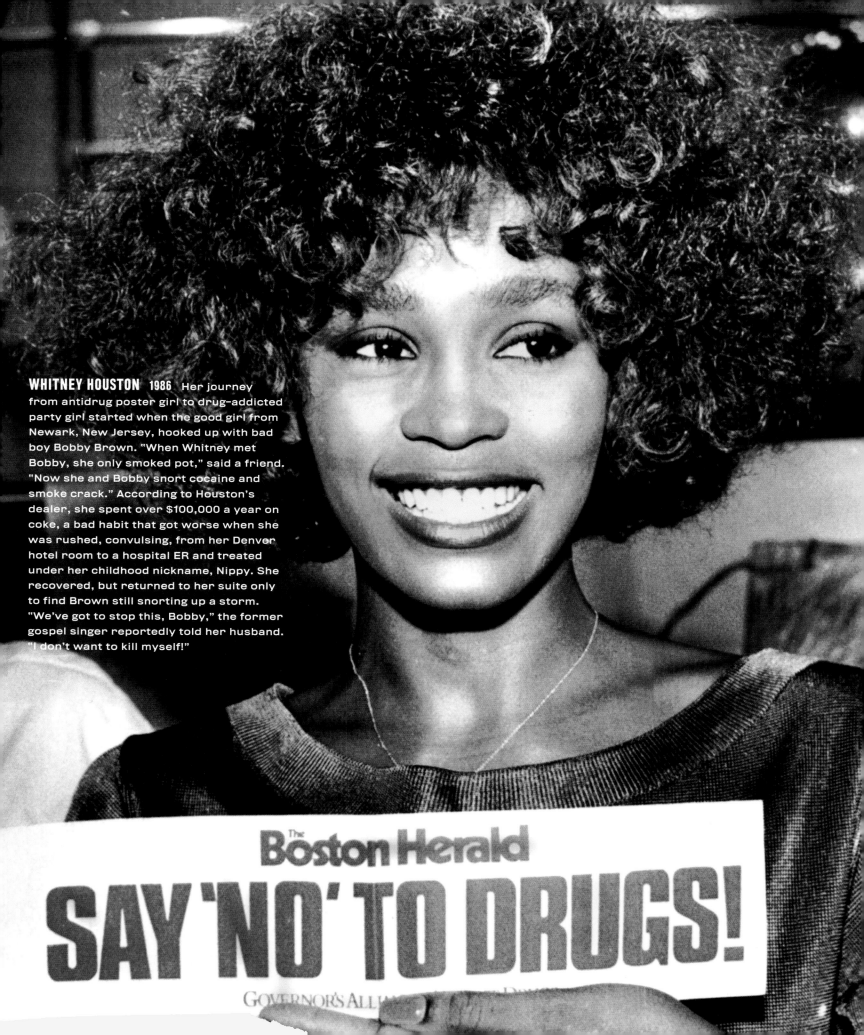

WHITNEY HOUSTON 1986 Her journey from antidrug poster girl to drug–addicted party girl started when the good girl from Newark, New Jersey, hooked up with bad boy Bobby Brown. "When Whitney met Bobby, she only smoked pot," said a friend. "Now she and Bobby snort cocaine and smoke crack." According to Houston's dealer, she spent over $100,000 a year on coke, a bad habit that got worse when she was rushed, convulsing, from her Denver hotel room to a hospital ER and treated under her childhood nickname, Nippy. She recovered, but returned to her suite only to find Brown still snorting up a storm. "We've got to stop this, Bobby," the former gospel singer reportedly told her husband. "I don't want to kill myself!"

The **Boston Herald**
SAY 'NO' TO DRUGS!
GOVERNOR'S ALL

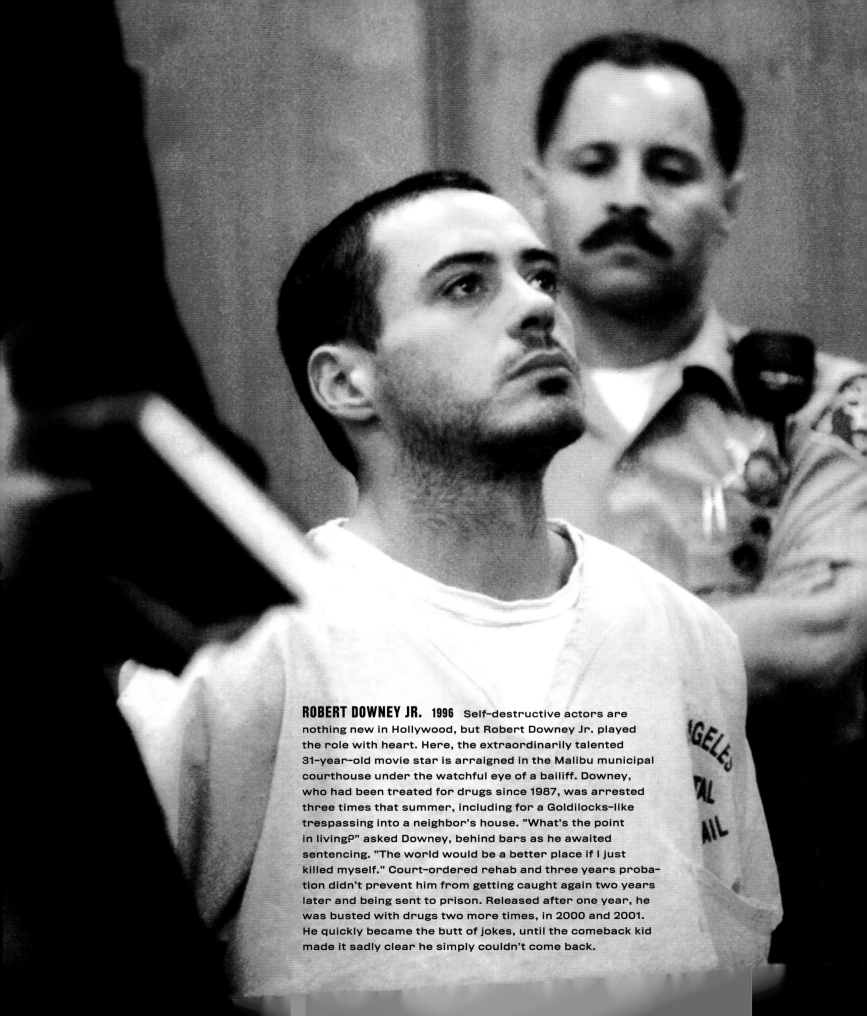

ROBERT DOWNEY JR. **1996** Self-destructive actors are nothing new in Hollywood, but Robert Downey Jr. played the role with heart. Here, the extraordinarily talented 31-year-old movie star is arraigned in the Malibu municipal courthouse under the watchful eye of a bailiff. Downey, who had been treated for drugs since 1987, was arrested three times that summer, including for a Goldilocks-like trespassing into a neighbor's house. "What's the point in living?" asked Downey, behind bars as he awaited sentencing. "The world would be a better place if I just killed myself." Court-ordered rehab and three years probation didn't prevent him from getting caught again two years later and being sent to prison. Released after one year, he was busted with drugs two more times, in 2000 and 2001. He quickly became the butt of jokes, until the comeback kid made it sadly clear he simply couldn't come back.

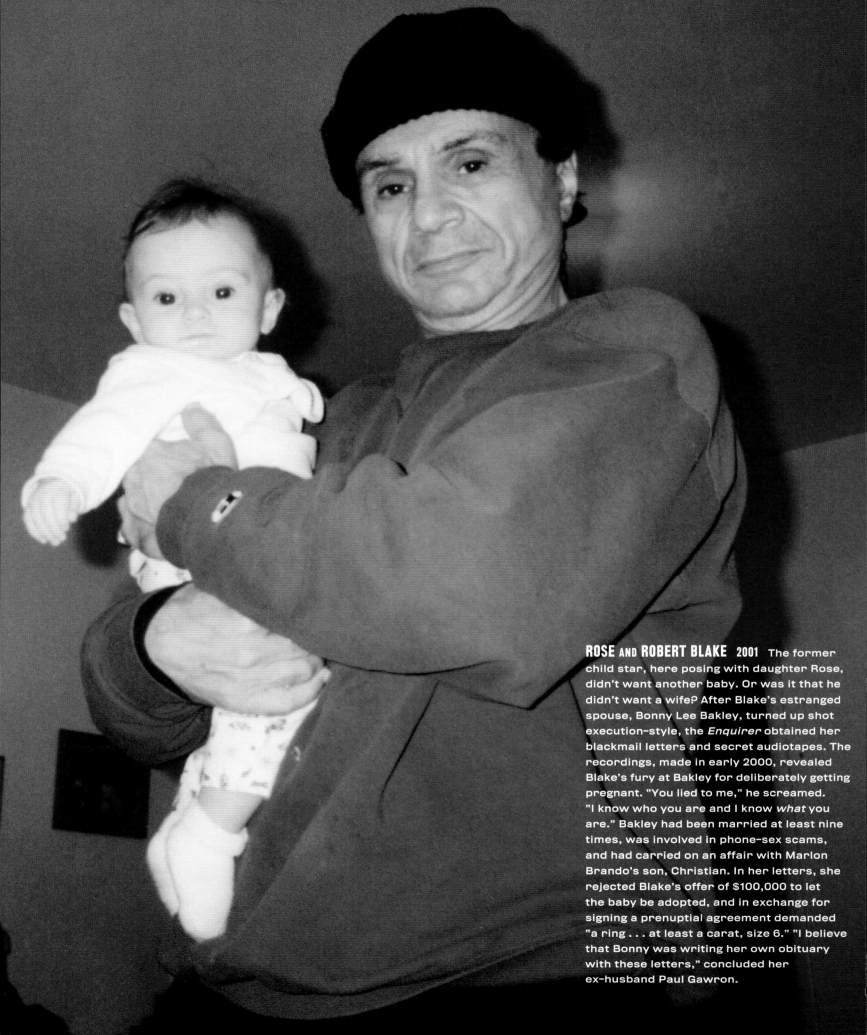

ROSE AND ROBERT BLAKE 2001 The former child star, here posing with daughter Rose, didn't want another baby. Or was it that he didn't want a wife? After Blake's estranged spouse, Bonny Lee Bakley, turned up shot execution-style, the *Enquirer* obtained her blackmail letters and secret audiotapes. The recordings, made in early 2000, revealed Blake's fury at Bakley for deliberately getting pregnant. "You lied to me," he screamed. "I know who you are and I know *what* you are." Bakley had been married at least nine times, was involved in phone-sex scams, and had carried on an affair with Marlon Brando's son, Christian. In her letters, she rejected Blake's offer of $100,000 to let the baby be adopted, and in exchange for signing a prenuptial agreement demanded "a ring . . . at least a carat, size 6." "I believe that Bonny was writing her own obituary with these letters," concluded her ex-husband Paul Gawron.

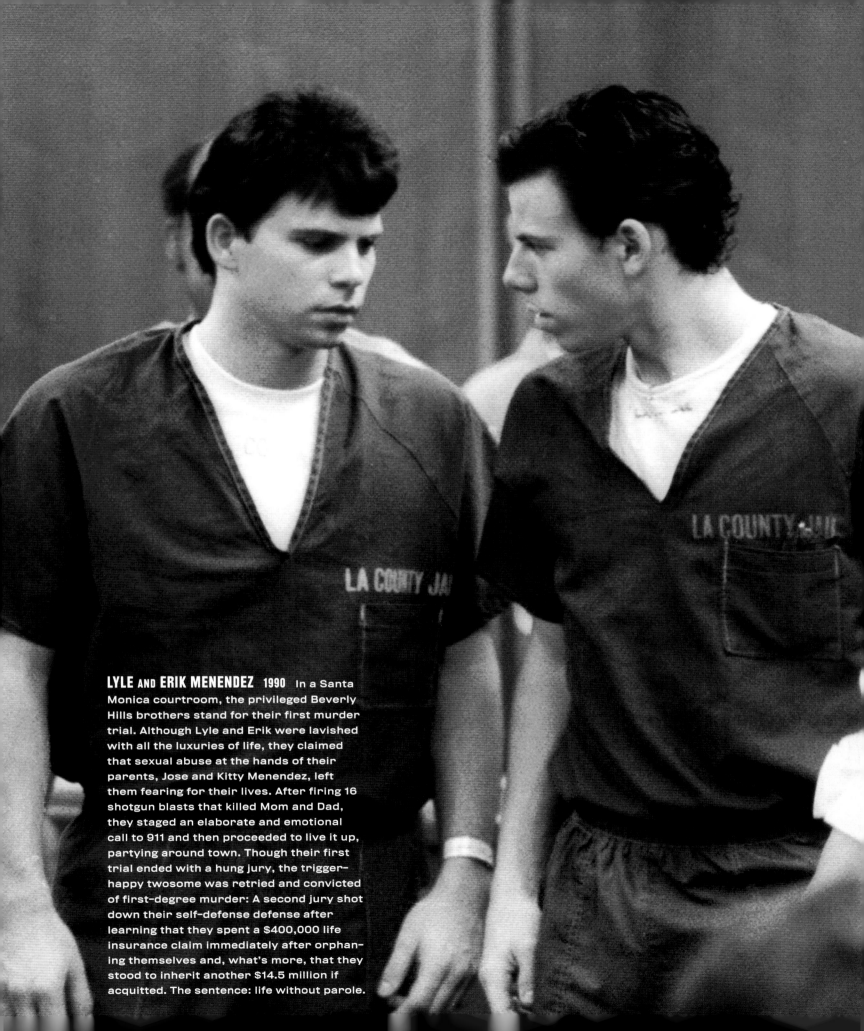

LYLE AND ERIK MENENDEZ 1990 In a Santa
Monica courtroom, the privileged Beverly
Hills brothers stand for their first murder
trial. Although Lyle and Erik were lavished
with all the luxuries of life, they claimed
that sexual abuse at the hands of their
parents, Jose and Kitty Menendez, left
them fearing for their lives. After firing 16
shotgun blasts that killed Mom and Dad,
they staged an elaborate and emotional
call to 911 and then proceeded to live it up,
partying around town. Though their first
trial ended with a hung jury, the trigger-
happy twosome was retried and convicted
of first-degree murder: A second jury shot
down their self-defense defense after
learning that they spent a $400,000 life
insurance claim immediately after orphan-
ing themselves and, what's more, that they
stood to inherit another $14.5 million if
acquitted. The sentence: life without parole.

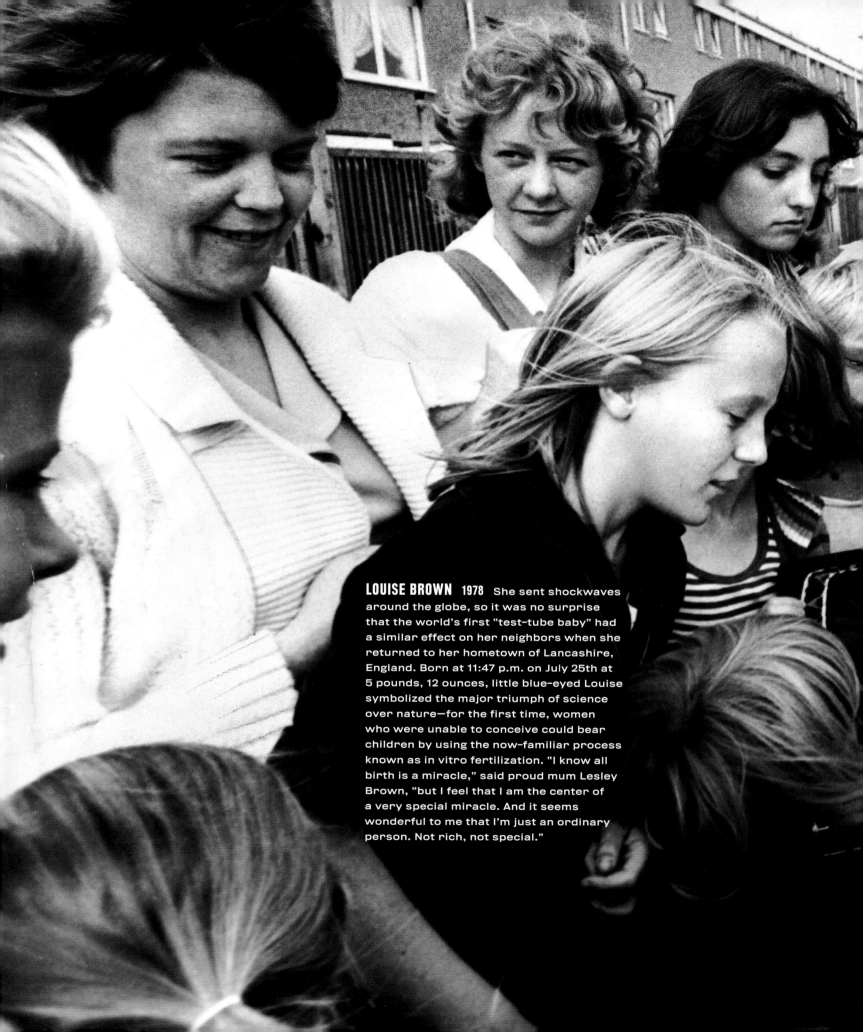

LOUISE BROWN 1978 She sent shockwaves around the globe, so it was no surprise that the world's first "test-tube baby" had a similar effect on her neighbors when she returned to her hometown of Lancashire, England. Born at 11:47 p.m. on July 25th at 5 pounds, 12 ounces, little blue-eyed Louise symbolized the major triumph of science over nature—for the first time, women who were unable to conceive could bear children by using the now-familiar process known as in vitro fertilization. "I know all birth is a miracle," said proud mum Lesley Brown, "but I feel that I am the center of a very special miracle. And it seems wonderful to me that I'm just an ordinary person. Not rich, not special."

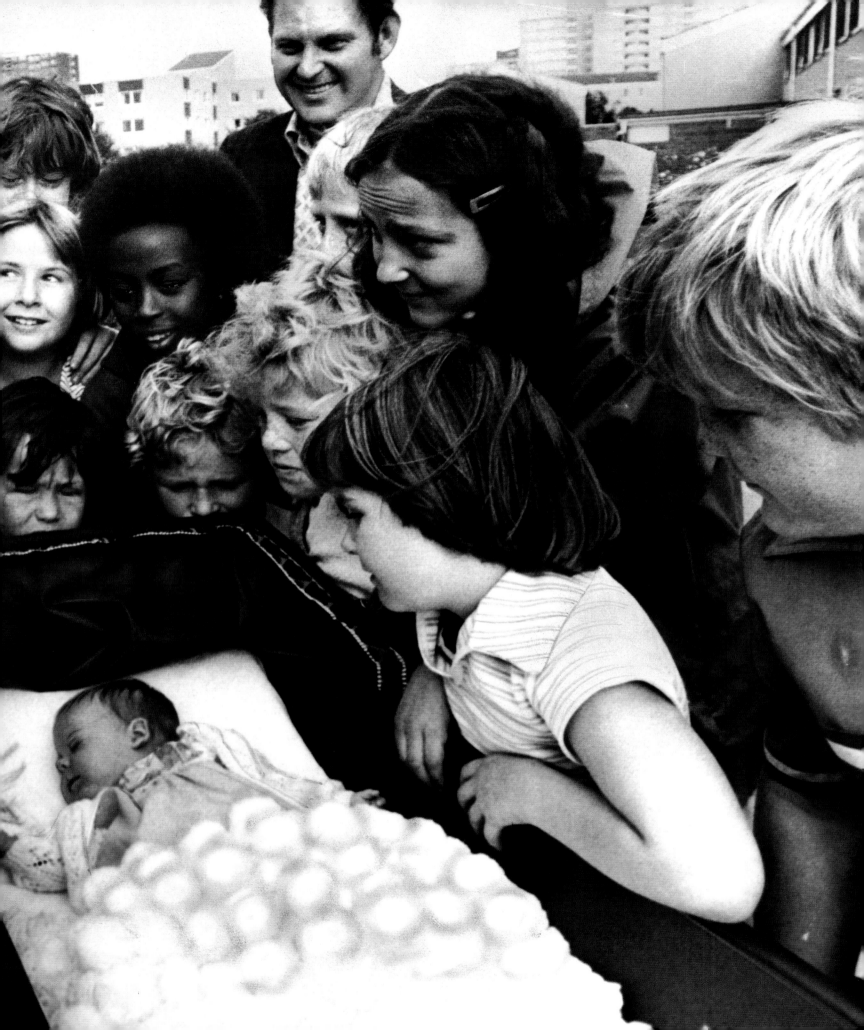

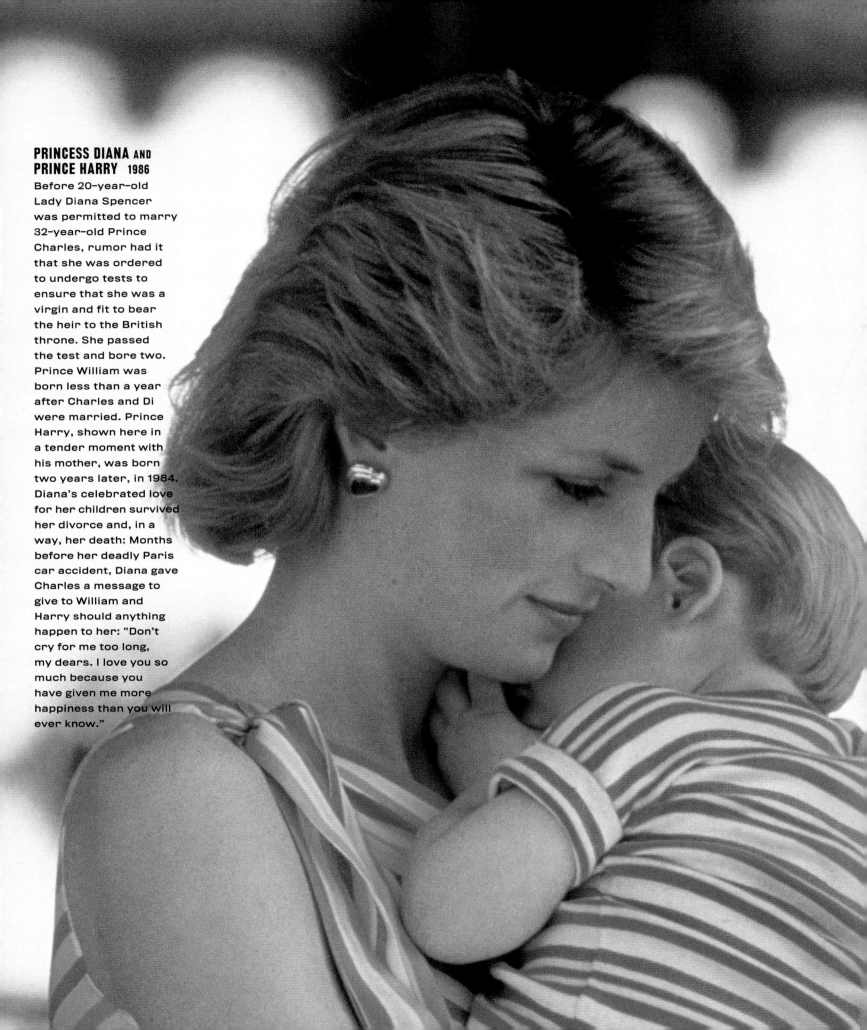

PRINCESS DIANA AND PRINCE HARRY 1986

Before 20-year-old Lady Diana Spencer was permitted to marry 32-year-old Prince Charles, rumor had it that she was ordered to undergo tests to ensure that she was a virgin and fit to bear the heir to the British throne. She passed the test and bore two. Prince William was born less than a year after Charles and Di were married. Prince Harry, shown here in a tender moment with his mother, was born two years later, in 1984. Diana's celebrated love for her children survived her divorce and, in a way, her death: Months before her deadly Paris car accident, Diana gave Charles a message to give to William and Harry should anything happen to her: "Don't cry for me too long, my dears. I love you so much because you have given me more happiness than you will ever know."

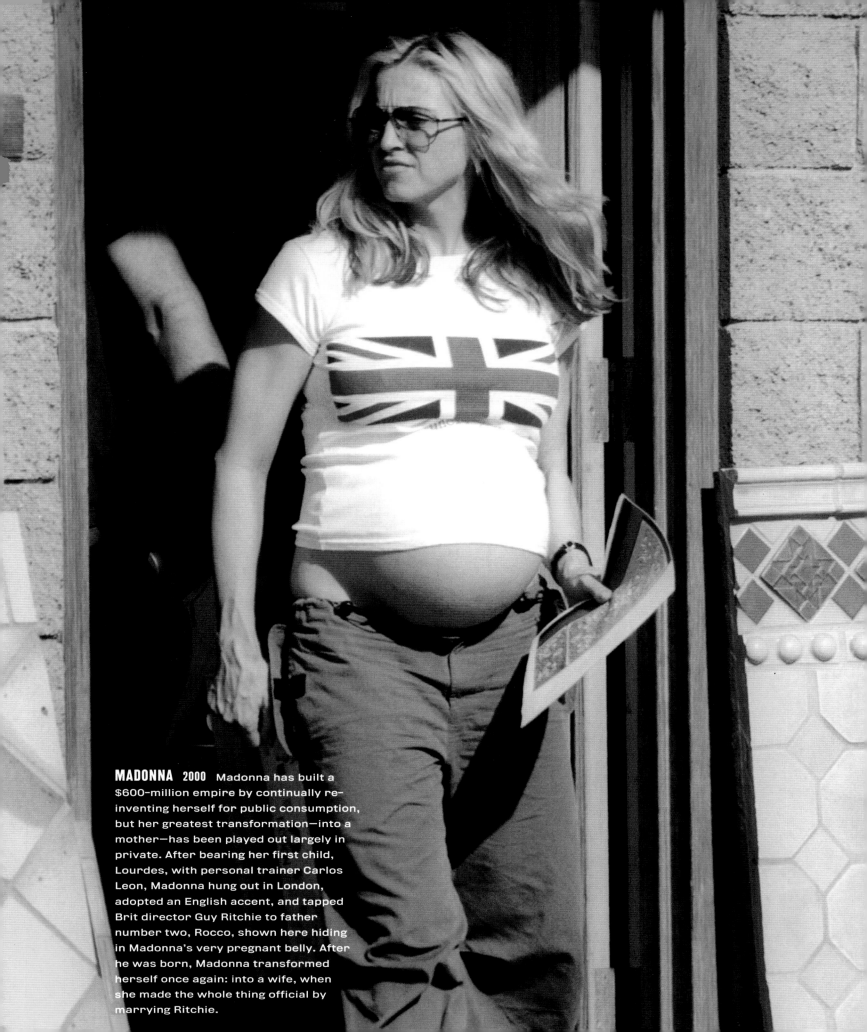

MADONNA 2000 Madonna has built a $600-million empire by continually re-inventing herself for public consumption, but her greatest transformation—into a mother—has been played out largely in private. After bearing her first child, Lourdes, with personal trainer Carlos Leon, Madonna hung out in London, adopted an English accent, and tapped Brit director Guy Ritchie to father number two, Rocco, shown here hiding in Madonna's very pregnant belly. After he was born, Madonna transformed herself once again: into a wife, when she made the whole thing official by marrying Ritchie.

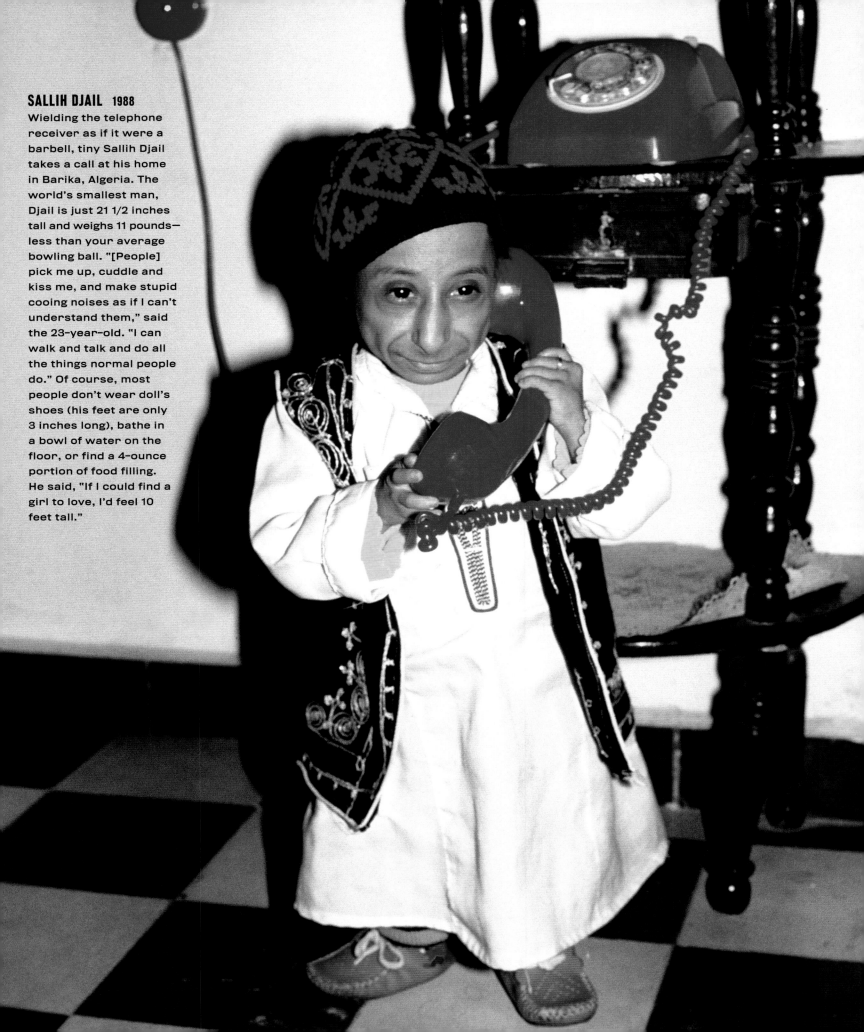

SALLIH DJAIL 1988
Wielding the telephone receiver as if it were a barbell, tiny Sallih Djail takes a call at his home in Barika, Algeria. The world's smallest man, Djail is just 21 1/2 inches tall and weighs 11 pounds—less than your average bowling ball. "[People] pick me up, cuddle and kiss me, and make stupid cooing noises as if I can't understand them," said the 23-year-old. "I can walk and talk and do all the things normal people do." Of course, most people don't wear doll's shoes (his feet are only 3 inches long), bathe in a bowl of water on the floor, or find a 4-ounce portion of food filling. He said, "If I could find a girl to love, I'd feel 10 feet tall."

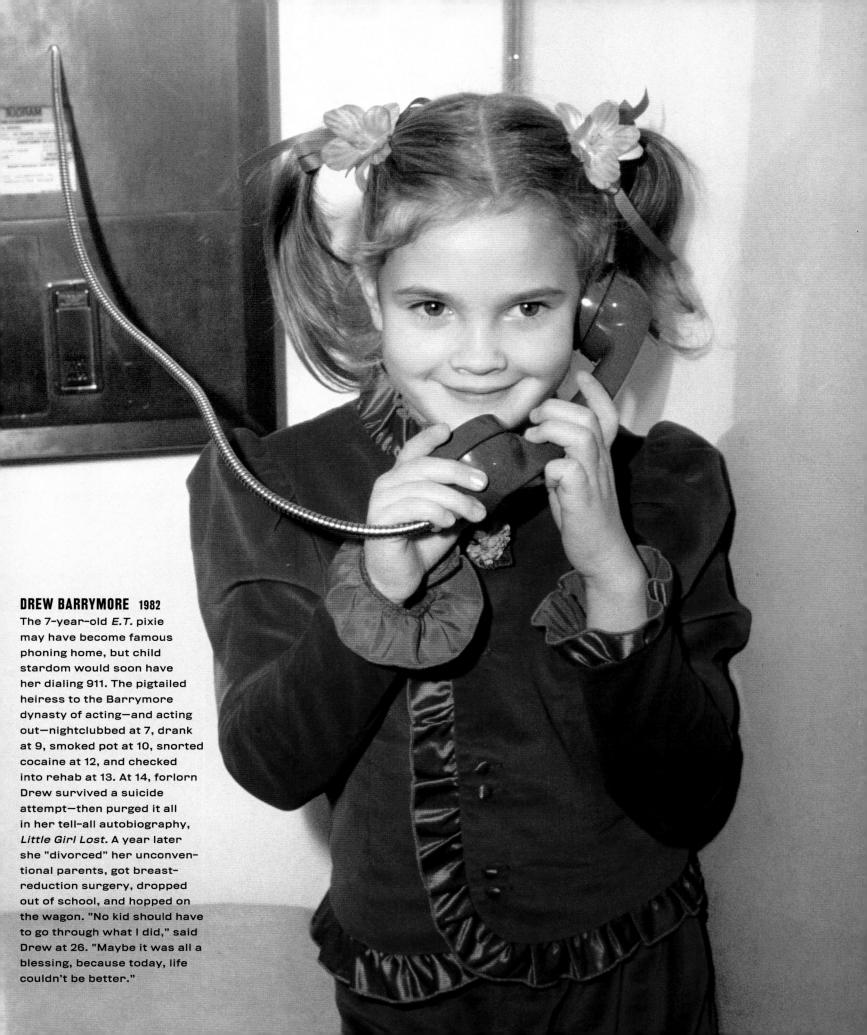

DREW BARRYMORE 1982
The 7-year-old *E.T.* pixie
may have become famous
phoning home, but child
stardom would soon have
her dialing 911. The pigtailed
heiress to the Barrymore
dynasty of acting—and acting
out—nightclubbed at 7, drank
at 9, smoked pot at 10, snorted
cocaine at 12, and checked
into rehab at 13. At 14, forlorn
Drew survived a suicide
attempt—then purged it all
in her tell-all autobiography,
Little Girl Lost. A year later
she "divorced" her unconven-
tional parents, got breast-
reduction surgery, dropped
out of school, and hopped on
the wagon. "No kid should have
to go through what I did," said
Drew at 26. "Maybe it was all a
blessing, because today, life
couldn't be better."

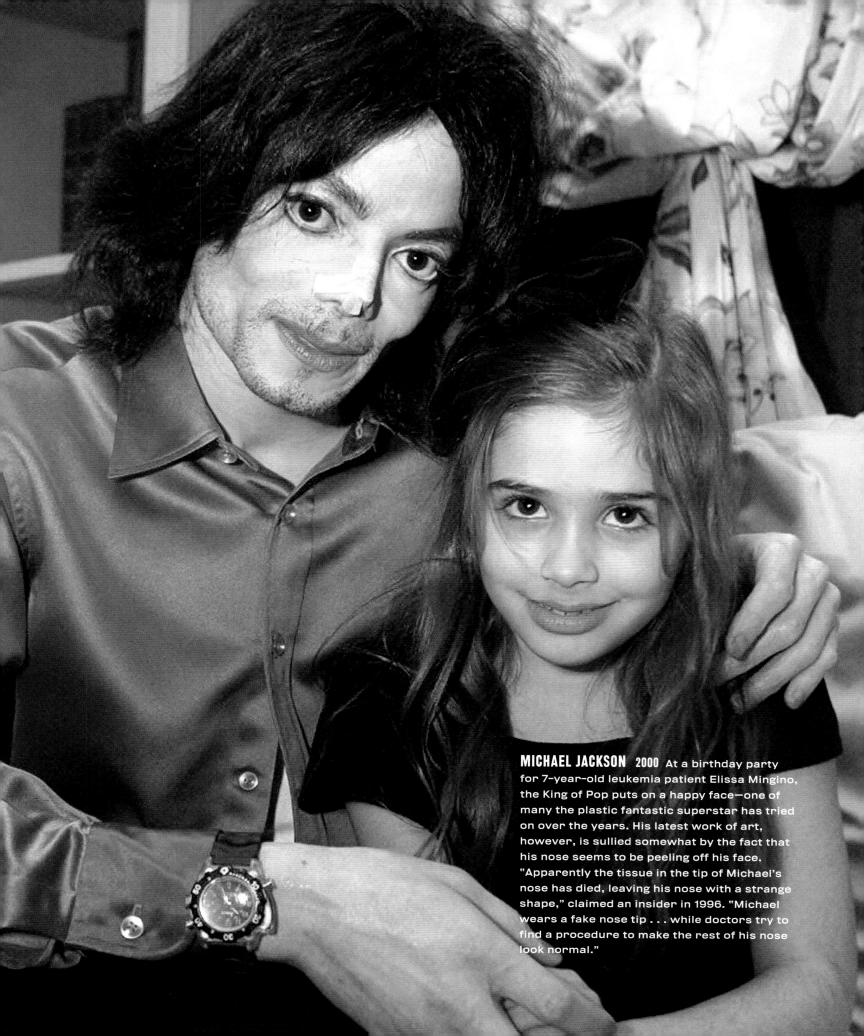

MICHAEL JACKSON 2000 At a birthday party for 7-year-old leukemia patient Elissa Mingino, the King of Pop puts on a happy face—one of many the plastic fantastic superstar has tried on over the years. His latest work of art, however, is sullied somewhat by the fact that his nose seems to be peeling off his face. "Apparently the tissue in the tip of Michael's nose has died, leaving his nose with a strange shape," claimed an insider in 1996. "Michael wears a fake nose tip . . . while doctors try to find a procedure to make the rest of his nose look normal."

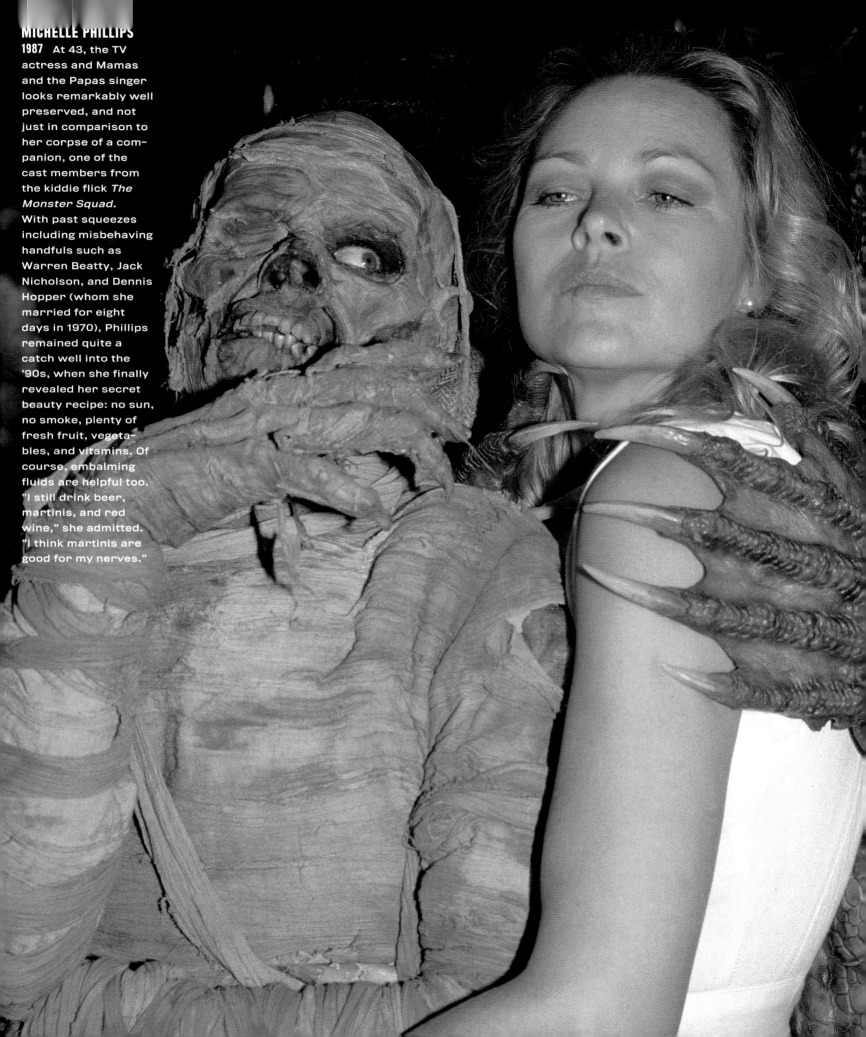

MICHELLE PHILLIPS
1987 At 43, the TV actress and Mamas and the Papas singer looks remarkably well preserved, and not just in comparison to her corpse of a companion, one of the cast members from the kiddie flick *The Monster Squad.* With past squeezes including misbehaving handfuls such as Warren Beatty, Jack Nicholson, and Dennis Hopper (whom she married for eight days in 1970), Phillips remained quite a catch well into the '90s, when she finally revealed her secret beauty recipe: no sun, no smoke, plenty of fresh fruit, vegetables, and vitamins. Of course, embalming fluids are helpful too. "I still drink beer, martinis, and red wine," she admitted. "I think martinis are good for my nerves."

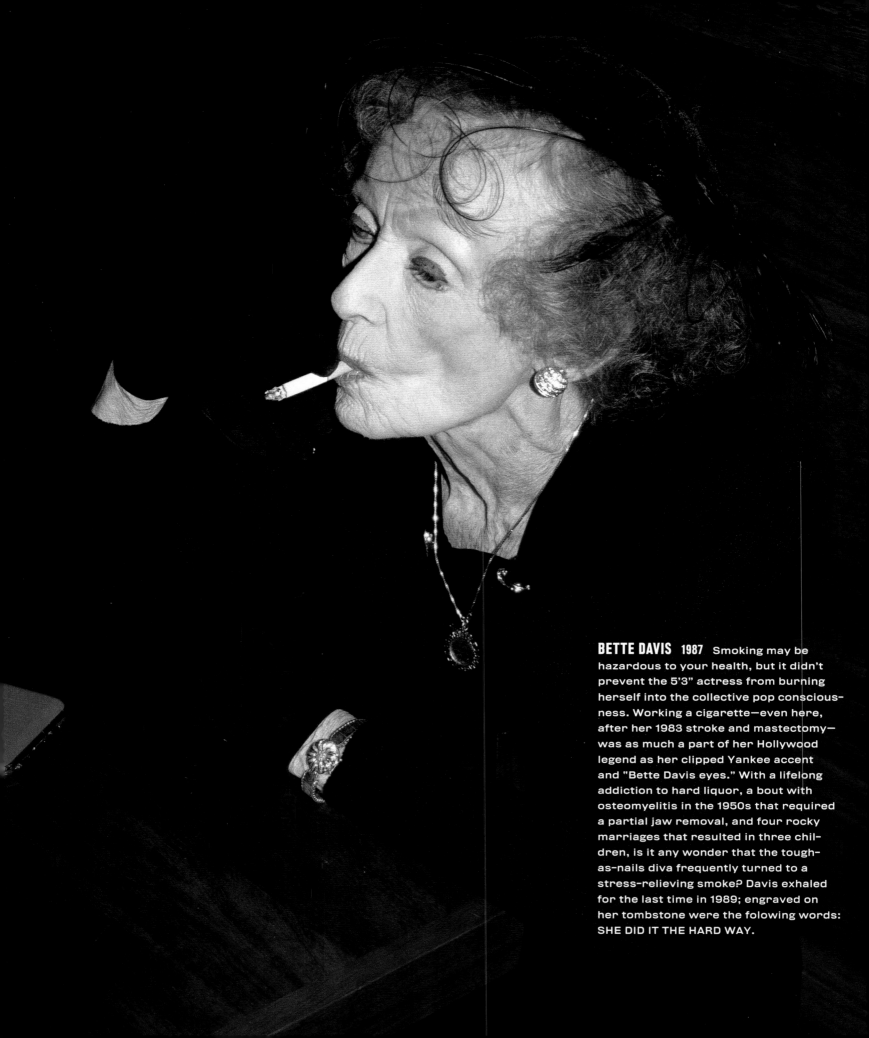

BETTE DAVIS 1987 Smoking may be hazardous to your health, but it didn't prevent the 5'3" actress from burning herself into the collective pop consciousness. Working a cigarette—even here, after her 1983 stroke and mastectomy—was as much a part of her Hollywood legend as her clipped Yankee accent and "Bette Davis eyes." With a lifelong addiction to hard liquor, a bout with osteomyelitis in the 1950s that required a partial jaw removal, and four rocky marriages that resulted in three children, is it any wonder that the tough-as-nails diva frequently turned to a stress-relieving smoke? Davis exhaled for the last time in 1989; engraved on her tombstone were the following words: SHE DID IT THE HARD WAY.

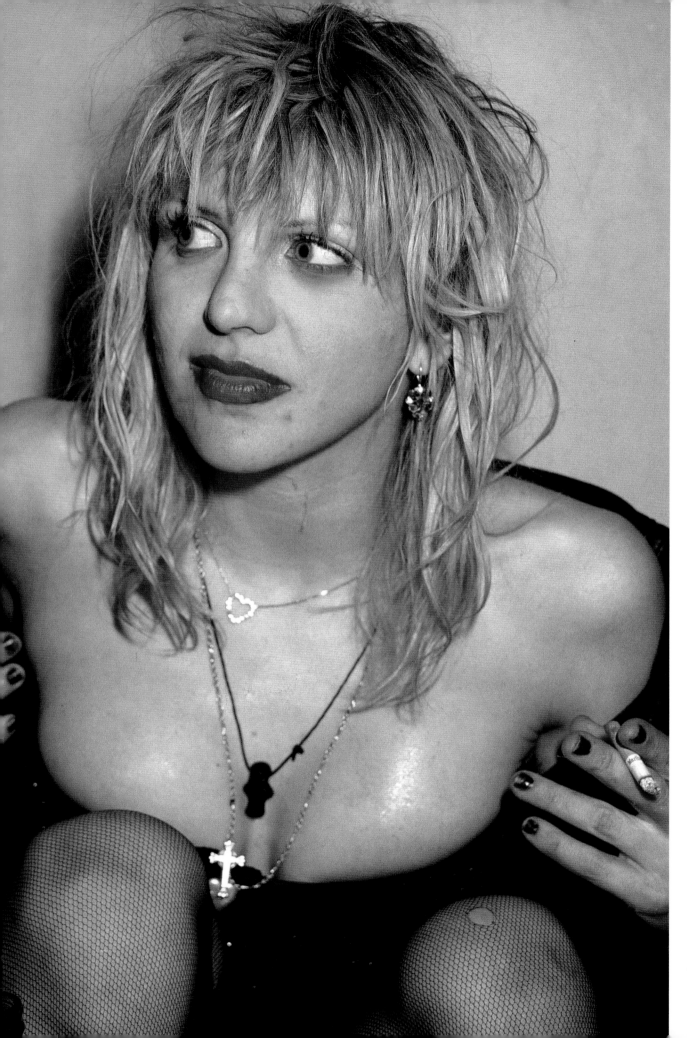

COURTNEY LOVE 1995
When the lipstick-smeared, foulmouthed Love found nirvana with Kurt Cobain, she established herself as an anti-fashion femme fatale, marrying the crown prince of grunge in a gown once owned by the lobotomized Hollywood outcast Frances Farmer. "I took heroin, pot, cocaine—anything I could get my hands on," Love admitted. She was even accused of doing smack while pregnant with her daughter Frances Bean, which she denied. After her husband's 1994 suicide, the former stripper and Hole frontwoman, who once complained that men didn't watch her undress because she was fat, remade herself with yoga, Buddhism, and cosmetic surgery. The Seattle-based sow's ear then captured the Hollywood silk purse: a career as an actress, specializing, unsurprisingly, in playing paramours to outlaws like Larry Flynt and Andy Kaufman.

199

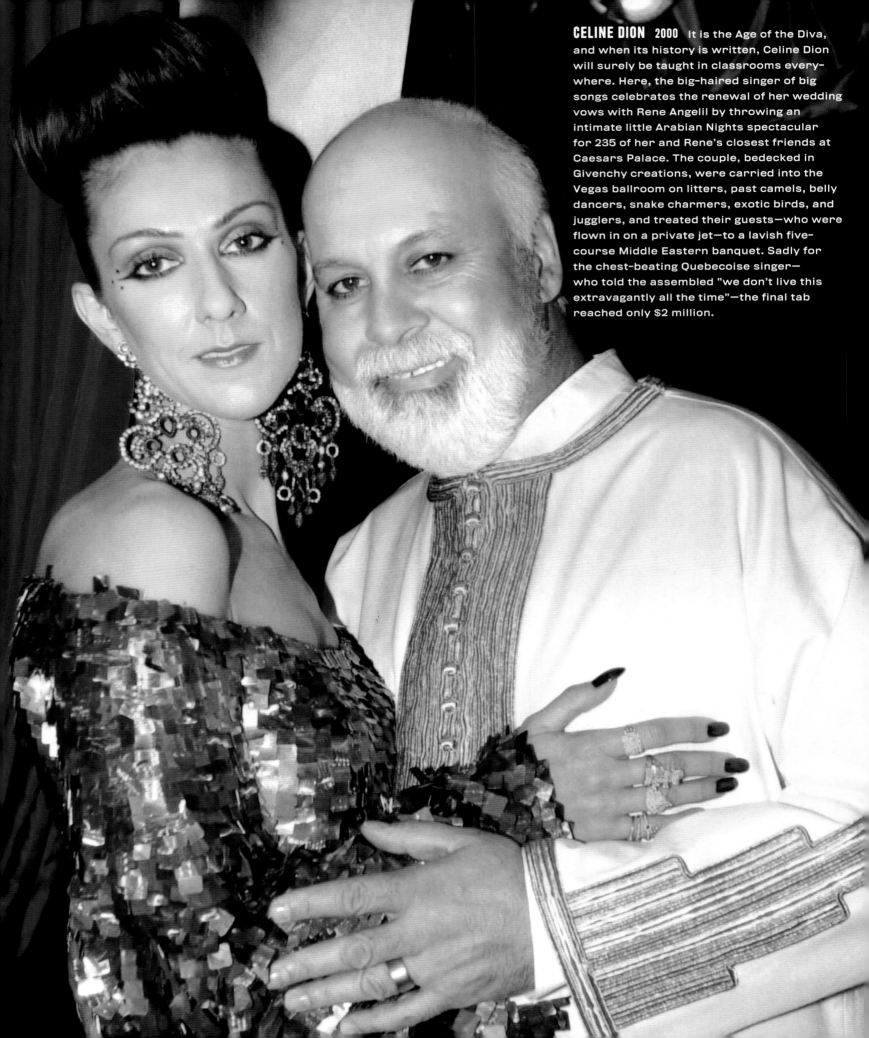

CELINE DION 2000 It is the Age of the Diva, and when its history is written, Celine Dion will surely be taught in classrooms everywhere. Here, the big-haired singer of big songs celebrates the renewal of her wedding vows with Rene Angelil by throwing an intimate little Arabian Nights spectacular for 235 of her and Rene's closest friends at Caesars Palace. The couple, bedecked in Givenchy creations, were carried into the Vegas ballroom on litters, past camels, belly dancers, snake charmers, exotic birds, and jugglers, and treated their guests—who were flown in on a private jet—to a lavish five-course Middle Eastern banquet. Sadly for the chest-beating Quebecoise singer—who told the assembled "we don't live this extravagantly all the time"—the final tab reached only $2 million.

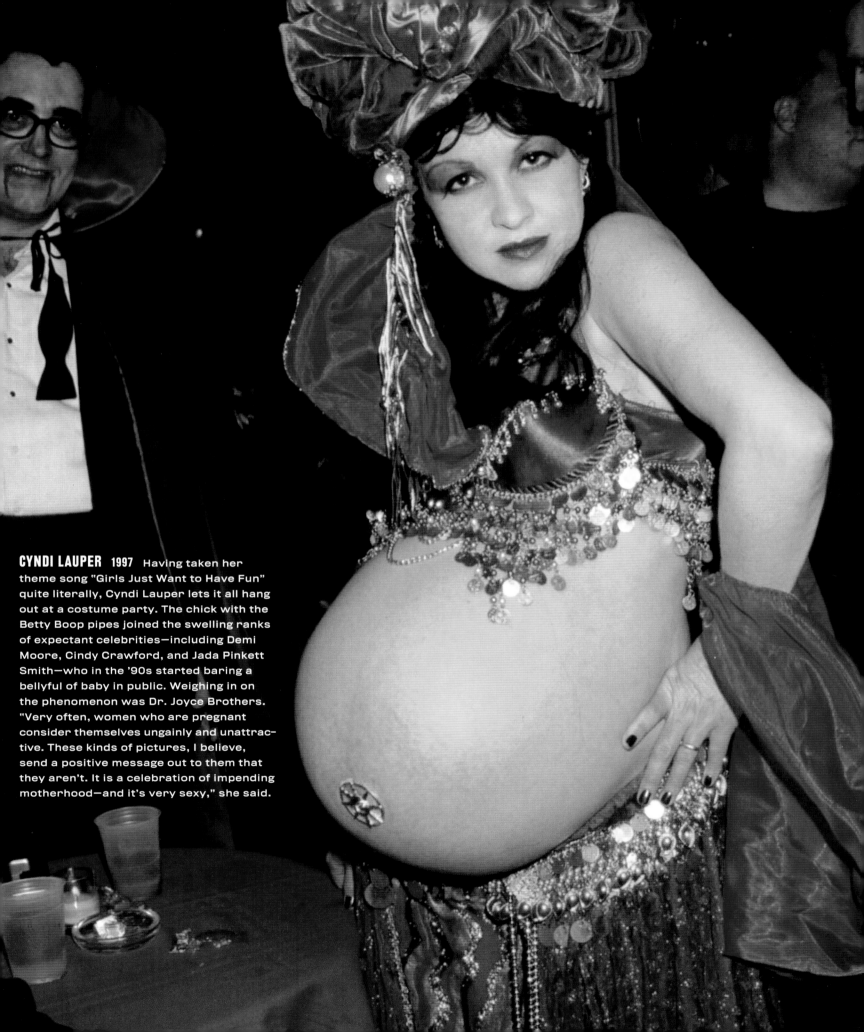

CYNDI LAUPER 1997 Having taken her theme song "Girls Just Want to Have Fun" quite literally, Cyndi Lauper lets it all hang out at a costume party. The chick with the Betty Boop pipes joined the swelling ranks of expectant celebrities—including Demi Moore, Cindy Crawford, and Jada Pinkett Smith—who in the '90s started baring a bellyful of baby in public. Weighing in on the phenomenon was Dr. Joyce Brothers. "Very often, women who are pregnant consider themselves ungainly and unattractive. These kinds of pictures, I believe, send a positive message out to them that they aren't. It is a celebration of impending motherhood—and it's very sexy," she said.

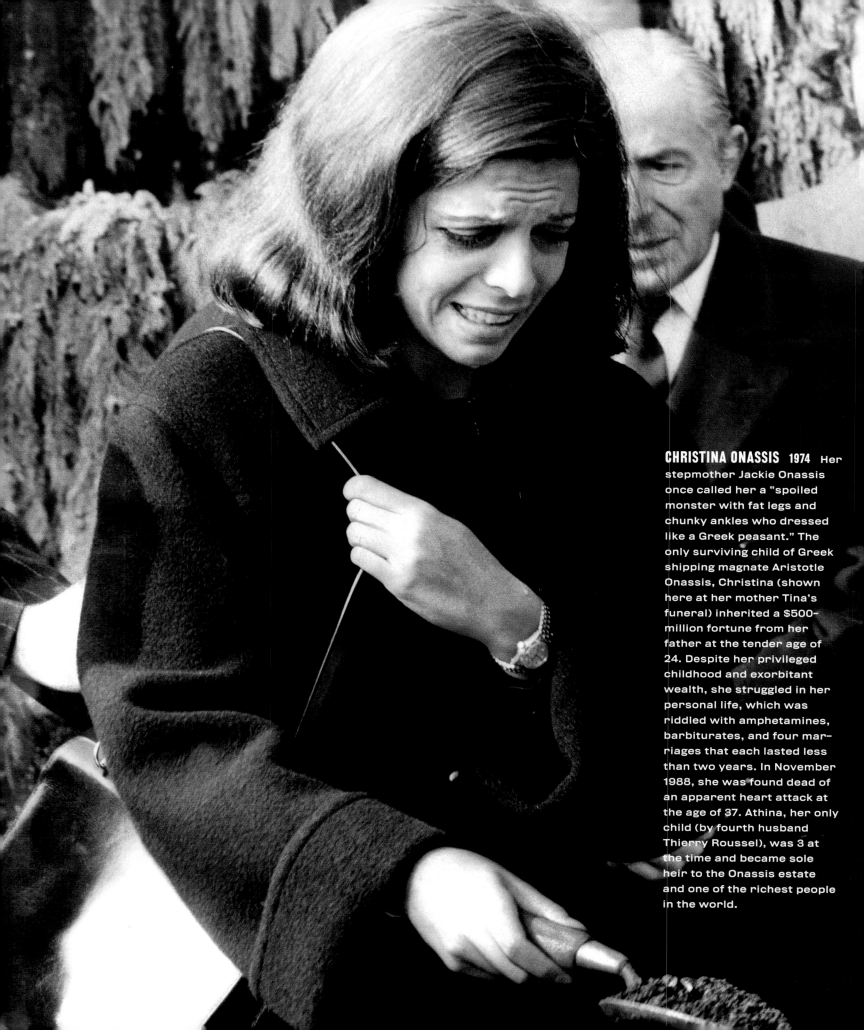

CHRISTINA ONASSIS 1974 Her stepmother Jackie Onassis once called her a "spoiled monster with fat legs and chunky ankles who dressed like a Greek peasant." The only surviving child of Greek shipping magnate Aristotle Onassis, Christina (shown here at her mother Tina's funeral) inherited a $500-million fortune from her father at the tender age of 24. Despite her privileged childhood and exorbitant wealth, she struggled in her personal life, which was riddled with amphetamines, barbiturates, and four marriages that each lasted less than two years. In November 1988, she was found dead of an apparent heart attack at the age of 37. Athina, her only child (by fourth husband Thierry Roussel), was 3 at the time and became sole heir to the Onassis estate and one of the richest people in the world.

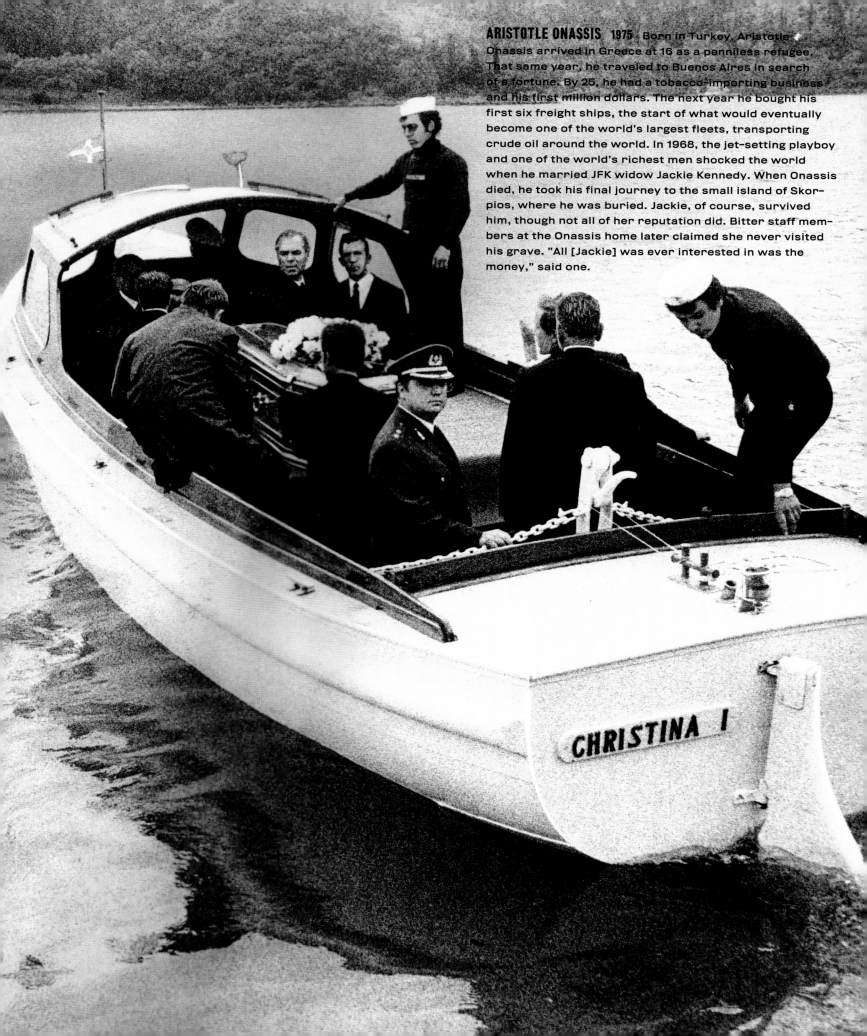

ARISTOTLE ONASSIS 1975 · Born in Turkey, Aristotle Onassis arrived in Greece at 16 as a penniless refugee. That same year, he traveled to Buenos Aires in search of a fortune. By 25, he had a tobacco-importing business and his first million dollars. The next year he bought his first six freight ships, the start of what would eventually become one of the world's largest fleets, transporting crude oil around the world. In 1968, the jet-setting playboy and one of the world's richest men shocked the world when he married JFK widow Jackie Kennedy. When Onassis died, he took his final journey to the small island of Skorpios, where he was buried. Jackie, of course, survived him, though not all of her reputation did. Bitter staff members at the Onassis home later claimed she never visited his grave. "All [Jackie] was ever interested in was the money," said one.

CHRISTINA I

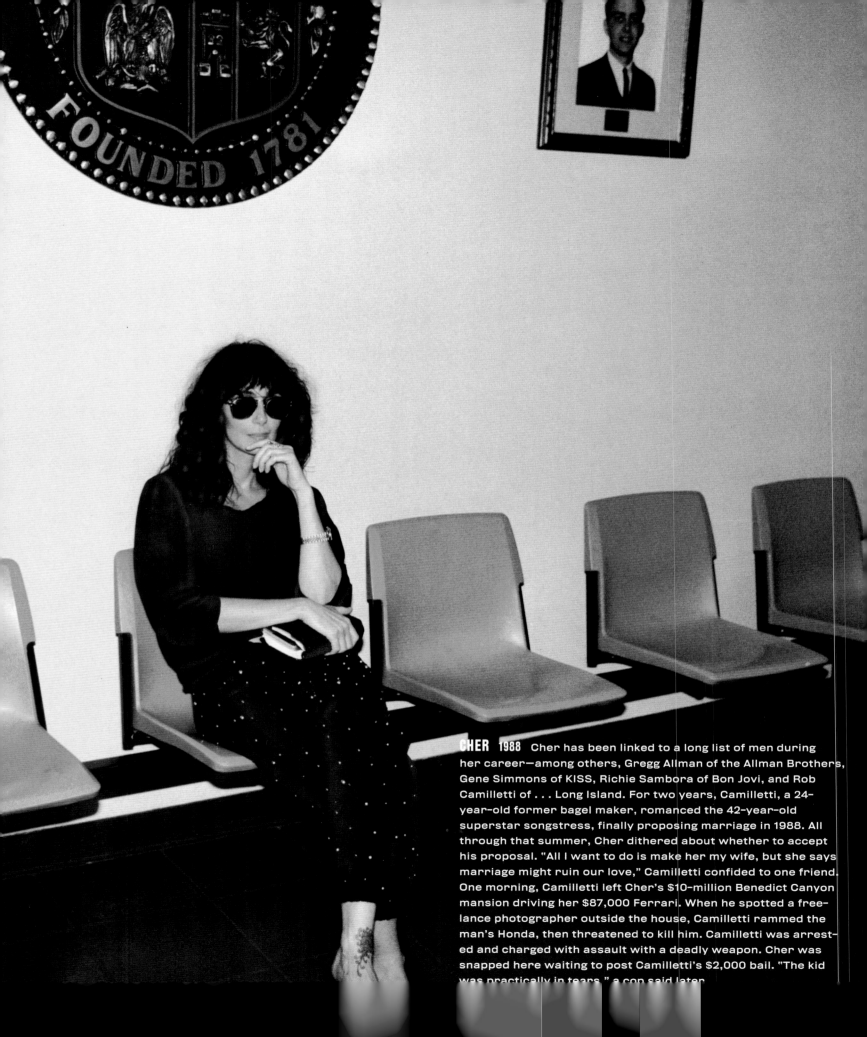

FOUNDED 1781

CHER 1988 Cher has been linked to a long list of men during her career—among others, Gregg Allman of the Allman Brothers, Gene Simmons of KISS, Richie Sambora of Bon Jovi, and Rob Camilletti of . . . Long Island. For two years, Camilletti, a 24-year-old former bagel maker, romanced the 42-year-old superstar songstress, finally proposing marriage in 1988. All through that summer, Cher dithered about whether to accept his proposal. "All I want to do is make her my wife, but she says marriage might ruin our love," Camilletti confided to one friend. One morning, Camilletti left Cher's $10-million Benedict Canyon mansion driving her $87,000 Ferrari. When he spotted a free-lance photographer outside the house, Camilletti rammed the man's Honda, then threatened to kill him. Camilletti was arrested and charged with assault with a deadly weapon. Cher was snapped here waiting to post Camilletti's $2,000 bail. "The kid was practically in tears," a cop said later.

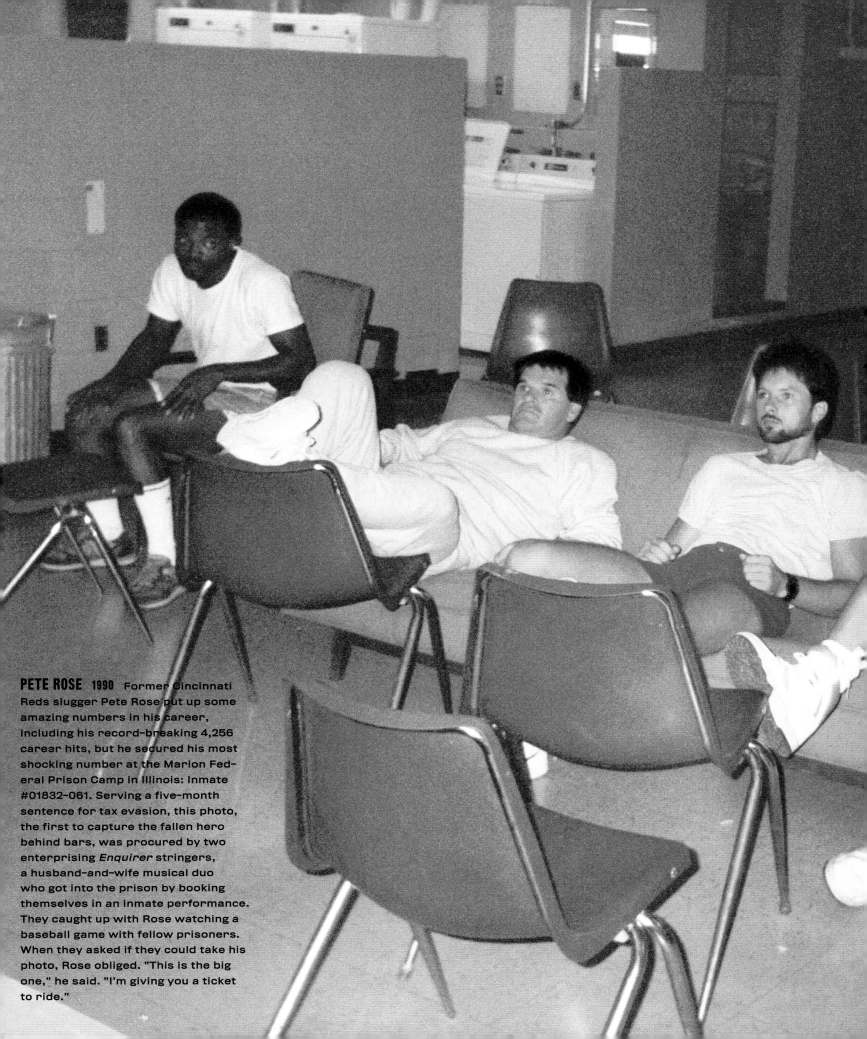

PETE ROSE 1990 Former Cincinnati Reds slugger Pete Rose put up some amazing numbers in his career, including his record-breaking 4,256 career hits, but he secured his most shocking number at the Marion Federal Prison Camp in Illinois: Inmate #01832-061. Serving a five-month sentence for tax evasion, this photo, the first to capture the fallen hero behind bars, was procured by two enterprising *Enquirer* stringers, a husband-and-wife musical duo who got into the prison by booking themselves in an inmate performance. They caught up with Rose watching a baseball game with fellow prisoners. When they asked if they could take his photo, Rose obliged. "This is the big one," he said. "I'm giving you a ticket to ride."

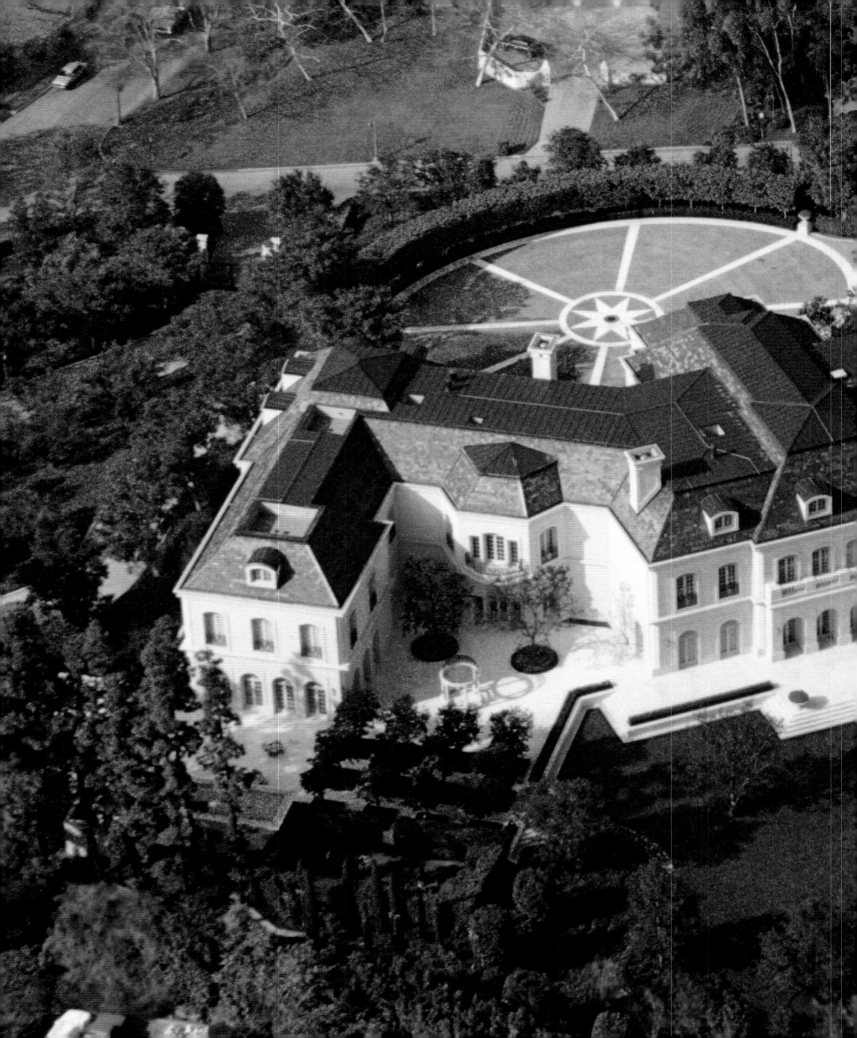

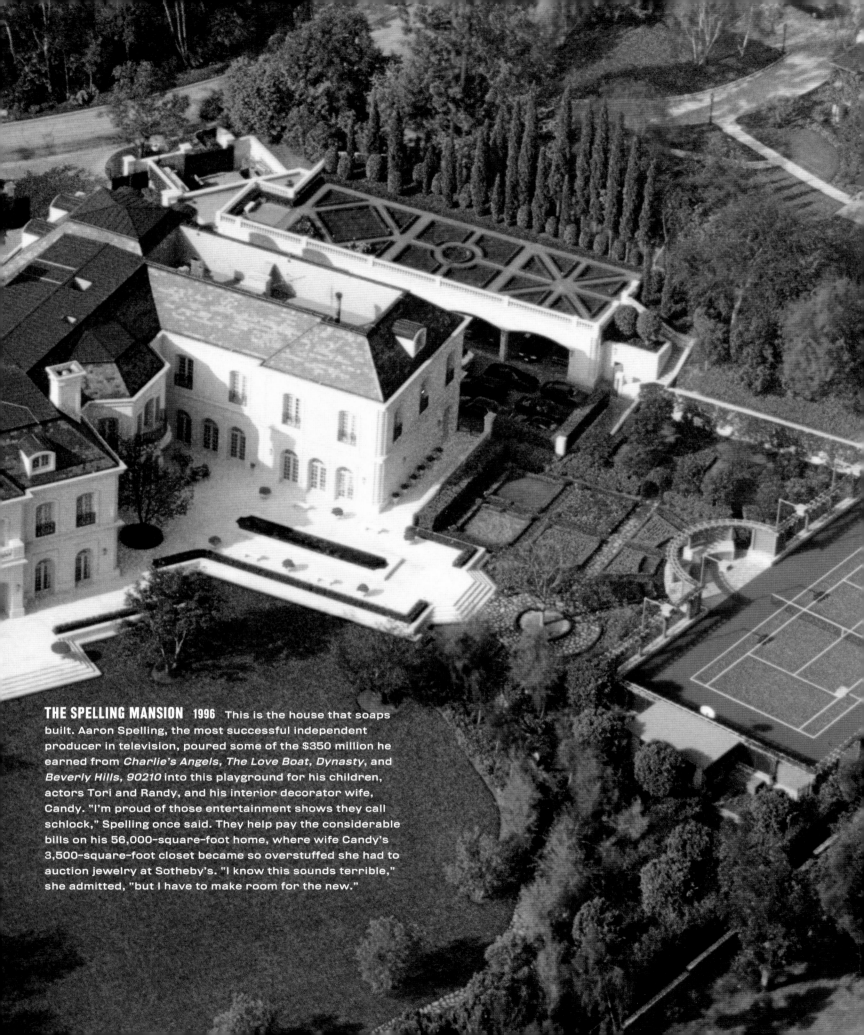

THE SPELLING MANSION 1996 This is the house that soaps built. Aaron Spelling, the most successful independent producer in television, poured some of the $350 million he earned from *Charlie's Angels*, *The Love Boat*, *Dynasty*, and *Beverly Hills, 90210* into this playground for his children, actors Tori and Randy, and his interior decorator wife, Candy. "I'm proud of those entertainment shows they call schlock," Spelling once said. They help pay the considerable bills on his 56,000-square-foot home, where wife Candy's 3,500-square-foot closet became so overstuffed she had to auction jewelry at Sotheby's. "I know this sounds terrible," she admitted, "but I have to make room for the new."

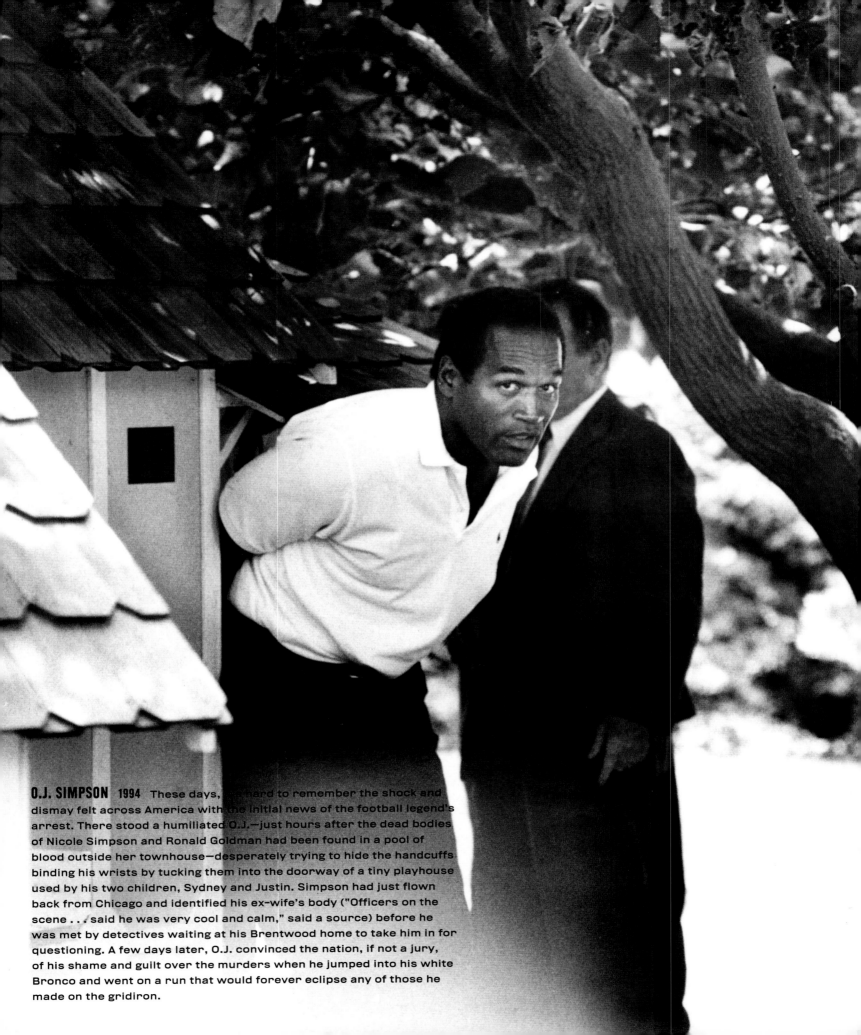

O.J. SIMPSON 1994 These days, it's hard to remember the shock and dismay felt across America with the initial news of the football legend's arrest. There stood a humiliated O.J.—just hours after the dead bodies of Nicole Simpson and Ronald Goldman had been found in a pool of blood outside her townhouse—desperately trying to hide the handcuffs binding his wrists by tucking them into the doorway of a tiny playhouse used by his two children, Sydney and Justin. Simpson had just flown back from Chicago and identified his ex-wife's body ("Officers on the scene . . . said he was very cool and calm," said a source) before he was met by detectives waiting at his Brentwood home to take him in for questioning. A few days later, O.J. convinced the nation, if not a jury, of his shame and guilt over the murders when he jumped into his white Bronco and went on a run that would forever eclipse any of those he made on the gridiron.

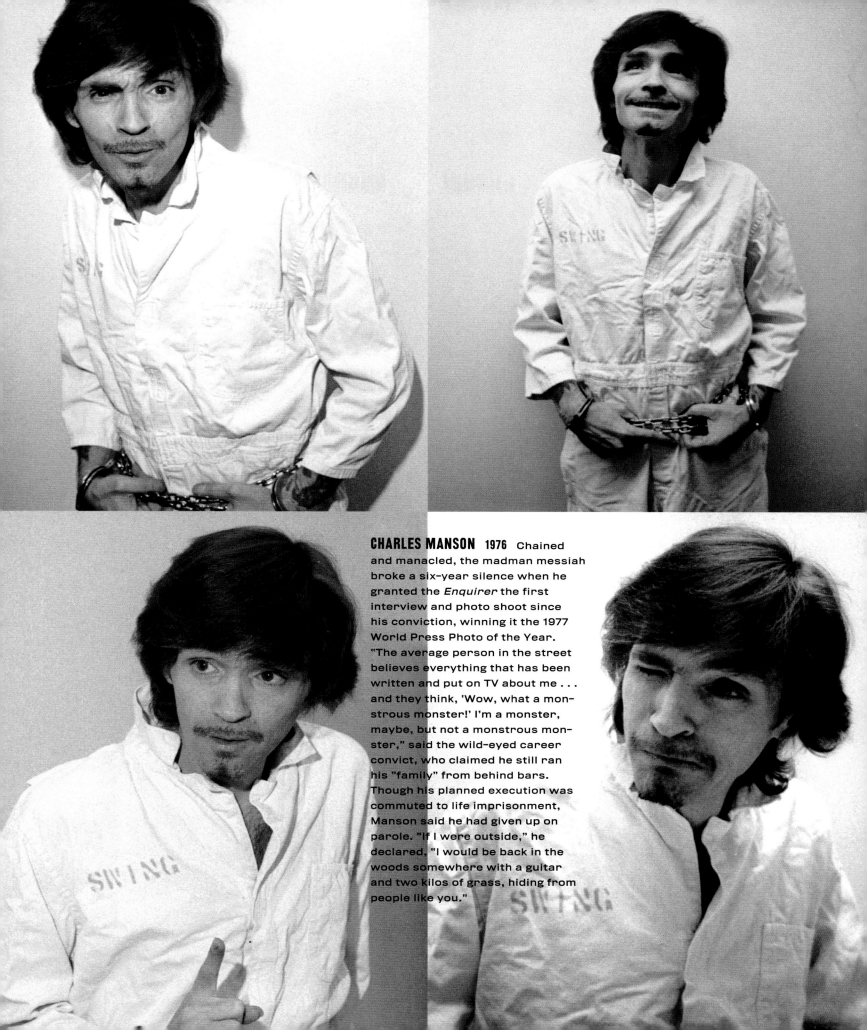

CHARLES MANSON 1976 Chained and manacled, the madman messiah broke a six-year silence when he granted the *Enquirer* the first interview and photo shoot since his conviction, winning it the 1977 World Press Photo of the Year. "The average person in the street believes everything that has been written and put on TV about me . . . and they think, 'Wow, what a monstrous monster!' I'm a monster, maybe, but not a monstrous monster," said the wild-eyed career convict, who claimed he still ran his "family" from behind bars. Though his planned execution was commuted to life imprisonment, Manson said he had given up on parole. "If I were outside," he declared, "I would be back in the woods somewhere with a guitar and two kilos of grass, hiding from people like you."

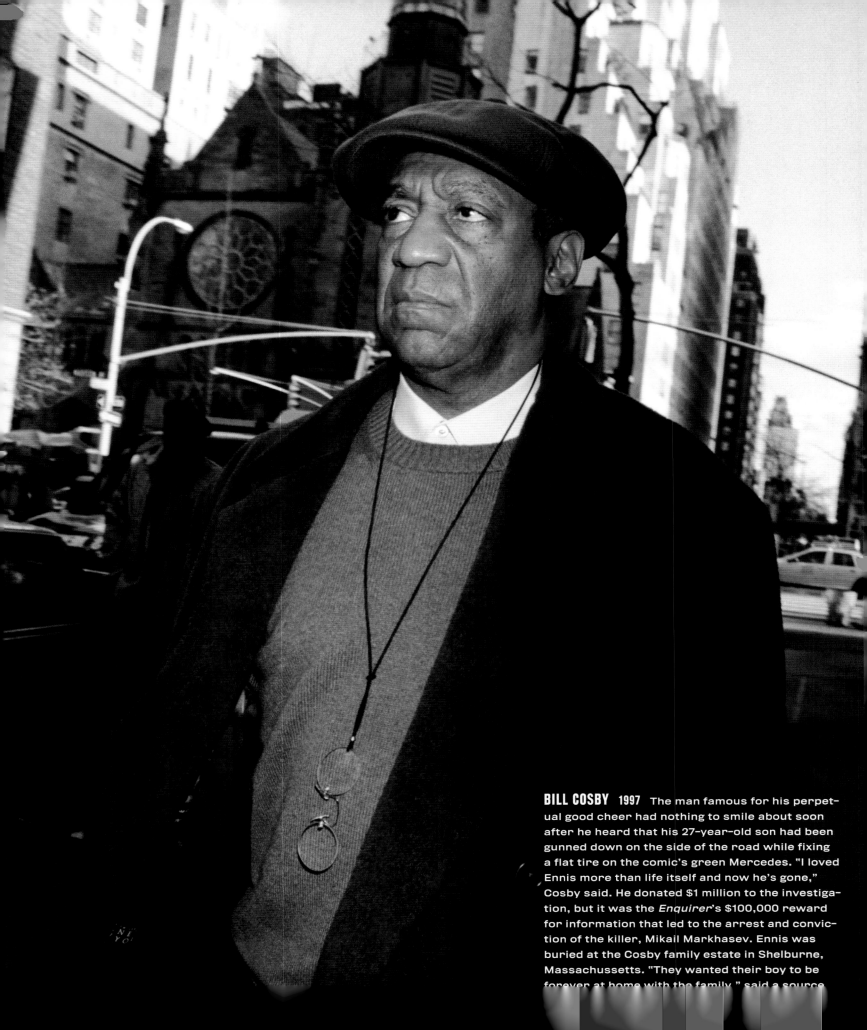

BILL COSBY 1997 The man famous for his perpetual good cheer had nothing to smile about soon after he heard that his 27-year-old son had been gunned down on the side of the road while fixing a flat tire on the comic's green Mercedes. "I loved Ennis more than life itself and now he's gone," Cosby said. He donated $1 million to the investigation, but it was the *Enquirer*'s $100,000 reward for information that led to the arrest and conviction of the killer, Mikail Markhasev. Ennis was buried at the Cosby family estate in Shelburne, Massachussetts. "They wanted their boy to be forever at home with the family," said a source

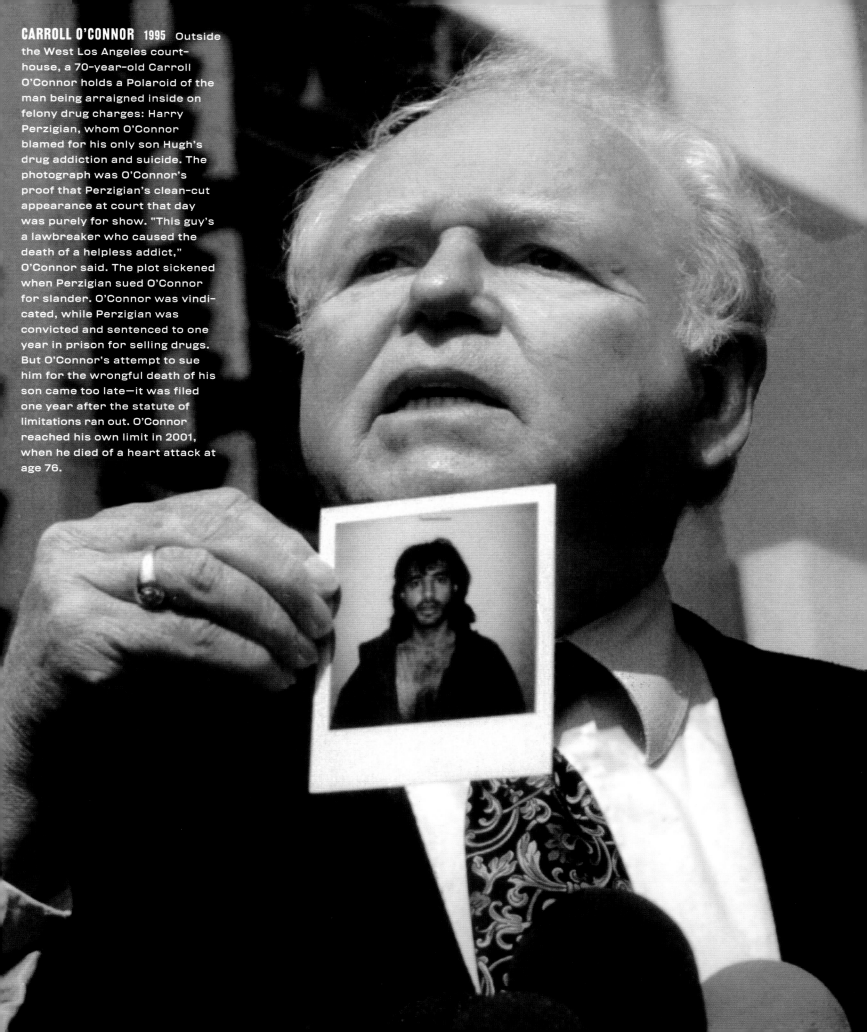

CARROLL O'CONNOR 1995 Outside the West Los Angeles courthouse, a 70-year-old Carroll O'Connor holds a Polaroid of the man being arraigned inside on felony drug charges: Harry Perzigian, whom O'Connor blamed for his only son Hugh's drug addiction and suicide. The photograph was O'Connor's proof that Perzigian's clean-cut appearance at court that day was purely for show. "This guy's a lawbreaker who caused the death of a helpless addict," O'Connor said. The plot sickened when Perzigian sued O'Connor for slander. O'Connor was vindicated, while Perzigian was convicted and sentenced to one year in prison for selling drugs. But O'Connor's attempt to sue him for the wrongful death of his son came too late—it was filed one year after the statute of limitations ran out. O'Connor reached his own limit in 2001, when he died of a heart attack at age 76.

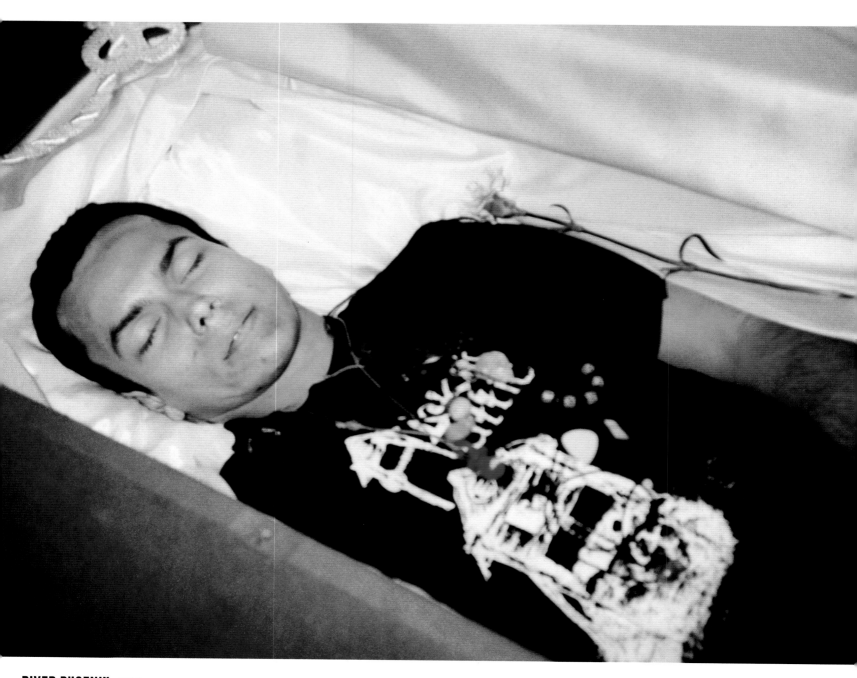

RIVER PHOENIX 1993 The 23-year-old actor had a reputation for a hippy-dippy childhood and healthy vegan diet, but there was nothing at all natural about his sudden death one Halloween night outside the Viper Room in Los Angeles: He collapsed on the sidewalk after injecting a cocaine-and-heroin speedball. In this final portrait, taken during the viewing at the Milam Funeral Home in Gainesville, Florida, the star who was to appear in *Interview with the Vampire* rests in his coffin wearing his band's T-shirt, surrounded by notes and necklaces from friends and fans and a single carnation placed there by his mother. "Some of the numbed onlookers sat and just swayed back and forth in their grief," one mourner reported. Phoenix was cremated and, contrary to the hopes of his fans, is not likely to rise from his ashes.

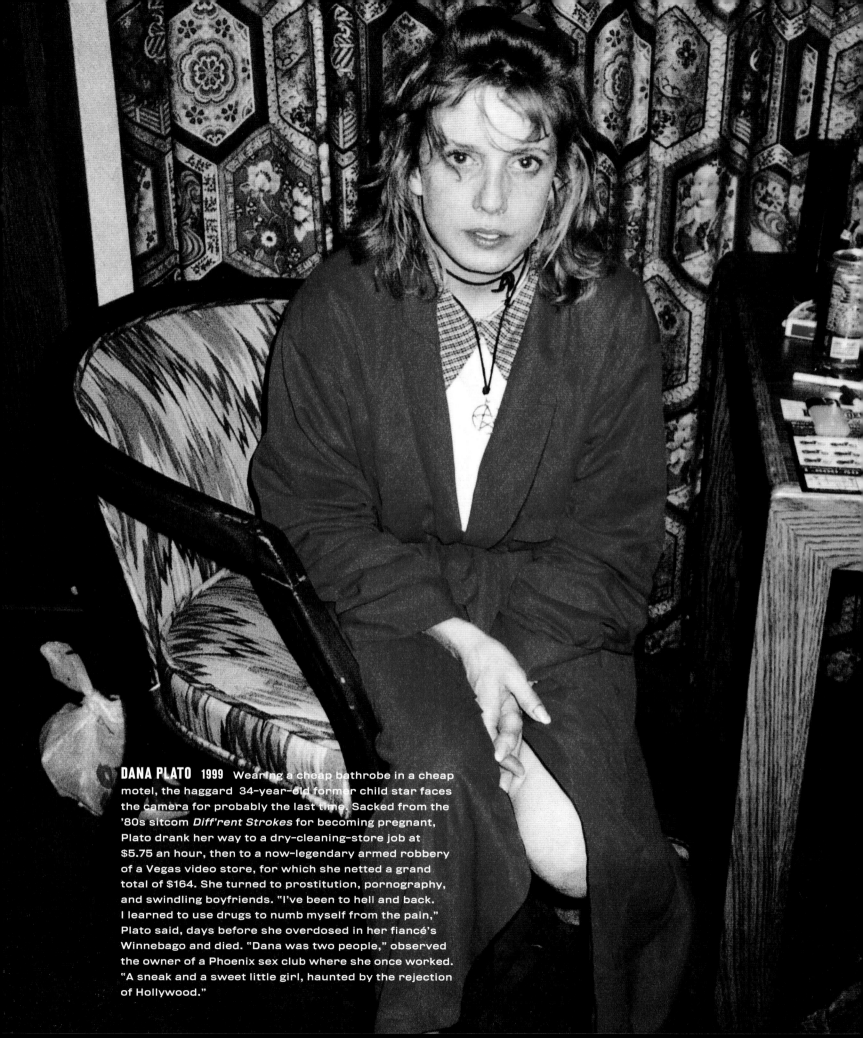

DANA PLATO 1999 Wearing a cheap bathrobe in a cheap motel, the haggard 34-year-old former child star faces the camera for probably the last time. Sacked from the '80s sitcom *Diff'rent Strokes* for becoming pregnant, Plato drank her way to a dry-cleaning-store job at $5.75 an hour, then to a now-legendary armed robbery of a Vegas video store, for which she netted a grand total of $164. She turned to prostitution, pornography, and swindling boyfriends. "I've been to hell and back. I learned to use drugs to numb myself from the pain," Plato said, days before she overdosed in her fiancé's Winnebago and died. "Dana was two people," observed the owner of a Phoenix sex club where she once worked. "A sneak and a sweet little girl, haunted by the rejection of Hollywood."

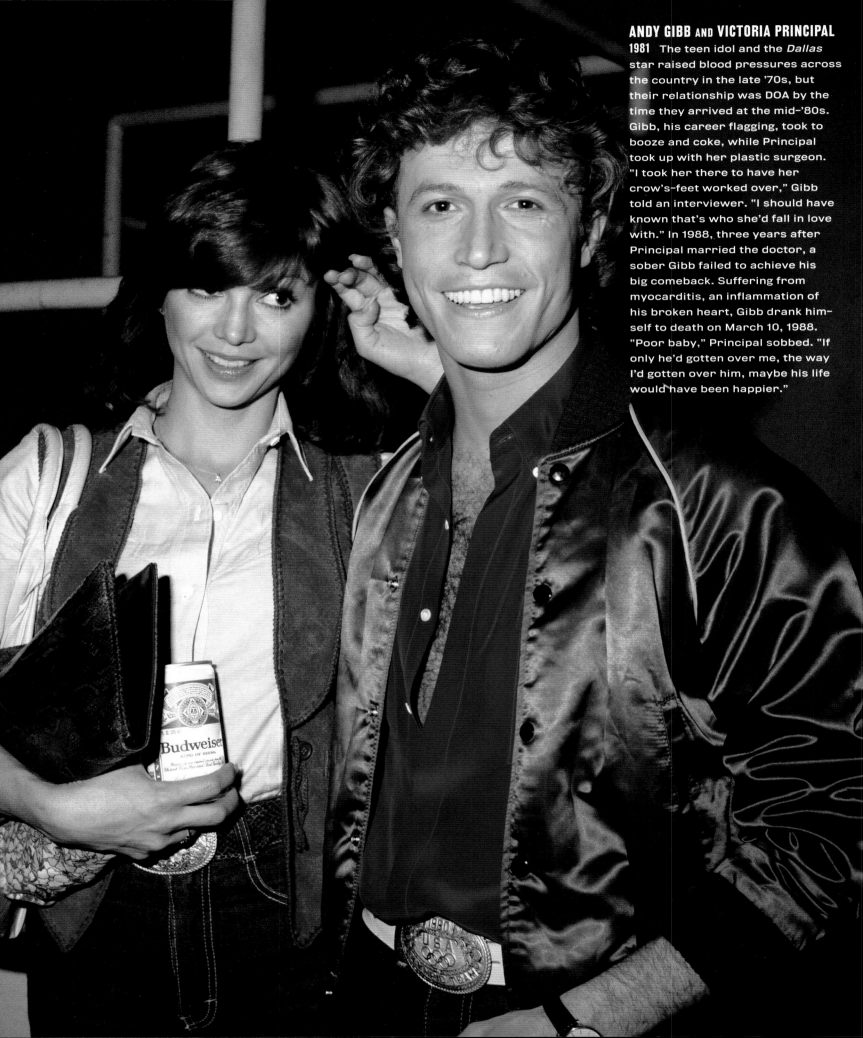

ANDY GIBB AND VICTORIA PRINCIPAL

1981 The teen idol and the *Dallas* star raised blood pressures across the country in the late '70s, but their relationship was DOA by the time they arrived at the mid-'80s. Gibb, his career flagging, took to booze and coke, while Principal took up with her plastic surgeon. "I took her there to have her crow's-feet worked over," Gibb told an interviewer. "I should have known that's who she'd fall in love with." In 1988, three years after Principal married the doctor, a sober Gibb failed to achieve his big comeback. Suffering from myocarditis, an inflammation of his broken heart, Gibb drank himself to death on March 10, 1988. "Poor baby," Principal sobbed. "If only he'd gotten over me, the way I'd gotten over him, maybe his life would have been happier."

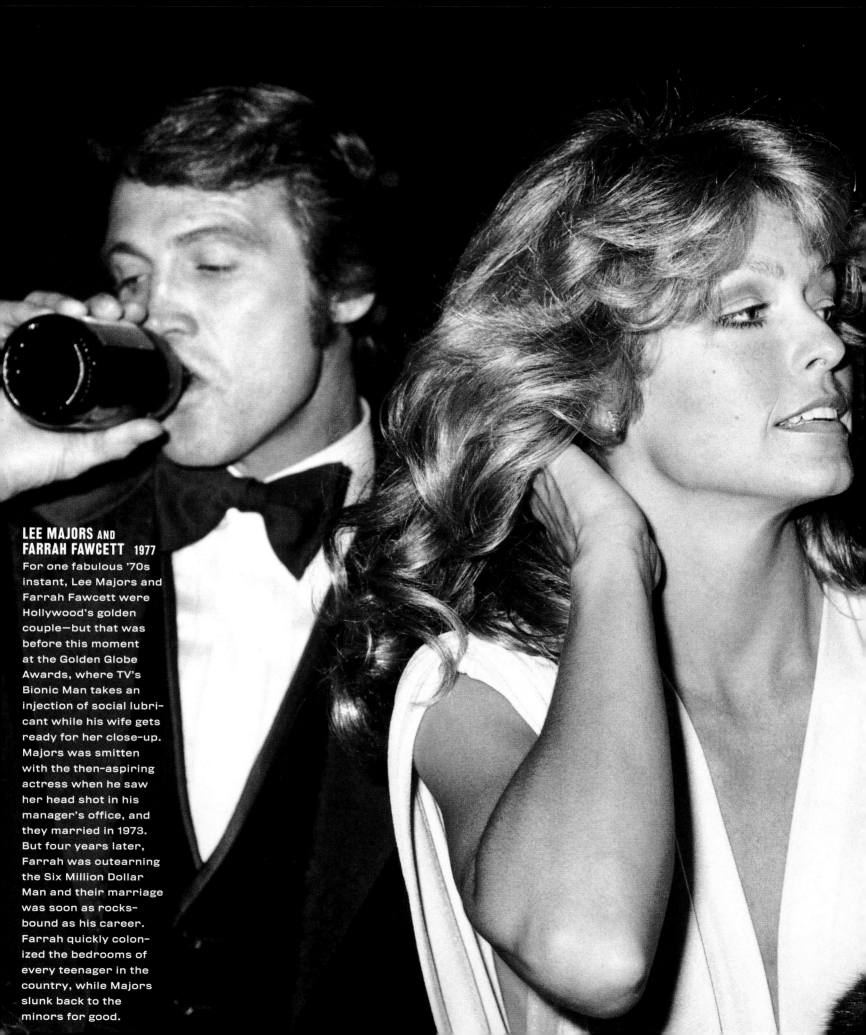

LEE MAJORS AND
FARRAH FAWCETT 1977
For one fabulous '70s
instant, Lee Majors and
Farrah Fawcett were
Hollywood's golden
couple—but that was
before this moment
at the Golden Globe
Awards, where TV's
Bionic Man takes an
injection of social lubri-
cant while his wife gets
ready for her close-up.
Majors was smitten
with the then-aspiring
actress when he saw
her head shot in his
manager's office, and
they married in 1973.
But four years later,
Farrah was outearning
the Six Million Dollar
Man and their marriage
was soon as rocks-
bound as his career.
Farrah quickly colon-
ized the bedrooms of
every teenager in the
country, while Majors
slunk back to the
minors for good.

LAUREN BACALL 1978 "You know how to whistle, don't you?" said Bacall in her first film, *To Have and Have Not.* "Just put your lips together and . . . blow." The immortal line, uttered in her trademark low, husky voice, would instantly make the 19-year-old into a national sex symbol. Her costar, Humphrey Bogart, was not immune: They were married a year later, in 1945, and kicked off a famous romance that also led to costarring roles in several more film masterpieces: *The Big Sleep, Dark Passage,* and *Key Largo.* After 12 years of marriage, Bogie died of throat cancer, devastating Bacall. Although she tried marriage once more—to Jason Robards—after her divorce in 1969, Bacall remained solo, as she is caught here, dancing at Elizabeth Taylor's 46th birthday bash at the Ginger Man in New York City.

PETER LAWFORD 1978 The monogram-shoed Rat Packer, seen here kicking up his heels solo at a nightclub, was a gentleman to the end. Lawford, once married to Pat Kennedy—sister of Jack— likely knew about the philandering president's secret dates and was probably privy to plenty of juicy details about the dirty dancings of friends Frank Sinatra and Dean Martin. But several decades, three wives, and many girlfriends later, at a time when his personal coffers were at an all-time low, the actor turned down a hefty sum to write a tell-all book on his famous friends' love lives. When Lawford was asked to rate the president's way with the ladies, he said, "I'm not gonna blacken [Jack Kennedy's] name no matter how much I need the money."

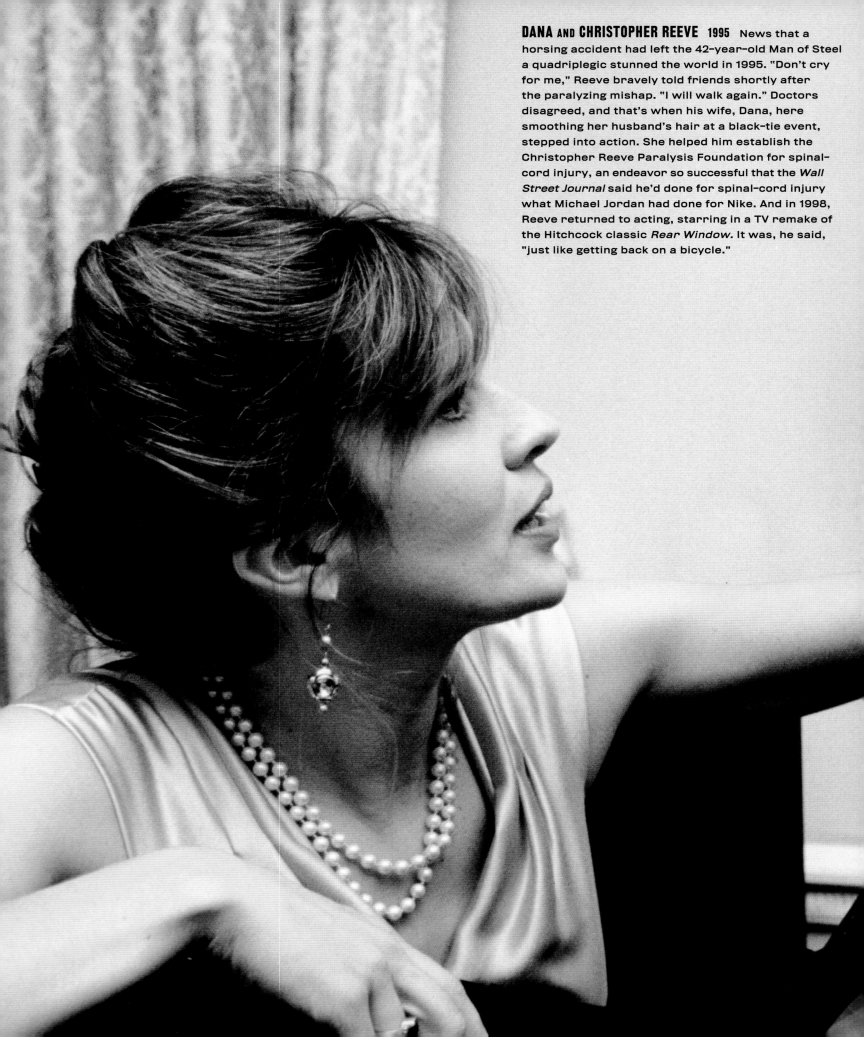

DANA AND CHRISTOPHER REEVE 1995 News that a horsing accident had left the 42-year-old Man of Steel a quadriplegic stunned the world in 1995. "Don't cry for me," Reeve bravely told friends shortly after the paralyzing mishap. "I will walk again." Doctors disagreed, and that's when his wife, Dana, here smoothing her husband's hair at a black-tie event, stepped into action. She helped him establish the Christopher Reeve Paralysis Foundation for spinal-cord injury, an endeavor so successful that the *Wall Street Journal* said he'd done for spinal-cord injury what Michael Jordan had done for Nike. And in 1998, Reeve returned to acting, starring in a TV remake of the Hitchcock classic *Rear Window.* It was, he said, "just like getting back on a bicycle."

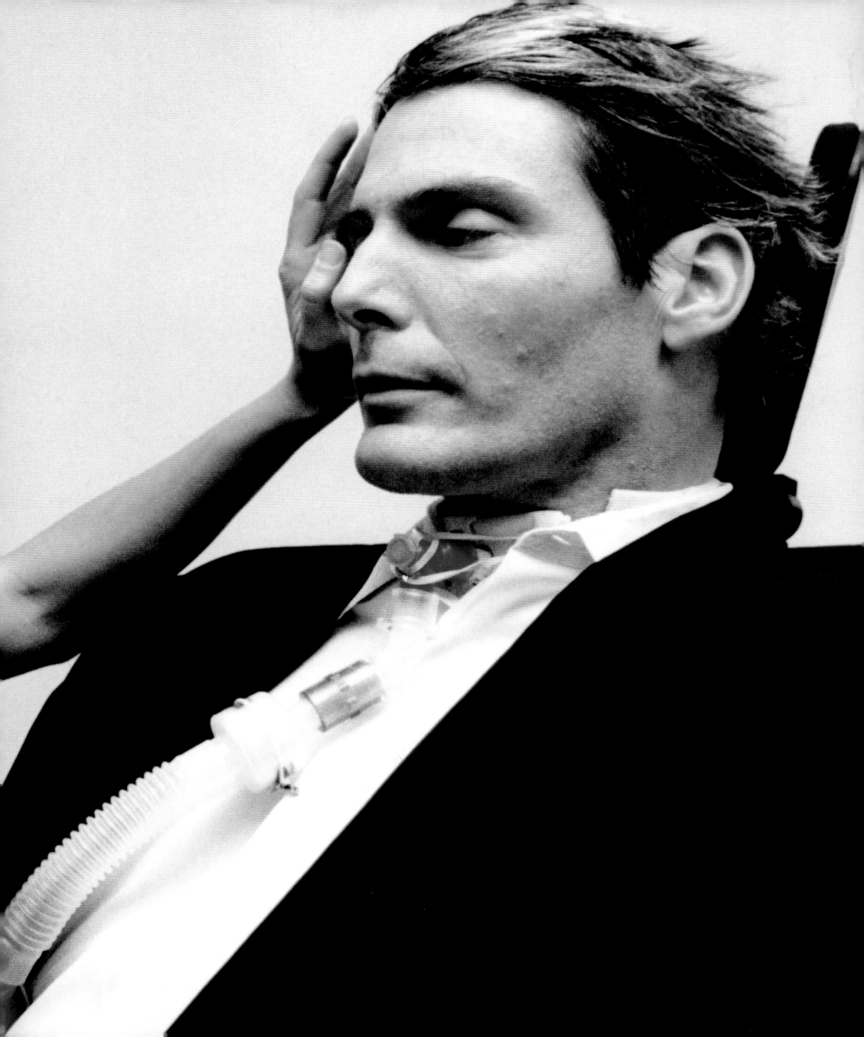

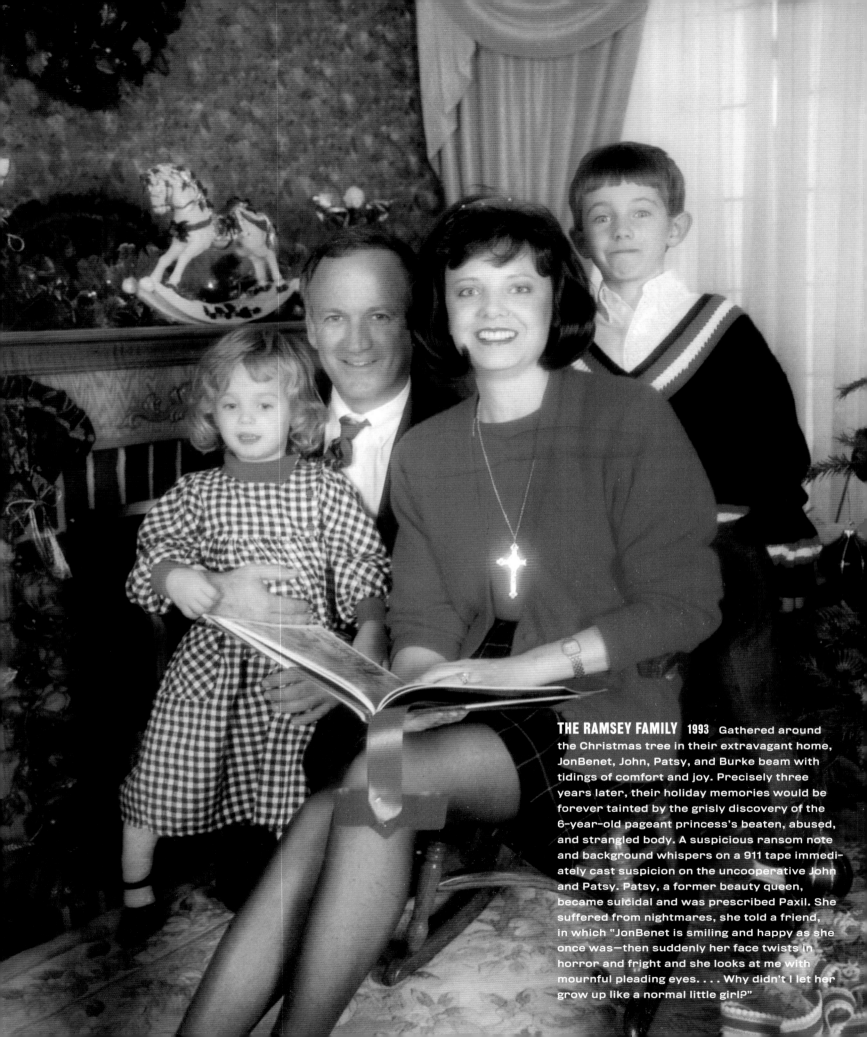

THE RAMSEY FAMILY 1993 Gathered around the Christmas tree in their extravagant home, JonBenet, John, Patsy, and Burke beam with tidings of comfort and joy. Precisely three years later, their holiday memories would be forever tainted by the grisly discovery of the 6-year-old pageant princess's beaten, abused, and strangled body. A suspicious ransom note and background whispers on a 911 tape immediately cast suspicion on the uncooperative John and Patsy. Patsy, a former beauty queen, became suicidal and was prescribed Paxil. She suffered from nightmares, she told a friend, in which "JonBenet is smiling and happy as she once was—then suddenly her face twists in horror and fright and she looks at me with mournful pleading eyes. . . . Why didn't I let her grow up like a normal little girl?"

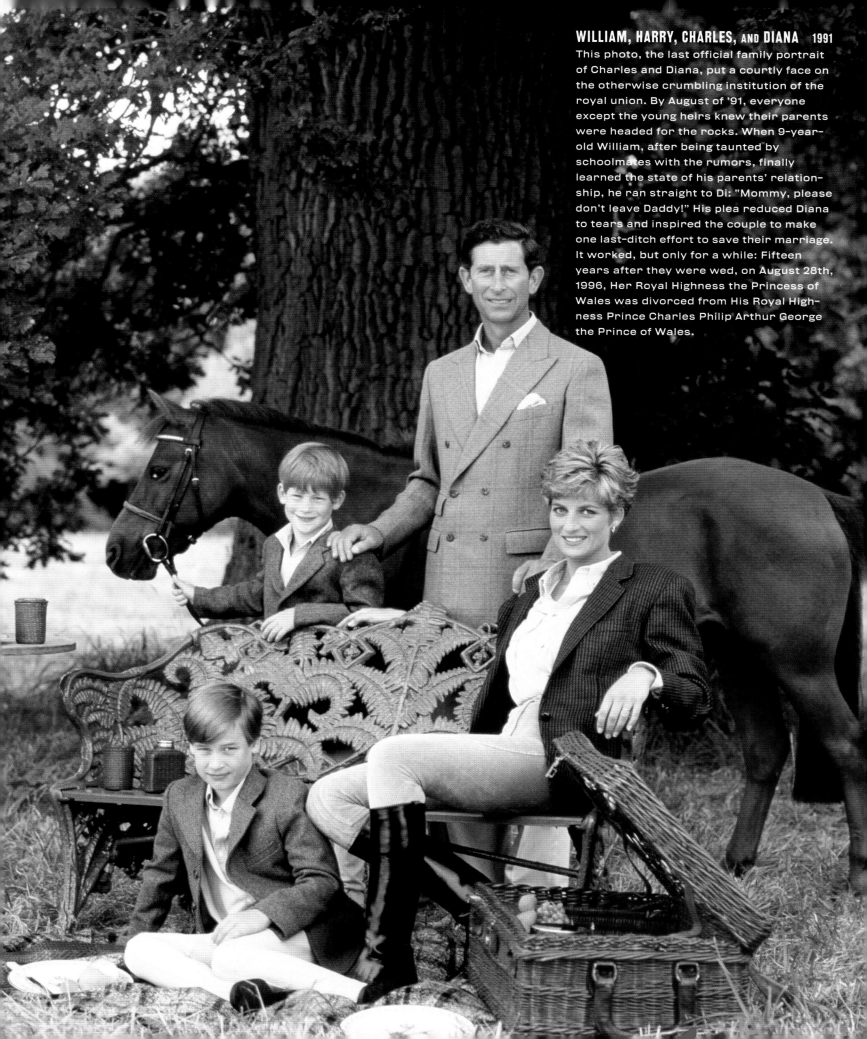

WILLIAM, HARRY, CHARLES, AND DIANA 1991

This photo, the last official family portrait of Charles and Diana, put a courtly face on the otherwise crumbling institution of the royal union. By August of '91, everyone except the young heirs knew their parents were headed for the rocks. When 9-year-old William, after being taunted by schoolmates with the rumors, finally learned the state of his parents' relationship, he ran straight to Di: "Mommy, please don't leave Daddy!" His plea reduced Diana to tears and inspired the couple to make one last-ditch effort to save their marriage. It worked, but only for a while: Fifteen years after they were wed, on August 28th, 1996, Her Royal Highness the Princess of Wales was divorced from His Royal Highness Prince Charles Philip Arthur George the Prince of Wales.

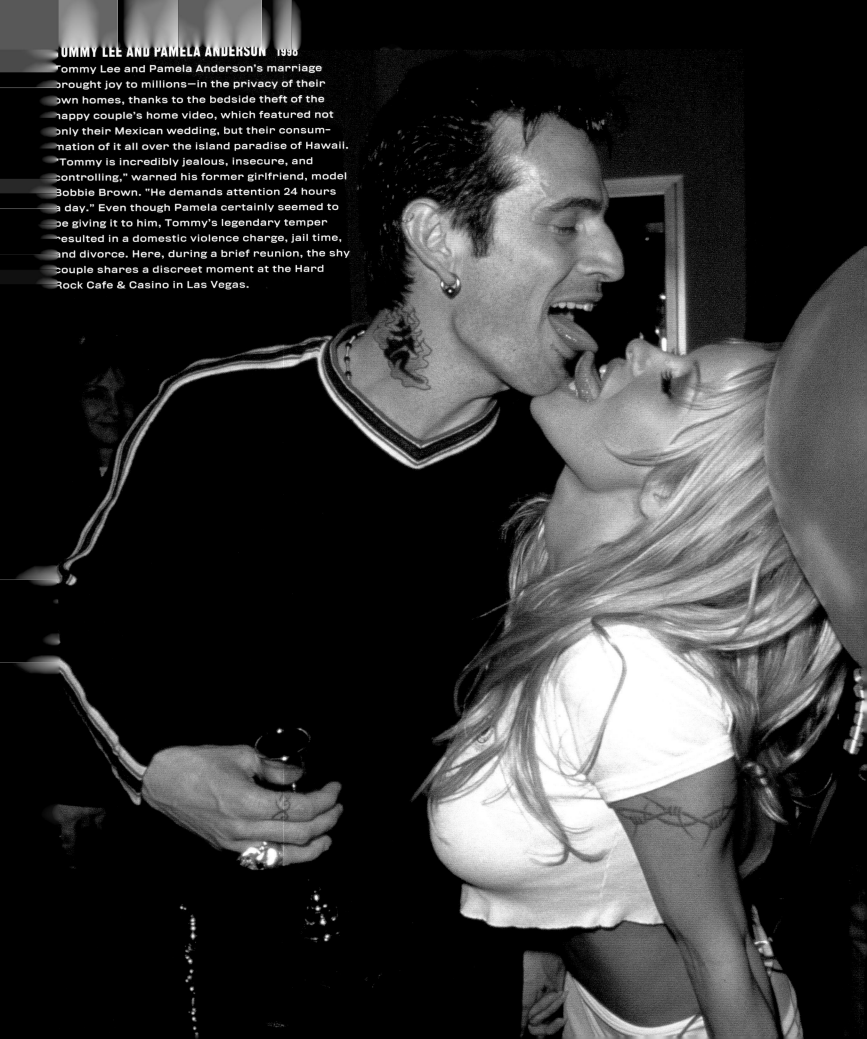

TOMMY LEE AND PAMELA ANDERSON 1998

Tommy Lee and Pamela Anderson's marriage brought joy to millions—in the privacy of their own homes, thanks to the bedside theft of the happy couple's home video, which featured not only their Mexican wedding, but their consummation of it all over the island paradise of Hawaii. "Tommy is incredibly jealous, insecure, and controlling," warned his former girlfriend, model Bobbie Brown. "He demands attention 24 hours a day." Even though Pamela certainly seemed to be giving it to him, Tommy's legendary temper resulted in a domestic violence charge, jail time, and divorce. Here, during a brief reunion, the shy couple shares a discreet moment at the Hard Rock Cafe & Casino in Las Vegas.

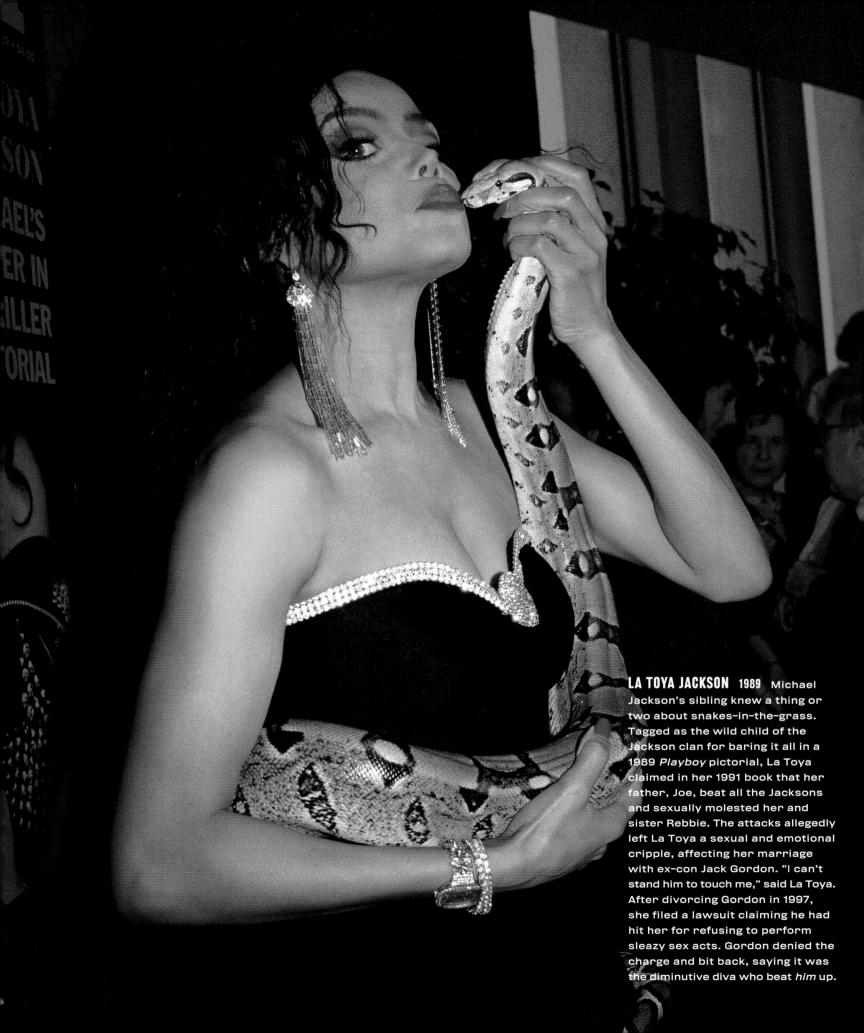

LA TOYA JACKSON 1989 Michael Jackson's sibling knew a thing or two about snakes-in-the-grass. Tagged as the wild child of the Jackson clan for baring it all in a 1989 *Playboy* pictorial, La Toya claimed in her 1991 book that her father, Joe, beat all the Jacksons and sexually molested her and sister Rebbie. The attacks allegedly left La Toya a sexual and emotional cripple, affecting her marriage with ex-con Jack Gordon. "I can't stand him to touch me," said La Toya. After divorcing Gordon in 1997, she filed a lawsuit claiming he had hit her for refusing to perform sleazy sex acts. Gordon denied the charge and bit back, saying it was the diminutive diva who beat *him* up.

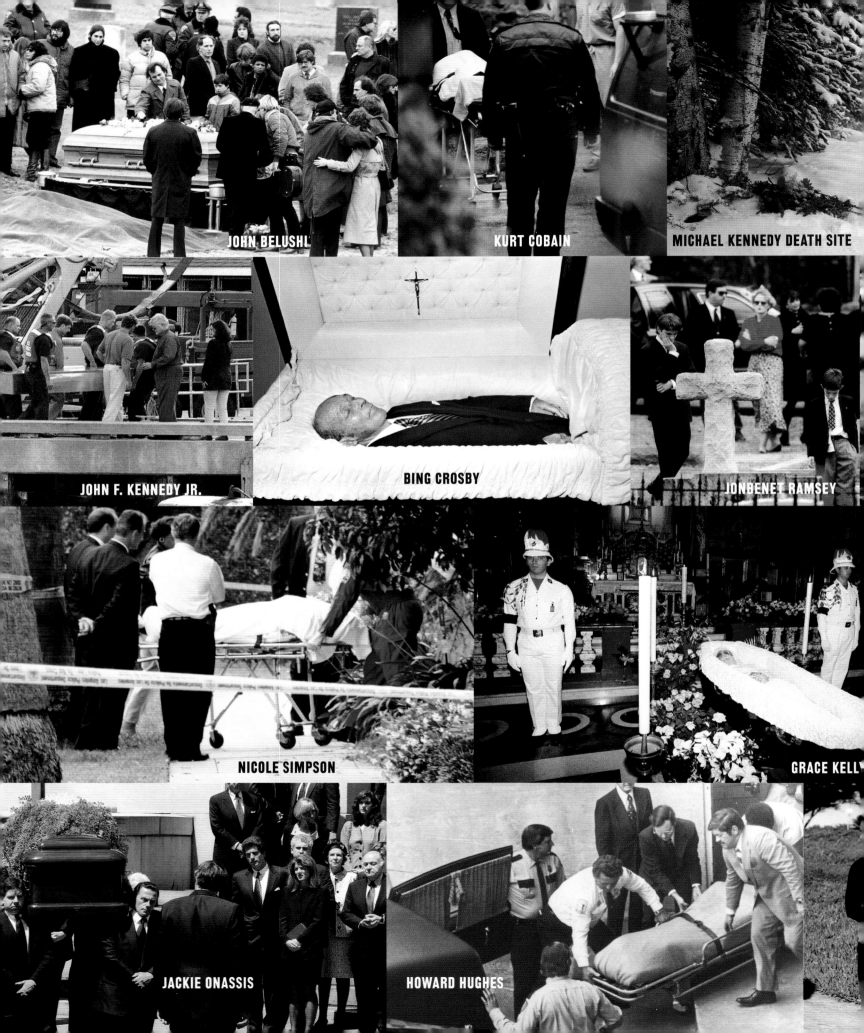

JOHN BELUSHI

KURT COBAIN

MICHAEL KENNEDY DEATH SITE

JOHN F. KENNEDY JR.

BING CROSBY

JONBENET RAMSEY

NICOLE SIMPSON

GRACE KELLY

JACKIE ONASSIS

HOWARD HUGHES

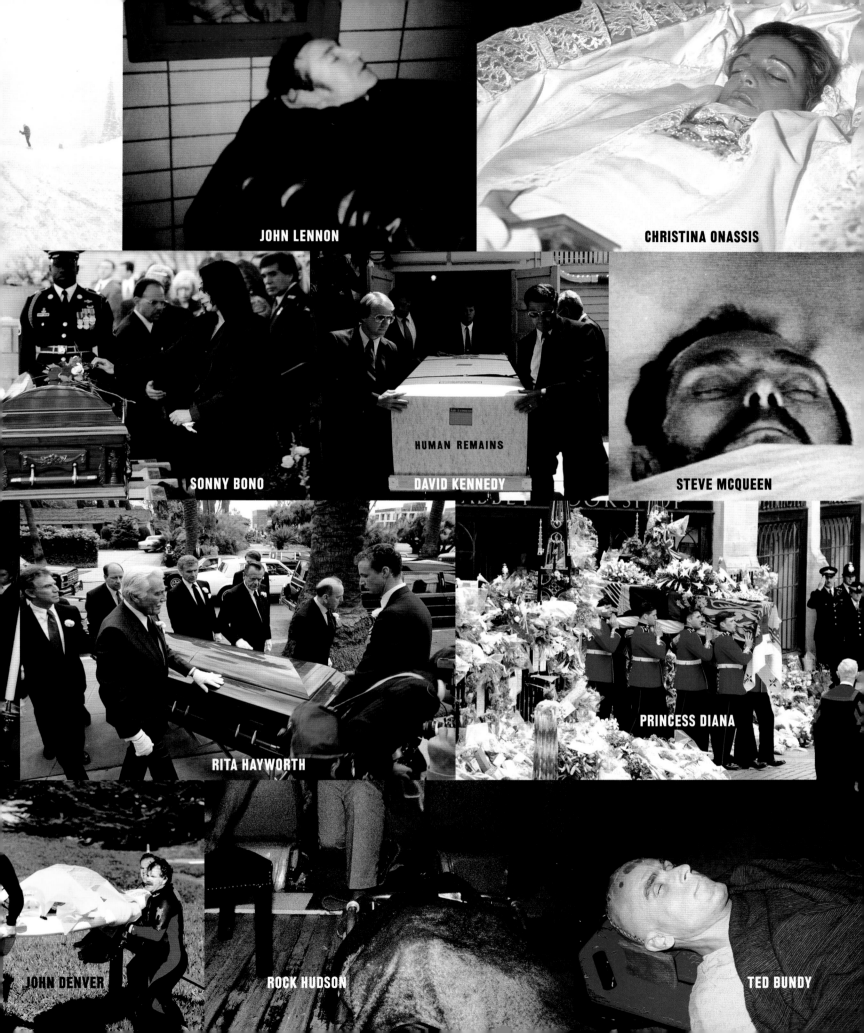

JOHN LENNON

CHRISTINA ONASSIS

SONNY BONO

HUMAN REMAINS

DAVID KENNEDY

STEVE McQUEEN

RITA HAYWORTH

PRINCESS DIANA

JOHN DENVER

ROCK HUDSON

TED BUNDY

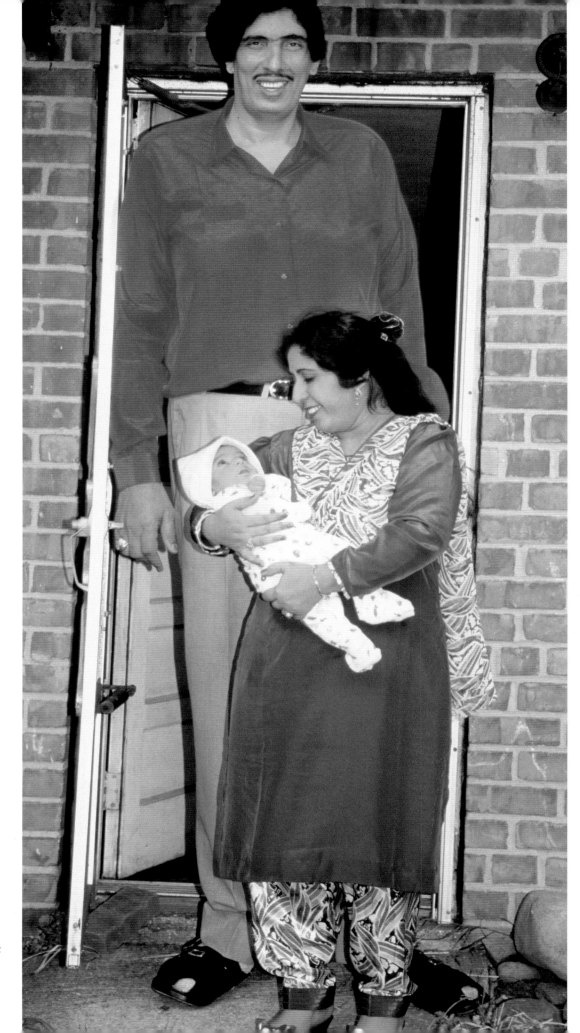

MOHAMMED ALAM CHANNA 1990

He wasn't anyone's first-round NBA draft choice, but the Pakistani former farmer did make the *Guinness Book* team, topping out at a record-setting 8'3" tall. "It isn't easy being this big," said the size-22-shod giant. "I have to sit down to take a shower." The 367-pounder suffered kidney problems and spent much of the last year of his life lying on two hospital beds laid end to end before passing on to an extra-large cloud in the sky. But he did leave a little something behind: Married to a 5'2" woman, Nasim, he fathered a son, Abid Ali. Although he was born a very normal-sized 19 1/2 inches, "he has big hands and feet," the proud papa said at the time. "You never know!"

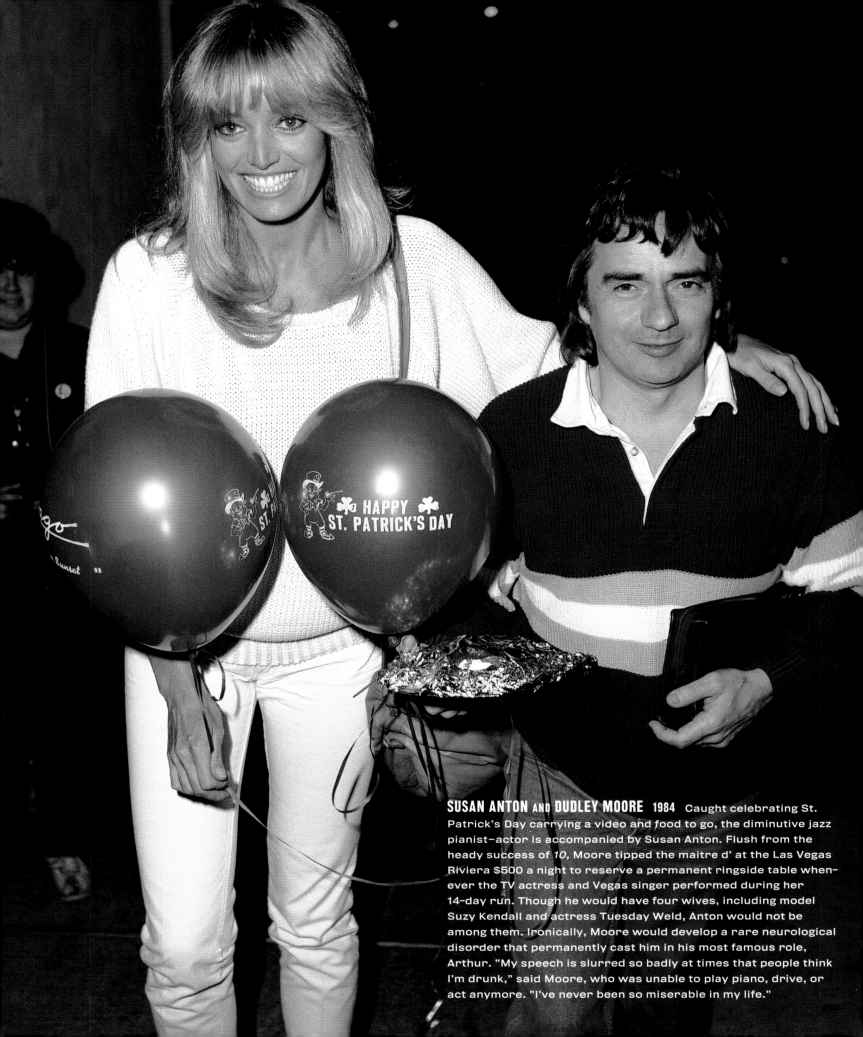

SUSAN ANTON AND DUDLEY MOORE 1984 Caught celebrating St. Patrick's Day carrying a video and food to go, the diminutive jazz pianist–actor is accompanied by Susan Anton. Flush from the heady success of *10*, Moore tipped the maitre d' at the Las Vegas Riviera $500 a night to reserve a permanent ringside table whenever the TV actress and Vegas singer performed during her 14-day run. Though he would have four wives, including model Suzy Kendall and actress Tuesday Weld, Anton would not be among them. Ironically, Moore would develop a rare neurological disorder that permanently cast him in his most famous role, Arthur. "My speech is slurred so badly at times that people think I'm drunk," said Moore, who was unable to play piano, drive, or act anymore. "I've never been so miserable in my life."

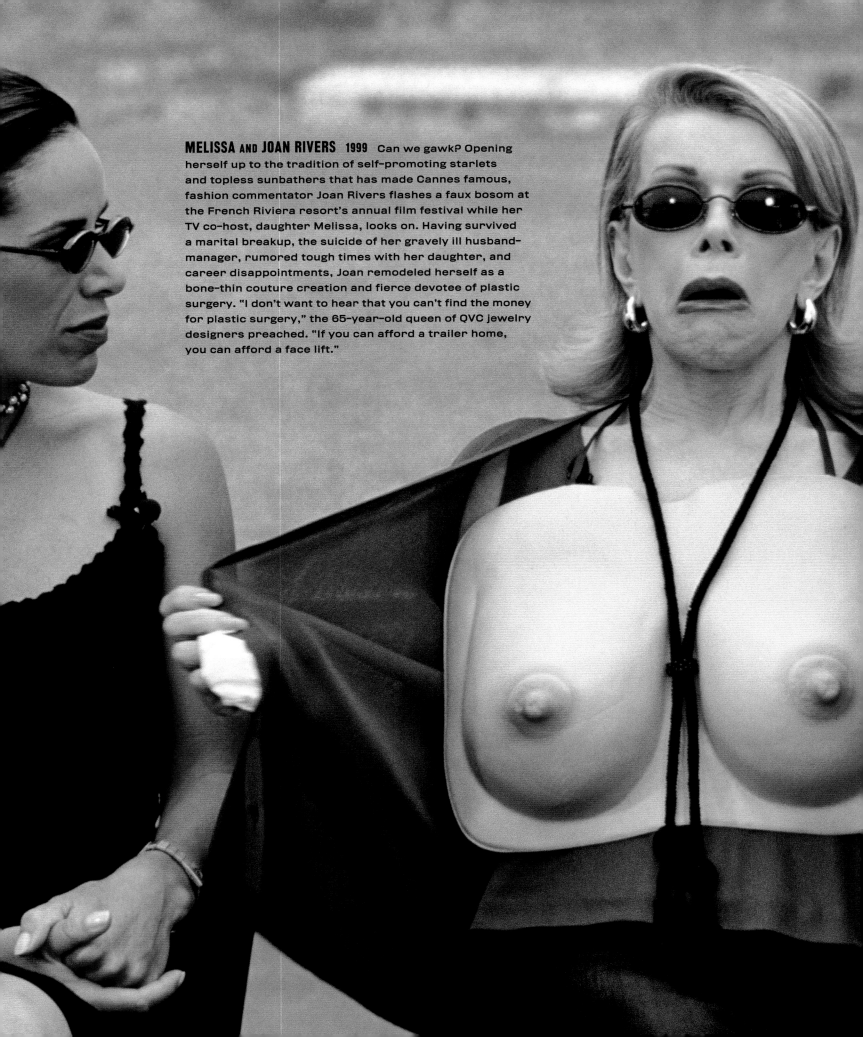

MELISSA AND JOAN RIVERS 1999 Can we gawk? Opening herself up to the tradition of self-promoting starlets and topless sunbathers that has made Cannes famous, fashion commentator Joan Rivers flashes a faux bosom at the French Riviera resort's annual film festival while her TV co-host, daughter Melissa, looks on. Having survived a marital breakup, the suicide of her gravely ill husband-manager, rumored tough times with her daughter, and career disappointments, Joan remodeled herself as a bone-thin couture creation and fierce devotee of plastic surgery. "I don't want to hear that you can't find the money for plastic surgery," the 65-year-old queen of QVC jewelry designers preached. "If you can afford a trailer home, you can afford a face lift."

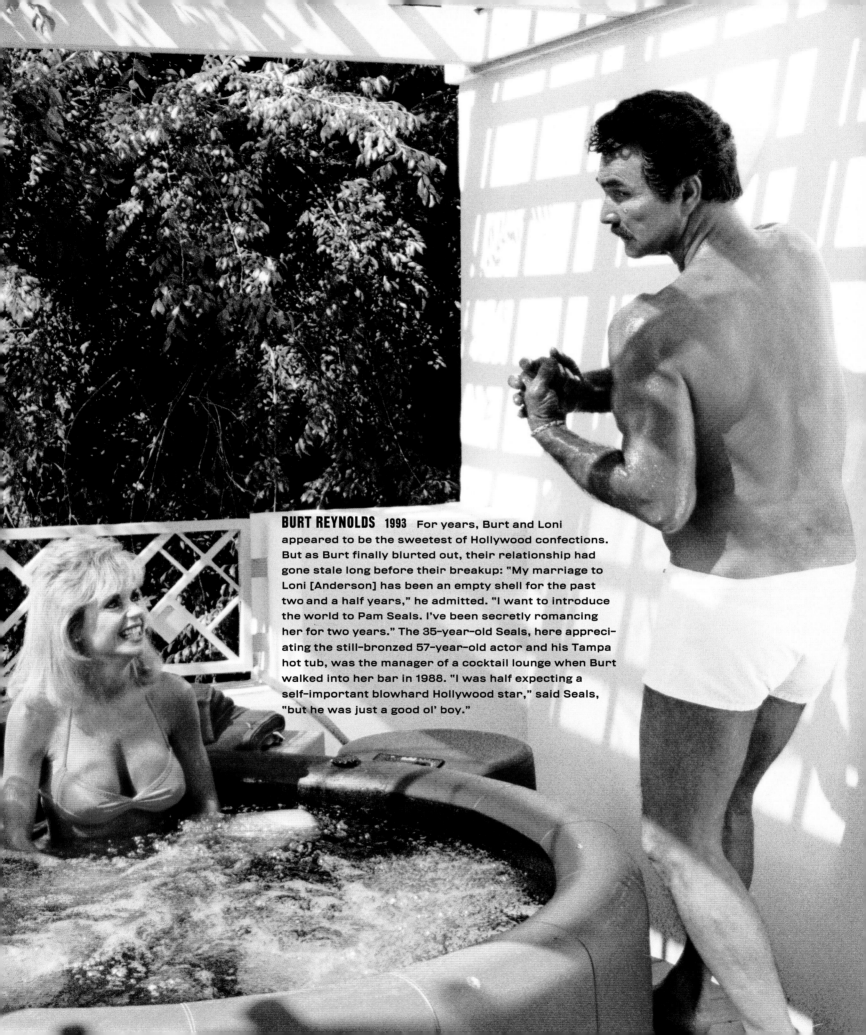

BURT REYNOLDS 1993 For years, Burt and Loni appeared to be the sweetest of Hollywood confections. But as Burt finally blurted out, their relationship had gone stale long before their breakup: "My marriage to Loni [Anderson] has been an empty shell for the past two and a half years," he admitted. "I want to introduce the world to Pam Seals. I've been secretly romancing her for two years." The 35-year-old Seals, here appreciating the still-bronzed 57-year-old actor and his Tampa hot tub, was the manager of a cocktail lounge when Burt walked into her bar in 1988. "I was half expecting a self-important blowhard Hollywood star," said Seals, "but he was just a good ol' boy."

PHYLLIS DILLER AND LOU FERRIGNO 1981 In a novel twist on *Beauty and the Beast,* funny lady Phyllis Diller works a little magic on muscleman Lou "The Incredible Hulk" Ferrigno at Zuma Beach, California. In their day, each of these performers may have seemed freakish, but they left a culturally significant legacy we can all be proud of: Ferrigno smashed down doors for bodybuilder–actors like Arnold Schwarzenegger, while the wacky, 110-pound Diller, who joked about her goofy appearance and freely admitted to plastic surgery, made Joan Rivers possible.

GEORGE HAMILTON 1986 Although George Hamilton's film career
has faded, his moment in the sun lives on and on, as his deep, year-
round tan attests. For Hamilton, who launched his own skin-care
system in the '80s, being permanently bronzed has been worth its
weight in gold. "I had succeeded in creating the perception of great
wealth, and that has been the story of my entire life," confessed the
happy-go-lucky actor. "I bought a 39-room mansion because my
brother told me that is what movie stars did." No doubt his radiant
glow and ever-present smile have also won over the countless
women who have adorned the infamous bachelor's arm, a list that
includes luminaries as various as Lynda Bird Johnson, Elizabeth
Taylor, and Imelda Marcos.

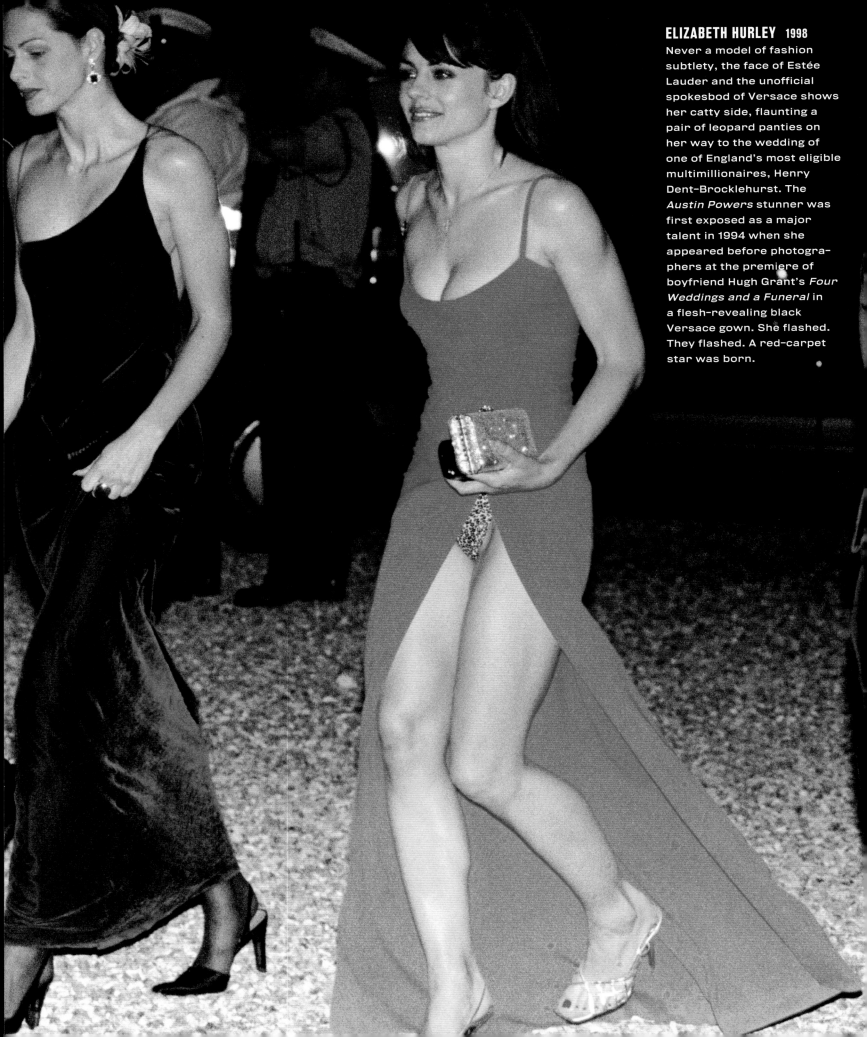

ELIZABETH HURLEY 1998
Never a model of fashion subtlety, the face of Estée Lauder and the unofficial spokesbod of Versace shows her catty side, flaunting a pair of leopard panties on her way to the wedding of one of England's most eligible multimillionaires, Henry Dent-Brocklehurst. The *Austin Powers* stunner was first exposed as a major talent in 1994 when she appeared before photographers at the premiere of boyfriend Hugh Grant's *Four Weddings and a Funeral* in a flesh-revealing black Versace gown. She flashed. They flashed. A red-carpet star was born.

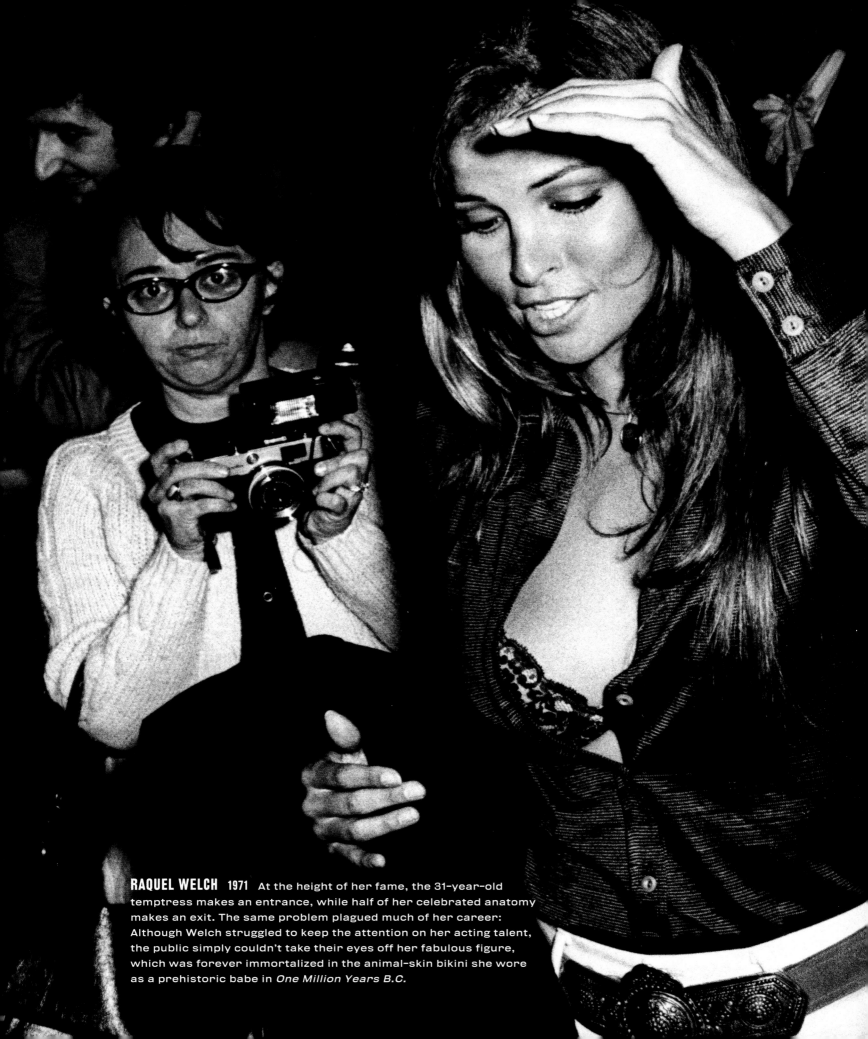

RAQUEL WELCH 1971 At the height of her fame, the 31-year-old temptress makes an entrance, while half of her celebrated anatomy makes an exit. The same problem plagued much of her career: Although Welch struggled to keep the attention on her acting talent, the public simply couldn't take their eyes off her fabulous figure, which was forever immortalized in the animal-skin bikini she wore as a prehistoric babe in *One Million Years B.C.*

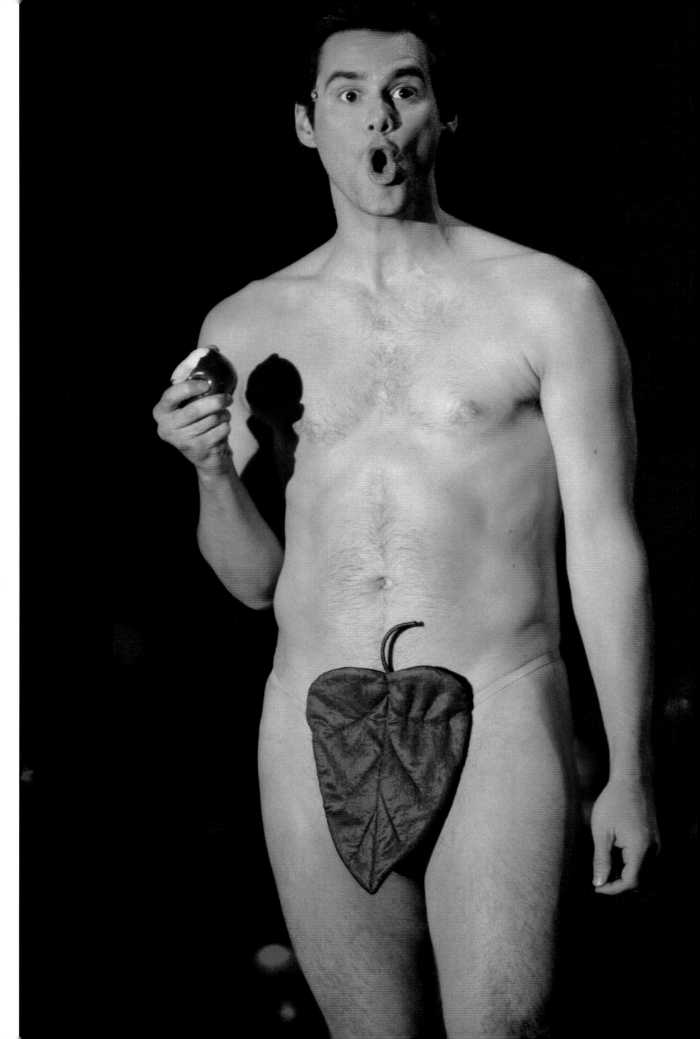

JIM CARREY 1997

Jim Carrey showed off everything but his funny bone at the 1997 VH1 Fashion Awards ceremony. After the laughing and cheering died down, the loose-limbed 35-year-old comic, whose breakout movie *Ace Ventura: Pet Detective* had him literally talking out his ass, explained to the audience that the giant fig leaf he wore onstage was a tribute to "where fashion began." It wasn't the first time the *In Living Color* alumnus had let it almost all hang out: For the Comedy Store's 20th-anniversary show, Carrey tastefully sported a sock over his jock—and thankfully kept his foot out of his mouth—when he performed at the comedy club where his career took off.

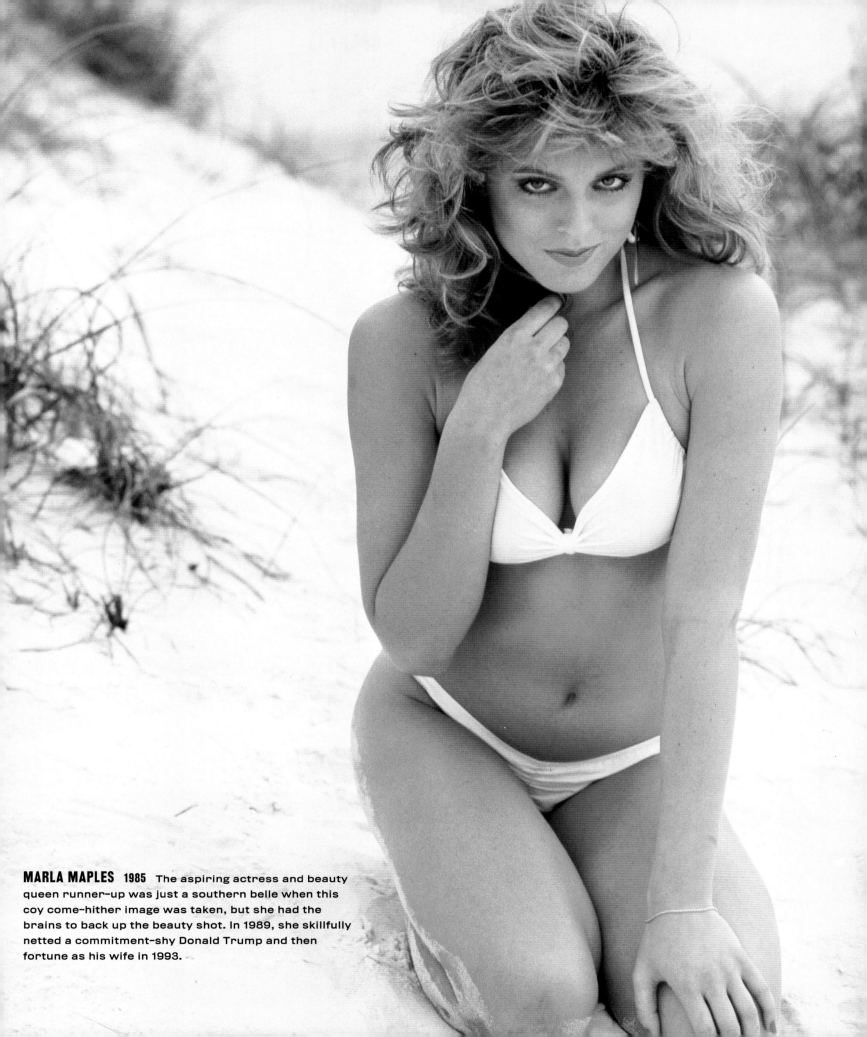

MARLA MAPLES 1985 The aspiring actress and beauty queen runner-up was just a southern belle when this coy come-hither image was taken, but she had the brains to back up the beauty shot. In 1989, she skillfully netted a commitment-shy Donald Trump and then fortune as his wife in 1993.

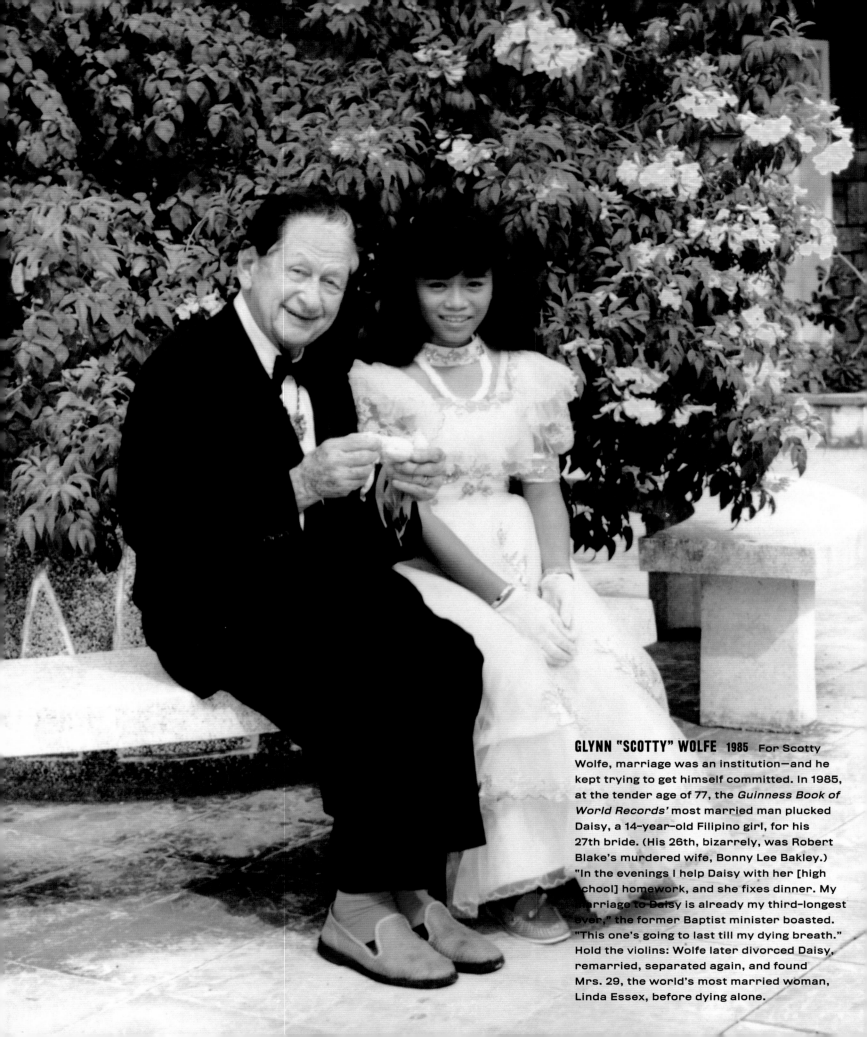

GLYNN "SCOTTY" WOLFE 1985 For Scotty Wolfe, marriage was an institution—and he kept trying to get himself committed. In 1985, at the tender age of 77, the *Guinness Book of World Records'* most married man plucked Daisy, a 14-year-old Filipino girl, for his 27th bride. (His 26th, bizarrely, was Robert Blake's murdered wife, Bonny Lee Bakley.) "In the evenings I help Daisy with her [high school] homework, and she fixes dinner. My marriage to Daisy is already my third-longest ever," the former Baptist minister boasted. "This one's going to last till my dying breath." Hold the violins: Wolfe later divorced Daisy, remarried, separated again, and found Mrs. 29, the world's most married woman, Linda Essex, before dying alone.

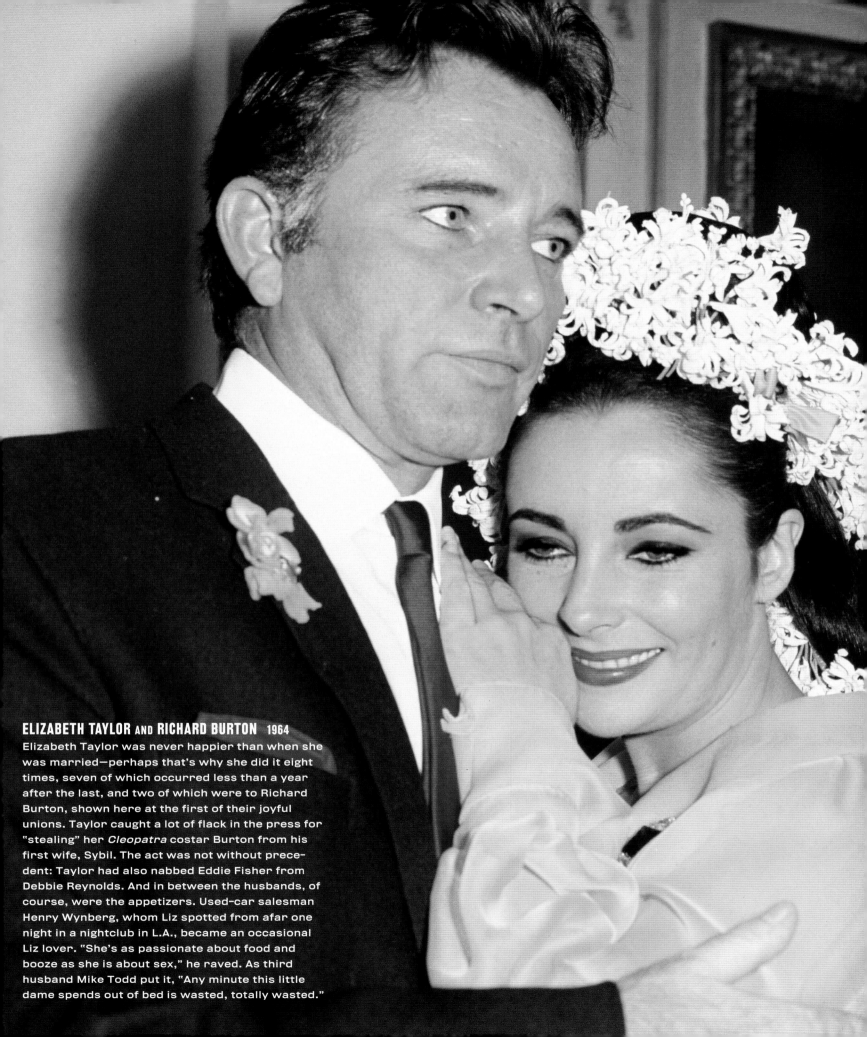

ELIZABETH TAYLOR AND RICHARD BURTON 1964
Elizabeth Taylor was never happier than when she was married—perhaps that's why she did it eight times, seven of which occurred less than a year after the last, and two of which were to Richard Burton, shown here at the first of their joyful unions. Taylor caught a lot of flack in the press for "stealing" her *Cleopatra* costar Burton from his first wife, Sybil. The act was not without precedent: Taylor had also nabbed Eddie Fisher from Debbie Reynolds. And in between the husbands, of course, were the appetizers. Used-car salesman Henry Wynberg, whom Liz spotted from afar one night in a nightclub in L.A., became an occasional Liz lover. "She's as passionate about food and booze as she is about sex," he raved. As third husband Mike Todd put it, "Any minute this little dame spends out of bed is wasted, totally wasted."

BROOKE ASTOR 1999 Don't let the dolphin fool you: The nearly 100-year-old freewheeling socialite, a descendant of one of the signers of the Declaration of Independence, has never had to depend on anyone for anything. Astor, who made the acquaintance of the sea creature at the Manatee Park resort while on vacation in the Dominican Republic, is heir to one of America's oldest fortunes. Still, except for giving it away—she is one of New York City's greatest philanthropists—dollars don't interest the doyenne of dinner parties. "I love life and I love people," says Astor, who lives alone in Manhattan with two miniature dachshunds and a French maid, and attends functions every evening. "But in my day, people used to talk more about interesting things, about politics and books. Now all people do is talk about money."

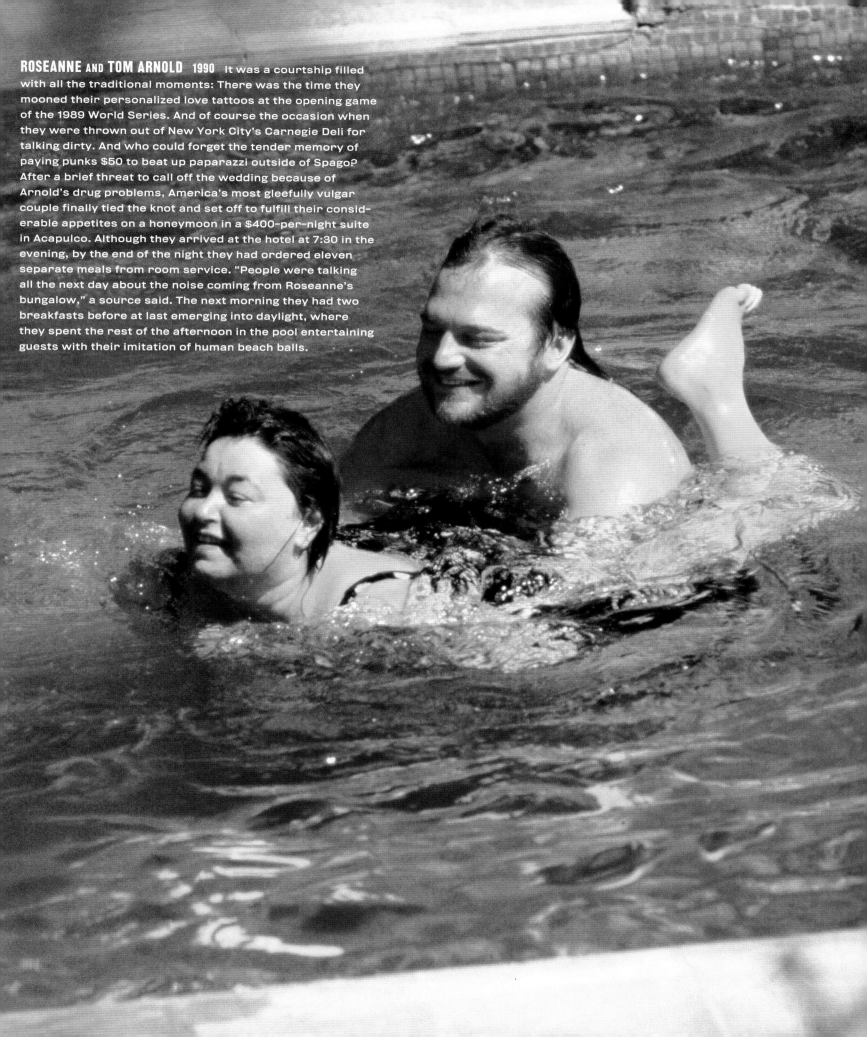

ROSEANNE AND **TOM ARNOLD** 1990 It was a courtship filled with all the traditional moments: There was the time they mooned their personalized love tattoos at the opening game of the 1989 World Series. And of course the occasion when they were thrown out of New York City's Carnegie Deli for talking dirty. And who could forget the tender memory of paying punks $50 to beat up paparazzi outside of Spago? After a brief threat to call off the wedding because of Arnold's drug problems, America's most gleefully vulgar couple finally tied the knot and set off to fulfill their considerable appetites on a honeymoon in a $400-per-night suite in Acapulco. Although they arrived at the hotel at 7:30 in the evening, by the end of the night they had ordered eleven separate meals from room service. "People were talking all the next day about the noise coming from Roseanne's bungalow," a source said. The next morning they had two breakfasts before at last emerging into daylight, where they spent the rest of the afternoon in the pool entertaining guests with their imitation of human beach balls.

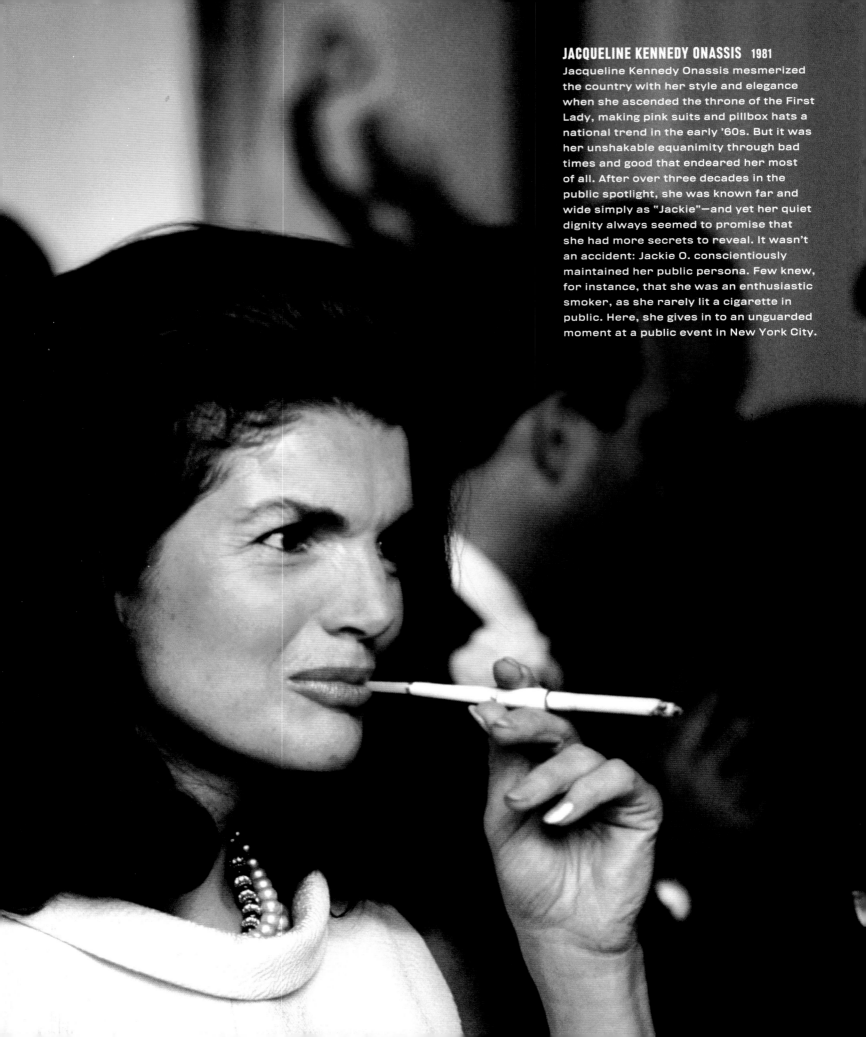

JACQUELINE KENNEDY ONASSIS 1981

Jacqueline Kennedy Onassis mesmerized the country with her style and elegance when she ascended the throne of the First Lady, making pink suits and pillbox hats a national trend in the early '60s. But it was her unshakable equanimity through bad times and good that endeared her most of all. After over three decades in the public spotlight, she was known far and wide simply as "Jackie"—and yet her quiet dignity always seemed to promise that she had more secrets to reveal. It wasn't an accident: Jackie O. conscientiously maintained her public persona. Few knew, for instance, that she was an enthusiastic smoker, as she rarely lit a cigarette in public. Here, she gives in to an unguarded moment at a public event in New York City.

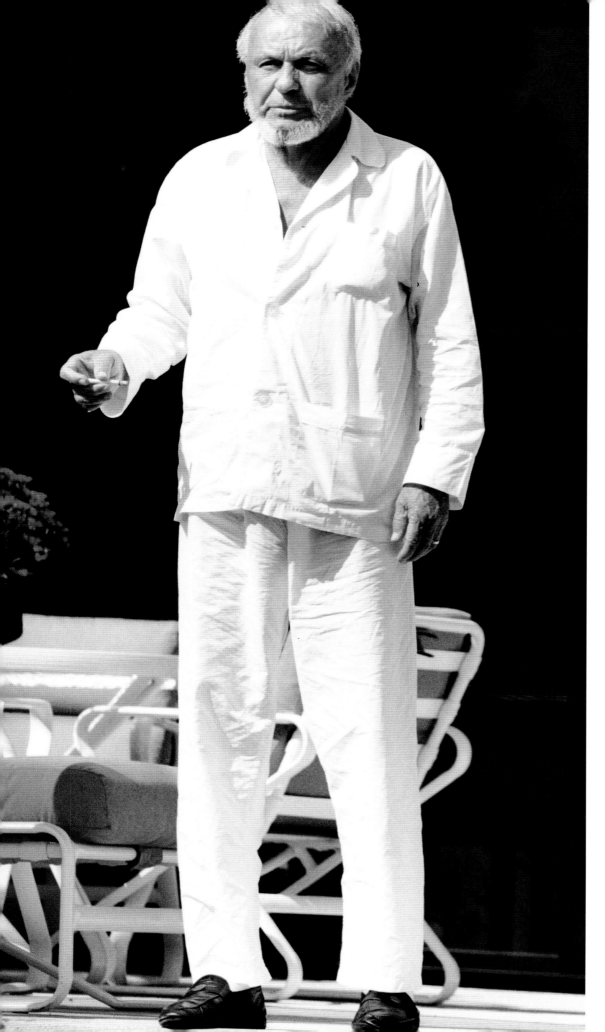

FRANK SINATRA 1996 "For me," Frank Sinatra once said, "a tuxedo is a way of life." Obviously, the Chairman of the Board decided that once you hit 80, casual Fridays every day of the week will suffice. Wracked in his later years by severe back pain, hearing loss, fading eyesight, heart failure, and cancer of the bladder, Sinatra had to hang up his penguin suit and put the decades of hell-raising and nightclubbing behind him. "Frank . . . can't remember the words to his songs," his wife, Barbara, confided to friends. Here, sporting a Caesar-like beard, the increasingly reclusive icon roams the grounds of his Malibu estate—and enjoys one of his few remaining pleasures, a cigarette. He succumbed to a heart attack on May 14, 1998.

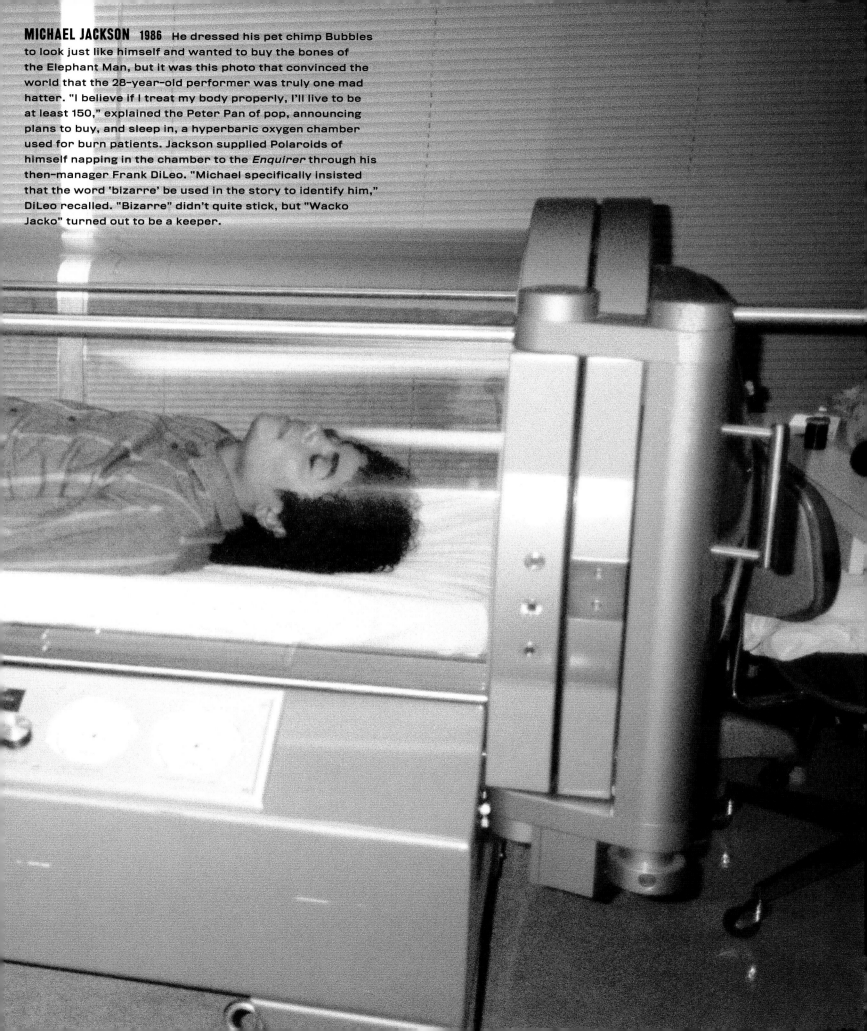

MICHAEL JACKSON 1986 He dressed his pet chimp Bubbles to look just like himself and wanted to buy the bones of the Elephant Man, but it was this photo that convinced the world that the 28-year-old performer was truly one mad hatter. "I believe if I treat my body properly, I'll live to be at least 150," explained the Peter Pan of pop, announcing plans to buy, and sleep in, a hyperbaric oxygen chamber used for burn patients. Jackson supplied Polaroids of himself napping in the chamber to the *Enquirer* through his then-manager Frank DiLeo. "Michael specifically insisted that the word 'bizarre' be used in the story to identify him," DiLeo recalled. "Bizarre" didn't quite stick, but "Wacko Jacko" turned out to be a keeper.

THE NATIONAL ENQUIRER: A TABLOID STORY

by Jonathan Mahler

Royal pains, movie stars, Hollywood murder mysteries, and hairy tales of Wacko Jacko. Just another news week—February 2, 1988—for the *National Enquirer*.

IN THE EARLY 1970S, when an Australian publishing tycoon by the name of Rupert Murdoch came to America—his tabloid sensibility in tow—the nation's arbiters of journalistic decorum were aghast. In no time at all, Abe Rosenthal, the executive editor of the ever august *New York Times,* had accused Murdoch of dirtying American journalism with his tabloid sleaze, of pandering to our proud nation's basest curiosities. The thing is, American journalism didn't need any help from Murdoch in that regard: It already had the *National Enquirer,* the greatest scandal sheet of them all—and a gloriously American creation to its core.

The *Times* may tell hundreds of thousands of Americans what they *need* to know, but the *Enquirer* tells millions of Americans what they *want* to know. The *Times* has its own street, Arthur Sulzberger Way, you say? Well, for thirty years (until a recent relocation) the *Enquirer* had its own zip code: 33464! Somewhere along the way, even the *Times* realized that it ignored the *Enquirer* at its peril; nowadays, the nation's most high-minded broadsheet frequently credits the nation's most beloved—and, yes, reviled—tabloid as the source for this or that story.

In the time-honored American tradition, the history of the *Enquirer* has been one of constant invention and reinvention. So it makes perfect sense that the paper's founding father, Gene Pope, was the child of immigrants. To understand Gene Pope, it is necessary to reach back a generation further, to Generoso Pope, Sr., whose insatiable hunger for power and success left an indelible imprint on his favorite son.

Generoso Pope was one of the most influential Italian-Americans of the century, a Horatio Alger with dark edges who came to New York on the S.S. *Madonna* in 1906 with little more than the loose change in his pocket and the shabby clothes on his back. Young Generoso got right to work shoveling dirt for a sand and gravel company, and before long he was shimmying his way up the company's ladder. His big break came several years later, when his employer was threatened with bankruptcy. Generoso engineered a plan to save it; soon, he owned the entire company. Before long, he had established an effective monopoly on Manhattan's sand and stone contracts.

But what Generoso really craved was power, and what better way to amass—and wield—it than to have his very own newspaper, a vehicle to bolster his allies and undermine

his enemies? So in 1928, he bought the largest Italian-American newspaper in the country, *Il Progresso Italo-Americano,* for $2 million. The following year, he paid a visit to Italy, where the onetime peasant was treated like royalty; he was even granted a private audience with Mussolini. So charmed was he by the once and future dictator that when Generoso returned to New York, he took up the cudgel on Mussolini's behalf, stubbornly championing his cause in *Il Progresso* and spearheading a lobbying campaign to persuade President Franklin Delano Roosevelt to remain friendly toward an increasingly fascist Italy. In 1941, he finally got around to publishing an editorial repudiating fascism. By then, however, Generoso had much bigger problems on his hands. The whispers about his unsavory business connections (read: Mafia ties) were growing louder. He was earning a name as a full-fledged gangster and racketeer.

So this was the world in which Generoso Pope's youngest son, Gene, was nurtured, a place where ambition loomed large and bad reputations came with the territory.

It was no coincidence that Generoso had named his third son after himself. From birth, Gene had been charged with the responsibility of carrying on the family legacy. Thus when he graduated from MIT in 1946 (at age 19!), Generoso named him editor of *Il Progresso,* even though that meant removing one of Gene's older brothers from the post.

Gene Pope, the publisher who turned a tiny New York City crime sheet into America's best-selling tabloid, alone reserved the right to use a red pen to correct galleys.

Generoso died a few years later, and young Gene's bright future grew dim. The acting mayor of New York City, Vincent Impellitteri, summoned him to City Hall to ask for *Il Progresso*'s endorsement in the upcoming mayoral race. Ordinarily, Pope would have been happy to oblige, but there was a complication. A big complication. Pope's godfather, the infamous Frank Costello, was backing Impellitteri's principal opponent. Pope could hardly be expected to cross one of his late father's closest friends, a man who had himself played no small role in building the family's empire. Pope politely declined Impellitteri's request. The future mayor went on a rampage, publicly accusing Pope of being in the pocket of the Mafia.

From here, things only got worse for Pope. Tired of watching the anointed son receive special treatment, his family took him off the masthead of *Il Progresso* and tried to relegate him to a junior position at the construction company. Refusing to suffer such an indignity, Pope quit the family business and moved out of their lavish Fifth Avenue apartment. He would remain estranged from his mother and brothers for the rest of his life.

Fortunately, Pope still had some rich and powerful friends, most notably Frank Costello. In 1952, Costello loaned him $25,000, interest-free, and Pope purchased a struggling weekly broadsheet called the *New York Enquirer* from William Randolph Hearst. (THWARTED MEDIA SCION DISOWNS FAMILY, BUYS OWN PAPER—WITH MOB MONEY!)

Even fifty years ago, $25,000 was not much for a weekly newspaper, but Pope may well have been ripped off. The *New York Enquirer*'s circulation was all of 17,000, and the vast majority of these "readers" bought the paper only for its racing tips. Its office was a dump. The air was thick and sour from years of cigarette smoke. Roughly half of its twelve manual typewriters worked.

Still, Pope had big dreams for his little paper. His first issue featured this lofty mission statement: "In an age darkened by the menace of totalitarian tyranny and war, the *New York Enquirer* will fight for the rights of man, the rights of the individual, and will champion human decency and dignity, freedom, and peace."

Pope knew how to run a newspaper. His father had been a newspaperman, so he had been born into the cloth. But building a *successful* newspaper, and from virtually nothing, was an altogether different matter. Pope managed to survive some severe hemorrhaging in those early years with more interest-free loans from Costello. The routine went something like this: Pope would borrow $10,000 from Costello, and the following week he would send his trusted lieutenant (Dino) out with an envelope full of cash from newsstand sales to meet Costello's right-hand man (Big Jim) at either the barbershop or the grill at the Waldorf-Astoria.

It was a symbiotic relationship. When newsstand dealers refused to carry the *New York Enquirer,* a ruffian named Mickey Zupa would persuade them to change their minds. In return, Pope did his share of favors for Costello. When the Mafia was running a numbers racket based on the Italian lottery, the *Enquirer* published the numbers. Then there was the case of Samuel Leibowitz, a judge who ran for mayor in 1953 on a platform that included a pledge to drive the mob out of New York: Pope assigned a reporter, Curly Harris, to write a three-part exposé on him. Pope also issued a standing order at his newspaper: The word "Mafia" was never to appear in its pages. It almost slipped through once, in the headline THE MAFIA IS A MYTH. Pope stopped the press midway through its run. Every copy that had been printed was destroyed.

The underworld's help not withstanding, Pope was having a hell of a time making his weekly viable. For a while, he believed the answer might be hard news, so when the Soviet Union invaded Hungary, he printed an additional ten thousand copies. Not one of them sold.

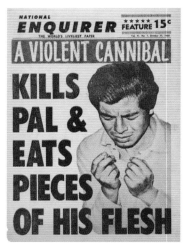

Throughout the '60s, real-life murders, lurid accounts of cannibalism, and horrifying urban myths were common themes that helped the *New York Enquirer* go national.

The muse finally fluttered down and perched on Pope's shoulder while he was driving home to New Jersey one evening in the late 1950s. The traffic, which had been flowing freely, suddenly slowed to a crawl. Pope crept along for a good hour before realizing what had been holding things up—people were rubbernecking at the scene of an auto accident. The following morning, Pope conveyed some very clear instructions to his photo editor. The next issue of the paper featured a page-one photo of a policeman clutching a decapitated head. The so-called Gore Era had begun. And sales? Houston, we have liftoff. In the reborn *New York Enquirer*—which was soon to become the *National Enquirer*—Americans had found the perfect antidote to the overweening "Ozzie and Harriet" optimism that held sway in the late '50s and early '60s. And wasn't this really what America was all about, anyway—democracy distilled, the discriminating consumer voting with his billfold? Gene Pope was the first newspaper editor in America to be driven solely and unabashedly by circulation.

Typical headlines during the infamous Gore Era looked something like this: A VIOLENT CANNIBAL KILLS PAL & EATS PIECES OF HIS FLESH. Or this: I CUT OUT HER HEART AND STOMPED ON IT! The stories tended to be short and graphic—newswire copy with pulp flourishes. In a couple of hundred words, you could learn about a boy smashing in his father's skull with a wooden board, rooting through the dead man's pockets for loose change, drinking up that loose change in a saloon, then, sober and full of remorse, begging the

judge to send him to the electric chair. (This particular story was illustrated with a photograph of the board and the blood-soaked bed.) Another hardy perennial during the Gore Era was the gross-out story with an ironic kicker: FAMILY EATS BARBECUED MEAT—FINDS IT WAS THEIR DOG. (But the butcher said it was ground round!) Or: HE CRASHES HEAD-ON INTO ANOTHER CAR AND KILLS DRIVER—HIS BROTHER. With this macabre formula, Pope managed to win over one million readers and take his paper—which he had already converted from a broadsheet to an easier-to-read tabloid—national.

By the late 1960s, though, the *Enquirer*'s circulation growth had stalled. The age of the old-fashioned news kiosk was drawing to a close. More and more Americans were buying their newspapers and magazines in the checkout lines of supermarkets and in drugstores, neither of which were eager to carry a publication with screaming banner headlines advertising lurid stories about hideous murders and gruesome accidents. Pope knew that if he wanted to continue to expand, it was time, once again, to reinvent his newspaper. The *National Enquirer* would have to become a family newspaper, or at least dress like one. Looking back on this moment a decade later, Pope explained that he wanted his paper to resemble *Reader's Digest*. "We bent over backwards to overcome the image of gore," Pope told a writer from *Forbes* magazine in 1978. He wanted stories that would inspire—the stuff of after-school specials, so-called gee-whiz journalism. So the *Enquirer* tacked hard toward what we now call human-interest features. Mystics, pop psychologists, UFO sightings, and tales of survival against impossibly long odds became standard fare in its pages. Out with the photos of headless horses. In with BEAT THE BLUES WITH VITAMINS, RANCHER'S 56 MEN ARE ALL RETARDED, and BURL IVES TELLS OF HIS EXPERIENCE WITH THE SUPERNATURAL.

After the *Enquirer* signed a five-year exclusive deal with the parents of the world's first surviving sextuplets, its enterprising editors arranged a special one-year portrait to commemorate the paper's relationship with the Rosenkowitz family.

Circulation dropped dramatically in the wake of the makeover. The *Enquirer* lost 250,000 readers in the span of just a few months, which was no small matter. Unlike most newspapers and magazines, the *Enquirer* has always sold relatively few subscriptions. Revenues came traditionally from copies bought at newsstands, not from advertisers. Pope held fast. Sure enough, in six months, the new, new *National Enquirer*'s circulation had climbed back up to one million. From there, it continued to soar. Pope had hit on another winning formula.

This time around, of course, there was one other critical ingredient: celebrity news. Pope had watched television saturate American culture, creating a new class of "stars," and he sensed a fresh appetite developing among Americans. Week by week, the *Enquirer*'s circulation numbers—an unimpeachable barometer of public taste—told the story: There was just no substitute for good celebrity dish. Soon, the *Enquirer* wasn't simply chasing celebrities, it was helping to create them. Over the next twenty years, the newspaper would develop an ever expanding ensemble cast of characters. Naturally, the ones who performed best on the newsstands turned up in the *Enquirer*'s pages most frequently—Sonny and Cher, Andy Gibb, Farrah Fawcett, Carol Burnett, Burt Reynolds, Gary Coleman, Loni Anderson, Kenny Rogers, Dolly Parton, Michael J. Fox, Vanna White, Jim and Tammy Faye Bakker, Michael Jackson. (Their contemporary heirs include O.J. Simpson, JonBenet Ramsey, Pamela Anderson, and

Monica Lewinsky. Taken together, they form a neat timeline of American obsession.) Along the way, the *Enquirer* branded its own type of star. How to define the *Enquirer* celebrity? He/she is human, vulnerable, flawed—the antithesis of the larger-than-life, mythic American hero, a distant cousin indeed of the silver-screen legends who had been canonized by *Life* in an earlier era. The new *Enquirer* was very much a product of its time, a creature of a disillusioned nation. America had outgrown idealization, and the *National Enquirer* served as a weekly reminder of that fact.

No story was ever too hot for the *Enquirer*'s action-hero reporters like Charlie Montgomery, who walked over a 12-foot-long bed of burning coals to get the scoop on "a California guru who specializes in building self-confidence."

The paper hit its stride in the mid-'70s. By then, Pope had already moved the *Enquirer* and its growing cadre of reporters, editors, and photographers to a one-story building with pebble walls in Lantana, Florida, a working-class community in the heart of Palm Beach County. Pope was a quintessential newsroom eccentric, an autocrat who inspired a combination of abject fear and fierce loyalty in his staff. He was known to walk the grounds of the *Enquirer* with a ruler, measuring the grass, which had to be precisely four inches high. His entire staff, from the top editors down to the lowliest cub reporters, referred to him as GP but addressed him as Mr. Pope. Prone to issuing sweeping edicts known as "papal decrees," Pope routinely fired reporters in bulk when they failed to break stories. The paper was his life. He was in his office marking up copy with a red pen (no one else was permitted to use red ink) seven days a week. A man of decidedly downscale taste, Pope shopped only at Sears and Kmart for his polyester blends. On weekends he'd leave his pants and loafers at home, donning a bathing suit and slippers instead. On occasion, he'd crank opera music in his office. Vacations? Out of the question. Once GP arrived in Florida, he simply refused to leave. Ever.

Pope paid his scribes handsomely, much better than most newspapers. In return, they were given one mandate: Deliver high-octane scoops. If that meant digging through Henry Kissinger's trash, literally, then so be it. If that meant dressing up as a llama to infiltrate a herd that was grazing near the site of Michael J. Fox's wedding, then so be it. If that meant posing as a priest at Bing Crosby's funeral, then so be it. (During the O.J. trial, one *Enquirer* reporter went so far as to start a local pool-cleaning business in order to gain access to O.J.'s backyard.) Pope also kept a safe in his office filled with cash, usually in excess of $100,000, for the sole purpose of acquiring stories. Reporters and photographers who were out on assignment always carried a couple thousand bucks in their pockets—a phone number might go for as little as $100, but they were allowed to pay up to $2,500 for an exclusive, no questions asked.

Not that $2,500 was always enough. Consider Elvis Presley's death in August 1977. Pope chartered a plane from Lantana to Memphis for the funeral. The *Enquirer*'s team took fifteen rooms at a Holiday Inn and installed special phone lines to ensure that no one could listen in on their conversations. It was a feeding frenzy; just about every media outlet in America had descended on Memphis to troll for stories. Getting an exclusive was not going to be easy—or cheap. The *Enquirer* staffers pooled their cash . . . then called home for more. Pope promptly sent his "bag man" up with an additional $25Gs. Meantime, the *Enquirer*'s reporters went to work compiling lists of Elvis's extended entourage, while systematically making their way through the local phone book. A photographer eventually happened across a teenage cousin of Elvis who was willing to cooperate. They gave him a small Instamatic camera, about the size of a pack of smokes, and $5,000, promising him more if he delivered. Elvis's body was already laid

out in Graceland, which was strictly off-limits to everyone outside the King's family. The kid walked in and snapped two pictures before a security guard told him to cut it out. Within a couple of hours, this distant cousin of Elvis was $18,000 richer—and the film was on its way to Lantana.

The now iconic print of Elvis in his coffin was splashed across the front page of the *Enquirer*'s next issue. More than six and a half million copies were sold, a tally that exceeds the circulation of the *New York Times,* the *Washington Post,* and the *Wall Street Journal* combined. (So legendary was this particular issue of the *Enquirer* that when Pope died more than ten years later, the *New York Post* headlined its obituary: NATIONAL ENQUIRER OWNER GOES TO MEET WITH ELVIS.) Pope was thrilled, if not exactly satisfied. He was determined to hit seven million every week. So in 1979, the year the paper went color, he launched the unforgettable television advertising campaign "Enquiring Minds Want to Know."

The pressure to get scoops was relentless, and if serving up an exclusive wasn't hard enough, *Enquirer* reporters often had to find ways to keep them exclusive for as long as two weeks, until the paper next went to press. Which brings us to Princess Grace. It was 1982, and the news had just broken that Grace had been in a car crash in Monaco—nothing serious, it seemed, just a broken leg. A stringer went to interview Grace's aunt at her home in Philadelphia. While the two were chatting over tea, the aunt's phone rang. It was a family member calling to deliver the news that Grace was brain dead; they were going to pull the plug on her life support. While the reporter was consoling Grace's hysterical aunt, he put in a call to the newsroom in Lantana. By that afternoon, nine *Enquirer* reporters were heading for Europe on a Lear jet, armed with notepads and $50,000 in cash. Pay whatever you must for the story, Pope told them, just stay out of the casinos with my money.

Sesto Lequio points to the spot where he helplessly watched the car carrying Monaco's Princess Grace and her daughter Stephanie tumble down the side of a cliff. The *Enquirer* paid Lequio, the first person on the scene, $15,000 for his account.

As it turned out, the princess had crashed in front of the home of a local gardener. An *Enquirer* reporter tracked him down and discovered that he had knelt beside the princess during her final moments of consciousness. He offered the gardener $15,000 for his story. The gardener agreed. Beautiful. But how were they going to ensure that he didn't talk to anyone else? Pope offered to send him anywhere in Europe (with two reporters as escorts), but he didn't want to go. Instead, he became a prisoner in his own home. Whenever the phone rang, an *Enquirer* reporter answered it. Whenever he needed groceries, an *Enquirer* reporter would fetch them. The gardener started to go mad, at one point loading his rifle and blowing a hole in his ceiling. Pope's staff calmed his frayed nerves with more money. The story was headlined, PLEASE TELL THEM I LOVE THEM ALL—Princess Grace's last words. Nearly six million copies were sold.

Five years later, the *Enquirer* broke its biggest story yet. The jockeying for the 1988 presidential primary had just begun, and rumors were circulating that one of the most promising Democratic aspirants, Gary Hart, had been having an affair. (Reality check: Fifteen years ago, this was considered big news. Honest.) Hart challenged the press to prove it. The *Enquirer* did. For $60,000, they managed to get their hands on a photograph of Hart with his girlfriend, Donna Rice, sitting on his lap. If that wasn't enough, Hart happened to be wearing a T-shirt that said "Monkey Business"—the name of the yacht that he and Rice were aboard when the picture was taken. The page-one photograph single-handedly torpedoed Hart's bid for the presidency.

It was a moment of triumph for Pope, a vindication of his approach to newspapering. What a cruel paradox, then, that the Gary Hart story has since come to symbolize the beginning of a uniquely trying era in the life of the *Enquirer*. The sharp line that had separated the tabloids from the so-called mainstream press—and in so doing had protected the *Enquirer* from competition—began to blur. The paper had done its job all too well.

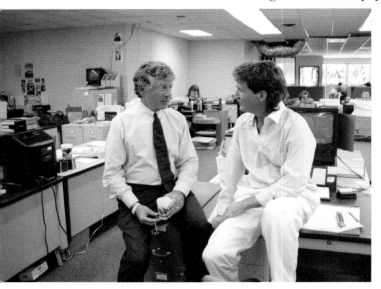

Nightline anchor Ted Koppel schmoozes David Perel, the editor in charge of the O.J. Simpson story, at the paper's Lantana offices while preparing a show devoted to the *Enquirer*'s pacesetting reporting on the crime of the decade.

Worse yet, Pope suffered a heart attack and died the following year. In 1989, the paper was sold in a silent auction for $412.5 million. Iain Calder, a gritty newspaperman from a small mining town in Scotland who had been Pope's long-time deputy, took the helm, guiding the paper through these difficult times. Circulation plummeted, and the *Enquirer* was left casting about to redefine its identity, to distinguish the paper from a mainstream media that suddenly seemed to have stolen its playbook. Salvation finally came in 1994, in the person of the greatest open-field runner in the history of the National Football League.

News editor Steve Coz assigned upward of twenty reporters to Team O.J. Led by a young editor named David Perel, they produced a breathtaking string of scoops. The *Enquirer* broke the story that O.J. had been heard yelling "I did it!" during a prison meeting with his minister, another famous ex-footballer named Rosey Grier. The *Enquirer* broke the story that O.J. had been stalking his ex-wife, Nicole Brown Simpson, for weeks before her murder. The *Enquirer* broke the story that the blood samples found in O.J.'s legendary white Bronco matched those of Nicole and Ron Goldman.

But the scoop that truly put the *Enquirer* on the map was the discovery that O.J. had bought a knife at an upscale cutlery store a few weeks before the murders. It started with a tip from a source at the LAPD. One of the *Enquirer*'s primary O.J. reporters, Alan Smith, questioned the alleged knife salesman, Jose Camacho, who said that it was not true. Other reporters had already been to see Camacho and had been met with the same response. But Smith was relentless. For ten days, he pestered Camacho about the knife, periodically assuring him that he would be well compensated for coming clean. Camacho finally caved, for $35,000. He even showed Smith an autograph that O.J. had given him on the day of the sale (O.J. told Camacho that he had a knife collection). Consider the irony: When confronted by reporters with no cash at their disposal, the knife salesman had lied. When offered a financial incentive to do so, he had told the truth. Even the staunchest critics of checkbook journalism had to scratch their heads.

In 1995, Coz, a fourteen-year veteran of the *Enquirer*, was named its editor-in-chief. The future of the weekly, as he envisioned it, lay in hard news. It was an unconventional notion. By the mid-1990s, most newspapers were cutting back on their investigative units, punching up their commitments to fluffy features instead. But Coz wanted to return the paper to its muckraking tradition. "Unlike magazines, we can't rely on setting scenes, creating mood, using alliteration, on playing with language," says Coz. "The *Enquirer*'s whole purpose is the explosion of a sledgehammer on an event." It's an apt description of the impact that the *Enquirer*'s biggest O.J. scoop—and, for that matter, one of the most sensational scoops of the decade—had on Simpson's 1997 civil trial, a story that turned on an innocent pair of Italian loafers.

During the criminal trial, Simpson had denied ever having owned a pair of Bruno Maglis—the designer shoes that had left bloody footprints at the scene of the murders. In the heat of the civil trial, the *Enquirer* set out to prove otherwise. Perel assigned as many as fifteen reporters to the task of looking through every photograph taken of Simpson during the year leading up to the murders, when O.J. was doing color commentary for professional football games. The vast majority of the pictures, of course, didn't go below O.J.'s belt, let alone down to his feet, but Perel insisted on an exhaustive search. ("I knew that this was the Holy Grail," as he puts it.) After several months of fruitless digging, an *Enquirer* reporter found a photographer for the Associated Press who had taken some shots of O.J. before a game. At the time, the photographer had just bought a new telephoto lens and wanted to experiment with it, so he took some full-length pictures of the ex–running back strolling

Time magazine named the *Enquirer*'s editor-in-chief, Steve Coz, one of the twenty-five most influential people in America for 1997. "Our role is to get to the truth of what these people who become icons are really like," he said.

through the end zone. One of them captured O.J. midstride—his Bruno Magli sole in plain view. Several shoe experts confirmed that this was, without a doubt, the same model of loafer that had left footprints at Nicole's house on the night of the murders. Photographic experts confirmed that the photo had not been doctored. More damning still, this was a rare make of Maglis: Only 300 pairs had been sold in the United States. The *Enquirer* story, and accompanying photo, became the key piece of evidence in O.J.'s civil conviction. One of O.J.'s criminal defense lawyers was heard breathing a sigh of relief when the story broke. "I'm just glad I didn't have to contend with that during the criminal trial," he muttered.

If the Gary Hart story had served as a sort of affirmation of the types of stories that had long been the bread and butter of the *Enquirer*, O.J.—and the Bruno Magli story in particular—represented a vindication for the newspaper itself. *Time* drove the point home in 1997, when it included Coz on its list of America's twenty-five most influential people. Reporters from the blue-chip news sources, the *New York Times* included, who had once turned up their noses at the *Enquirer*'s no-holds-barred approach to newspapering, now routinely found themselves chasing down stories first published in the weekly's pages. Moreover, each and every one of the *Enquirer*'s O.J. scoops turned out to be true. The paper's staff knew that their newfound credibility was hard-won. They had to be especially careful precisely because they were the *Enquirer*.

Alas, this new era of respectability was just beginning to grow roots at the *Enquirer* when the weekly received an unwelcome visit from its seamier past. Satisfying the national id carries a cost: Sometimes America becomes disgusted with its own appetites. When it does, the *Enquirer* invariably finds itself under attack. Princess Diana's fatal car accident in 1997 is a case in point. The echoes of the car wreck in New Jersey that spawned the paper's Gore Era are hard to ignore, only this time the end result was anything but inspiring. In the wake of Di's death at the hands of a drunk driver, the *Enquirer* was plunged into a period of crisis and soul-searching. The denunciations began the moment word surfaced that the paparazzi had been present at the scene of the crime. In short order, an endless parade of celebrities, many of whom had their own axes to grind with the *Enquirer*, were appearing on national TV, inveighing against the tabs. Did they have a point? Well, it is true that the issue of the *Enquirer* that was on newsstands when the princess died bore this unfortunate headline: SEX MAD DI: I CAN'T GET ENOUGH. But the tabloid backlash that followed the accident—a backlash that included death

threats leveled at a number of the paper's top editors—was as much about national self-loathing as anything else. The American public had gotten a glimpse of itself in the mirror, and it didn't like what it saw.

Anticipating America's tabloid cravings can be a complicated business, a fact underscored by Monica, the story that would, after a couple of false starts, eventually rescue the *Enquirer* from its Di doldrums. In addition to renewing the paper's focus on hard news, Coz aspired to push the *Enquirer* in a new direction: politics. Or, more precisely, politicians. Bill Clinton had given Washington some much needed sex appeal; for the first time since the gauzy days of JFK and Camelot, Americans wanted to read about the lives of the people who were running the country. In the case of the incorrigible William Jefferson Clinton, there was plenty to read.

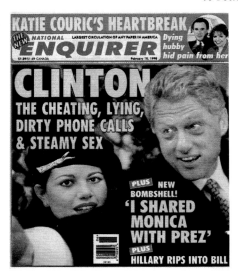

The tabloids and the mainstream media collided when *Time* and the *Enquirer* both ran the infamous photo of Clinton and Lewinsky as a cover exclusive.

It seems logical, then, to assume that the tawdry story of an intern performing fellatio on the American president—and in the Oval Office!—should have been instant pay dirt, a tailor-made story for the *Enquirer*. On the contrary. Enduring misconceptions notwithstanding, the *Enquirer* is a conservative newspaper; its readership embodies a staunchly middle-class morality. Thus, when Monicagate first broke, *Enquirer* readers were still inclined to give their president the benefit of the doubt. Coz learned this the hard way. After running a few articles on Monica during the early days of the scandal, the paper was flooded with angry letters from readers. The *Enquirer* dropped the story.

In a few months' time, however, the landscape had changed. It was now abundantly clear that President Clinton had behaved badly and lied to the nation. The vast majority of the American public felt betrayed, and it was no longer necessary, or for that matter possible, to protect Clinton. The *National Enquirer* jumped back in. Something else, too, was now working in the paper's favor: Hillary, formerly a bit player in the scandal, had given the story an extra dimension. Neither Bill—the irrepressible cad—nor Monica—the clingy intern—had offered an emotional hook for *Enquirer* readers. They didn't feel invested in the story. But with the entrance of the cuckolded yet stubbornly loyal wife, the triangle was complete. "Once Hillary got involved, it became a Greek tragedy," says Coz. "You've got the most powerful man in the world, filled with rogue charm. You've got the intelligent woman, the driven queen. And then you've got the tart." The tabloids and the mainstream media had again collided. *Time*, the quintessential Establishment magazine, bought the famous photo of Bill and Monica in a crowd and, to help defray the cost, licensed it to the *Enquirer*, the great American tabloid. The picture ran on the cover of both publications. The transformation that had begun with the Gary Hart story had reached its apotheosis.

In 1999, the *Enquirer* changed hands. David Pecker and Evercore Capital Partners bought the *Enquirer,* the *Star,* and several related media properties for $835 million. Pecker, the former CEO of Hachette Filipacchi Magazines, became chairman and CEO of the tabloids. He and his partners at Evercore, primarily venture capitalist Austin Beutner, invested $50 million in an expansion that included a redesign, an advertising campaign, and a New York bureau. The paper placed an even greater emphasis on its investigative efforts, and the results have already been plain to see. The *Enquirer* was the first to report that Michael Skakel, a member of the Kennedy family, had allegedly confessed to his role in the murder of his Greenwich, Connecticut, neighbor, Martha Moxley. It was the first to report that Clinton's brother-in-law,

Hugh Rodham, had taken $200,000 to lobby for a last-minute pardon for a wealthy health-care-company owner who had been convicted of perjury and mail fraud. And it was the first to report that the Reverend Jesse Jackson, the self-appointed conscience of America, had fathered a child out of wedlock.

Like many of the *Enquirer*'s scoops, the Jesse Jackson story, which broke in early 2001, began with a tip, this one passed along to the paper's hard-charging New York bureau chief, Barry Levine. A handful of *Enquirer* staffers worked the story for several weeks before turning up the name of the mother, Karin Stanford, a former professor at the University of Georgia, who was now living in Los Angeles. The next step was to start building a profile of Stanford. The *Enquirer* discovered that she had written an academic book on Jesse's views on foreign policy, and that she had once worked for the reverend in the Washington office of his Rainbow Coalition. Next the *Enquirer* started talking to some of Stanford's friends: She did have a child, and she was not married. It was not an easy story to nail down, in part because the *Enquirer* kept getting thrown off the scent by other stories of Jesse's flirtations with various women.

Levine decided it was time for one of his reporters, Pat Shipp, to "door-knock" Stanford at her home in L.A. Stanford wouldn't confirm the story. More to the point, though, she didn't deny it. The *Enquirer* had also learned that Jesse's affair with Stanford had put a considerable strain on his marriage, so Levine directed a reporter to approach Jesse's wife. She, too, declined to confirm—or deny—the story. A close friend of Stanford's agreed to fill in some of the blanks. But the *Enquirer* still wanted a shot of Stanford and Jesse together. Within a few days they had found one, an official White House photo, taken in the Oval Office—with President Clinton—four or five months into Stanford's pregnancy. At the time of the photograph, Jesse was giving Clinton "spiritual counseling" on the president's indiscretions with Monica. On Thursday evening, January 18, 2001, Tom Brokaw, Dan Rather, and Peter Jennings—America's three voices of record—all led their broadcasts with reports on Jesse's love child.

When David Pecker, a New York magazine executive, was chosen to oversee the *Enquirer* in 1999, he vowed to restore its reputation as "the magazine with the guts to tell it like it is."

It's hard to imagine Walter Cronkite soberly telling the nation about the extramarital sex life of one of its most respected spiritual leaders. But we're living in a different country today, one in which it would be considered irresponsible for news organizations *not* to do so. Whether this is a transformation that ought to be celebrated (the people's taste prevails!) or lamented (is nothing sacred?) remains an open question. One thing is certain, though: It's a change that would not have taken place without the *National Enquirer*.

PHOTOGRAPH CREDITS

PAGE 1: Parker/Alpha/Globe Photos. PAGE 2: Corbis Sygma. PAGE 6: Andy Hayt. PAGE 12: Brian Strickland. PAGE 14: Thorpe/Getty Images. PAGE 15: Carroll/Corbis Sygma. PAGE 17: Zuma Press. PAGE 18: Jeff Werner/IncredibleFeatures.com. PAGE 19: Allen/Corbis. PAGE 20: Harry Scull. PAGE 21: *National Enquirer.* PAGE 22: Karnbad/Celebrity Photo. PAGE 23: Mirror Syndication International. PAGE 24: *National Enquirer.* PAGE 25: *National Enquirer.* PAGE 26: Willows/Sipa Press. PAGE 27: Skinner/ Celebrity Photo. PAGE 30: Stewart Cook. PAGE 31: AP/Wide World Photos. PAGE: 32: Robin Nelson. PAGE 33: Bettmann/Corbis. PAGE 34: John Osborne. PAGE 36: Ken Sparks. PAGE 38: Gough/California Features. PAGE 39: DMI/TimePix. PAGE 40: Joyce Silverstein. PAGE 41: Rochelle Law. PAGE 42: *National Enquirer.* PAGE 43: Chris Bell. PAGE 44: Corbis Saba. PAGE 45: Getty Images. PAGE 46: Betty Burke Galella/Ron Galella, Ltd. PAGE 47: © Gene Spatz. PAGE 48: Downie/Celebrity Photo. PAGE 49: Lari/Corbis Sygma. PAGE 50: Young/Rex USA. PAGE 51: Courtesy of Cindy Landon. PAGE 52: Richard Corkery/New York Daily News. PAGE 53: Hudson/Corbis Sygma. PAGES 54-55: Bettmann/Corbis. PAGE 56: Davila/Retna. PAGE 57: Scope/Rex USA. PAGE 58: Renault/Globe Photos. PAGE 59: Campbell/Globalphoto/Getty Images. PAGE 60: Adam Butler/PA Photos. PAGE 61: Eliot Press. PAGE 62: Leivdal/Shooting Star. PAGE 63: Steve Hodgson. PAGE 64: Joe DiMaggio. PAGE 65: Buckmaster/Retna. PAGE 66: Karnbad/Michelson Photo Agency. PAGE 67: Ron Galella. PAGE 68: Clockwise from top left: Thomas/Sipa Press, Wolfson/London Features, Ramey Photo Agency, Winter/Celebrity Photo Agency. PAGE 69: Ramey Photo Agency. PAGE 70: Pool Photo/Palm Beach Post. PAGE 71: AP/Wide World Photos. PAGE 74: Judie Burstein. PAGE 75: Greg Mathieson/MAI. PAGE 76: Razlikli/ Sipa Press. PAGE 77: Kiriacou/ Rex USA. PAGES 78-79: *Left to right, top to bottom:* Judie Burstein, Decker/Michelson Photo Agency, Dave Hogan/Rex USA, Starr/Corbis Saba, Corbis Sygma, McBroom/Globe Photos, Allan Adler, Lopinot/Corbis Sygma, AP/Wide World Photos, No credit, Jeffrey Ballard, Tom Strickland, John Roca, Montfort/Globe Photos. PAGE 80: Holz/Michelson Photo Agency. PAGE 81: *National Enquirer.* PAGE 82: Peter Borsari. PAGE 83: Davila/Retna. PAGE 84: Jeff Werner/IncredibleFeatures.com. PAGE 85: Bettmann/Corbis. PAGE 86: Pacific Publications. PAGE 87: Arroyo/Celebrity Photo. PAGES 88-89: Ramey Photo Agency. PAGE 90: Rickerby/Sipa Press. PAGE 91: Rousseau/PA

Photos. PAGE 92: Jeff Werner/IncredibleFeatures.com. PAGE 93: Allan Adler. PAGE 94: Jeff Werner/IncredibleFeatures.com. PAGE 95: Hank Delespinasse. PAGE 96: DeGuire/Celebrity Photo. PAGE 98: Aylott/Getty Images. PAGE 100: Tazio Secchiaroli. PAGE 101: Nieh/Globe Photos. PAGE 102: Johnson/Hutchins Photo Agency. PAGE 103: Niko-Hadj/Sipa Press. PAGE 104: DeGuire/Ron Galella, Ltd. PAGE 105: Holz/Michelson Photo Agency. PAGES 106-107: Henry Grossman. PAGE 108: Jeff Werner/IncredibleFeatures.com. PAGE 109: Steve Pope. PAGE 110: Nikos Vinieratos. PAGE 111: Jim Selby. PAGE 112: Schwartzwald/Getty Images. PAGE 113: Schwartzwald/Getty Images. PAGE 114: Karnbad/Michelson Photo Agency. PAGE 115: Bettmann/Corbis. PAGE 116: Haroun/Alpha/Globe Photos. PAGE 117: Rex USA. PAGE 118: Pele/Retna. PAGE 119: Scope/Rex USA. PAGE 120: Icon Images. PAGE 121: Michelson Photo Agency. PAGE 122: Prouser/Sipa Press. PAGE 123: Elkouby/Michelson Photo Agency. PAGE 124: Whitby/Sportsphoto. PAGE 125: Andrea Venturini. PAGE 128: Mike Sergieff. PAGES 130-131: EFE/Sipa Press. PAGE 132: Jack Lakey. PAGE 133: Fairall/Photoreporters/Ipol. PAGE 134: Ramey Photo Agency. PAGE 135: Ramey Photo Agency. PAGE 136: Peter Borsari. PAGE 137: Ralph Crane for *National Enquirer.* PAGE 138: Richard Corkery/New York Daily News. PAGE 139: Holz/Michelson Photo Agency. PAGE 140: Shell/Ron Galella, Ltd. PAGE 142: Ramey Photo Agency. PAGE 143: Ramey Photo Agency. PAGE 144: Joel Rieman. PAGE 145: Downie/Celebrity Photo. PAGE 146: Ortega/Celebrity Photo. PAGE 147: Scott/Celebrity Photo. PAGES 148-149: Fame Pictures. PAGE 150: *National Enquirer.* PAGE 151: *National Enquirer.* PAGE 152: Mark Perlstein. PAGE 153: Raul DeMolina. PAGE 154: DMI/TimePix. PAGE 155: Peter Borsari. PAGE 156: Irvine/Zuma Press. PAGE 157: Downie/Celebrity Photo. PAGE 158: Jeff Werner/IncredibleFeatures.com. PAGE 160: Neil Leifer. PAGE 162: Catherine A. Brown. PAGE 163: Vai/Celebrity Photo. PAGE 164: The Express Syndication. PAGE 165: Tom King. PAGE 166: Six Flags Marine World. PAGE 167: Globe Photos. PAGE 168: Campbell/Sipa Press. PAGE 169: Alba Productions. PAGE 170: Cisotti/Deidda/Matrix. PAGE 171: Young/RDR/Rex USA. PAGES 172-173: *National Enquirer.* PAGE 174: Volland/Celebrity Photo. PAGE 175: Wireimage.com. PAGE 176: Rodriguez/Globe Photos. PAGE 177: Doughton/Michelson Photo Agency. PAGE 178: Reavley/Matrix. PAGE 179: Reuters/Jaffe/Hulton Archive/Getty Images. PAGES 180-181: *Left to right, top to bottom:* Paschal/Celebrity Photo, Tammy Arroyo, Gough/Celebrity Photo, Hutchins/ Hutchins Photo Agency, Finn/Alpha/Globe, Gene Spatz, Steve

Granitz/Celebrity Photo, Prouser/Sipa Press, Tammy Arroyo, Joyce Silverstein, Greg Pace, Barrett/Globe Photos, Alpha/Globe Photos, Flores/Celebrity Photo, Downie/Celebrity Photo, Scott/Celebrity Photo, Smith/Featureflash/Retna, Peter Borsari, Rex USA, Skinner/Celebrity Photo, Marzella/Retna. PAGE 182: Zasi. PAGE 183: AP/Wide World Photos. PAGE 184: Laski/Sipa Press. PAGE 185: AP/Wide World Photos. PAGE 186: Arthur Pollock/Boston Herald. PAGE 187: Pool Photo/Globe Photos. PAGE 188: *National Enquirer.* PAGE 189: AP/Wide World Photos. PAGES 190-191: Atlantic Syndication/Daily Mail. PAGE 192: Fraser/Sipa Press. PAGE 193: Fame Pictures. PAGE 194: Zaourar/Sipa Press. PAGE 195: Gough/California Features. PAGE 196: Corbis Sygma. PAGE 197: Mickelson/Michelson Photo Agency. PAGE 198: Karnbad/Michelson Photo Agency. PAGE 199: Skinner/Celebrity Photo. PAGE 200: AFP Photo. PAGE 201: Gerber/Corbis. PAGE 202: Artault/Gamma. PAGE 203: Andanson, Nogues/Corbis Sygma. PAGE 204: Alan Zanger. PAGE 205: Sammie Mays. PAGE 206: Ramey Photo Agency. PAGE 208: Thomas Hinton. PAGE 209: Bob Aylott/ Fleetstreetpictures.com. PAGE 210: Renault/ Globe Photos. PAGE 211: AP/Wide World Photos. PAGE 212: *National Enquirer.* PAGE 213: *National Enquirer.* PAGE 214: Gough/California Features. PAGE 216: Hulton Archive/Getty Images. PAGE 216: Oscar Abolafia. PAGE 217: Oscar Abolafia. PAGES 218-219: AP/Wide World Photos. PAGE 220: Zuma Press. PAGE 221: Snowden/Camera Press/Retna. PAGE 222: Granitz/Retna. PAGE 223: Judie Burstein. PAGES 224-225: *Left to right, top to bottom:* Corbis Sygma, AP/Wide World Photos, Fame Pictures, *National Enquirer,* Bettmann/Corbis, Boston Herald/Corbis Sygma, *National Enquirer,* Noel/Corbis Sygma, Ryba/ Globe Photo, Corbis Sygma, *National Enquirer,* Ramey Photo Agency, UK Press, Holz/Michelson, AP/Wide World Photos, Renault/Globe Photos, AP/Wide World Photos, Kuno/Getty Images, Ramey Photo Agency, *National Enquirer.* PAGE 227: Granitz/Celebrity Photo. PAGE 228: Laszlo/Retna. PAGE 229: Lisa Smith. PAGE 230: Vincent Eckersley. PAGE 231: Williams/Shooting Star. PAGE 232: PA Photos. PAGE 233: Ron Galella. PAGE 234: Christensen/ Sipa Press PAGE 235: Bob Tillman. PAGE 236: AP/Wide World Photos. PAGE 237: Hulton Archive/Getty Images. PAGE 238: Leshay/PHOTOlink. PAGE 239: Alec Byrne. PAGE 240: Oscar Abolafia. PAGE 241: Fame Pictures. PAGES 242-243: *National Enquirer.* PAGES 244-250: *National Enquirer.* PAGE 251: Harry Scull. PAGES 252-254: *National Enquirer.* PAGE 256: *National Enquirer.*

ABOUT THE AUTHORS

CHARLES MELCHER is the publisher of Melcher Media, an award-winning producer of illustrated books.

VALERIE VIRGA has served as the *Enquirer*'s senior photo director since 1990; in addition, she has recently been named president of the American Media book division.

STEVE COZ, after 14 years as a reporter and six years as the editor-in-chief of the *National Enquirer,* was recently named the executive vice-president and editorial director for all American Media publications, including the *National Enquirer*, the *Star*, the *Globe, Country Weekly,* and *¡Mira!.* A graduate of Harvard University, he regularly appears on TV and radio news programs.

DAVID KEEPS is a freelance writer who has contributed to such publications as the *New York Times, GQ, Rolling Stone, Elle, Architectural Digest,* and *Teen People,* among others. He is the co-author of *All-American: A Tommy Hilfiger Style Book* and is currently a contributing editor at *US Weekly.*

JONATHAN MAHLER is a contributing writer and founding editor of *Talk* magazine. In addition to his work for *Talk,* he writes articles, reviews, and essays for the *New York Times,* the *Wall Street Journal,* and the *New Republic.* He is currently working on his first book, which is about New York and baseball in the 1970s.

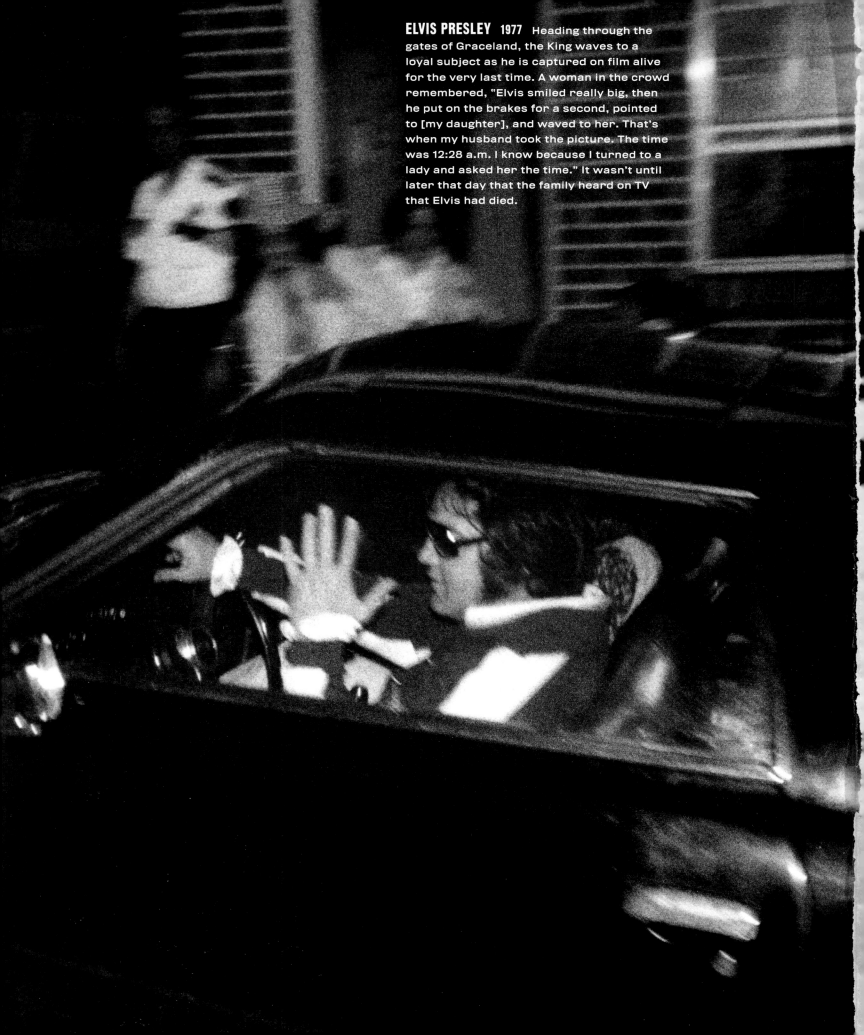

ELVIS PRESLEY 1977 Heading through the gates of Graceland, the King waves to a loyal subject as he is captured on film alive for the very last time. A woman in the crowd remembered, "Elvis smiled really big, then he put on the brakes for a second, pointed to [my daughter], and waved to her. That's when my husband took the picture. The time was 12:28 a.m. I know because I turned to a lady and asked her the time." It wasn't until later that day that the family heard on TV that Elvis had died.